Monet
THE EARLY YEARS

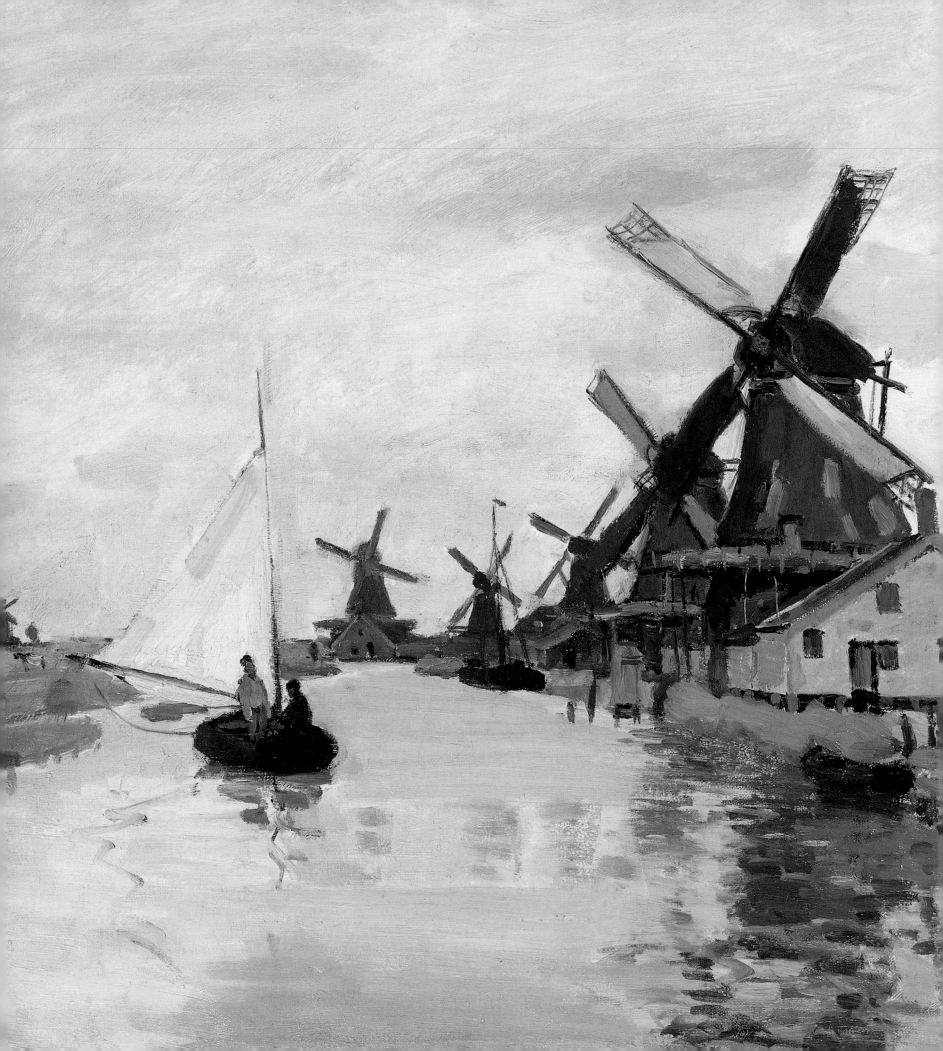

Monet

THE EARLY YEARS

George T. M. Shackelford

With essays by
Anthea Callen
Mary Dailey Desmarais
Richard Shiff
Richard Thomson

Kimbell Art Museum

Distributed by Yale University Press, New Haven and London

The exhibition is organized by the Kimbell Art Museum, Fort Worth,
in collaboration with the Fine Arts Museums of San Francisco.

The Kimbell Art Museum's presentation of the exhibition is supported by
a grant from the Leo Potishman Foundation, JPMorgan Chase, Trustee.

The Fine Arts Museums of San Francisco's presentation of the exhibition
is made possible by presenting sponsor Diane B. Wilsey.

The exhibition is supported by an indemnity from the
Federal Council on the Arts and the Humanities.

Exhibition dates:
Kimbell Art Museum, October 16, 2016–January 29, 2017
Fine Arts Museums of San Francisco, February 25–May 29, 2017

Kimbell Art Museum
3333 Camp Bowie Boulevard
Fort Worth, Texas 76107-2792
www.kimbellart.org

Yale University Press
302 Temple Street
P.O. Box 209040
New Haven, Connecticut 06520-9040
www.yalebooks.com/art

Produced by the Publications Department of the Kimbell Art Museum
Megan Smyth, Manager of Publications
Mark Krauter, Designer

Printed in Italy by Elcograf

ISBN
Softcover: 978-0-912804-55-2
Hardcover: 978-0-300221-85-5

Details: FRONT COVER: *The Red Kerchief* (cat. 12); BACK COVER: *The Bridge at Bougival* (cat. 33); FRONTISPIECE: *Windmills in Holland* (cat. 43);
PAGE 68: Étienne Carjat, *Portrait of Claude Monet*, c. 1864, photograph. Private collection; PAGES 80–81: *Red Mullets* (cat. 29);
PAGE 207: *Still Life with Flowers and Fruit* (cat. 28)

Contents

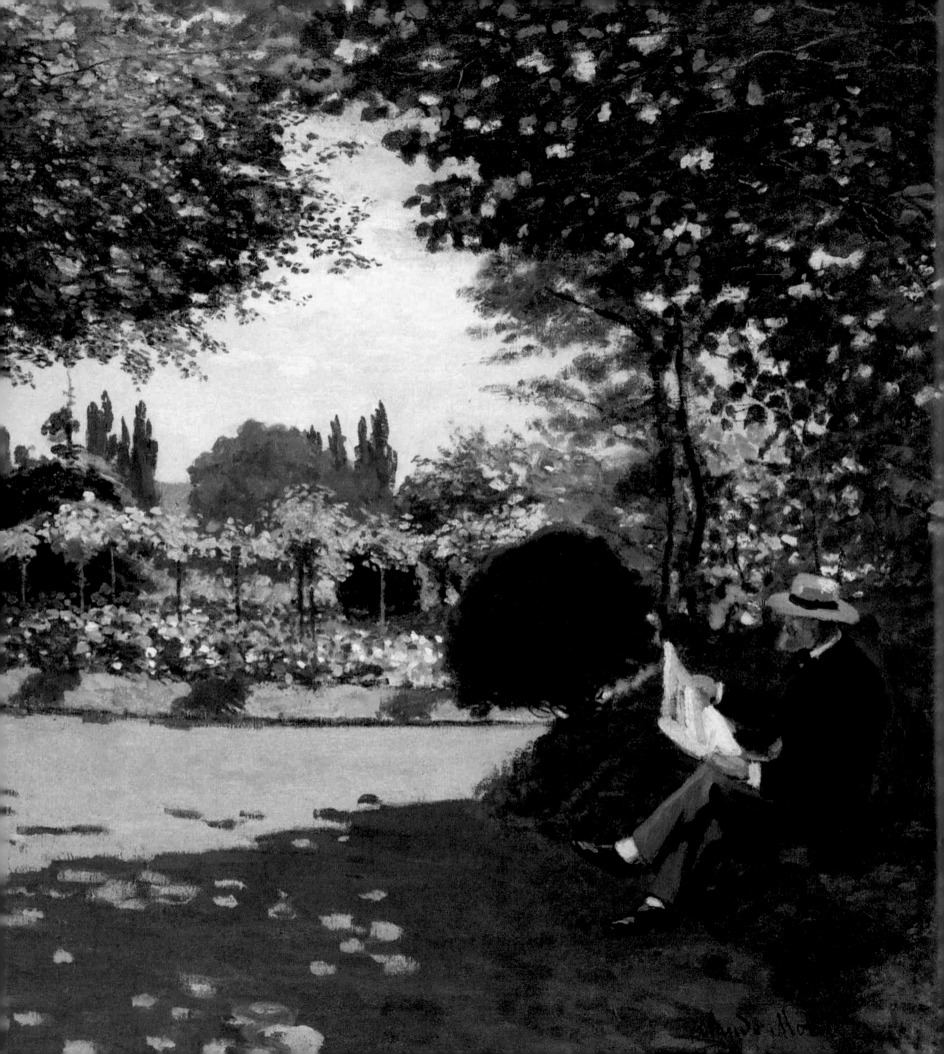

Foreword

In 2014, a plan was sparked at the Kimbell Art Museum to bring together an exhibition about the early work of Claude Monet, exemplified in the museum's collection by the great *Pointe de la Hève, Low Tide*. Presented to the public for the first time at the Salon of 1865—Monet's first submission to the Salon—the painting was acquired a little more than a century later by the Kimbell Art Foundation, some five years before the museum opened its doors in 1972. The Fine Arts Museums of San Francisco emerged as an ideal partner, given their longstanding commitment to exhibitions and scholarship surrounding nineteenth-century French painting. *Monet: The Early Years* is the first of two exhibitions planned to investigate the chronological extremes of the artist's sixty-year-long career; *Monet: The Late Years* will be shown, also in partnership with San Francisco, in two years' time.

The Kimbell Art Museum and the Fine Arts Museums of San Francisco take great pleasure in presenting this exhibition as a chance to discover in depth that period in Monet's art when, with energy, assurance, and even bravery, he set out in search of a new path for modern painting. Although individual masterworks from this first decade of work are among the artist's most famous paintings—*Luncheon on the Grass*, for example—there has never before been an exhibition focusing exclusively on this period. We believe *Monet: The Early Years* will be a revelation to our visitors, even to those who think they know Monet well.

We would like to thank George T. M. Shackelford, deputy director of the Kimbell Art Museum, who has been the organizing curator of the exhibition, and whose conversation with Eric Lee in 2014 set this project on its path to fruition. With the collaboration of Esther Bell, curator in charge of European paintings at the Fine Arts Museums of San Francisco, George has selected the works on view and has secured the cooperation of many people across the world to bring the show and its catalogue into being. To them, to their many colleagues at both our museums, and to the scholars who have contributed to this impressive volume, we offer our profound thanks.

The Kimbell would like to thank Kay and Ben Fortson and the Board of Directors of the Kimbell Art Foundation for their unfailing support of the project and would like to acknowledge the grant from the Leo Potishman Foundation, JPMorgan Chase, Trustee. The Fine Arts Museums of San Francisco would like to thank Diane B. Wilsey, the presenting sponsor at the Legion of Honor, along with their Board of Trustees. The Federal Council on the Arts and the Humanities, which granted the exhibition an indemnity, is gratefully acknowledged; special thanks are due to Patricia Loiko, indemnity administrator.

Of course, the success of an exhibition depends on the quality of the works of art it presents. Thus we owe the utmost debt of gratitude to the lenders—both public institutions and private collectors—who have agreed to part with their masterworks for the duration of the exhibition. A particular debt is owed to the Musée d'Orsay, Paris, and its president, Guy Cogeval, for the unparalleled loan of eight paintings from their collections. Thanks to the generosity of all these people, this exhibition can tell the story of Monet's early years as never before.

Eric M. Lee
Director
Kimbell Art Museum

Max Hollein
Director
Fine Arts Museums of San Francisco

Claude Monet, *Adolphe Monet Reading in a Garden* (detail), cat. 23

Acknowledgments

I would like to first extend my deepest gratitude to the collectors, directors, curators, and scholars who have so generously facilitated the loans of the works that have made this beautiful and groundbreaking exhibition possible, and who have graciously shared their knowledge of Monet and his world. In particular, I would like to thank William Acquavella, Cassandra Albinson, David Anderson, Christoph Becker, Jonathan Binstock, Richard Brettell, Caroline Campbell, Thomas P. Campbell, Patrick de Carolis, Keith Christiansen, Alan Chong, Cyanne Chutkow, Michael Clarke, Guy Cogeval, Penelope Curtis, Philipp Demandt, Andria Derstine, Frouke van Dijke, Walter Elcock, Larry Ellison, Ella Elphick, Jeremiah Evarts, Bernard Fibicher, Gabriele Finaldi, Michael Findlay, Hartwig Fischer, Anne-Birgitte Fonsmark, Flemming Friborg, Davide Gasparatto, Ann and Gordon Getty, William M. Griswold, Gloria Groom, James Harwood, Deborah Hatch, Kimberly Jones, Laurence Kanter, Daniel Katz, Natasha Khandekar, Udo Kittelmann, Mr. and Mrs. William I. Koch, Felix Kraemer, Paul Lang, Catherine Lepdor, Stuart Lochnan, Thomas Loughman, Laurence Madeline, Jean-Yves Marin, Marianne Mathieu, Marc Mayer, Margaret McDermott, Olivier Meslay, Sally Metzler, Adrien Meyer, the late Charles S. Moffett, Mary Morton, David Nash, Nicole Myers, Otoyo Nakamura, Nancy Norwood, Maureen O'Brien, Line Clausen Pedersen, Paul Perrin, Anabelle Ponka, Clarissa Post, Timothy Potts, Earl A. Powell III, Mrs. Joseph Pulitzer, Richard Rand, Xavier Rey, Jock Reynolds, Joseph P. Rishel, William Robinson, James Rondeau, Timothy Rub, Luísa Sampaio, Simon Shaw, Amanda Shore, Olivier Simmat, John W. Smith, Susan Alyson Stein, Susan Strickler, Charles F. Stuckey, Kurt Sundstrom, Katsushige and Narumi Susaki, Martha Tedesco, Benno Tempel, Jenny Thompson, Oliver Tostmann, Paul Hayes Tucker, Roxana Velásquez, and Victoria Zoellner. I am grateful as well to those who wish to remain anonymous and to those who have been inadvertently omitted.

At the Kimbell Art Museum, I want to thank the Board of Directors, led by Kay Fortson, for their support of the exhibition. In addition, thanks are due to our museum director, Eric M. Lee; Brenda Cline, executive vice president and chief financial officer of the Kimbell Art Foundation; Susan Drake, deputy director of finance and administration; Claire Barry, director of conservation, with Rafael Barrientos; Patricia Decoster, collections manager and registrar, with Samantha Sizemore and Shelly Threadgill; Jessica Brandrup, head of marketing and public relations, with Claire Lukeman and Madison Ladd; Robert McAn, membership and special events manager, with Ann Huffman; Angie Bulaich, head of corporate partnerships; Larry Eubank, operations manager, with Jesse Hernandez, Bert Herrington, Cory Ottinger, and Rickey Honaker; Connie Hatchette-Barganier, education manager; Liz Johnson, executive assistant to the director; Robert LaPrelle, photographer; Gary Yawn, visitor services manager; Megan Smyth, manager of publications; Mark Krauter, designer; Regina Palm, curatorial assistant; and fellow curators Jennifer Casler-Price and Nancy E. Edwards.

The Fine Arts Museums of San Francisco wish to thank the president of our Board of Trustees, Diane B. Wilsey, along with all of the other members of the Board; Max Hollein, director; Richard Benefield, deputy director and chief operating officer; Julian Cox, chief curator and founding curator of photography; Sabri Ozun, interim chief financial officer; and Esther Bell, curator in charge of European Paintings, for their dedicated support of the presentation in San Francisco. Further gratitude is extended to others at the Museums, including Krista Brugnara, director of exhibitions, and Hilary Magowan, senior exhibitions coordinator; Melissa Buron, associate curator of European Paintings; Elise Effmann Clifford, head paintings conservator; Abigail Dansiger, research librarian; Leslie Dutcher, director of publications; Deanna M. Griffin, director of registration and collections; Stuart Hata, director of retail operations; Tomomi Itakura, head of exhibition design; Susan Klein, director of marketing and communications; Dan Meza, chief designer and art director; Lisa Podos, director of advancement and engagement; Sheila Pressley, director of education; and all of their talented staffs that make all of our programs possible. Our presentation has been graciously supported by Diane B. Wilsey, our presenting sponsor.

The exhibition at both venues is further supported by an indemnity from the Federal Council on the Arts and the Humanities.

Finally, I would like to thank the scholars who have contributed such insightful and engaging essays to the catalogue: Mary Dailey Desmarais, Anthea Callen, Richard Shiff, and Richard Thomson. Their writing enriches this groundbreaking exhibition and gives form to the young genius and power of self-invention of one of the world's best-known artists.

George T. M. Shackelford
Deputy director, Kimbell Art Museum,
and curator of the exhibition

Lenders to the Exhibition

Canada
VKS Art Inc., Ottawa

Denmark
Ny Carlsberg Glyptotek, Copenhagen
Ordrupgaard, Copenhagen

France
Musée d'Orsay, Paris
Musée Marmottan Monet, Paris

Germany
Staatliche Museen zu Berlin, Alte Nationalgalerie
Städel Museum, Frankfurt am Main

Japan
Marunuma Art Park, Asaka

The Netherlands
Gemeentemuseum Den Haag

Portugal
Museu Calouste Gulbenkian, Lisbon

Switzerland
Kunsthaus Zürich
Musée cantonal des Beaux-Arts, Lausanne
Musées d'Art et d'Histoire de la Ville de Genève

United Kingdom
Daniel Katz Gallery, London
The National Gallery, London

United States
Acquavella Galleries, New York City
Allen Memorial Art Museum, Oberlin College,
 Oberlin, Ohio
The Art Institute of Chicago
The Cleveland Museum of Art
Currier Museum of Art, Manchester, New Hampshire
Dallas Museum of Art
The J. Paul Getty Museum, Los Angeles
Harvard Art Museums/Fogg Museum, Cambridge,
 Massachusetts
Kimbell Art Museum, Fort Worth
Memorial Art Gallery of the University of Rochester,
 Rochester, New York
The Metropolitan Museum of Art, New York City
Museum of Art, Rhode Island School of Design, Providence
National Gallery of Art, Washington, DC
Philadelphia Museum of Art
San Diego Museum of Art
Sterling and Francine Clark Art Institute, Williamstown,
 Massachusetts
Union League Club of Chicago
Wadsworth Atheneum Museum of Art, Hartford,
 Connecticut
Yale University Art Gallery, New Haven, Connecticut

Private Collections
Larry Ellison Collection
Ann and Gordon Getty
Private collection, care of Gladwell & Patterson
William I. Koch Collection
Collectors who wish to remain anonymous

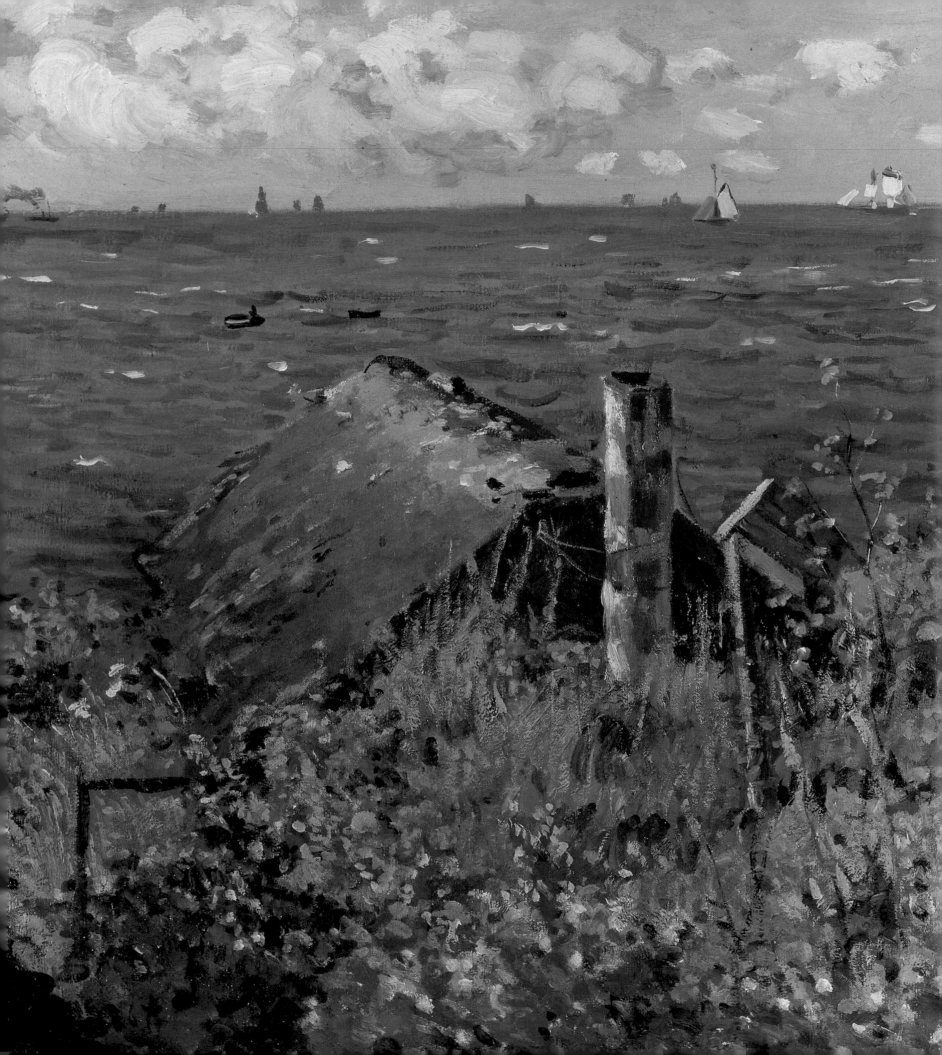

Introduction:
The Invention of Monet

George T. M. Shackelford

Deputy director, Kimbell Art Museum

Our project to organize an exhibition of the early work of Claude Monet has been met, from the beginning, with an extraordinarily enthusiastic response. Scholars and connoisseurs alike were excited to know that the remarkable works Monet produced in the first decade of his career would be brought together for study, first at the Kimbell Art Museum and then at the Fine Arts Museums of San Francisco. Some lovers of Monet's art even professed their great preference for the artist's early work over his later, even better-known production. But when shown the paintings under consideration for the project, many expressed surprise that they were discovering paintings they vowed they'd never encountered previously. "Where is *that* from?" they'd ask. "I've never seen that before!"

The outlines of Monet's early years were well known during his lifetime, and the list of the most critical paintings from the 1860s was well established long ago, even by his first biographers. John Rewald's discussion of the origins of the vanguard movement in his foundational *History of Impressionism* laid down the essential facts: the meeting of Monet, Renoir, Sisley, and Bazille in the studio of Charles Gleyre in the early 1860s; their continuing interaction through the decade; their exchanges of ideas; their side-by-side painting campaigns; the gradual development of distinctive hands and ambitions as the decade turned, countered by their interdependence up to and through the earliest of the Impressionist exhibitions. Building on Rewald's scholarship, subsequent authors have extended the study of the friends as a group, while others have isolated Monet for closer study, delving deep both as biographers and connoisseurs.

Chief among these chroniclers of Monet's production was Daniel Wildenstein and the team of experts who produced, in the 1970s, the first systematic catalogue of the artist's oeuvre. Near the time of the appearance of the catalogue raisonné, a number of detailed studies also took form, among them Joel Isaacson's focused investigation

Claude Monet, *A Hut at Sainte-Adresse* (detail), 1867, cat. 21

11

Monet: *Le déjeuner sur l'herbe* (1972), Kermit Champa's *Studies in Early Impressionism* (1973), and Isaacson's *Claude Monet: Observation and Reflection* (1978), which put the advances of Monet's first decade into the context of his career. Since the 1960s, in fact, as the literature on Impressionism in general has proliferated, the study of Monet in particular has burgeoned, with specialized studies of distinct periods in Monet's life taking their place in the literature alongside more synthetic treatments of the painter's lifelong predilections and preoccupations. The catalogue raisonné was extended and republished in a widely distributed and accessible trade edition in the mid-1990s, bringing to a much greater audience of amateurs and scholars the results of the Wildenstein Institute's detailed research and record-

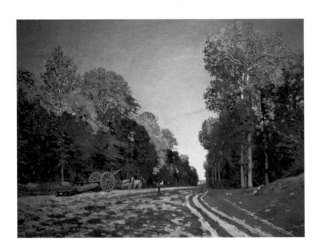

Fig. 1. Claude Monet, *The Pavé de Chailly in the Forest of Fontainebleau*, 1864, oil on canvas. Present location unknown

keeping. It is at this juncture that two major exhibitions focused attention again on Monet's beginnings and on his early work in particular. *The Origins of Impressionism*, organized by Henri Loyrette and Gary Tinterow for the Musée d'Orsay / Galeries Nationales du Grand Palais and the Metropolitan Museum of Art, gathered together more than thirty canvases from 1864 to 1870, while Charles F. Stuckey's magisterial retrospective exhibition of Monet in 1995 at the Art Institute of Chicago included twenty-seven paintings made before the end of 1872—the terminus date for *Monet: The Early Years*.[1] Fifteen years later, the retrospective exhibition organized by Guy Cogeval, Sylvie Patin, Sylvie Patry, Anne Roquebert, and Richard Thomson for Orsay and the Grand Palais featured some two dozen paintings from the early phase of the artist's life.[2]

Monet: The Early Years comprises more than fifty-five canvases, beginning with the first painting Monet exhibited, in 1858, and coming to a close in 1872, before the execution of *Impression: Sunrise* near the end of that year. Although figure paintings and still lifes are among these, our focus has been on landscape, clearly Monet's preponderant theme. With the exception of the *View Near Rouelles* (cat. 1) from 1858, the paintings date from a ten-year period beginning in summer

1863. It is this decade, in our view, that constitutes the critical early phase of Monet's development.

The exhibition hopes to communicate the nature of Monet's invention, in every sense: to explore Monet's creativity but also his creation of an artistic personality; to reveal the stages of construction of a reputation while exploring the construction of the works of art

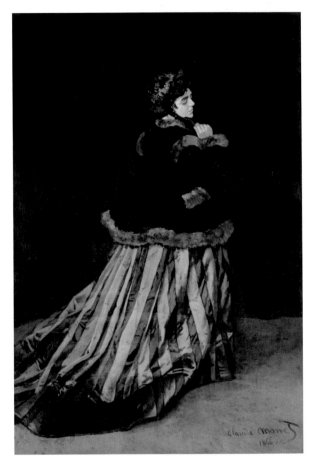

Fig. 2. Claude Monet, *Camille (The Woman with a Green Dress)*, 1866, oil on canvas. Kunsthalle Bremen

themselves. Achieving critical and commercial success was of intense concern to Monet throughout his life, from the time of his first "exhibition" of caricatures in the window of a color merchant in Le Havre in the mid-1850s. But the difficulty of launching that success, starting from nothing, was a daunting challenge. From time to time, because of his equally discouraging personal circumstances, the energies expended on becoming recognized nearly equaled the enormous will to create that drove him.

As John House summed it up, Monet was concerned from an early age with finding the best way of bringing his art into the public eye and

with crafting the impression that he would leave by choosing or preparing the right sort of painting for each occasion.[3] Public exhibition came before critical recognition, of course, and it became—to the extent that he could control what the public saw—the principal means by which he invented the character, the personality, that would be recognized as Claude Monet in the public imagination.

As we shall see, by his late forties Monet could serve as his own curator, crafting his own history by becoming a kind of historian of his proper oeuvre. At the beginning of his career, however, he had little control over what was admitted to the public view, in the Salon, except for the critical choice of selecting the works to submit. Thus, as a twenty-four-year-old, he sent to the jury for the first time a pair of seascapes that reflected his origins in Normandy and particularly in Le Havre but also capitalized on the rising fashion for marine paintings (see cat. 5). Their warm reception was surely a boon to his ego. But rather than continue along the path of view painting, the artist proposed to demonstrate a range of talents by creating for the next Salon a picture of monumental proportions—which was, of course, the *Luncheon on the Grass* (cat. 9). Unable to finish the huge painting of fashionable figures set in a forest glade, he improvised, retaining the themes of the *Luncheon* by submitting both a landscape that showed a forest cut through by a road and a full-length portrait of his lover Camille Doncieux attired in a modish green and black striped silk dress (figs. 1, 2). Again, his works were admired by critics. *Camille*, in particular, served as the brunt of many cartoon parodies, a sure sign that a painting was considered one of the most notable in an exhibition that, in this case, comprised nearly 3,300 entries.[4]

In 1867, the painter seems to have made an effort to show the considerable transformation in his art during the previous year while still maintaining continuity. He chose for submission two themes that dovetailed with his 1865 and 1866 success while presenting his new manner. Thus a painting of figures in a landscape, *Women in the Garden* (fig. 3), a large depiction of women in up-to-the-minute summer dresses arranged *en plein air*, was submitted with another work nearly as imposing, a seaside view of a multitude of boats in the *Port of Honfleur* (see fig. 98). His gambit was not successful. In the wake of the nearly wholesale rejection of works painted not only by Monet but by his followers, their half-hearted efforts to organize an official exhibition of the *refusés* morphed into the notion of a secession from future Salons in favor of private exhibitions—an idea that would come to pass for this group only in 1874.

As Monet later explained it, the Academy had identified his circle as "a 'gang' with pretensions to a new and revolutionary art." In Monet's estimation, the Academy's reaction to the painters in the "gang" was to say: " 'A few are undeniably talented. [But] if we seal their union with our approval, if we appear to attribute some value to their collective effort . . . it will mean the end of great art and of tradition.' "[5] In default of the Salon, opportunities were found for the immediate display of Monet's rejected paintings on the premises of Parisian dealers, where they were seen, at least, by the growing circle of artists and connoisseurs who took an interest in the direction painting was taking.[6]

But the rejection must have stung, and Monet's evident desire to create a work that might fare better with a conservative jury must be what led him to concoct for the next Salon a painting almost wholly out of keeping with the general trajectory of his art. *The Jetty at Le Havre* (fig. 4), at some five by eight feet in size, seemed to conflate

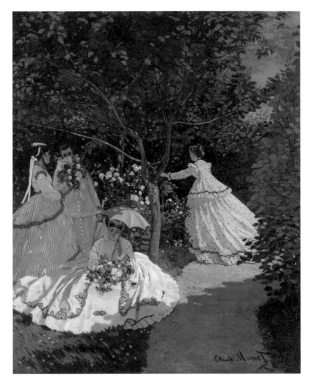

Fig. 3. Claude Monet, *Women in the Garden*, 1867, oil on canvas. Musée d'Orsay, Paris

elements of the pair of paintings from Monet's Salon debut (see cat. 5). Charged with narrative—townspeople and tourists gather on the jetty near the lighthouse in the wake of a storm to view the resulting rainbow and crashing waves—*The Jetty* must have been calculated to appeal to more traditional tastes. The paint was laid on not in the broad, flat patches and strokes that characterized his 1867 production, but in the manner of a modernized, if dramatized, painting by Boudin. Still, it was rejected. But the jury accepted the painter's other submission, *Boats Leaving the Port of Le Havre*, a painting, now lost, that might

have looked something like a seascape by Manet (fig. 100). Noticed by more than one cartoonist, it was lampooned with a crude, childish rendering of the composition but afforded an unusually long caption, in the form of a quatrain (fig. 5). The ditty began "There was a . . . very big ship /Very well painted by M. Monnet / That hurries on and seems to say," concluding, in English, with a named-based pun, "*Go head! time is money!*" The parodist's suggestion that Monet's manner of painting was motivated by expediency must have rankled—particularly when the painting in which he had deliberately modified his style had not met with favor. Still, Monet had once again been noticed, and the quality of his painting had been understood, if not admired. Being the butt of a witty joke was surely proof that his campaign for recognition was at least a partial success.

Later in the season, an opportunity arose to assemble a group of representative paintings for public display at the International Marine Exposition, held in Le Havre at the end of the summer and into September. Allowed to submit a greater number of works, Monet chose to send *Camille (The Woman with a Green Dress)*, his "hit" of the Salon of 1866; two paintings that had been rejected by the Salon in 1867 and 1868, *The Jetty at Le Havre* and *Port of Honfleur*; and one more painting, called simply *A Hut at Sainte-Adresse* (cat. 21).

Even to this day, in the context of Monet's other exhibits (and certainly in the greater context of the hordes of paintings shown in the Exposition), *A Hut at Sainte-Adresse* seems a remarkable choice. It is impossible to know exactly what the *Port of Honfleur* was like in terms of color (it is assumed it was destroyed in the Second World War), but from the related studies, it seems likely that it was painted mostly in whites, grays, and blacks, with bright patches of color on the hulls of the boats. The overall tonalities of *Camille* and *The Jetty*, as well as their standards of execution and subjects, were likewise sober and restrained. Not so the subject, color, or facture of the *Hut*, in which a brilliant blue sky rises over an intense turquoise sea, with a patch of weeds and a tumble-down cabin in the foreground, the whole painted with a

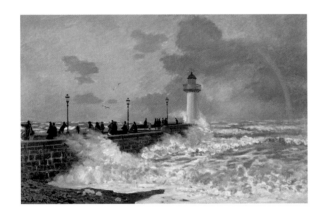

Fig. 4. Claude Monet, *The Jetty at Le Havre*, 1868, oil on canvas. Present location unknown

nervous, agile brush flickering across the surface of the canvas. Almost certainly painted in the summer of 1867, along with *Adolphe Monet Reading in a Garden*, *The Terrace at Sainte-Adresse*, and views of the shoreline (cat. 23, fig. 78), *A Hut at Sainte-Adresse* looks beyond even these advanced works towards Monet's much later manner of painting and must surely have come as a surprise to most viewers.

The sale of *Camille* to the publisher Arsène Houssaye provided at least some encouragement. But Monet's submissions to the next two Salons—*Fishing Boats at Sea*

MONET. — La sortie du port.

Il était un... très-gros navire,
Très-bien peint par M. Monnet,
Qui file vite et semble dire :
Go head! time is money !
M.

Fig. 5. Cartoon of Monet's *Boats Leaving the Port of Le Havre*, in *Le Tintamarre*, June 18, 1868, p. 4

and *The Magpie* in 1869 and *The Luncheon* and another work, probably the now-lost painting of the bathing place at *La Grenouillère* in 1870—were again rejected (cat. 25; figs. 80 and 97). In both cases, the pairing of the paintings gives the impression of being quite calculated for contrast of subject and affect. A brilliant and almost brash Normandy marine painting is paired with a close-hued and infinitely quiet snowscape; a tranquil, domestic scene of the artist's family at table, painted in browns, blacks, and whites, is paired with a scintillatingly lit view of a pleasure-spot known to be more than usually racy. In neither case, however, did Monet's attempts to shape his reputation have an effect. At least the sale of one of his paintings of the environs of the Louvre meant that a more adventuresome recent work was on display at a dealer's.

Henri Fantin-Latour set out to paint a large group portrait for the Salon of 1870, using Édouard Manet as the focal point for a group of his admirers and "followers." (fig. 6). In his *Studio in the Batignolles*, men of letters were represented by the critics Zacharie Astruc and Émile Zola, while the now-forgotten Otto Scholderer joined Renoir, Bazille, and Monet to represent the world of painters—in Fantin's composition, at any rate, in the thrall of the best-known and most controversial artist among them, Manet seated at his easel. Renoir, in a black hat, seems to have been given a "halo" in the guise of a gold picture frame; Bazille, exceptionally tall, is shown as a dandy in fashionable tartan trousers; while Monet, in the shadows at the extreme right, seems either to have arrived after all the others or to be reluctant to push himself forward, or perhaps even out of sorts. Such might have been his mood when the painting went on exhibition, both of his paintings having been refused; but by mid-summer he was a married man, on his honeymoon in Trouville (see cats. 34–37).

In the autumn of 1870, of course, the Monets decamped for England and remained outside France until the autumn of 1871. There was no Paris Salon in 1871, in the wake of foreign and civil war, but ironically it no longer particularly mattered to Monet, for he had a new avenue for exhibition and sale—through the dealer Paul Durand-Ruel. Meeting Monet and Camille Pissarro while all three were in exile in Britain, Durand-Ruel himself saw a new avenue for his firm in the work of the younger painters who might be understood and marketed as the successors to the masters of the Barbizon school, heretofore his stock in trade. To Durand-Ruel's "First Annual Exhibition of the Society of French Artists," held in London at the end of 1870, Monet contributed the *Breakwater at Trouville, Low Tide*, painted the previous summer (fig. 82). In 1871, at the International Exhibition held at the South Kensington Museum, he showed a reduced replica of *Camille* and another portrait of his wife, painted since their arrival in London (cat. 38). Later that year, at the Second Annual Exhibition organized by Durand-Ruel in Mayfair, he showed yet another painting, *On the Beach at Trouville*, which likely featured a portrait of Camille. It was purchased from the exhibition and is now unidentified.[7]

From the time of his return to France and his arrival at Argenteuil in early 1872 until spring 1874, Monet exhibited regularly with Durand-Ruel, but always in London. The works that were chosen for these exhibitions,

presumably by the dealer rather than the artist, were no more than five years old, and most were quite recently completed; on occasion, for local interest, one of Monet's London paintings was shown. But though a collector might encounter recent works by Monet for sale with Durand-Ruel, who was regularly buying paintings from the artist and placing them with clients, the journal-reading art lover would find no mention of Monet.

And so when, in 1874, Monet participated as one of the organizers of the first showing of the *Société anonyme des artistes peintres, sculpteurs, graveurs*, now known as the first exhibition of the Impressionists, it was a sort of new beginning. His work was, again, chosen from the last few years of his production. Seven pastels were included, along

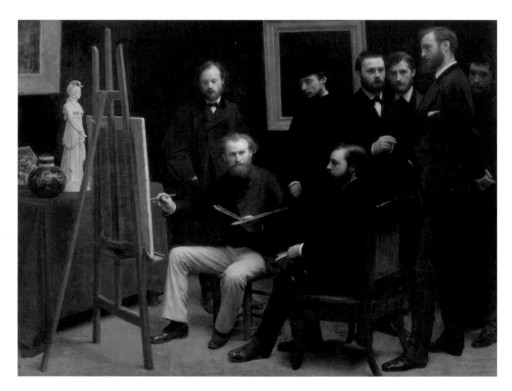

Fig. 6. Henri Fantin-Latour, *A Studio in the Batignolles*, 1870, oil on canvas. Musée d'Orsay, Paris. Acquired from Mrs. Edwin Edwards

with four conventionally sized easel paintings, which, as House notes, displayed a marked range of technique, from the lightly touched but still quite detailed *Poppies* to the apparent nonchalance of *Impression: Sunrise* (fig. 7).[8]

It happened that, in each of the four Impressionist exhibitions in which Monet participated from 1874 to 1879, one or more paintings from "the early years" of his career, before 1872, was shown. Of course in the first exhibition, in 1874, this time gap was meaningless. Still, in juxtaposition with *Impression: Sunrise*, Monet's other

"early" work, *Luncheon*, presented a striking contrast, of subject, of scale, of hue, and of course of facture. Though only four years old—and little more than two years earlier than *Impression*—and in spite of the distinction of having been scorned by the Salon in 1870, *Luncheon* must have struck the savvy amateur as something of an old-fashioned painting, a harkening back to the "Realist" Monet of *Camille*. (The very astute viewer in 1874 might even have recognized the fashions as being five years out of date.)

Perhaps *Luncheon* was selected because of its scale, as one of the only large paintings that Monet had to hand. (*Women in the Garden* was in Montpellier with the parents of the late Frédéric Bazille, its first owner.) But

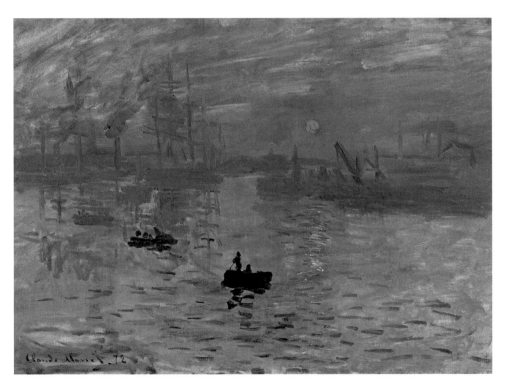

Fig. 7. Claude Monet, *Impression: Sunrise*, 1872, oil on canvas. Musée Marmottan Monet, Paris

in 1876, when scale was again required, Monet supplied it with a new purpose-made painting, the well-known fantasy portrait of Camille, represented full length in a garish Japanese robe.[9] Among the fifteen paintings Monet showed in 1876 were four completed before 1872, two of which dated from the 1860s. Though the color and finish of *Regatta at Sainte-Adresse* (1867, fig. 8), the painting now called *Apple Trees in Blossom* (1872, cat. 51), and another now called *The Reader* or *Springtime* (1872) merged seamlessly with the later views of Monet's garden, nearby pastures, or the banks of the Seine, one

painting must have stood out. *La Grenouillère* of 1869 (cat. 32)—what Monet had once called a "bad sketch"—was conspicuously unlike the other paintings, if for nothing more than its deliberately summary execution, employing extreme contrasts of light and dark achieved through the liberal use of black mixed into the shadows. It is possible to see the inclusion of *La Grenouillère* as Monet's attempt to demonstrate to a public the evolution of his art from the 1860s to the mid-1870s; it seems likely, however, that without any displayed dates or a greater knowledge of the artist's career, most viewers would have been unable to peg *La Grenouillère* as an "early" work.[10]

When the group next exhibited in 1877, Monet premiered the series of paintings he had just finished in and around the Gare Saint-Lazare, balancing these views of modern urban industry with scenes of parks, gardens, and woods. Two portraits were included as well as two seaside paintings, one a recent work called *The Grand Quai at Le Havre: Sketch* and the other, remarkably enough, the curious view of the *Hut at Sainte-Adresse* of 1867, first exhibited nine years before. The *Hut*, much more than the *Grenouillère* at the previous exhibition, was perfectly camouflaged among works just off the easel, so forward-looking had it been when painted ten years earlier.

For the fourth exhibition of the group, in 1879, Gustave Caillebotte, rather than the painter himself, saw to the collecting of paintings by Monet to be shown. He had asked Monet for a checklist of suggestions, and whether this was provided or whether Caillebotte improvised, the result was a selection of twenty-nine canvases that formed a virtual retrospective of Monet's work of the past fifteen years, looking back to his beginnings by including five paintings from the 1860s, two from 1870 and 1871, and the 1872 *Impression: Sunrise* (see cats. 15, 28; figs. 7 and 78). In this case, however, several of the early works were singled out pointedly as such, their dates of execution given as if to call specific attention to the painter's trajectory between past and present.[11]

Monet participated in neither the 1880 nor 1881 Impressionist exhibitions, deciding, in 1880, to enter two works for the Salon for the first time in a decade. Of these only one was accepted—*The Seine at Lavacourt*, an unusually large canvas now at the Dallas Museum of Art. The other, a depiction of an ice floe, was among the fifteen paintings that were exhibited during the Salon in the premises of Georges Charpentier, publisher of *La Vie Moderne* and a patron of Renoir.

Two early works were among them, an interior by lamplight and, once again, the *Hut at Sainte-Adresse*—exhibited for the third time and lent on this occasion by the collector-critic Théodore Duret.[12] This trend continued: two years later, when Durand-Ruel held his first solo exhibition for Monet, seven of the fifty-five paintings were from Monet's early years; among these were three Zaandam views and *Impression: Sunrise*, also marking its third showing. And three early works by Monet figured in the exhibition of Impressionist paintings Durand-Ruel organized in New York in 1886, including the 1872 *Tea Service* (cat. 53), the 1865 *Pavé de Chailly*, and a view of the Trouville boardwalk from 1870, but all were from the dealer's stock; the landscapes were sold from the exhibition.

Far and away the most important group of early works to be included in any exhibition organized by Monet himself was shown in 1889, in the retrospective exhibition of his paintings and Rodin's sculptures held at the Galerie Georges Petit, Paris. The Georges Petit exhibition was an enormously important one for Monet's reputation, falling on the eve of the decade in which his new strategy as the painter of series—stacks of grain, poplars, cathedrals, and so forth—would seal his critical success and his future financial security. The 1889 exhibition was intended to place before the public a resumé of the artist's development, giving due recognition to his most recent work—the series of paintings of the River Creuse in central France—but more importantly telling the public how he had arrived at his position as the preeminent landscape painter of the French avant-garde. The catalogue of the exhibition made its intentions clear:

> [This exhibition] is of interest, as well, because of its biographical nature, because it covers a period of twenty-five years of dogged labor and unrelenting struggle: it is, one may say, in large part a summation of the artist's career. It shows us how that career, from its beginnings, has progressed up to the present, taking us through not so much the history of his transformations, but the chronology of that progress. . . . Study his paintings in order of their dates and you will see how, time and time again, his methods grow richer, his sensibility develops, his eye conquers new forms and discovers unknown, shimmering light.[13]

It was possible for the visitor to "study his paintings in the orders of their dates" because each catalogue listing was scrupulously annotated with the painting's date of execution; numbers one through sixteen of the catalogue of some 150 paintings were from the years 1864–72. This segment of the exhibition, in our view, constitutes Monet's first systematic attempt to do honor to his own beginnings, the paintings of his early years.

The selection of the paintings is far from random. Each of the paintings was marked with its owner's name, and to the likely visitor to the exhibition these names were significant. The greatest number of paintings—six in all—were listed as belonging to the opera singer Jean-Baptiste Faure (including cat. 18). The businessman and patron of Renoir, Léon Clappison, lent *On the Bank of the Seine, Bennecourt* (cat. 30). Victor Choquet, the government official turned collector, lent *Seascape* (cat. 16), while Georges de Bellio, a Romanian immigrant who was a physician to many of the Impressionists and a collector, in depth, of the works of Monet, lent *Impression: Sunrise.*

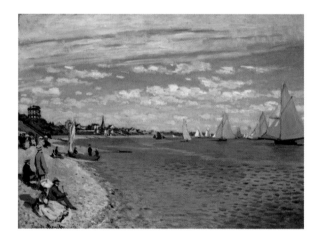

Fig. 8. Claude Monet, *Regatta at Sainte-Adresse*, 1867, oil on canvas. The Metropolitan Museum of Art, New York. Bequest of William Church Osborn

The critic Théodore Duret, future biographer of the Impressionists, lent a Zaandam *Windmill* and, once again, *Hut at Sainte-Adresse* (cat. 21).

As to the latter, it is difficult to understand Monet's desire to show, on four occasions, the curious painting of a cabin perched on a hillside above the sea. As far as the public then, as now, were concerned, it had nothing of the historical importance of *Impression: Sunrise*, the picture that had unwittingly given its name to a movement. The *Hut* stands out among the canvases

the artist completed in the busy summer spent at Sainte-Adresse in 1867, many of which celebrate the glorious gardens of his family's home or show boats on the beaches following the conventions established by Jean-Baptiste Isabey or Johan-Barthold Jongkind. It is a kind of misfit, an awkward "Cinderella," its subject conspicuously banal, particularly in contrast with the scintillating beauty of its surface and its joyful color scheme. Though it was presumably grouped with the paintings of the 1860s at the Georges Petit exhibition, it would have resonated most strongly with the paintings Monet had completed at the beginning of the 1880s; it begs comparison with the many views of the cabin on the Normandy cliffs (variously localized as at Varengeville or Petit-Ailly), two of which were included in the 1889 exhibition (figs. 9, 10).[14] It thus was the perfect illustration of the concept of steady continuity throughout the painter's evolution that was, according to Octave Mirbeau, one of the principal lessons of the exhibition:

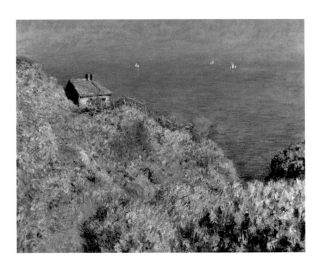

Fig. 9. Claude Monet, *The Fisherman's House, Petit Ailly*, 1882, oil on canvas. Private collection

Fig. 10. Claude Monet, *The Fisherman's House, Varengeville*, 1882, oil on canvas. Museum Boijmans van Beuningen, Rotterdam

One thing is striking, astonishing; this is the absolute unity of the oeuvre within its diversity and its abundance; it is, within his passion, the absolute equilibrium in his brain. From the first day that M. Claude Monet picked up a brush and confronted a painting, he has known where he wanted to go, and he has gone there, directly, as a conqueror, not turning for an instant from his path, without detours into this and that, in a rut of vague hopes, without losing himself along the branching paths of uncertain ambition. . . . He is all of one piece, in the subtle, complicated mechanism of his genius, the admirable receiver of the most diverse sensations, the creator of the most divergent forms.[15]

To demonstrate Monet's constancy, however, Mirbeau goes on to cite examples drawn from the works of the artist's past in juxtaposition with his latest production. From *Camille* to the dazzling figures from Giverny; from Argenteuil's joyfulness to the somber tragedy of the Creuse Valley; from fields with leaden skies to snow-touched stacks of grain in a radiant sunrise, "he has not once contradicted himself." For Mirbeau, and for many an author since, the early works of Monet—by our definition fewer than 250 in number—though distinct in their qualities, are consistent with and predictive of his future. They are apart from, and yet continuous with, the totality of the artist's oeuvre, which would amount to nearly two thousand paintings in the succeeding half-century. It seems likely that Monet thought so, too.

In the last decades of Monet's life, visitors to his house and studio at Giverny might have seen, among the paintings of many periods that he had kept with him—or that he had bought back, having once sold them—a number of key works from the 1860s. One of these was the poignant image of his first wife, Camille, seen through the window of a room, wearing a red hooded cape and walking in the snow (cat. 12). But the paintings that are most consistently discussed by visitors to Giverny are *Women in the Garden* and *Luncheon on the Grass*. It seems that Monet may have made these paintings an element of the visitor's experience of Giverny, taking the opportunity, perhaps, to act as his own chronicler, to cast a young visitor's imagination back to the era of his youth.

Louis Vauxcelles, in an article published in 1905, recounts a discussion that he and the painter had. Referring to *Women in the Garden*, he said that "the

composition, the green of the trees and the flesh tones of the subjects, and their dress as well . . . reminded me oddly of Édouard Manet" and noted that Monet dated it to 1865 or 1866, saying that it "was the first of my canvases to be rejected by the Salon." Beside it was hanging one "equally as large but more diffuse, with less relief," which Monet told him was "part of a huge, still earlier composition, probably around 1864. I found it not very long ago when I was moving house. It had been rolled up, and part of it was damaged, so I cut that part off."[16]

A few years later the American painter and writer Walter Pach described looking with Monet at *Women in the Garden*, "a figure subject something not common with this painter. The group of ladies whom one sees on the bright green turf and the sandy walk are painted in as pure a light and with as much frankness as it would seem possible to get. The style of their dresses, however, proclaims the picture as belonging to a decade long past. It is in fact of the early sixties." He mistakenly claims that it was "no less important a thing than the painting which represented Monet at the historic *Salon des refusés*."[17]

Shortly after Monet's death in 1926, the Duc de Trévise published a recollection of his 1920 visit to Monet at Giverny. Monet invited him to visit the first independent studio he had built, employed as a kind of gallery since the construction of a giant studio needed to paint his waterlily decorations (fig. 11). There Trévise saw "framed paintings of slender gentlemen in light-colored jackets, ladies in crinolines [that] evoke the Second Empire." He recounts that Monet said, "I just want to show you two pictures composed entirely differently." Pointing to the *Luncheon on the Grass*, Monet said:

> This one, the earlier one, is a picnic which I did after Manet's. At that time I did what everyone else did; I proceeded bit by bit with the studies done from nature which I would then put together in my studio. I am much attached to this piece of work that is so incomplete and mutilated. I owed my rent so I gave it as security to my landlord who rolled it up in his cellar. I was finally able to redeem it. You can see how long it moldered.

Monet then recounted the history of *Women in the Garden*—how he had obtained it from Manet, who had previously received it from Bazille's parents. It was, he reminded the duke, "actually painted from nature, right then and there. Something that wasn't done in those days."

"Those days," the days of his youth, were half a century in the past. But in memory they continued, it would seem, to resonate for the painter, now past eighty—not as youthful idylls but as vivid moments of growth and struggle, of the joyfully ambitious abandon of *Luncheon on the Grass* and *Women in the Garden*, and of the tender melancholy of his wintry portrait of a beloved wife. "I am much attached to this piece of work," Monet said of *Luncheon*, and it is easy to understand, a century and a half later, why it was so. For *Luncheon on the Grass*, though "incomplete and mutilated," stood as a reminder of the early years in which he not only invented the artist known as Monet, but found a way to give wing to his own remarkable powers of invention.

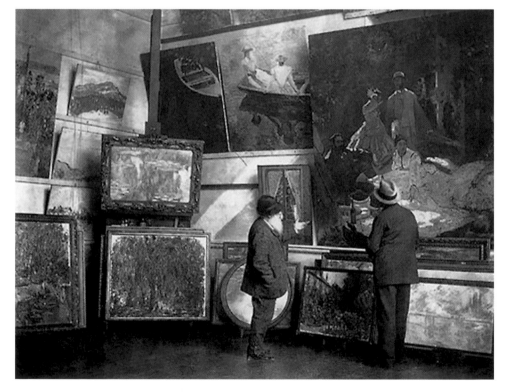

Fig. 11. Monet and the Duke of Trévise in the studio at Giverny before the central part of *Luncheon on the Grass* and *The Red Kerchief*, 1920, photograph. Musée du Louvre, Paris

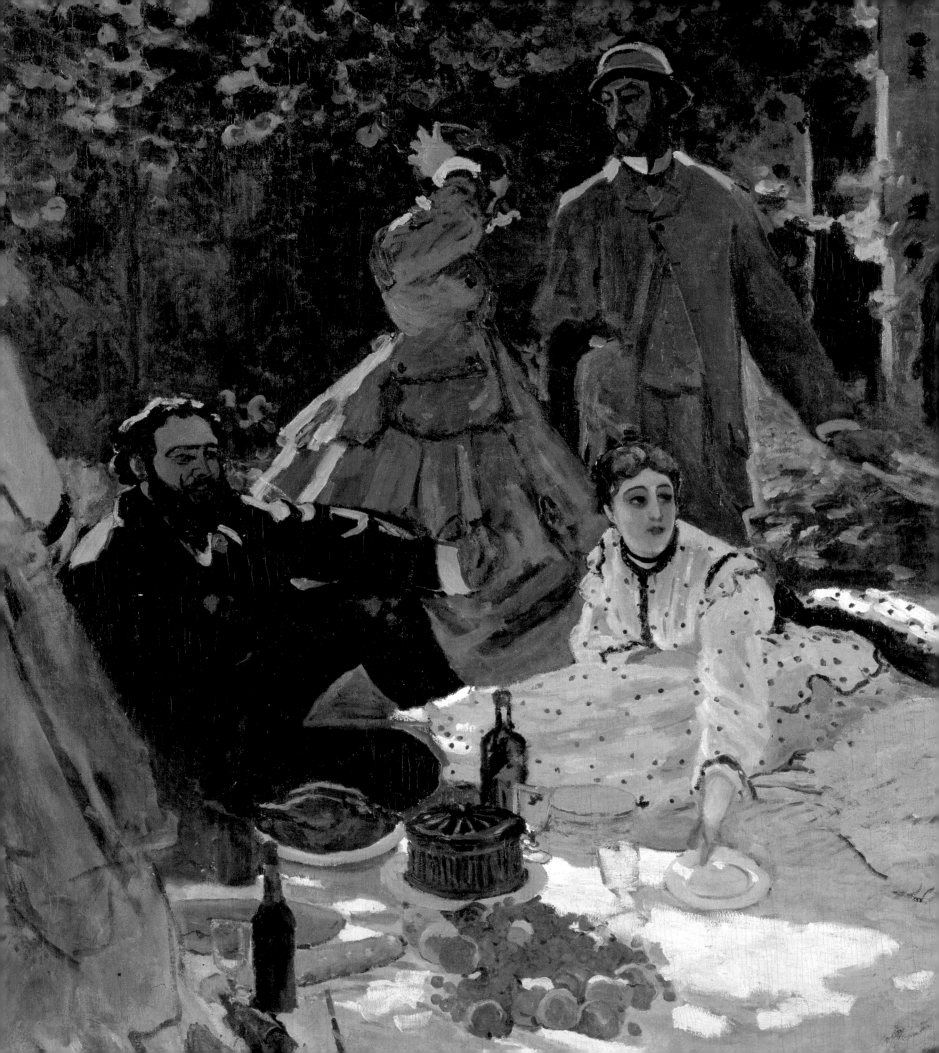

Hunting for Light:
Luncheon on the Grass

Mary Dailey Desmarais

Curator of international modern art, Musée des Beaux-Arts de Montréal

At some point in 1865, Monet began what would be his largest and most ambitious picture to date, *Luncheon on the Grass (Le déjeuner sur l'herbe)* (fig. 12). The painting was originally more than four by six meters, but only two large fragments now remain, in addition to several preparatory sketches and a large oil study. Nevertheless, the oil study gives us some idea of the final picture (fig. 13). It was to be a springtime picnic with life-size figures in contemporary dress rendered to simulate the experience of light *en plein air*. Monet's friends and acquaintances, including fellow painter Frédéric Bazille and Monet's future wife, Camille Doncieux, posed for the figures. Gustave Courbet also makes an appearance; he is shown seated at the center of the large fragment of the final painting. With this scene of his friends, costumed in the latest fashions and set around a picnic in the forest of Fontainebleau, Monet was to rewrite the eighteenth-century tradition of *fêtes galantes* in the language of a contemporary bourgeois outing and respond to the more recent example of Édouard Manet's *Luncheon on the Grass (Le déjeuner sur l'herbe)* (1863, fig. 14) by moving from the studio to the outdoors and making his picture more than five times bigger than Manet's.

Despite the fact that Monet's *Luncheon on the Grass* was never completed (or perhaps because of it), the painting remains one of Monet's best-known and most written about works.[1] Much has been said about the outsized overreach of Monet's response to Manet and about Monet's unparalleled technical virtuosity in representing the fleeting effects of light in the forest. Yet the true audacity of Monet's endeavor is most fully revealed in the strangeness of the painting and its preparatory oil study—the awkward stiffness of the figures' poses in comparison to the pulsating immensity of the sunlit trees behind them; the crouching figure in the shadows of the oil study, behind the tree at right, who appears peculiarly sinister and oddly offstage; and the fact that the entire scene takes place on a hunting ground under the sign of love: a heart carved into a tree at right. In choosing this setting, Monet was not only responding to the Rococo but also calling upon the latent power of the forest of

Claude Monet, *Luncheon on the Grass* (detail), cat. 9

Fontainebleau to make a picture that would illuminate the social and artistic transformations to which he was witness.

The idea for *Luncheon on the Grass* must have been brewing in Monet's mind as early as 1863—the year of his first trip to Fontainebleau as a professional painter and coincidentally the year that Manet exhibited his *Luncheon on the Grass* at the Salon des Refusés.[2] There is no documentary proof that Monet visited this Salon, but we know he had encountered one of its most notorious paintings: Monet thought of *Luncheon on the Grass* as being "after Manet."[3]

Monet's *Luncheon* not only constitutes a response to Manet's earlier painting of the same theme but also suggests that he was looking to Manet's *Music in the Tuileries Gardens* (1862, fig. 15), which shows a crowd of modern-day Parisians (including Manet himself, as well as Charles Baudelaire and Jacques Offenbach) enjoying the leisure activity of a

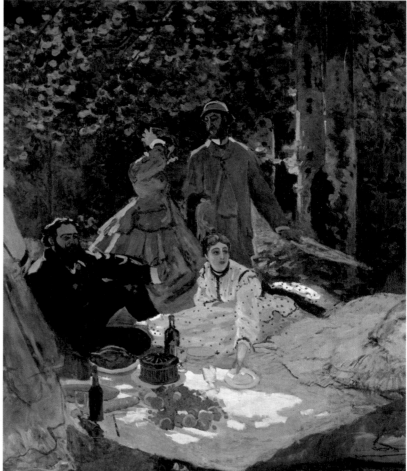

Fig. 12. Claude Monet, *Luncheon on the Grass (Le déjeuner sur l'herbe)* (two extant panels), 1865–66, oil on canvas. Musée d'Orsay, Paris. Cat. 9.

concert in the park. Joel Isaacson wryly states, "Monet's final painting may be described as a combination of Manet's *Déjeuner sur l'herbe* and *La musique aux Tuileries* blown up to Courbet-like proportions."[4] Apparently Courbet made several comments about the painting when Monet was working on it, and, according to some accounts, it was in part Courbet's words that frustrated Monet's attempts to complete it in time for the 1866 Salon.[5]

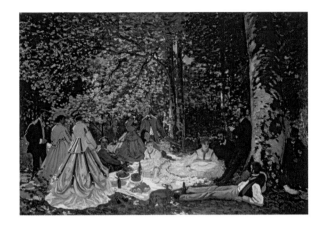

Fig. 13. Claude Monet, *Luncheon on the Grass*, 1865–66, oil on canvas. Pushkin Museum of Fine Arts, Moscow

To a twenty-first-century viewer, Monet's painting might seem rather tame in the context of Manet's *Luncheon*, with its naked and half-dressed women in the company of clothed men. But preliminary studies for Monet's *Luncheon* reveal that his response is more complicated than meets the eye. A large charcoal drawing of the ensemble of figures contains what appear to be several direct allusions to Manet's work (fig. 16). The drawing lays out the basic composition of what was to become the final painting, although there are fewer figures in this sketch. At its center is a reclining female figure whose face is turned toward the viewer and whose pose, with legs outstretched toward the left of the canvas, recalls that of Manet's *Olympia* (1863), as well as his *Young Woman Reclining in Spanish Costume* (1863), which in turn looks back to Francisco de Goya's *Maja* (1800–1805), although in reverse.[6] With this and with other quotations, Monet was following Manet's example of incorporating art-historical precedents into his painting by citing the work of Manet himself. But in the final painting, the reclining nude in the background is eliminated altogether in favor of the more presentable figure of a seated and, more importantly, clothed woman and man.

So what made Monet change his mind? Did the overwhelmingly negative criticism that Manet's *Olympia* received at the 1865 Salon give Monet pause when it came to confronting his audience with a nude in the company of people in contemporary dress? Or did he look past the surface of Manet's painting to see its deeper roots in the art of the past—not in the Italian Renaissance, but in the French eighteenth century and in the work of Jean-Antoine Watteau in particular?

The connections between Monet's *Luncheon on the Grass* and the paintings of Watteau (1684–1721) have been consistently underemphasized compared with the more conspicuous links between Monet's work and Manet's *Luncheon*,[7] despite Monet stating that if he could borrow only one painting from the Louvre it would be Watteau's *Embarkation for Cythera* (1717), and despite Watteau being mentioned in connection with Monet's painting by some of his most prominent contemporary critics.[8] But both the large charcoal sketch and the completed oil study for *Luncheon on the Grass*, as well as (from what we can tell) the final canvas, suggest that certainly as much as if not more than to Manet, Monet was looking to the example of Watteau.

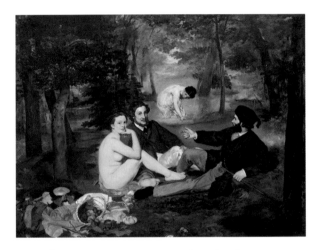

Fig. 14. Édouard Manet, *Luncheon on the Grass (Le déjeuner sur l'herbe)*, 1863, oil on canvas. Musée d'Orsay, Paris

Monet's depiction of figures in contemporary clothing enjoying leisure activities outdoors was a direct allusion to eighteenth-century *fêtes galantes* and to the work of Watteau, who was among the first French painters to remake mythological scenes in modern dress.[9] *Luncheon on the Grass* thus roots Monet firmly in his historical moment, when a "Rococo revival" reached its peak.[10] Period taste for the Rococo was evidenced not only in literature, particularly in the works of the Goncourt brothers, but also in theater and in contemporary fashion—notably in the crinoline, which was a mid-nineteenth-century take on the eighteenth-century petticoat.[11] Watteau's realism, however, was also a focus. "Watteau!" wrote Théophile Thoré. "Before him, they painted princesses, and he painted shepherdesses; they

painted goddesses, and he painted women; they painted heroes, and he painted mountebanks."[12]

In keeping with the example of Watteau, Monet took great pains to ensure that the costumes for his figures in *Luncheon on the Grass* were up to date. Visible pentimenti show that while working he updated the costumes to the latest fashions.[13] In his attention to the detail of dress and in his figures' poses and placement outdoors, Monet may have been looking to contemporaneous fashion plates.[14] Significantly, fashion plates of the period placed figures in outdoor settings reminiscent of Rococo *fêtes galantes*, in yet another manifestation of period interest in the eighteenth century.[15]

More importantly, *Luncheon on the Grass* draws on the language of eighteenth-century paintings of hunting parties—including Watteau's own version of this theme, *The Halt during the Chase (Repas de chasse)* (c. 1718–20, fig. 17), which was exhibited at the Galerie Martinet in 1860. The *repas de chasse*, a tradition of aristocratic hunting, was a picnic that took place in the middle of the hunt. As if in evocation of this practice, the figure of Courbet in the final version of Monet's painting is positioned in the exact same way as the central figure of Watteau's painting. This is especially interesting given that Courbet was an avid hunter. There is also a resemblance between the standing figure of Bazille leaning against the tree at right and the man similarly positioned in Watteau's painting.

Not only does Monet's painting look to Watteau's *Halt during the Chase* but also to other eighteenth-century versions of this theme—notably Carl Van Loo's *Break during the Hunt* (1737, fig. 18), which Monet could have seen in the Louvre. Indeed, comparing the charcoal sketch for *Luncheon on the Grass* to Van Loo's *Break during the Hunt* reveals that the valet in Van Loo's picture offers a more compelling precedent for Monet's picture than the bathing figure in Manet's *Luncheon*. At the same time, the figure of the valet in Monet's painting recalls the *commedia dell'arte* character Crispin as seen in Watteau's paintings, particularly his *French Comedians* (c. 1720, fig. 19), in which Crispin is

separated from the central drama of the painting by a colonnade. Like Crispin, the valet in *Luncheon on the Grass* is positioned at a remove from the main action of the painting. But in Monet's painting, a tree, not a column, separates the valet from the others. Moreover, crouching forward with his left elbow bent, Monet's valet is positioned exactly as Crispin is in the earlier picture. There is also a similarity between the dress of the two figures: both wear black suits with black hats, a white collar, and beige gloves. And just as Crispin is positioned next to a vague outline of what appears to be Cupid or a putto, the valet in Monet's painting is next to the sign of love.

Monet's interest in the theater is documented, and he quite possibly would have read about Crispin or even seen him portrayed on the stage. Even if he did not, Monet would have had occasion to see Watteau's other representations of him, reproduced in engravings and paintings. An eighteenth-century painted copy of Watteau's engraving *Harlequin, Pierrot, and Scapin* (1719, fig. 20), in which Crispin appears in the same pose as in *The French Comedians*, was in the collection of Louis La

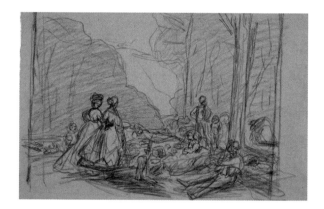

Fig. 16. Claude Monet, *Sketch for Luncheon on the Grass*, c. 1865, black chalk on blue laid paper. National Gallery of Art, Washington, D.C. Collection of Mr. and Mrs. Paul Mellon

Caze, which was frequently open to the public during the 1860s and part of which was exhibited on the boulevard des Italiens in 1860.

The Crispin-esque valet who is strangely at the margins of the main action of Monet's *Luncheon* and is the only figure that appears to look directly at the viewer performs a critical function in the picture. He is the emblem of the role this painting performs. Monet's *Luncheon* costumes an elite social practice in the language of a bourgeois picnic.[16] In doing so, Monet draws again on the example of Watteau,

Fig. 15. Édouard Manet, *Music in the Tuileries Gardens*, 1862, oil on canvas. The National Gallery, London. Sir Hugh Lane Bequest

whose *fêtes galantes* have been shown to appropriate preexisting forms of popular expression.[17] Monet's painting effectively did much the same thing, but in reverse. *Luncheon on the Grass* reframes an elite social practice, the hunting party luncheon, as a popular pastime at a moment when the older tradition was being transformed by the influx of tourists to the forest of Fontainebleau.

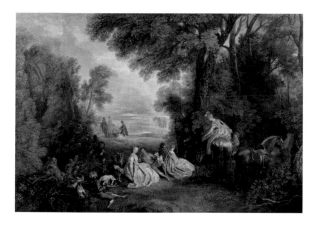

Fig. 17. Jean-Antoine Watteau, *The Halt during the Chase*, c. 1718–20, oil on canvas. The Wallace Collection, London

The traces of the hunt that remain in *Luncheon on the Grass* become more evident when we consider that the Fontainebleau forest is one of the oldest hunting grounds in all of France. Located thirty-five miles south of Paris, the forest was the preferred hunting ground of the French kings since the Middle Ages.[18] Surrounded by rivers on three sides—the Seine to the north, the Essonne to the west, and the Loing to the east—the forest is home to grand oak, beech, and pine trees, which provided the perfect shelter for wolves, wild boars, and birds.

The revolutions of 1789 and 1848 temporarily opened hunting in the forest of Fontainebleau to everyone; in an effort to strip hunting privileges from the royal domain, hunting lands were sold, and vast amounts of game were killed.[19] During the reign of Napoleon III, under the aegis of Empire, hunts in Fontainebleau had once again become a privilege of the elite. In 1852, Napoleon III recreated the "civil list," after the model of Louis XVI, which gave the emperor power over some of the most prestigious properties in France, including all lands that once belonged to French royalty: the Elysée Palace and the Tuileries in Paris and the forests and chateaux of Compiègne and Fontainebleau.[20]

When Monet first arrived in Fontainebleau in 1863, and even on his subsequent visits, imperial hunts were a regular occurrence.[21] Indeed the collision between artmaking and hunting was conspicuous and, at times, catastrophic, occasionally leading to deadly accidents or encounters with wild animals.[22] As late as 1877, Robert Louis Stevenson described the forest as follows:

> Still the forest is always, but the stillness is not always unbroken . . . you hear suddenly the hollow, eager violent barking of dogs; scared deer flit past you through the fringes of the wood; then a man or two running, in green blouse, with gun and game-bag on a bandolier; and then, out of the thick of the trees, comes the jar of rifle-shots. Or perhaps the hounds are out, and horns are blown, and scarlet-coated huntsmen flash through the clearings, and the solid noise of horses galloping passes below you, where you sit perched among the rocks and heather. The boar is afoot, and all over the forest, and in all the neighboring villages, there is a vague

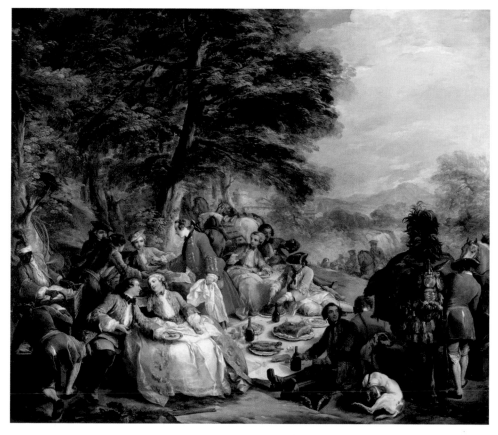

Fig. 18. Carle Van Loo, *A Break during the Hunt*, 1737, oil on canvas. Musée du Louvre, Paris

excitement and a vague hope; for who knows whither the chase may lead? And even to have seen a single piqueur, or spoken to a single sportsman, is to be a man of consequence for the night.[23]

Although Monet, like Stevenson, was not an avid hunter, he could not have avoided this ancient French pastime while painting in Fontainebleau.

The period during which Monet was working in Fontainebleau also witnessed a dramatic increase in tourism to the forest. While tourists and artists had been visiting the forest long before Monet was born, the tourist industry in Fontainebleau really began to thrive with the opening of the railway line from Paris directly to Fontainebleau in 1849.[24] The new line shortened the travel time from between six to eight hours to "one hour and five minutes," as the advertisement in Joanne's guide boasts.[25] In 1857 alone, 135,877 visitors passed through the Fontainebleau station. Much to the chagrin of those who had frequented Fontainebleau in its less popular days (including George Sand and Philippe Burty),[26] tourist guide books, especially Claude-François Denecourt's *Guide du voyageur dans le palais et la forêt de Fontainebleau* (1843) and *L'indicateur de Fontainebleau. Itinéraire descriptive du palais, de la forêt et des environs* (1868),[27] made the forest into something of a rural amusement park for the bourgeoisie.[28] Monet's painting at once speaks to the growth of tourism in the forest and to the broader connections between landscape painting and the rapid growth of modern industry in the city.[29] At the same time, subliminal references to the hunt in *Luncheon on the Grass* evoke the traditions of the forest that modern developments were beginning to alter.

To writers as well as to painters, Fontainebleau asserted a sort of mythic power, tempered by the arrival of the modern world. Flaubert's novel *A Sentimental Education* (1869) speaks to the collision of these different aspects of the forest in ways particularly relevant to

Fig. 19. Jean-Antoine Watteau, *The French Comedians*, c. 1720, oil on canvas. The Metropolitan Museum of Art, New York. The Jules Bache Collection

Monet's *Luncheon on the Grass*. Published after Monet painted *Luncheon* but written at exactly the time Monet was working on the painting, the novel depends upon the very specific collision between history, myth, and modernity in the forest—the confluence of factors at issue in—indeed, the central issue of—Monet's *Luncheon on the Grass*. (It is worth noting that Monet also seems to have felt something of an affinity for Flaubert's writing, once exclaiming, "If Flaubert had been a painter, what would he have written, my God!"[30])

In his novel, Flaubert deliberately creates friction between the myth and ritual surrounding the site and what he describes as the crassness of contemporary bourgeois society. When his protagonists, the lovers Frédéric and Rosanette, enter one of the rooms into which the original hunting gallery of the château had been divided, they confront the past: "Everywhere, armchairs were hidden under coarse linen sheets; over the doors there were Louis Quinze hunting scenes and, here and there, tapestries depicting the gods of

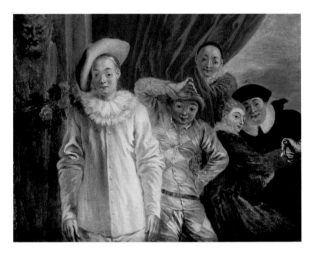

Fig. 20. After an engraving by Jean-Antoine Watteau, *Harlequin, Pierrot, and Scapin*, c. 1719, oil on canvas. Musée d'Art et d'Archeologie, Moulins, France

Olympus, Psyche, or Alexander's battles. Whenever she passed in front of a mirror, Rosanette would stop for a moment to smooth her hair."[31] In a single gesture, the spell of the place and of the hunt and of ancient heroes is broken by the ephemeral glance in a mirror; the weight of history becomes subordinate to self-fashioning and surface reflection.

Similarly, Monet rewrites the romance of the place and the ritual of the hunt in the language of bourgeois tourism, echoing a vain girl's obsession in the shimmer of sunshine on the surface of a dress.

As Flaubert uses Rosanette's ignorance of the ritual of the hunt to reinforce its ancient and enduring significance, part of the power of Monet's painting is rooted in the painter's simultaneous evocation and sublimation of the hunt through the representation of fashion and the fleeting effects of light.

The full force of this tension would motivate Émile Zola's *La curée (The Kill)*, the literary next step to Flaubert's use of the hunt as a metaphor for a broader sociocultural transformation. Published in 1872, *The Kill* is a thinly veiled critique of rampant commercial

Many of Monet's contemporaries also took up the theme of the hunt in ways pertinent to sociocultural developments in the second half of the nineteenth century. Among them was Gustave Courbet, whose participation in the picnic taking place in Monet's *Luncheon* suggests that he and his works played an important role in its development. Courbet, coming from the provinces, was familiar with hunting and hunters of every background and social class. His oeuvre is replete with deer-filled landscapes alongside studies of hunting dogs and depictions of poachers,

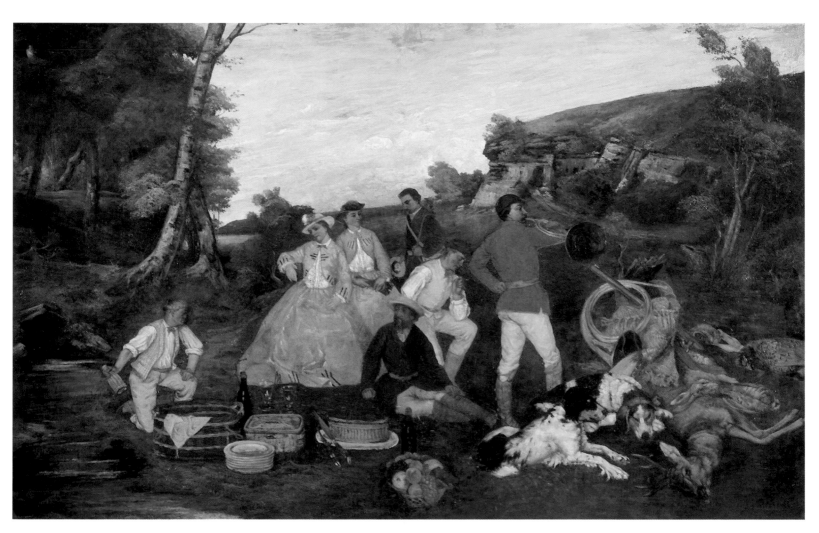

Fig. 21. Gustave Courbet, *The Huntsman's Picnic*, 1858, oil on canvas. Wallraf-Richartz-Museum and Fondation Corboud, Cologne

speculation and corruption in Second Empire Paris. In the novel, metaphors of the hunt are used to express what Zola experienced as the dissolution of moral fiber in the capital. "*The Kill*," wrote its author, "is an unwholesome plant that sprouted out of the dungheap of the Empire, an incest that grew on the compost pile of millions."[32]

trappers, and hunters—some with the artist's own features. But it is a multi-figure composition from 1858, Courbet's *Huntsman's Picnic* (fig. 21), that is especially relevant to Monet's *Luncheon on the Grass*.

The theme of the luncheon as an episode in a day of hunting, an underlying motif of Monet's *Luncheon*, is explicit in *The Huntsman's Picnic*. Like Monet, Courbet

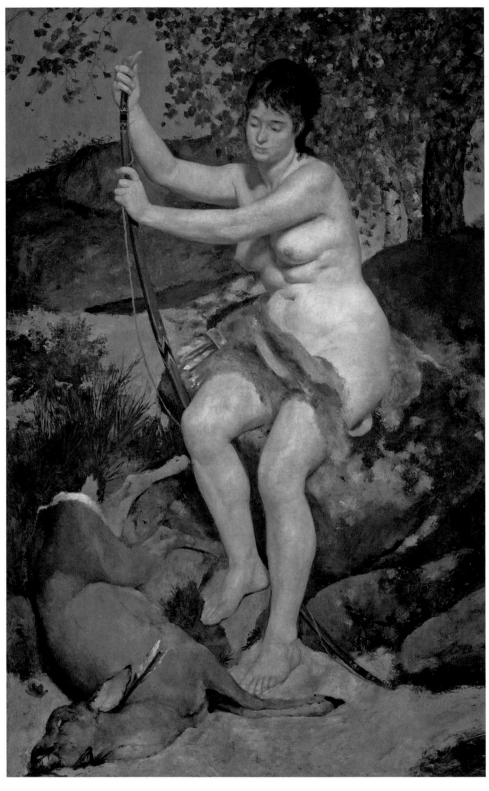

Fig. 22. Pierre-Auguste Renoir, *Diana*, 1867, oil on canvas. National Gallery of Art, Washington, D.C.

looks to the model of eighteenth-century *repas de chasse* paintings; but instead of aristocrats in hunting habit, he depicts members of the petit bourgeoisie and their hired servants. In the foreground, a young man unpacks food from a picnic basket and leans forward to lay it directly on the ground. Opposite him is a man dressed as a poacher or woodsman, while the two men in more elegant riding habit behind him would have formed part of the team hired to direct the *chasse à courre*. Meanwhile, the two women in the middle ground are ladies of the petit bourgeoisie of the countryside, the Jura region of France. In what ultimately amounts to a classed hunting picture, the composition of *The Huntsman's Picnic* is also significant, with the men of lower ranks on a plane equal to the dogs and the more well-to-do picnickers at a slightly elevated level.[33] (This stratification might reflect what T. J. Clark identified as Courbet's own ambivalent position, somewhere between the peasantry and the rural bourgeoisie.[34])

As he had done in so many of his paintings, here Courbet paints his figures as though he were an illustrator for *Épinal*.[35] The people are placed in awkward and stiff poses, ill at ease in the setting, as if to mock the pretense of their posing as though in an aristocratic hunting luncheon. In effect, the painting ironically lends weight to Théophile Gautier's comment that Courbet was the "Watteau of ugliness."[36] Although different in tone than Courbet's painting, Monet's *Luncheon on the Grass* similarly draws on the language of the *repas de chasse* to reflect social change.

Within a year of Monet abandoning his *Luncheon on the Grass*, Renoir too took up the theme of the hunt with his *Diana* (1867, fig. 22), which shows the goddess of the hunt contemplating a dead deer at her feet.[37] The painting's setting is the forest of Fontainebleau, which in reality played a significant role in its development. Renoir's model was his mistress, Lise Tréhot, whom he had met in Marlotte, a small town on the edge of the forest, while he was staying with his friend the painter Jules Le Coeur. Between 1865 and 1866, while Monet was working nearby on *Luncheon on the Grass*, Renoir spent considerable time in Marlotte with the Le Coeur family. His painting of Diana suggests a certain familiarity with the history of the forest and Diana's relevance to it, but the painting was clearly created in the studio, evidenced by the artificial flatness of the

backdrop, which pushes the spotlit body of Diana and the dead doe forward.[38]

Despite not being made in a natural setting, the painting is very much about the natural body, about flesh and a carnal, even erotic, connection between humans and animals, discernible in the similar poses of the dead doe (a female deer) and Diana—both of whom are positioned with their legs slightly parted against the rocks and their head gently tilted. The erotic charge of Renoir's painting is heightened by the pink ribbon and the fur running between Diana's legs, which place the emphasis on and serve as the correlative to her sexual organs. The libidinal energy of this painting is characteristic of many of Renoir's nudes. As Renoir himself explained, "I like a painting that makes me want to stroll in it, if it is a landscape, or to stroke a breast or back, if it is a figure."[39]

Renoir's next picture of Lise (*Lise* or *Woman with a Parasol*, 1867, fig. 23), also painted in the forest of Fontainebleau, shows Lise dressed in the latest Parisian promenade clothes. Here, the carnality of *Diana* has been sublimated into the representation of fashion *en plein air*. There is perhaps no more telling sign of this shift than the reappearance of the pink ribbon: previously running through Lise's legs in *Diana*, it is wrapped around her hair in *Lise*. The language of the hunt is rewritten in terms of the specific social phenomenon of fashionable tourism in the Fontainebleau forest. At the same time, the two paintings demonstrate a critical shift in Renoir's art—and therefore in Monet's immediate circle—from an art rooted in the past and in the studio to an art that sought to look only forward, and *en plein air*. In Monet's *Luncheon on the Grass*, this transition occurs in the space of a single picture.

To extend the metaphor of the hunt, this shift might be framed in terms of a movement from a corporeal hunt to an optical one. Monet's painting clearly draws on the language of the *repas de chasse*, and it does so in a setting that was a historical hunting ground. Yet nowhere in this picture, with the possible exception of a hound, is there any outward sign of the hunt. The true object of Monet's pursuit is not physical or animal, but optical and ephemeral. In parallel with a cultural shift from a society shaped by class structures and aristocratic traditions to one based on bourgeois tourism, industrial transportation, and the rise of a commercial culture that fractured

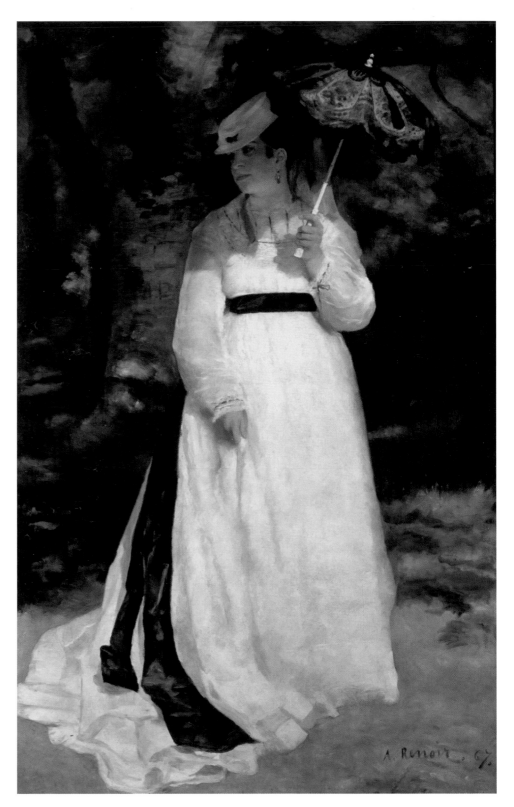

Fig. 23. Pierre-Auguste Renoir, *Lise (Woman with a Parasol)*, 1867, oil on canvas. Museum Folkwang, Essen, Germany

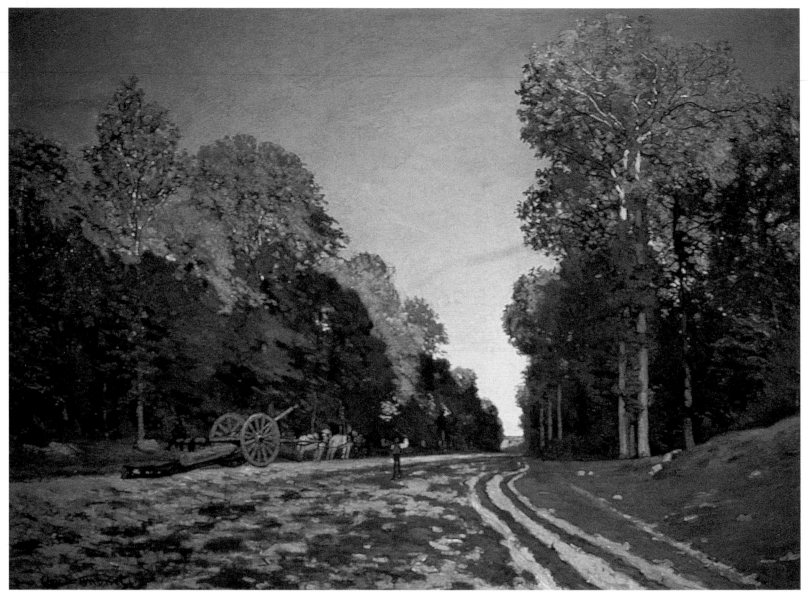

Fig. 24. Claude Monet, *The Pavé de Chailly in the Forest of Fontainebleau*, 1864, oil on canvas. Present location unknown

social relationships, *Luncheon on the Grass* embodies the transformation of a traditional practice that emphasized the solid and durable interactions between bodies and things into one increasingly preoccupied with ephemeral surface appearances.

Against the backdrop of the chase, that shift between an art concerned with the body and one dominated by the eye might be extended. Could it be that there was something of a predatory pursuit in modern painting? Charles Baudelaire's essay *The Painter of Modern Life*, a text that abounds in metaphors of the hunt, strongly suggests as much. The painter of modern life is endowed with an "eagle eye" directed at targeting the latest fashion trends. Baudelaire writes:

"If the fashion or cut of a garment has been slightly modified, if bows and curls have been supplanted by cockades . . . if waists have been raised and skirts have become fuller, be very sure that his eagle eye will already have spotted it from however great a distance." In other words, the painter of modern life approaches the "fugitive" and "transitory" element as though it were a darting animal.[40] Like the painter of the hunt, he seeks to render and explain his quarry in pictures more living than life itself—inherently unstable and fleeting. In Baudelaire's analysis there is a drifting between the carnal and the optical, the body and the eye, that signals a kind of shift in emphasis from the material weight of the world—of bodies and

appetites and things—toward surface reflection—the spectacle, "flickering grace," and "electrical energy" of urban modernity.[41]

In *Luncheon on the Grass*, this shift is evident not only in the sublimated energies of the hunt running through it but also in Monet's handling of the light, which is no longer rooted only in mimetic representation. The juxtaposition of high-keyed hues in the treetops and the unmixed patches of white on the tablecloth are not *representations* of light, but light itself, revealed to be an abstract entity that refers to no more than the material of painting. In *Luncheon on the Grass*, paint becomes unburdened from the work of description. In this way, the painting might be said to contain the process whereby the Impressionists' fidelity to observed reality paradoxically resulted in abstraction.[42] Yet a painting like *Luncheon* can help us to see that the movement toward abstraction in Monet's work was not as straightforward or seemingly accidental as it has often been portrayed.[43] Monet's use of Watteau and his intimation of a level of theatricality in this depiction of an outdoor picnic betray a degree of consciousness of the transformation his painting represents—the transformation of a particular tradition, practiced on a specific site, and the transformation of painterly systems of representation, from traditional illusionism to something more indefinite, more abstract.

The abstracting action of the light in Monet's *Luncheon on the Grass* is filtered by the observation and imagination of the painter, who captures the image of light through conventional means. But some of the most innovative exploration of light at Fontainebleau was undertaken by artists who used daylight as a tool in the making of their images. These were the photographers. As far as we know, Monet did not practice photography in Fontainebleau, nor did he mention it in letters or in conversation. However, he would not easily have escaped knowledge of the landscape photographs that proliferated painters' studios and constituted a formidable presence at the Salons.[44] From the late 1840s, photographers and painters worked side by side in the forest. Many of the Fontainebleau photographers were trained as painters, and many of the Fontainebleau painters collected landscape photographs. When Jean-Baptiste-Camille Corot died in 1875, there were more than two hundred photographs in his studio. Like fellow Barbizon painters Charles-François Daubigny and Henri Rousseau, Corot also practiced cliché-verre, a printmaking technique that employed photographic plates and light-sensitive printing processes.[45]

From his earliest painting excursions in Fontainebleau, Monet appears to have followed the photographer's example or at least to have engaged a similar set of concerns. Some of the first paintings Monet created in the forest, such as *The Pavé de Chailly in the Forest of Fontainebleau* (fig. 24), indicate that he positioned his easel much as the photographer Gustave Le Gray positioned his lens when he photographed the same subject a few years before (fig. 25). Like Le Gray before him, Monet returned to the same site several times to capture it under different light conditions. In both Monet's paintings and in Le Gray's photographs of the pavé de Chailly, the masses of trees become almost abstract shapes, altered depending on the condition of the light. In one painting (cat. 7), the trees at left cast long shadows that seem to have a weight all their own, while in another (fig. 93) the daubs of white paint in the foreground emulate bright light dotting the forest floor in Le Gray's photograph.[46]

Whether or not Monet was looking at photographs of Fontainebleau, his practice was necessarily bound to photography. The substance of his paintings, like the substance of all photographs, is light.[47] The form of his paintings, like that of the photographs of the forest, present light as obfuscating and unpredictable and seemingly at odds with the legible picture of the world provided by the naked eye.[48] For nineteenth-century viewers of the medium, only recently accustomed to the new invention of photography, photographs seemed to provide the proof that we never really know *a priori* what we see, and what we see does not necessarily correspond to what we think we know. As the modern-day scholar Rosalind Krauss observed, early photography provided a picture of the "lost intelligibility" of the world.[49]

The ensemble of paintings Monet made in Fontainebleau in his early years, some twelve in all, show him arriving at this understanding on his own

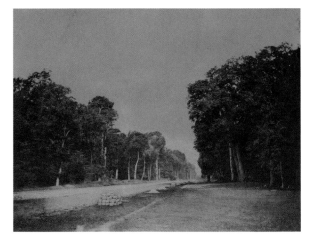

Fig. 25. Gustave Le Gray, *The Pavé de Chailly*, 1852, photograph. Bibliothèque nationale de France, Paris

terms. Never before Fontainebleau had Monet returned to the same site so extensively, experimenting with so many different ways of registering light. Many of these are used, simultaneously, in *An Oak at Bas-Bréau (The Bodmer)* (cat. 8), a small but powerful painting of 1865. Here, light falls across the forest floor in swaths, creating beige and light brown patches on the upper branches of the tree, but below, a large patch of white, almost unmixed paint marks the place where light strikes the tree the strongest. The shape formed by the light also appears quasi-independent and abstract, a brightness unto itself, as if beyond the artist's control. It acts in the same way as the light in the photograph by Gustave Le Gray of the same tree, or in the photograph by Constant Famin of a pathway in the forest where light seems to come from nowhere and cohere into large, dandelion-like masses floating through the air.

The experiments with light that Monet conducted in Fontainebleau culminate with *Luncheon on the Grass*, in which his method of capturing the light signals his move away from traditional systems of representation. In some ways, the picnic might be only a pretext for Monet's exploration of this larger point. Still, the absence of legible interaction between the people in *Luncheon* marks this shift as a loss, or "lost intelligibility," to use Krauss's term, as figure after figure attempts, but just fails at, a convincing interchange with another figure. It is as if leaving behind representation meant leaving behind the painting of meaningful human connection.

This lack of interpersonal connection between the figures brings us back to Watteau, from whose work stems this zigzagged rhythm of crisscrossed gestures and exchanged glances. One of the most often cited characteristics of Watteau's paintings is their vague sense of melancholy, which is due in part to the fact that his figures appear oddly indifferent to one another, as though they are playing a role, and also from the fact that there is often no clear meaning to his painting, no release from the innuendo of the interactions staged therein.[50] Although Watteau's paintings cannot be read this way in any general sense, "melancholy" was a resounding refrain from critics of Watteau in Monet's day, especially in the context of the *Embarkation for Cythera*, Monet's favorite painting in the Louvre (fig. 26).

In the *Embarkation*, men and women wind their way through the countryside. A river is visible in the distance, where putti frolic in the clouds and sky. In the foreground at right is a statue of Venus with roses wrapped around her. In speaking of the painting, Edmond and Jules de Goncourt wrote:

> It is Cythera, but it is Watteau's Cythera. It is love, but it is a poetic love, a love that thinks and feels, modern love, with its aspirations and its crown of melancholy. Yes, at the bottom of this work by Watteau, I know not what slow and vague harmony murmurs behind the laughing words; I know not what sadness, musical and softly contagious, is dispersed in these gallant parties.[51]

As the repeated "I know not" in this passage suggests, part of the perceived melancholy in Watteau's painting is rooted in what cannot be discerned within its frame. As Norman Bryson explains, "In the melancholic gaze, the world is no longer apprehended as *sufficient*, as completed presence; something is missing, but what it is can never be named, because it is absence."[52] Longing stems from the evocation of what is no longer there.

This sense of something missing in Monet's painting is made all the more poignant by the heart carved into the tree. Whether it was really present on the tree that served as the painter's model and which he felt obliged to record, or whether it was invented by Monet, cannot be known. But in calling attention to it, Monet gives the heart the role of a symbol of love—the role played by the statue of Venus in Watteau's *Embarkation*, now degraded to a roughhewn carving. The extent to which the placement and pose of Monet's figures in *Luncheon on the Grass* draws from the body of Watteau's work suggests that he was conscious of that fact. After all, to him the forest of Fontainebleau was something of a real life *jardin d'amour*. But if his future wife posed for more than one woman in the picture, nowhere in this painting is there any indication of his connection to her. The heart would seem to summon love only to carve it out.

In this way, *Luncheon on the Grass* is arguably as important for what it is not as for what it is. The painting is neither a *fête galante* nor a *repas de chasse* nor a *jardin d'amour*, and yet its setting and the visual language on which it draws forcibly call this history to mind. Like Watteau before him, Monet makes a point of what is absent from within his painting's

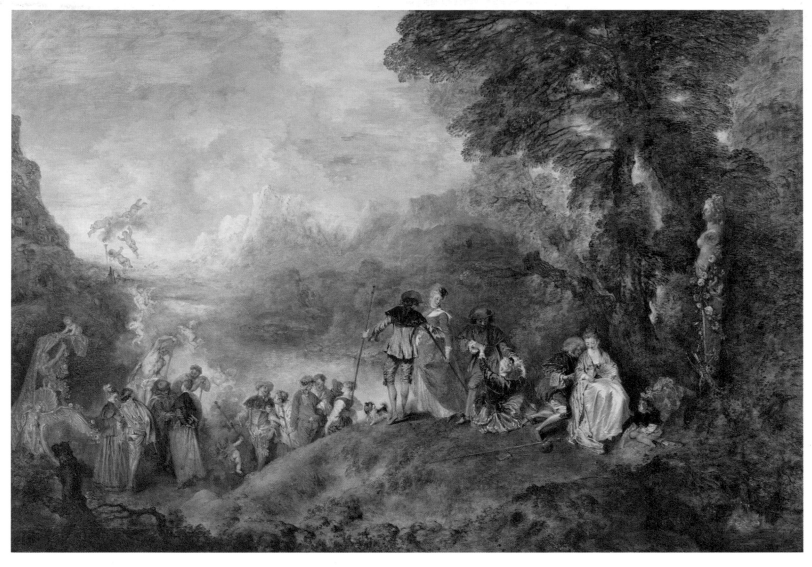

Fig. 26. Jean-Antoine Watteau, *Embarkation for Cythera*, 1717, oil on canvas. Musée du Louvre, Paris

frame. In the case of *Luncheon on the Grass*, the absence that is most evident is the painting's lack of completion—not only the fact that it is not finished, but the fact that large fragments of it, cut away by Monet, are lost.

We will never know exactly why Monet did not finish *Luncheon on the Grass*. But when we take into account the history of the site and of the hunt and of the sources from which Monet drew in making his painting, the challenges he faced become clear. The difficulty and enormity of his project was not just to outdo Manet or to incorporate some comments Courbet may have made; it was not even simply to reconcile three-dimensional illusionism with surface unity, as has been suggested elsewhere.[53] Rather, the painting and its preparatory sketch suggest that their undoing stemmed from the difficulty of reconciling the myth of the place and the reality of the moment, the weight of real bodies in space and the abstracting action of the light, and of collapsing history and contemporaneity, loss and love into a single picture.

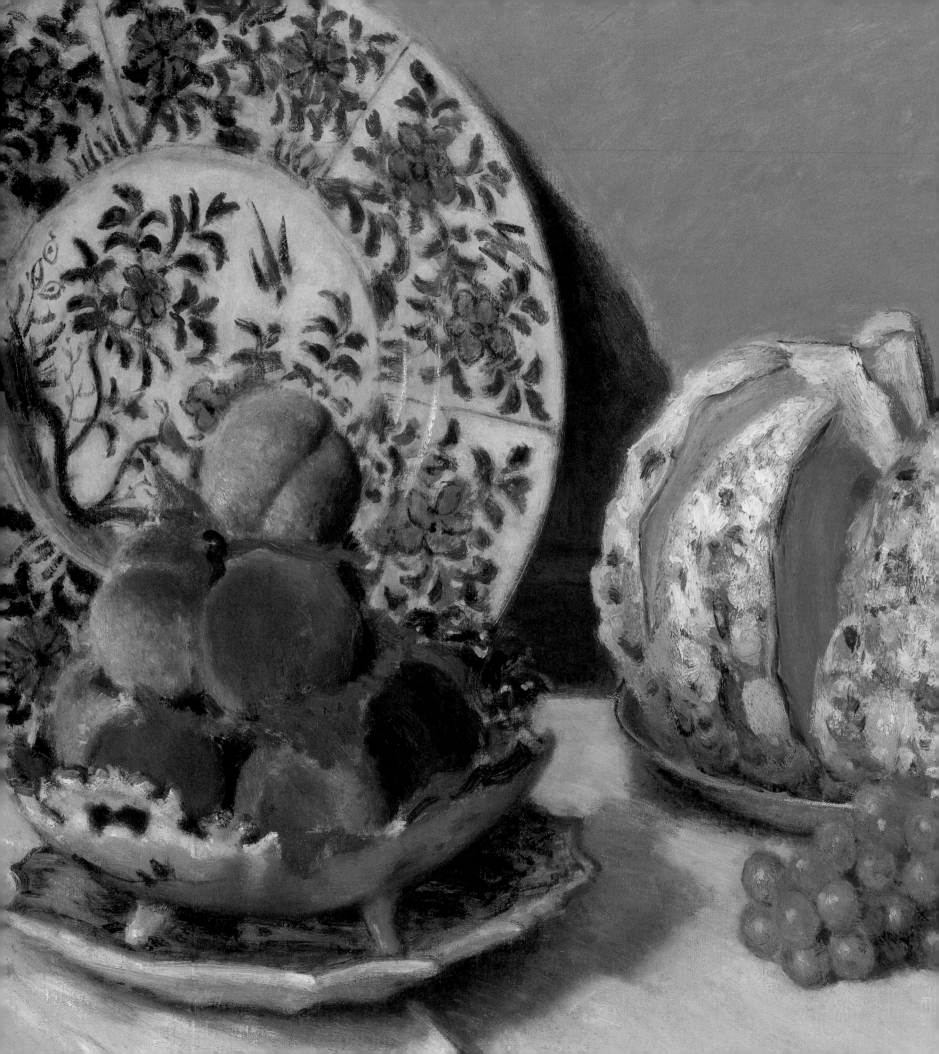

Emergent Naturalism: Reflections on Monet's Early Paintings, 1864–1874

Richard Thomson
Watson Gordon Professor of Fine Art, University of Edinburgh

The paintings Claude Monet made during the first decade of his career are quite remarkable. From his mid-twenties, he produced canvases of striking confidence and authority, as contemporary critics were swift to recognize. Even in his earliest works, his considerable skill in portraying a great variety of natural effects—of light, weather, and atmosphere—is readily apparent. Though he chiefly concentrated on landscapes, Monet's range over those ten years was wide in terms of subject, covering not only a rich variety of outdoor motifs—from sea to city, forest to field—but also figure subjects, portraits, and still lifes. To tackle that ambitious spectrum, Monet drew upon his artist's eye and skill as a painter, and to understand these canvases, of course, requires looking closely at how he composed and crafted them. Monet's early development as an artist, both in his choice of subject and how he executed it, was also shaped by current debates in French artistic circles. These questioned what painting should be and what its responsibilities were. If Monet emerged as an artist at a time when young painters were increasingly drawn to painting from nature as an end in itself, the issue remained of how that might best be done and how description of actuality might still permit the articulation of individual artistic identity.

As Monet's development as a painter made him confident enough to begin exhibiting his canvases in the mid-1860s, the nature of naturalism was a matter of debate. The emergence around 1848, at the time of political revolution in France, of the realism of Gustave Courbet and Jean-François Millet had led to an uncomfortable association of the direct depiction of the visible, material world with subversion. The frankly painted representation of a simple regional landscape, unadorned with either imaginary nymphs or picturesque old buildings but populated instead by peasants and

animals, might be unwelcome by the urban bourgeoisie both as a rejection of painting's conventional ideals of high finish and elevated subject and also as a focus on the socially ordinary. But gradually the cultural climate was changing, apparent during the 1860s from the art criticism of Ernest Chesneau, a well-informed and balanced writer. In 1864, a collection of his recent writing, which included a review of the previous year's Salon des Réfusés at which paintings such as Édouard Manet's *Luncheon on the Grass* and James Whistler's *White Girl* had scandalized the public, opened with an essay called "Le Réalisme et l'Esprit Français dans l'Art" (Realism and the French Spirit in Art).[1] In it, Chesneau traced a tendency to depict the unexceptional and everyday in the work of seventeenth-century French artists such as the Le Nain brothers through eighteenth- and early nineteenth-century successors like Jean-Baptiste-Siméon Chardin and Théodore Géricault. He acknowledged that the main strain in French painting was an instinct towards idealization, the urge to stylize and harmonize, and ended with an appeal for compromise: "The vitality of French realism is only powerful because it can link itself to the ideal."[2] Four years later, in a book reflecting on the international art exhibited at the 1867 Exposition Universelle in Paris, Chesneau's position was more confident. He particularly praised contemporary French landscape painters, who, he asserted, "show themselves to be original, sincere, passionately engaged by truth, curious about every new pictorial effect, searching ceaselessly to penetrate the secrets of their one and only master: Nature" and who dismiss "shabby conventions."[3] Chesneau's stance seems to have adapted, moving away from a requirement that the descriptive should be mollified by a degree of idealization to an appreciation of landscape painters' individual drives to depict anything that nature might present in personal terms. This was—no doubt quite independently—consistent with the dictum voiced by the young novelist Émile Zola, exactly Monet's contemporary, in 1866, when he had defined a work of art as "un coin de la nature

Fig. 27. Claude Monet, *Road toward the Farm Saint-Siméon, Honfleur*, 1867, oil on canvas. Harvard Art Museums/Fogg Museum, Bequest of Grenville L. Winthrop

vu à travers un tempérament" (a corner of nature seen through a temperament).[4] That Zola preferred the term "naturalism" to "realism" also marks a development in the debate.

As a young man, Monet was still in the process of discovering for himself what his instincts as an artist were. These were, to a considerable extent, shaped by his allegiance to naturalism, to the observation and description of his surroundings. One of its tenets

Fig. 28. Claude Monet, *The Road to the Farm of Saint-Siméon in Winter*, 1867, oil on canvas. Private collection

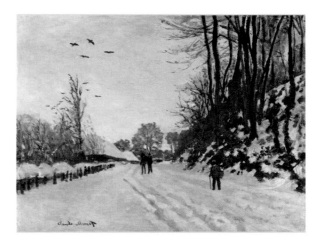

Fig. 29. Claude Monet, *The Road to the Farm of Saint-Siméon in Winter*, 1867, oil on canvas. Private collection

was that actuality of every kind, thus nature in all its moods, should be tackled by the artist. In 1865, Monet painted the road from Trouville to Honfleur near the Saint-Siméon farm with a cart making its way through a heavy fall of snow (cat. 24). Two years later, his willingness to paint in cold conditions lead to four canvases painted in the same vicinity, each composition

using the perspective of the road and the stark flanking trees to give a sense of depth in landscapes compressed by the blanching unity of snowfall and blanketed sky (figs. 27–29). Monet was evidently very confident of his capacity to paint such winterscapes, requiring sharp contrasts of value between the enfolding white snow and protruding dark trees or structures. But his submission of *The Magpie* (cat. 25) to the Paris Salon of 1869 was unsuccessful, its rejection by the jury due perhaps to its size—more than four feet across was unconventionally large for a motif of little more than a bird perched on a bare gate—or to its insistent whiteness, true to wintry nature but at odds with the norms of landscape painting. Monet also ventured out in rain and high winds. *The Jetty at Le Havre in Rough Weather* (fig. 30), painted in 1867, represents both fishing boats and a large ship keeling over in a strong northeasterly gale, as rain lashes the figures on the quay watching the vessels making for the shelter of the harbor. The following year, he submitted a large canvas of a similar subject, *The Jetty at Le Havre* (fig. 31), to the Salon, from which, like *The Magpie* a year later, it was rejected. The jury's motives might also have involved scale but can scarcely have been based on inattention to detail. Monet carefully measured out the man-made elements—the stone jetty, the regular lampposts, the lighthouse at the end—and the natural ones—the breakers crashing onto the pier, the sky clearing to the west, and the rainbow marking the downpour from the somber clouds.

His creativity centered on landscape painting, Monet's commitment to the descriptive drove him to work as much as possible out-of-doors, *en plein air*. This practice of working directly in front of what one was painting—*sur le motif*, in the parlance of painters—was intended to optimize the accuracy of representation and the immediacy of response to changing effects of light and weather (*effets*). The grains of sand and fragments of shell found embedded in the paint of studies Monet made on the beach at Trouville in 1870 are the microscopic evidence of his methods.[5] That said, there was considerable diversity in Monet's practice at this period. Reporting to Frédéric Bazille on the work he had done with Auguste Renoir at La Grenouillère in the western suburbs of Paris during the summer of 1869, Monet deprecated his canvases as "some poor sketches" (*quelques mauvaises pochades*).[6] This indicates that he saw those paintings as

exploratory, records of the motif and observations of effects such as the sunlight on the river Seine that would serve as preparatory for a larger and more finished work—which in the event he never made. That Monet sometimes followed such standard practice is evident from, for example, the major painting that he exhibited at the Salon of 1865, *La Pointe de la Hève at Low Tide* at the Kimbell Art Museum (cat. 5). The composition was based on a canvas half the size that he had painted the previous year. Monet retained the same sweep of the beach and tumbling diminuendo of the headland but changed the ancillary figures and

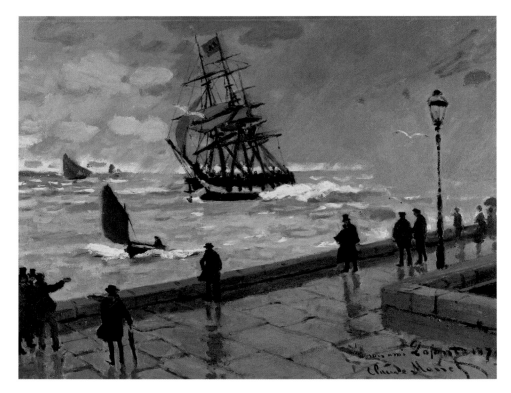

Fig. 30. Claude Monet, *The Jetty at Le Havre in Rough Weather*, 1867, oil on canvas. Private collection

introduced a more threatening sky. At nearly five-feet wide, it is unlikely that *La Pointe de la Hève at Low Tide* was painted out-of-doors, but rather in the studio.[7] In other words, the naturalism of Monet's practice was inconsistent and multifaceted. Truth to nature might involve working out-of-doors, on the beach, in the snow. But it might also necessitate studio work, the reprise of a previous painting, or the dramatization of an observed *effet*.

For Monet could be both inconsistent and consistent. In 1866, he produced a group of seascapes of the English Channel, which are remarkable both for their depth

of color and simplicity of touch. Paintings such as *The Green Wave* (cat. 15) and *Stormy Seascape* (cat. 17) reduce the brushstrokes to a very small repertoire of broad patches and smaller blocks, while the zones of sea and sky are handled in deep-toned greens and grays, heightened by patches of white bow waves and strips of sunlit sea. With their abrupt and concise character, they make a contrast to the more closely observed, even detailed, texture of wave and cloud which Monet usually favored. If these 1866 paintings have a somewhat inconsistent identity, however, another

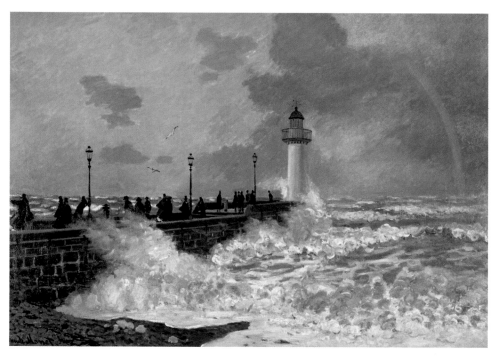

Fig. 31. Claude Monet, *The Jetty at Le Havre*, 1868, oil on canvas. Present location unknown

aspect of Monet's practice was more consistent. From as early as 1864, he quite regularly painted variants of the same motif. A case in point are two canvases of the same size representing the lighthouse at the entrance to Honfleur harbor (cats. 3 and 4). They depict different times of day, one sunset and the other full day, and different *effets*, the first showing the dying light illuminating layers of high clouds and the second rain-filled cumulus gathering under a blue sky. Such repetition challenged Monet to respond to the variety of nature's moods. And he did so not just by what he represented—here different times of day and cloud formations—but also by adjusting his brushwork, for the sunset painting is executed in flatter strokes while the other used more fluid paint to give a sense of

the moisture and translucency of the clouds. Within Monet's consistency there might be inconsistency, the better to respond to what he saw in nature.

Almost a decade later, repetition was crucial to Monet as he settled at Argenteuil, in the northern suburbs of Paris. It almost seems that the three pairs of paintings he made within a few months of his arrival there in December 1871—two of a branch of the Seine and the third of women seated in the shadow of blossoming lilacs—had a psychological importance for the artist as he settled into his new surroundings, taking stock of place and possibilities.[8] The two paintings of the petit bras (small branch) of the river were painted from more or less the same spot, with the same stand of poplars on the far bank (figs. 32, 33). These are clearly paintings about *effet*, but in this case the days depicted appear very similar: calm, relatively windless, with a blue sky and very few clouds. The difference lies in the time of year, as the canvas with the sailing boat depicts trees in bud rather than in leaf, making it the slightly earlier painting. Such pictures used the same framework to test Monet's capacities to respond to changing *effets*. Part of this process was honing his sensibility (*sensation*, in painterly parlance), the artist constantly questioning himself: What brings out the best in me when I paint? How do I respond to this motif and this *effet*? How do I put it down in paint?

That same year, the very productive Monet painted four canvases of the same motif at Argenteuil (cat. 54, figs. 34–36). As one would expect, they explore different *effets*—various amounts of cloud cover; midday, late afternoon, and early evening light—and are viewed from slightly different positions, always with the same villa and its rather pretentious conical tower as a focus. All four canvases rehearse the same repertoire: middle-class women strolling along the riverbank to the right, sailing boats out on the unruffled Seine to the left, ahead on the horizon the villa and factory chimneys, and on the right-hand margin the strong verticals of trees rising from the path to the upper edge. The composition is based on the right angle of the river and the trees, a formidable pictorial architecture, simple and strong. This sturdy armature brackets an image of industry and prosperity, leisure and calm. Given that these paintings from the summer of 1872 were painted little over a year after France's signing of the humiliating Treaty of Frankfurt following her defeat in the Franco-Prussian War and the suppression

of the Paris Commune in May 1871, effectively a civil war in which around 30,000 were killed, they project a remarkable atmosphere of social order restored, commerce reestablished, and bourgeois stability revalidated. No doubt Monet repeated this motif because it satisfied his sensibilities and offered a pleasing range of *effets*. But the fact that all four sold to the dealer Paul Durand-Ruel in the year they were painted indicates that Monet's naturalist landscapes could convey more than just his fascination with the

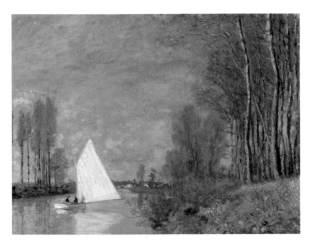

Fig. 32. Claude Monet, *Sailboat on the Small Branch of the Seine, Argenteuil*, 1872, oil on canvas. Private collection

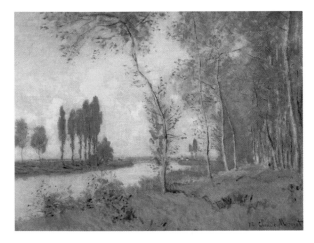

Fig. 33. Claude Monet, *Spring in Argenteuil*, 1872, oil on canvas. Private collection

nuances of the physical world and his ability to find a satisfying order in nature, even a nature as equivocal as the suburbs of Paris. They could also articulate social associations reassuring to the bourgeoisie of the newly established Third Republic and the art market that served it.[9]

Another aspect of naturalism—initiated by Gustave Courbet and followed by Monet—was the willingness to make big statements with ordinary subjects. Monet did this with the paintings he submitted to the Salons in the second half of the 1860s. With its view across the open waters towards a blue breach in the clouds, *The Mouth of the Seine at Honfleur* (fig. 37) makes a contrast to its pendant, the identically sized *La Pointe de la Hève at Low Tide*, the beachscape under lowering skies that was also exhibited at the Salon of 1865. Despite the scale of the painting, Monet managed to conjure up a remarkable sense of the momentary in *The Mouth of the Seine*. The fishing boats are all tilted by the choppy waves; a single sail is illuminated by a shaft of sunlight breaking through a temporary gap in the cloud; seagulls are wheeling in the sky, pinpointed by the light against the gray above. Here, Monet's ability to give an arresting sense of a passing moment in nature exemplifies the twenty-five-year-old painter's remarkable abilities as an artist of the actual. But *The Mouth of the Seine* also demonstrates how adept Monet was at picture-making. The white sail on the right, for instance, picks up a white house on the left, both marking the same plane. And that white sail, set against gray clouds in the picture space beyond, is the strongest value-contrast in the picture. Monet's paintings may be remarkable records of nature observed, but they are also manifestations of a fiercely intelligent sense of pictorial organization.

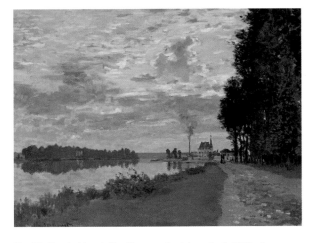

Fig. 34. Claude Monet, *The Promenade at Argenteuil*, 1872, oil on canvas. Private collection

Monet's naturalist instincts and his picture-making coincided in unexpected ways, such as where he chose to position himself in relation to his subject, which typically set up challenges about looking and responding to actuality. On occasion, he chose to work very close to his motif—for example, in paintings of trees and undergrowth made in the Fôret de Fontainebleau, such as the 1865 canvas of the *Bodmer Oak* (cat. 8). This also occurs in other subjects, like the *Fishing Boats* (cat. 14), painted the following year, in which Monet viewed the vessels from such close proximity that the masts and their reflections fill the

canvas from top to bottom edge, creating an effect not unlike the density of a forest. In 1867, Monet painted his common-law wife Camille next to a cradle bearing their first-born son, Jean (cat. 10). Here again, vantage is crucial. This is a paternal position, the viewpoint of the artist standing over his sleeping child and his seated wife. Instinctively, Monet chose an angle that is possessive and protective—and true to life.

For Monet's naturalism extended to his use of the human figure. His landscape paintings are often animated by small-scale figures, people engaged in ordinary manual labor and daily activities, be they farm workers, fishermen, or women with children. He also made a number of ambitious, large figurative compositions, the biggest of which was *Luncheon on the Grass* of 1865–66, which he later cut up into sections (cat. 9). What is intriguing about this project is how

from the interior through French windows as she passes through the snow-covered garden. It corresponds, one might well argue, not only to the instant sight of her moving past but also to Monet's momentary emotion as he saw her, affection and desire requiring it to be recorded. Once again, Monet's eye for the naturalistic proved itself adaptable, not restricted to fixed parameters of painting but responsive to a wide variety of challenges and experiences.

Monet's naturalism may have been a commitment to observing and describing material actuality, but that did not mean that what he painted was entirely natural. Artifice, in the form of man's control of nature, was something he did not avoid. In the cityscapes of Paris that Monet painted in 1867, he necessarily represented a man-made world. The trees outside Saint-Germain l'Auxerrois had been recently planted as part of Baron

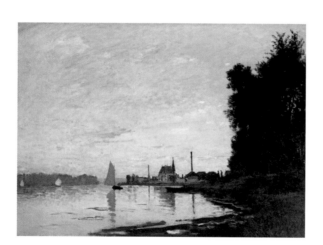

Fig. 35. Claude Monet, *Argenteuil, Late Afternoon*, 1872, oil on canvas. Private collection

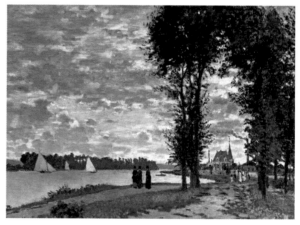

Fig. 36. Claude Monet, *The Banks of the Seine at Argenteuil*, 1872, oil on canvas. Private collection

accurately Monet, already a specialist landscape painter, depicted gesture. In the largest fragment, his shrewd eye for observing and recording the actuality of behavior is evidenced by the woman seen in profile who lifts both her hands to her head as she adjusts her pill-box hat, or her escort gesturing with her parasol to a place on the ground where she might sit, his head turned the other way as he makes his suggestion. These observations are nuances, but they shrewdly convey the petty likelihoods of social interchange; in other words, they demonstrate Monet's naturalist credentials. *The Red Kerchief,* painted in 1873 (cat. 12), is of a different order. Whereas *Luncheon on the Grass* was an elaborate and carefully pondered studio composition, *The Red Kerchief* represents a momentary glimpse of Camille

Georges Haussmann's redevelopment of Paris, one of the aims of which was to introduce more greenery into the metropolis. So this natural element in an otherwise entirely built environment was an artifice of urbanization, and Monet's frank observation of it was naturalist (cat. 18). A similar result can be found in his figure paintings. *Adolphe Monet Reading in a Garden* (cat. 23) is natural enough, with its relaxed sitter posed on a bank reading his newspaper. But he is essentially peripheral, and the artist's primary interest is the large curving flowerbed beyond, with its rose trees atop their posts and the blanket of red and white geraniums beneath: not a natural landscape, but a carefully planned and cultivated horticultural display. Indeed, Monet's own viewpoint—along a path whose

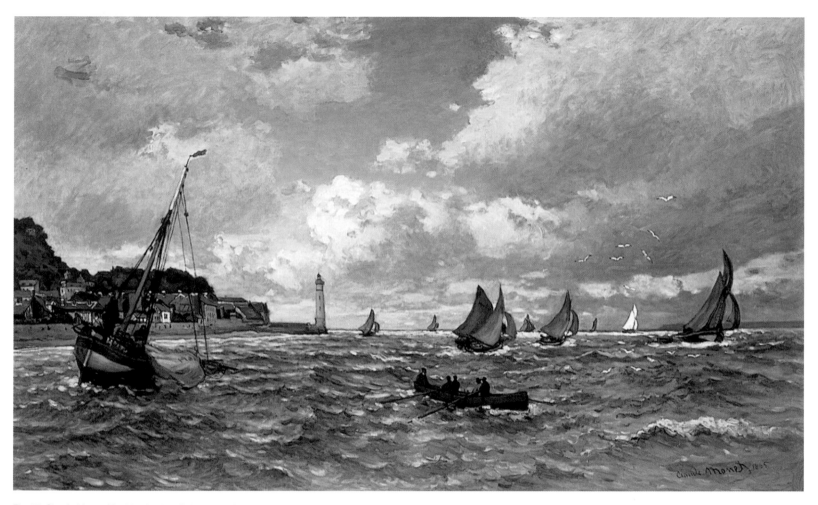

Fig. 37. Claude Monet, *The Mouth of the Seine at Honfleur*, 1865, oil on canvas. The Norton Simon Foundation, Pasadena, California

foliage above and shadow below frames the flowerbed in an elongated oval echoing the shape of the viewer's eye—is both plausible and artfully contrived. Even landscapes that represent nature entirely untouched by man might be manipulated for effect. Take a view of Étretat painted in the late 1860s (cat. 27). It makes the most of the dramatic rock formations that flank the fishing village, where, over millennia, time and tide have crashed holes in and carved columns from Normandy's massive chalk cliffs. Monet chose a view from the east, looking towards the west and the sunset through the huge natural portal known as the Porte d'Amont, using it to frame the Aiguille (Needle), a vast pillar of chalk on the other side of the bay. Such a choice had been made by the photographer Louis-Alphonse Davanne in 1864, but from the other direction, when he had taken a plate of the Aiguille viewed from the west and seen through the enormous Manneporte (fig. 38).[10] Neither Davanne nor Monet recorded anything that was not visible, but both photographer and painter

Fig. 38. Louis-Alphonse Davanne, *The Manneporte at Étretat*, c. 1864, photograph. Bibliothèque nationale de France

Fig. 39. Claude Monet, *Still Life, Pears and Grapes*, 1867, oil on canvas. Private collection

deliberately arranged his vista to optimize nature at its most dramatic and grandiose.

Curiously enough, the least naturalistic paintings Monet completed during this period are still lifes, especially those painted in the late 1860s—such works as *Still Life, Pears and Grapes*, which are so consciously posed, balanced, and choreographed (fig. 39). They are characterized by rather obvious contrasts—of fruits in different warm tones, of light and shadow, of somber backdrop and white cloth—and by posed objects, like a cock pheasant artfully arced across the

horizontal canvas to fill the picture space (fig. 40). The still lifes Monet painted in 1872 have a rather different character. Above all, they have a more sophisticated grasp of chromatics, as well as of the value of asymmetry as a means of animating the obvious. *Still Life with Melon* (cat. 52) sets off the blue of the oriental plate against the orange of the fruit's flesh. But there is more than a play of complementary colors here, because the segments of the melon match those around the margin of the plate, creating a highly nuanced parallel between the divided sphere and

the intact disc. *The Tea Service* (cat. 53) is even more asymmetrical and sets the diagonals of the spoon, the tray, and the pleats in the tablecloth—all man-made elements—against the curving irregularities of the natural forms of the plant's leaves. This disjunction is harmonized by the silvery tones that play across the damask, the foliage, and the gloss of the ceramic. With experience, Monet's still lifes had become not more naturalistic, but more stylish. In the end, it becomes clear that Monet's naturalism was not entirely natural; it was negotiated.

He instinctively followed Chesneau's prescription to be sincere and curious in his dedication to nature and to dismiss the conventional. He registered as a painter of both naturalistic observation and genuine temperament with Zola, who defended the rejected *The Jetty at Le Havre* for its "dirty waves, these surges of sandy water which must have horrified the jury accustomed to shiny babbling little waves in sugar-candy seascapes."[11] As Monet emerged as a leading naturalist painter in the late 1860s and early 1870s, he proved himself an artist of range and initiative, not satisfied with simple solutions. Monet's naturalism was not restricted either by subject or style. He regularly essayed his descriptive powers with figure subjects and still lifes as well as landscapes, and his notion of landscape was one of breadth and challenge, from the view straight out to sea to the urban vista, from wind-blown spray to the bark of an oak, from sunset to cliff-face. And in all these canvases, he refused to rely on formula, adjusting his touch for different *effets*, repeating motifs to address a change of light or weather. With such endeavors carried through so strongly across three hundred canvases, the young Monet proved himself to be a naturalist painter of true temperament.

Fig. 40. Claude Monet, *The Pheasant*, 1869, oil on canvas. Private collection

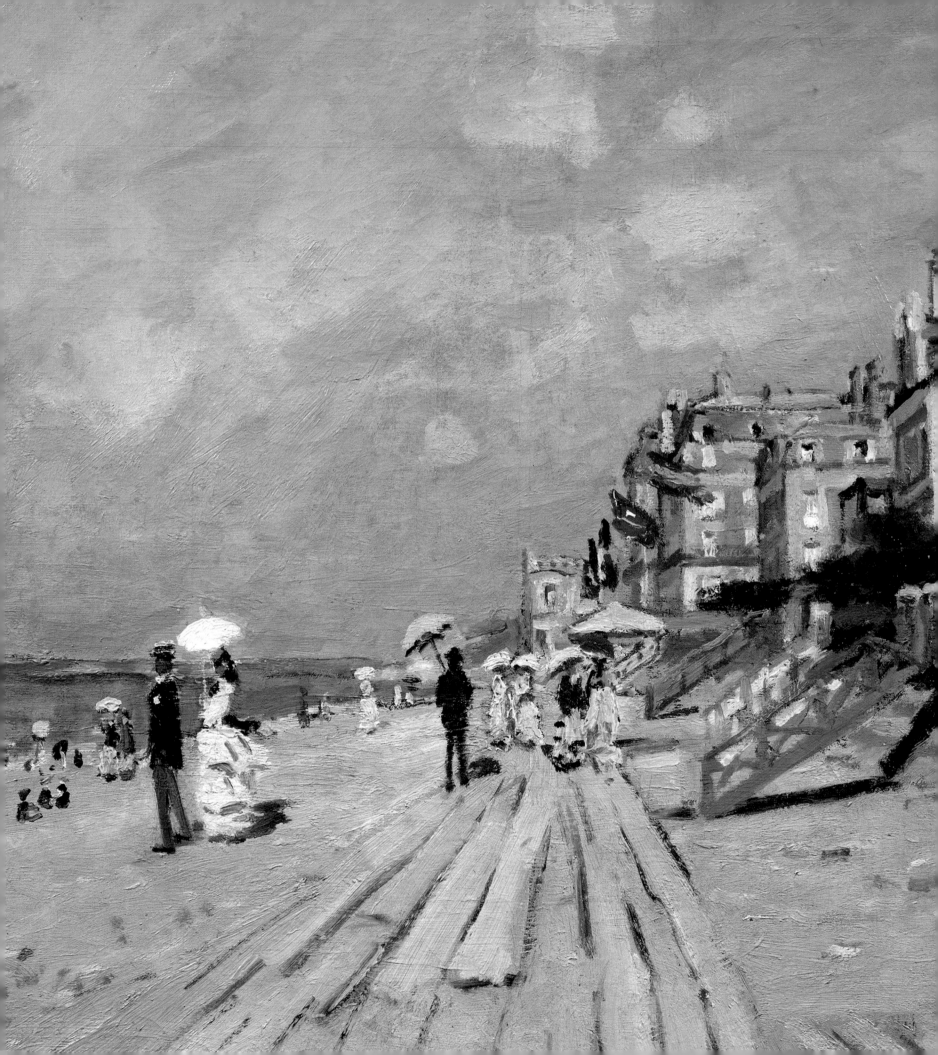

Taking Shape: Monet's Compositional Techniques

Anthea Callen

Professor emeritus of the Australian National University, Canberra, and professor emeritus of visual culture, University of Nottingham

Monet's first landscape paintings date from the late 1850s. It is for his work as a painter of landscape—"equal to the greatest painters of all time," as his friend Octave Mirbeau, the radical writer and critic, wrote in 1889—that he is best known. All the major blockbuster exhibitions of Monet in the last thirty years have focused chiefly on this aspect of his oeuvre. Yet as the present exhibition of Monet's early work demonstrates, up until the advent of Impressionism in 1874, his career path was less obvious. The major Salon exhibition entries he labored on during the 1860s dominated his time and were mainly figure paintings, executed both *en plein air* and in his various studios. Equally, his wide-ranging friendships included not only landscapists and the prominent realists Édouard Manet and Gustave Courbet but also society portraitist Carolus-Duran (1837–1917) and American painter James McNeill Whistler (1834–1903).[1]

Monet's output during his first fifteen years as an artist thus included major figure paintings, portraits, and self-portraits, alongside many still lifes and flower paintings, which served as useful foul-weather work and also sold well (see cats. 28, 52–53). Monet's skill as a draftsman, apparent from his mid-teens in the caricatures he intended for sale (see fig. 70), were inspired by the likes of Honoré Daumier and could have signaled a career as a preeminent painter of the modern figure; the talent was certainly there. In the event, his serious large-scale figure paintings fall broadly into distinct but delimited periods. The first and most important was in the formative years covered by this exhibition. The second was in the mid-1870s, when he painted a series of Camille Monet with a parasol, often from unusual vantage points (fig. 41). He returned briefly to the predominant figure in outdoor settings in 1886–89, most likely echoing the wealth of large figure paintings produced in the mid-80s by his

Claude Monet, *The Beach at Trouville* (detail), cat. 34

friends Pierre-Auguste Renoir and Camille Pissarro as well as by the young newcomer Georges Seurat, whose monumental *Bathers at Asnières* was shown in Paris in 1884 and his *A Sunday on La Grande Jatte – 1884* exhibited in the eighth Impressionist exhibition two years later. Yet from the first exhibition of his series paintings—in 1889—onward, Monet abandoned the outdoor figure. He excluded even the summary *staffage* (the "tongue-lickings" for figures famously satirized by critic Louis Leroy in 1874) that had been typical of his high-viewpoint urban landscapes of 1867—like *Saint-Germain-l'Auxerrois* and *Garden of the Princess* (cats. 18, 20)—and that had still been present, though even more abstract, by 1874 in his *Boulevard des Capucines* paintings (fig. 62).

How then did Monet develop these powerful artistic preferences? He began his career proper as a plein-air painter in his native Normandy under the eye of Eugène Boudin, the Norman landscapist who also ran an artists' materials shop and gallery in Le Havre. Boudin persuaded the young Monet to study directly from nature with him along a coast with which the youth was extremely familiar, using the materials in which Boudin himself excelled—first pastels (fig. 42) and then oils. Under Boudin's influence, Monet began by exploring wood as a support for two small oil studies of factories, a swift if incomplete study of the *Saint-Siméon Farm Road*,[2] and, on a larger scale, the painting *Faggot Gatherers in the Forest of Fontainebleau*. But Monet rapidly abandoned panel for the more interesting tooth that canvas offers to the moving paint brush—and, of course, its greater portability.

The authenticity of Boudin's vision, the emphasis in his work on observed nature, and the power especially of his studies of the changing northern skies were a profound influence on the younger artist and can readily be seen in Monet's marines of 1864–65, which

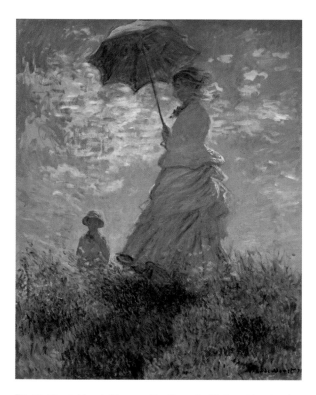

Fig. 41. Claude Monet, *Woman with a Parasol – Madame Monet and Her Son*, 1875, oil on canvas. National Gallery of Art, Washington, D.C. Collection of Mr. and Mrs. Paul Mellon

resulted in his successful Salon debut in spring 1865. His two submissions were, in the traditional manner, executed not out-of-doors but in the studio, using oil studies that had been painted on the scene. Both paintings were large-scale compositions on canvases of the same size: *La Pointe de la Hève at Low Tide* (cat. 5) and *The Mouth of the Seine at Honfleur* (fig. 37). Significantly, at 90 x 150 cm, their measurements do not match the range of ready-made standard formats available through art suppliers. Nearest in size was a vertical canvas designed for seascapes—a "marine 80," at 146 x 89 cm (see fig. 43). Monet thus made the strategic decision to order two canvases expressly made to measure for his Salon debut, which demonstrates his careful advance planning, both in making a "pair" of seascapes and in their requiring an even wider, more panoramic shape than the elongated marine formats readily available off the shelf. This is especially interesting given the contrasting-sized studies from

Fig. 42. Claude Monet, *Sunset at Sea*, c. 1865, pastel on buff paper. Ashmolean Museum, University of Oxford, United Kingdom. Bequeathed by Frank Hindley Smith

which the pair derived. *Horses at the Pointe de la Hève* (fig. 91) exploited a vertical marine size 20 turned on its side, while for *Le Phare de l'Hospice* (cat. 4), Monet used the more elongated horizontal marine in a size 25; both were already ambitious in scale for plein-air oil studies. Each was extended in width proportionately in their scaling up to large canvases for his Salon bid. Thus the original compositions were widened, deeper foregrounds added, and the internal relationships of scale subtly altered.

What this tells us is just how professionally calculating and strategic the twenty-four-year-old Monet already was in his selection of materials, the execution of his paintings, and his analysis of the market. Far from being spontaneous and unpremeditated, throughout

his career Monet sustained an astute and discerning practice that included highly deliberate choices in his support shapes and sizes specific not just to motifs and compositions but also to prospective patrons.

For the most part, Monet worked with the formats offered by the commercial market. The origin of the standard canvas system in France dates back at least to the late seventeenth century. The first commercially manufactured supports were in a format designed for small to mid-scale portraits. Though these original standard canvas sizes pre-date the emergence of an independent trade of specialized artists' suppliers (colormen), their creation was doubtless based on market forces. As early as 1684, the art theorist Roger de Piles wrote of "une toile de 20 sols" [a canvas of 20 sous]—showing that a direct relation between canvas size and price was already common currency in his time.[3]

A mid-eighteenth-century source, Antoine-Joseph Pernety's *Dictionnaire portatif de peinture*, provides a list of standard-sized canvases that could be bought ready-primed and mounted on stretchers. Pernety noted that French canvases were the best primed of all European artists' canvases and explained: "They can be found ready-primed at the 'Marchands de couleurs': they have all sizes; but normally they only ready-prime the 'toiles de mesure,' which is to say those of a fixed and standard size: they are named after the price they cost." Above the largest standard canvas (6 x 4 feet), neither size nor price was fixed.[4] Over seventy-five years later, in 1829, art theorist Paillot de Montabert confirmed that these same standard sizes were still being sold and definitively attributed their widespread adoption to suppliers' commercial interests, rather than to any painter's aesthetic concerns:

It is customary in Paris to give fixed sizes to canvases, and thus to stretchers; these fixed sizes are adopted without much thought. Artists generally believe that these dimensions have been determined by the experience of skilled masters, either for the good grace of portraits, or by some fitness of proportions which must be blindly respected: but it has nothing to do with all that. It is the color merchants who have found it more convenient, in order to prepare their canvases in advance, to give them fixed sizes; as a result,

by that means, they are less at the mercy of the painters' whims to adopt all sorts of sizes, and they make [painters] adopt these convenient sizes without consideration.[5]

As to aesthetics, the dimensions of the original range of standard sizes—the portrait formats—were in fact determined not by any ideal harmonious proportions, but simply by the most economical cutting of the hand loom widths of canvas then commonly available.[6] An added advantage was that color merchants could also

Fig. 43. Table of bare frame and stretched canvas sizes, Lefranc et Cie catalogue, 1892, Paris

Fig. 44. Table of canvas sizes showing dimensions in meters and pouces, Lefranc et Cie catalogue, c. 1855, Paris

ready-make picture frames in these standard portrait sizes and have them immediately available for purchase.

By the date of the earliest surviving French colormen's trade catalogues—from Lefranc—of around 1850 and 1855, fixed canvases for portraits included new numbers 1, 2, and 3, significantly adding greater choice at the smallest "study" end of the range. These highly portable formats would have been ideal for oil sketching *en plein air*. Yet it is notable that very few even of Monet's youthful plein-air oil studies

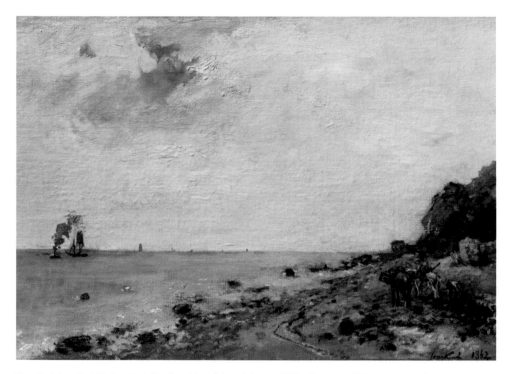

Fig. 45. Johan Bartold Jongkind, *The Seaside at Sainte-Adresse*, 1862, oil on marouflé paper mounted on canvas. Association Peindre en Normandie, Caen

measured less than a no. 10 (55 x 46 cm) canvas, and more commonly nos. 20 or 25 (up to 81 x 65 cm).

Also new by mid-century were the special standard-format canvases advertised for landscape and marine painting (see fig. 43). These new supports were evidently introduced after Paillot de Montabert's list of 1829 but before the surviving Lefranc catalogues of the 1850s. (Although not designated as such in Lefranc's catalogue of c. 1850, later references make clear that the four separate columns of sizes listed by the color merchant under each number (e.g. *toile de 5*, *toile de 6*) in fact designated vertical landscape, horizontal landscape, vertical marine, and horizontal marine.) The earliest landscape formats listed in these catalogues are shown both in modern metric and old-fashioned *pouces* measurements (fig. 44). However, as with portrait formats, these measurements make sense only in pouces, and thus they must have been introduced prior to the second metrication law in France (July 1837) and only converted after this date to the new metric system. With all these fixed formats, the length of the longer stretcher bar remained constant for each numerical denomination, while the shorter bar shortened an inch or two with each format to produce ever-more horizontal shapes. Starting with the original portrait format, the squarest, the landscape and marine formats grew increasingly narrow, and thus proportionally more horizontal, the horizontal marine being the longest and the narrowest. Initially, landscape and marine formats were only sold in sizes 5 to 30, but by the 1860s the range of vertical landscape and vertical marine sizes had expanded to match that of portrait-format canvases, from sizes 1 to 120, making a total of seventy-five off-the-shelf canvas sizes ready-stretched and -primed for immediate use (see fig. 43).[7] A glance at the measurements of Monet's paintings in the 1860s offers substantive evidence, despite the limited documentation, that along with the portrait shape, the horizontal landscape and horizontal marine shapes were by then widely available, as well.

The manufacture of specialist supports for landscape painting in addition to those for portraits confirms both the growing popularity of the new genre amongst painters in France and the rapid expansion in the market for landscape art. The fact that there remained only one portrait ratio (also available in a flattering oval variant) but a total of four different landscape/marine formats is symptomatic of this major cultural shift. By contrast, there is no mention of standard landscape supports in the earliest extant English colormen's trade catalogues, from 1840 and 1846. Landscape formats were first advertised in Winsor & Newton's 1849 catalogue, and only in one series of sizes.[8] This relative dearth of landscape canvas options offered in England by 1850 provides further evidence of how much more quickly the popularity of landscape painting had increased in France by that date.

Although Monet regularly used standard landscape and marine formats as supports for his land- and seascapes during the 1860s, like most professional artists, he was by no means a slave to these fixed sizes. While they offered the ease of convenience, they could also constrain, and during this period—as indeed

later in his career—Monet experimented widely with unconventional canvas shapes and sizes for his radical compositions and commissioned nonstandard shapes for particular painting campaigns. This emphasis on painting *campaigns*, a feature noted by Émile Zola as early as 1868,[9] is made immediately clear in Monet's choice of canvas formats during his formative years. Once he had identified a particular motif and considered its *mise-en-page*—the ordering and design of its compositional components within the confines of the canvas format—he chose the canvas shape and size he deemed best suited to it and, within minor variations, executed a series of views on similar supports. (These were often primed with the same ground tint, as with his paired seascapes for the Salon of 1865.) There is a direct and crucial relationship between the motif selected, its bounding shape, and Monet's choice of canvas format on which to render it.

of a boat's hull, and could rattle off the names of each and every rope in the masting."[10]

That Monet selected both the obvious and the unusual is typical: even familiar views he found new ways to represent. His earliest coastal compositions took their lead from prior artistic examples: Boudin and especially Johan Bartold Jongkind, a Dutch painter working in France whom Monet met in Sainte-Adresse in 1862.[11] Jongkind provided Monet with the closest example for his 1865 Salon exhibits. The composition of the Dutch artist's lively plein-air oil study *The Seaside at Sainte-Adresse* of 1862 (fig. 45) directly prefigures that of Monet's *La Pointe de la Hève at Low Tide* (cat. 5). Monet's study for this composition, *Horses at La Pointe de la Hève* (fig. 91) is larger in scale than Jongkind's étude, but it exploits the same viewpoint, ships, and staffage of local shellfish harvesters, though Monet adds horses and carts and also emphasizes the plunging

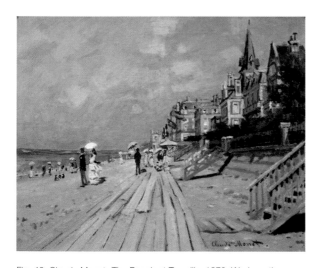

Fig. 46. Claude Monet, *The Beach at Trouville*, 1870, Wadsworth Atheneum, Hartford, Connecticut, cat. 34

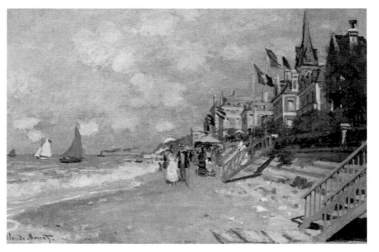

Fig. 47. Claude Monet, *The Boardwalk on the Beach at Trouville*, 1870, oil on canvas. Private collection

Identifying a motif, especially in a terrain with which the artist was not familiar, might entail long periods of exploration both geographic and observational, as Monet himself later complained on occasion. The advantage of his youthful subject matter—the Normandy coast, its towns and harbors—was its very familiarity. Having spent most of his life there, Monet knew well which were the optimum views, the most striking scenes and picturesque vantage points. As Zola commented in his enthusiastic Salon review of the painter in 1868: "In his seascapes, you can always spot the edge of a jetty, the corner of a dock, something that fixes it in time and place . . . He knows every inch

compositional diagonal. This is used to ever greater effect in his final Salon painting: the swerving line of the water-edge mirrors the skyline of the cliffs and meets it on a flattened horizon line right in the center of the composition, where the eye is drawn in by the brilliant light in the broken clouds. Positioned as was Jongkind, at ground level, Monet uses the meandering tracks of the cart to invite us to enter the compositional space—a traditional device that he was soon to subvert to dramatic effect in works like *The Beach at Trouville* (fig. 46; cat. 34) where the boardwalk plunges directly into the perspectival vanishing point.

In this painting, recession works to contradictory

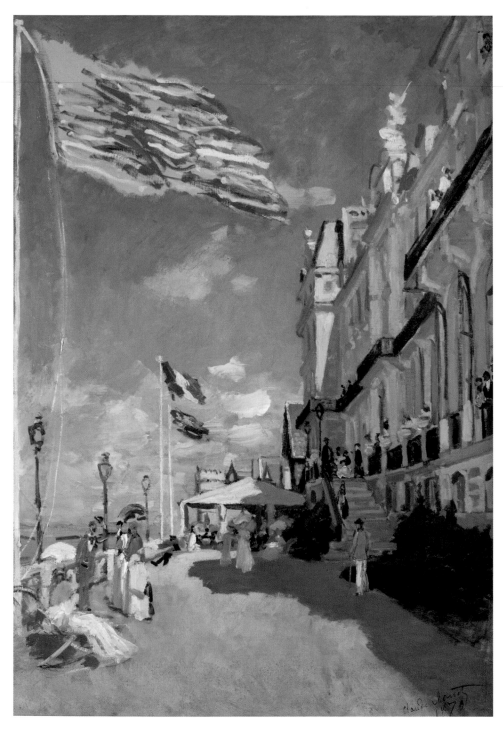

Fig. 48. Claude Monet, *Hotel des Roches Noires at Trouville*, 1870, oil on canvas. Musée d'Orsay, Paris

effect. On his squarish, portrait 15 format canvas, Monet establishes the central point of his composition in the canvas center and divides his picture into triangular slices, like a pie chart. In particular, the diagonal from top right to bottom left slices the scene in two. The brilliant midday sunlight drains the view of tonal contrasts, while cast shadows are short and figures float as if unanchored on flat slabs of cream sand and sun-bleached planking. The emerald green diagonals of the painted steps leading down to the beach articulate a movement into depth, which their brilliance also contradicts, their color linking across to the angled wedge of bright green sea. We have here then a tour de force of compositional ingenuity, a *mise-en-page* that went against all the received rules of both seascape and pictorial illusion. Just how radical this composition is becomes clear when it is compared to a more standard horizontal variant Monet painted in the same "series" (fig. 47). Although again positioned at ground level, the plunging recession is absent. In fact, the boardwalk in the squarer painting appears to have been introduced specifically to emphasize Monet's dramatic compositional gambit. Another work from this campaign, *Hotel des Roches Noires at Trouville* (fig. 48), demonstrates Monet's indifference to the designated format types; here, he deploys a horizontal marine 25 for a dramatically vertical scene, again cut by brutal diagonals. With his studies of Camille on the beach, painted at the same time, he shifted key altogether. For these works, so small and intimate in scale, he worked directly on squarer canvases (portrait 8; 38 x 46 cm) both vertically and horizontally.[12]

All of these small beach studies, as well as *Hotel des Roches Noires at Trouville*, appear to have the same mid-gray commercial priming (fig. 49), which appears unpainted amongst his rapidly applied strokes of color. This gray provides the ideal tinted base for northern seascapes while also speeding up the sketching process by serving as a ready-made color to augment his outdoor palette. In *Hotel des Roches Noires*, the priming visibly underlies the vivid strokes for the wind-blown flag and forms its basic hue. This then was another discrete campaign: Monet clearly anticipated the canvas formats and ground tints he would need for his Trouville motifs and planned accordingly, taking with him the specific canvases he required.

The composition of the small beach studies, too, are novel: Monet captures Camille, and at times

Madame Boudin, close up and cropped by the framing edge of his canvas, and he divides his compositions into starkly juxtaposed foregrounds and backgrounds, near and far, without the conventional transitions to register the middle ground. The horizon line is either unconventionally halfway up his canvases, or—even more unusually—above the mid-line (cat. 37). The extraordinary vertical double square (30 x 15 cm) for the study of Camille standing (cat. 35) is an exception in this series, otherwise on portrait size 8 canvases. Here, the seated painter places the horizon so that it almost divides the canvas in half behind Camille, counter-intuitively setting her cream costume against the pale beach, blond on blond, with her upper body silhouetted against a stormy, dark steel sky. As he was doubtless aware, placing the skyline or horizon-line[13] centrally across a composition tends to destroy the illusion of recession by encouraging the eye to see the two halves equally, almost abstractly, undermining the pictorial illusion of space.

Monet was not always as unorthodox in his perspective. His first Salon exhibits cannily conformed to the traditional convention of French landscape and marine paintings that positioned the horizon line in a harmonious, classicizing ratio of one to two, approximately one-third of the way up the composition. Seventeenth-century Dutch marine formats were frequently squarer with lower horizon lines, in sympathy with flat Low Countries' topography, and thus favored spectacular skies. This was the approach adopted by Boudin, allowing him to indulge his predilection for seascapes dominated by the changeable Normandy skies; under his tutelage, some of Monet's early observational pastels echoed this fascination (see fig. 42).

In 1866, Armand Cassagne's popular treatise on perspective illustrated a typical pictorial horizon at just under a third up, and he demonstrated how climbing upwards raised the horizon level (fig. 50). This latter is, however, theoretical, since the position of the horizon can be altered simply by lowering or raising the angle of the viewer's eyes vis-à-vis the scene. While it is self-evident that an elevated viewpoint gives a more expansive vista and a broader terrain to represent, the painter's chosen angle of vision and "screen" of view remain the key pictorial determinants. This can be seen in Monet's 1867 *A Hut at Sainte-Adresse* (cat. 21), which heralds his obsession with cliff-top vistas from

Fig. 49. Mid-gray commercial priming on ordinary-quality canvas

Fig. 50. Armand Cassagne, "L'Horizon," from *Traité pratique de perspective appliquée au dessin artistique et industriel*, 1866

the 1880s onwards. Here, the nonstandard canvas is unconventionally divided into three horizontal bands of sky, sea, and land. The sensation of looking down from above is even more apparent in Monet's similarly vertiginous *Sailboats at Sea* (cat. 22), in which his surveillant viewpoint overlooking the regatta elevates the skyline towards the top of the canvas. As demonstrated in such works, the artist's position—and hence our own implied viewing position—is of essential importance, whether low and seated at ground level, high and looking down, or indeed effectively floating, dislocated as before Monet's *Green Wave* (cat. 15) and forced to consider where we stand in relation to the painter's disruptive compositional gymnastics.

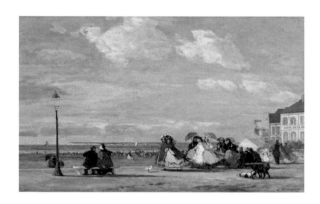

Fig. 51. Eugène Boudin, *The Beach at Trouville, the Empress Eugénie*, 1863, oil on panel. The Burrell Collection, Glasgow

While his manner of portraying sites may have been radical, Monet's strategies of motif selection were driven both by artistic precedent and by popular tourism. As the tourism industry developed, visitors were encouraged to see certain prized views, and, in a reflexive relationship, these became the prized subjects too of representation: the expensive art "postcards" for the wealthy to collect. Monet's motifs and their rendering not only depended upon but also helped fuel this new cult of "modern picturesque" sites.[14] Trouville, the favored seaside resort of rich Parisians made fashionable in the early 1860s by the Empress Eugénie herself (fig. 51) as well as by the advent of a direct rail link, is an obvious example. Other famed Normandy beauty spots included the dramatic rock formations at Étretat (the Porte d'Aval, the Porte d'Amont, and the Manneporte), depicted by Delacroix in the late 1830s and again in 1849 and a key motif of Courbet around 1869–70. Monet admired the latter's Étretat paintings at a posthumous retrospective in May 1882 and, thus prompted, revisited Étretat every summer between 1883 and 1886, painting upwards of fifty canvases set there. Monet had first essayed this famous motif in his 1864 *Étretat* (fig. 52), on a wide horizontal landscape 6 canvas. The hesitant over-complexity of his composition, including unresolved reflections in the calm low-tide pools, shows his youth when compared to the later confidence of his varied

mise-en-pages of these natural wonders in the 1880s. Yet what is original in Étretat is Monet's positioning of the vertical formed by the cliff face and its reflection to split his composition down the middle—a bold response designed to complicate an essentially horizontal vista and emphasize the towering immensity of the cliff, backlit against the evening sky. He thus divided his canvas geometrically, land and sky distinguished by dominant contrasting tones to create a formal surface pattern that vies with the presumed naturalism of the scene. His later views of Étretat would resume and amplify this decorative pictorial tendency.

Whereas the bold compositions of many of his '60s seascapes depended on dramatic juxtaposition of contrasting tonal blocks for their full effect, his snow scenes did the opposite. Close, high-key tonal values dominate whole scenes like *A Cart on the Snowy Road at Honfleur* and *The Magpie* (cats. 24, 25). These emphasize

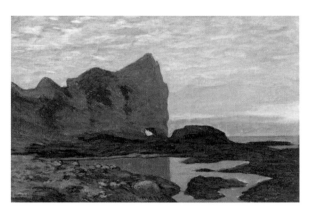

Fig. 52. Claude Monet, *Étretat*, 1864, oil on canvas. Association Peindre en Normandie, Caen

surface design by flattening space and stressing the linear pattern of darks. The apogee of these extraordinarily decorative designs during the 1860s was undoubtedly his *Terrace at Sainte-Adresse* of 1867 (see fig. 78), which Monet later dubbed his "Chinese" painting—meaning *Japoniste*—influenced by the widespread fashion for Japanese prints with their novel asymmetrical designs and non-naturalistic space.[15]

Another example of the powerful and unconventional devices developed by Monet is the inclusion of almost theatrical diagonal in works like the previously discussed *Hotel des Roches Noires* and the much earlier *Rue de la Bavole, Honfleur* (fig. 53) of 1864. A nonstandard, almost square canvas (55.9 x 61 cm) was expressly selected for this scene with an eye to the originality of his invention; indeed, without

the diminishing scale of the staffage here to articulate recession into depth, to break the flat planes and plunging diagonals, this composition would appear extraordinarily contrived. It is again all interlocking wedges, each forming a quarter of the canvas surface. The added slash of diagonal shadow creates a pictorial subtheme echoing the line of the right-hand pavement whilst cutting the road into two strong shapes. Stylistic naturalism vies with bold compositional design to produce a heightened pictorial tension characteristic from the outset of Monet's vigorous *mise-en-page*. Boudin himself commented in 1868 on the amazing "audacity of the composition" in Monet's work.[16]

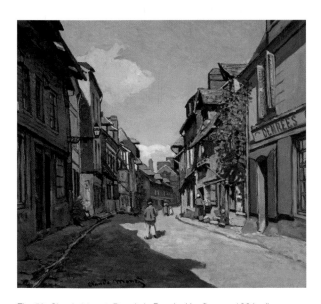

Fig. 53. Claude Monet, *Rue de la Bavole, Honfleur*, c. 1864, oil on canvas. Museum of Fine Arts, Boston. Bequest of John T. Spaulding

Such early audacious compositional devices reappear throughout Monet's career in different sites and settings. In his early drawn studies from the motif—like the stunning black chalk on ivory laid paper of *Cliffs and Sea, Sainte-Adresse* (fig. 54)—Monet's eye-line, at a seated, beach-level position, is unusual—lower than the aesthetic norm and close to Boudin's Dutch-inspired viewpoints. Here, the huge bulk of cliff rises far above the notional eye level almost to the paper top, its vertical edge all but centrally positioned, like that in the painter's 1864 *Étretat*. At first glance, the cliff in the drawing serves just as a *repoussoir* device designed (like a stage wing) to emphasize depth while drawing attention to the distant modern steamship, itself contrasted with an older sailing vessel. Yet in fact, with its backlit bulk steeped in dark self-shadow broken only by a glancing

sunlight that mirrors the lights of the sea, the cliff's shape forms one section of a whirligig pie-chart design centered around the point where horizon and vertical meet. The abandoned hull gives a consolidating marker of human scale while also signaling the distance to the low horizon. In his 1868–69 *La Porte d'Amont, Étretat* (cat. 27), Monet broached a novel close-up view of the cliff, with the Needle Rock seen through its arch and its strongly horizontal geological striations and dramatic contrasts blocking most of the sky. This painting is a far more simplified and powerful composition than *Étretat*—and the one that most directly presaged Monet's campaigns from 1883 onwards.

The same formula as in the 1864 *Étretat* can be seen reversed in Monet's river scenes along the Seine at Argenteuil in 1872 (cat. 54 and figs. 32–34),[17] while that in his *Port at Argenteuil* (cat. 55) is closer to the *mise-en-page* of his 1870 *Beach at Trouville* (cat. 34). All his comparable Argenteuil riverscapes from this campaign still privilege this low horizon. Positioning the artist-spectator seated at ground level in apparently gentle Corotesque compositions, the riverside promenade invites us to enter and enjoy a leisurely stroll, with alternating bands of light and shade to articulate our movement into depth. Yet simultaneously Monet

Fig. 54. Claude Monet, *Cliffs and Sea, Sainte-Adresse*, c. 1864, black chalk on ivory laid paper. The Art Institute of Chicago. Clarence Buckingham Collection

experimented with the compositional potential of high horizons and vertiginous viewpoints looking down, as in the previously mentioned *Hut at Sainte-Adresse* and *Sailboats at Sea* (cats. 21, 22). Thus Monet's complex pictorial designs require us to read the surface geometries of his compositions as much as their representational elements. Although rooted in observation of nature, Monet's viewpoints and *mise-en-page* were far from pure naturalism. They reveal a sophisticated eye that could identify among visible lines and forms in nature the key features that would give his works striking pictorial originality and a novel boldness quite distinct from those of his more conventional peers.

Thus despite his early debt to Boudin, Jongkind, and also Charles-François Daubigny—who exhibited his influential large-scale plein-air seascape *Villerville-*

sur-mer (fig. 55) at the Salon of 1864[18]—Monet rapidly found his own vision, learning all the while from those who were his greatest Realist contemporaries, Manet and Courbet. The young painter met Manet as a consequence of confusion over their painted signatures at the Salon of 1864 and was friends with Courbet by 1865. Courbet posed for Monet's huge studio tableau of 1865–66, *Luncheon on the Grass* (cat. 9), Monet's plein-air response to Manet's scandalous painting from the Salon des Refusés of 1863 (fig. 14). Even Manet's dramatic seascapes from 1864 were fair game; when he exhibited these at Martinet's Gallery early in 1865, both Monet and Whistler were

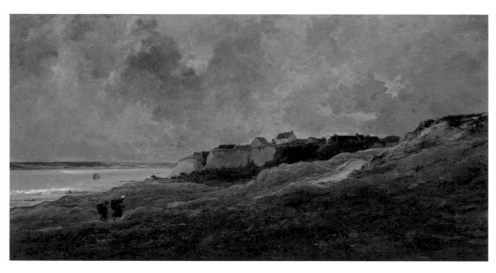

Fig. 55. Charles-François Daubigny, *Villerville-sur-mer*, 1864 and 1872, oil on canvas. The Mesdag Collection, The Hague

influenced by their radical compositions. In addition to his smaller seascapes, Manet's extraordinary studio-painted record of the American Civil War Battle of Cherbourg, completed within a month of the event in June 1864, had a profound impact (fig. 56). Pieced together from contemporary descriptions and illustrations, this composition dramatically subverted the conventions of marine battle painting, not least by orienting vertically an almost-square-format canvas. Manet's high horizon opens a vast expanse of sea as a stage for the battle, which left the sloop-of-war CSS Alabama sinking in the face of cannon fire from the Union's iron steamship Kearsarge. Monet learned from works such as this to create his own powerful—if smaller—variants, like the aforementioned *Green Wave* and *Seascape, Storm* (cat. 17), both on the vertical landscape 15 format (65 x 49 cm) used horizontally.

The Green Wave was by far the more adventurous of the two compositionally, with an unusually high horizon akin to that used by Manet. As we have seen, Monet exploited this formula more consistently in his coastal paintings of Normandy and Brittany of the 1880s. In *The Green Wave*, with nothing but sea before us and no place to stand to view it, Monet again takes his cue from Manet, who exploited the destabilizing effect of this device. Monet creates a powerful sensation of the massive weight of water rising above us—a feature admired in 1868 by Zola.[19] Monet lays the ocean on deftly and broadly with his loaded brush, following the sweep of the water; in contrast, he takes up the palette knife favored by Courbet to pick out the harsh whites of spume in the yacht's wake, troweling on the paint in thickly daubed slashes.[20] Another reference to his admiration for Courbet can be seen in Monet's

Fig. 56. Édouard Manet, *The Battle of the U.S.S. Kearsarge and the C.S.S. Alabama*, 1864, oil on canvas. Philadelphia Museum of Art. John G. Johnson Collection

uncompromisingly frontal composition for *Seascape* (cat. 16), which echoes the older Realist's *paysages de mer* (as he called them) painted in Trouville in the autumn of 1865 (fig. 57).

The mid-1860s can be seen as a watershed in Monet's approach to pictorial design. As his urban landscapes of 1867, painted from the east windows of the Louvre, amply demonstrate, he rapidly found revolutionary new viewpoints and forms for his compositions. In the

Garden of the Princess (cat. 20) in particular he radically subverts the familiar high viewpoint traditionally associated with urban topographies by orienting vertically his elongated horizontal marine size 30 canvas (91 x 62 cm). Divided into three bands, the oblique geometry of the green lawns in the foreground gives way across the center of the composition to a dense maze of streets, trees, and buildings topped off by the massive dome of the Pantheon rising beyond. The very spareness of Monet's foreground here, contrasting with the complexity of the central band, contradicts the basic principles of the urban panorama: to display a city's key sites legibly and to their best advantage. His horizontal *Saint Germain L'Auxerois* (cat. 18) from the same campaign does this far more effectively, and even his *Quai du Louvre* (cat. 19) serves this function more clearly. Taking advantage of the horizontal width of a vertical marine 30 (65 x 92 cm) canvas, Monet shows the scene with less-developed spring foliage: a more distant fragment is brought closer to us by the artist's astute compositional framing. However, neither horizontal painting is as bold and radical as *Garden of the Princess*.

Monet continued experimenting with a variety of canvas formats on his campaigns in London and Holland in 1870–71. At least two of his London paintings, *Meditation, Madame Monet Sitting on a Sofa* (cat. 38) and *Hyde Park* (cat. 39), are close in format to an English canvas size, 18 x 30 inches.[21] *Green Park* (cat. 40) is even wider and again nonstandard at 34 x 72 cm—more horizontal even than a double square, the format is well suited to this ambitious panorama of the London scene. A double square (35.2 x 71 cm)—a format Monet had utilized before, both vertically for *Camille on the Beach* (cat. 35) and horizontally for *Grainstacks at Chailly at Sunrise* (cat. 6) and *Rough Sea at Étretat* (fig. 58)—was custom-made for certain of his Dutch paintings, like *The Zaan near Zaandam* (fig. 59). Monet's selection of canvas format to suit a particular motif and composition was of course carefully pre-planned, and examples like this double-square riverscape are clear evidence of this premeditation.[22]

For all the many examples of Monet using canvas formats to radical, unconventional effect, however, there are equally instances of his selection conforming to designated orientations and categories. In fact, his most consistent format for the Zaandam campaign was the elongated standard horizontal marine 20

at 73 x 48 cm: a ready-made support well suited to these mainly flat, water-based scenes (fig. 60). (French canvases in standard sizes were available in Holland, but Monet may also have shipped canvases from Paris first to London in autumn 1870 and then to Holland the following year.) While *The Zaan near Zaandam* and a number of Monet's other Dutch pictures were pre-primed in a creamy-buff tint, pale gray was another commercial priming commonly found on canvases from this trip. This could indicate Monet's preconceptions regarding the Dutch landscape and the overcast northern weather and dull or wintery

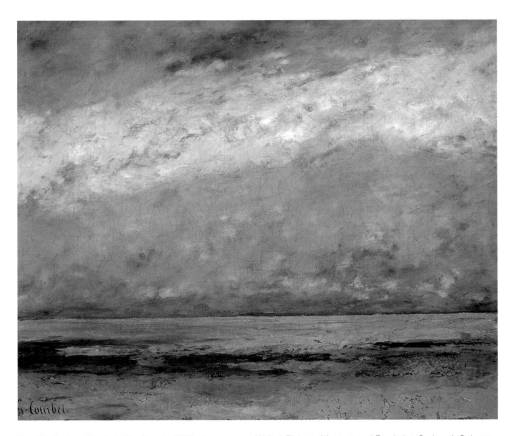

Fig. 57. Gustave Courbet, *The Beach*, 1865, oil on canvas. Wallraf-Richartz Museum and Fondation Corboud, Cologne, Germany. Acquired in 1956 as a gift from the Gutehoffnungshütte, Oberhausen

effects he would be painting, though he had used the same gray as a base for sunny mid-summer scenes like *The Hotel des Roches-Noires, Trouville* and his studies of Camille on the beach at Trouville.

Monet's interest in double square and later, more consistently, in square canvases, is significant. The square was recognized as a particularly problematic format, especially for landscape painting, and outside avant-garde circles was rarely used.[23] Whether horizontal or vertical, the traditional rectangle gives

the sensation that the spectator is seeing a convincing illusion of the real world through the framed picture window. Suspension of disbelief is made easier by the familiarity of this visual convention: the material reality of the two-dimensional canvas is more easily overlooked, allowing the paint to dissolve into the imaged pictorial world behind the picture plane. However, the square or double-square canvas undermines this normative window-on-the-world illusion. The symmetry of the square canvas entails a visual insistence on the framing edges, attracting the spectator's attention to the flat surface of the painting and the artifice of its composition. More subliminally, the double square asserts its constituent squares with a double symmetry that solicits the eye to identify echoing repetitions across the canvas and thus again refers back

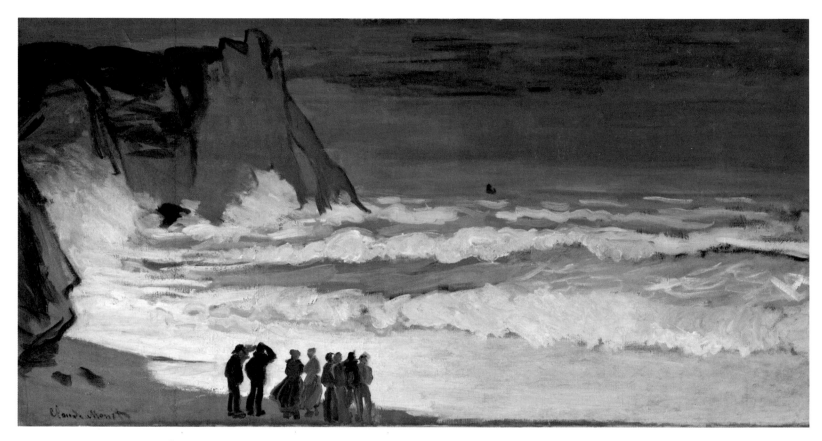

Fig. 58. Claude Monet, *Rough Sea at Étretat*, c. 1868–69, oil on canvas. Musée d'Orsay, Paris

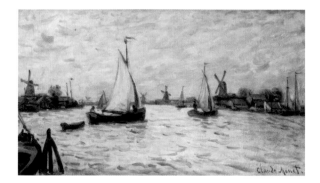

Fig. 59. Claude Monet, *The Zaan near Zaandam*, 1871, oil on canvas. Glynn Vivian Art Gallery, Swansea, Wales, United Kingdom. Presented in 1974 by Her Majesty's Treasury in lieu of settlement duties

to the material surface. Where the standard elongated marine formats read more straightforwardly as panoramic, the double square insistently draws attention to its own internal rhythm. Monet's emphatic surface designs on these symmetrical formats were enhanced by the flat opacity of his paint film and his bold brushwork and vigorous paint handling. The resulting tensions between materiality and illusionistic naturalism were consciously exploited by Monet to subvert traditional pictorial illusionism. As early as 1865, conservative critic Paul Mantz criticized this "lack of finesse" in his otherwise appreciative Salon review of Monet's seascapes. More in sympathy, Zola in 1868 identified Monet's "frankness" and "very harshness of touch"

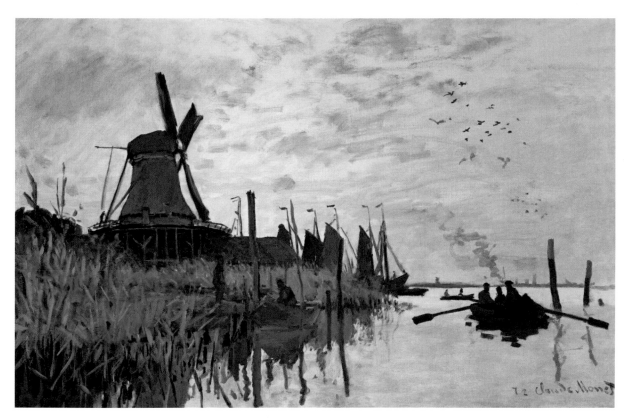

Fig. 60. Claude Monet, *Windmill at Zaandam*, 1871, oil on canvas. Ny Carlsberg Glyptotek, Copenhagen

as emblematic of the "harsh hues" he too recognized in nature: "I smelt that salty air."[24] Monet's close-up or high viewpoints on his landscape motifs, indeed his overall *mise-en-page*, were calculated to confront the spectator with the represented scene; his aim was to give a sensation of immediacy and spontaneity designed to suggest modernity while at the same time belying the complexity of the artist's technical procedures.

In the end, it was landscape that offered Monet the greatest aesthetic freedom to experiment with new compositional strategies as well as new modes of paint handling. Despite the radical advances made by Courbet and Manet in the 1850s and '60s, figure painting still carried a far greater burden of traditional historic values and academic conventions that constrained painting's modernizing potential. On the other hand, landscape was a relatively recent genre in France, less hampered by tradition but still highly desirable as a commodity on the art market.[25] As such, it held out the promise of new opportunities for the modern artist to develop a radical, personal vision in painting: to make a name as a modern master.

Thus what Monet's early work clearly demonstrates is the extent to which his painting, despite its apparent

naturalism, is inevitably artificed, in both his debts to past art and his own innovations, which play with startling viewing angles, pictorial geometries, and cropping. Significant, then, is Emile Bergerat's critique of 1877, that "hatred of composition is the characteristic sign of Impressionism; it rejects all intellectual and subjective organization and will accept only the free arrangements of nature,"[26] which is apt only in the context of traditional compositional conventions. Especially in his landscapes, Monet sought from the start new unconventional painting formats and modes of composition to represent the modern visual experience. Already in the 1860s Monet was intent on disrupting received pictorial conventions and creating new radical ways to compose his modern paintings: new formats, new designs, new viewpoints. Monet invented a new pictorial language of composition for the modern era. Despite the apparent immediacy of his painting, then, Monet was an artist for whom deliberation was paramount. Everything was calculated, from his material choices to his astute exhibition strategies: deliberately nonchalant and loose in style, Monet's vision was measured and intentional.

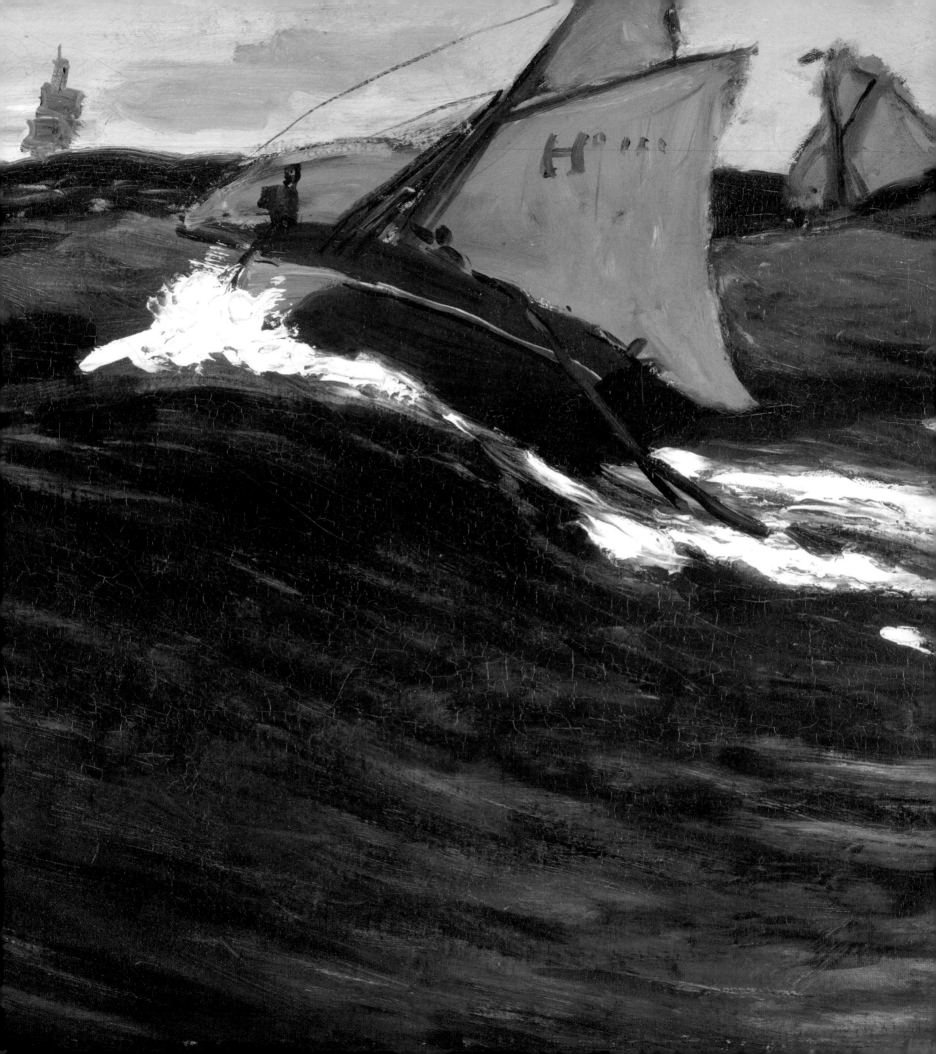

Paraph Painter

Richard Shiff

Effie Marie Cain Regents Chair in Art History, The University of Texas at Austin

Early Monet for the Twenty-First Century

> We are deprived through [our dependence on] words of an authentic intimacy
> with what we are, or with what the Other is. We need poetry, not to regain this
> intimacy, which is impossible, but to remember that we miss it and to prove to
> ourselves the value of those moments when we are able *to encounter other people,
> or trees, or anything,* beyond words, in silence.
> — Yves Bonnefoy, 1994[1]

> Man's first expression, like his first dream, was an aesthetic one. Speech was a
> poetic outcry rather than a demand for communication.
> — Barnett Newman, 1947[2]

The philosophizing moments of two twentieth-century luminaries, poet Yves Bonnefoy and painter Barnett Newman, offer a route to the lasting human value of Claude's Monet's early art—its value *now*, which can be different from then. Cultural values evolve. Nineteenth-century poets and artists made statements analogous to those of Newman and Bonnefoy, who cast forward, in altered form, their Romantic sentiments regarding intimate experience. By "now," I allude not merely to 2016 but to our familiar environment of increasingly high-resolution optical images of countless sorts. We receive representations at all scales of electronic transmission and projection; the screen can be a cell phone, the cinema, an outdoor concert display, a building façade.

The availability of digital imagery becomes a vital resource for scholars who have viewed many works of painting in the flesh, with their slightly raised, bumpy surfaces that subtly cast light one way or another, altering the play of color. As an aid to optical inspection, I can draw an electronic image toward or away from me without needing

Claude Monet, *Green Wave* (detail), cat. 15

59

to change my bodily position. It is convenient. But the high-resolution details I ponder on my dematerialized screen are substituting for works intended as low-resolution sensory experience—mobile experience, irregular, transient, scaled to the shifting of a human body—the sensation of the street, the land, the light. The "poetry" of such experience, to which Bonnefoy refers, would parallel Newman's vision of a primal aesthetic moment. A number of twentieth-century literary masters have sought to restore to the word its material physicality, its "outcry"; their colleagues in painting have struggled to retrieve the material mark from mere picture-making (fig. 61). Thinkers of the preceding two centuries, nineteenth and twentieth, theorized an aesthetic language of intimate sensation anterior to any language of referential signs. They were theorizing the impossible, perhaps. But, as Bonnefoy states, an artist's material sign or mark would bear value at least as an evocation of encountering something—*anything*—beyond conceptual hierarchies, beyond our customary verbal order. Newman approached the desired encounter by picturing nothing but the mark. Monet did it in the nineteenth-century manner, marking while picturing.

Fig. 61. Barnett Newman, *Onement IV*, 1949, oil and casein on canvas. Allen Memorial Art Museum, Oberlin College, Ohio

Reflecting on our high-resolution optics and the musings of Bonnefoy and Newman, I see the value (somewhat unintended) of a critical insight of 1915, when Monet was enjoying worldwide renown. It suggests that Monet's cultural fortune a century on—that is, now—continues to move toward an incompletely realized expressive potential. The insight belongs to the Swiss scholar Heinrich Wölfflin, specialist of the Renaissance and Baroque, who believed that Monet had long exceeded reasonable limits in his mimetic practice—but *why* this was so is Wölfflin's beautiful insight. Others may have noted much the same thing, but did so less analytically. In an introductory section of his far-reaching study, *Principles of Art History*, Wölfflin makes a passing reference to Monet as the ultimate Impressionist, acknowledging

his development of an expressive art that connotes the sensation of an instant, an achievement appreciated in his time as it is now. Monet's broader significance appears within our greater retrospect, affected by the experience of abstraction in painting during the twentieth century and by the digital revolution continuing into the twenty-first. Wölfflin's remark anticipates our *current* understanding, especially as it may concern the force of Monet of the early years.

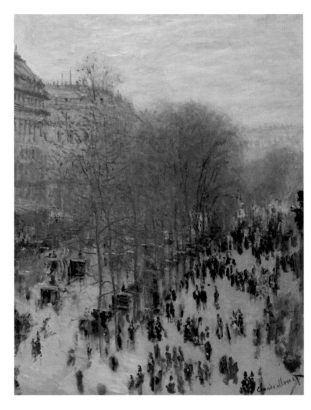

Fig. 62. Claude Monet, *Boulevard des Capucines*, 1873–74, oil on canvas. Nelson-Atkins Museum of Art, Kansas City

Wölfflin was well aware of the new styles of his time. He received his university degree in 1886, when the initial shock of Impressionism had passed. Even in mid-career, however, Monet's daring pictorial gestures continued to astound the public; and he, like other radicals of his generation, remained an occasional target for journalistic harrumph and caricature. As an art historian focused on earlier periods, Wölfflin could address this modern art with equanimity as an accomplished fact. He never wrote of Monet in any substantial way but used him as both paradigmatic example and extreme case. When the practice of representing immediate appearances extends too far, Wölfflin argued, we encounter an "alienation of

the sign from the thing [*Entfremdung des Zeichens von der Sache*]."[3] This disturbing effect was noticeable in Monet's art in particular: the sign (the accentuated brush mark, the energetic contour line) acquired no secure, discernible referent. It was drawing vision to itself. Wölfflin implies that Monet's mark or sign was failing its representational function, neither relaying nor signaling anything—except for the "anything" later sought by the likes of Newman and Bonnefoy, a rude material presence.

The context for Wölfflin's remark is his distinction between "linear" forms of representation in art and "painterly," coloristic forms. His comprehensive argument was this: over several centuries the practice of painting gradually shifted from representing the *nature* of things (their physical reality: the surface, edge, or texture you imagine touching) to representing the *appearance* of things (the intangibles of the optical field before you). Bear in mind that to represent base nature in Wölfflin's sense is different from the aim of presenting nature in the sense of Monet, Newman, or Bonnefoy. Wölfflin understood that the fundamental transition from linear to painterly had occurred long before Impressionism. The theme of *Principles of Art History* is the passage from Renaissance "nature" to Baroque "appearance"—from focusing on clear, tangible contours to featuring the play of illumination. Among many others, Rembrandt van Rijn and Diego Velázquez excelled in the art of appearance. Wölfflin makes an astute though debatable observation: with the masters of Baroque color and light, "the principle of Impressionism is already there."[4] Yet the evolution from nature to appearance had farther to go—too far.

Wölfflin invokes Monet as the generic representative of modern pictorial excess: "The picture of a busy street, say, as Monet painted it, in which nothing whatsoever coincides with the form which we think we know in life, a picture with this bewildering alienation of the sign from the thing is certainly not to be found in the age of Rembrandt."[5] Wölfflin's allusion to "a busy street" evokes a type of scene Monet was painting in the early 1870s; *Boulevard des Capucines* (1873–74, fig. 62) is a prominent example. I imagine Wölfflin recalling a detail such as the lower right corner of this painting, where black smears and daubs, in varying degrees of figural articulation, represent a stream of individuals on a vibrant commercial boulevard (fig. 63). Apparently, Wölfflin believed that in images

of this type he could perceive the black paint ("the sign") but no corresponding form of a human being ("the thing"). Ironically, the same detail of *Boulevard des Capucines* contains a more commonplace example of the "alienation of the sign from the thing"—a signature that tails off into a final letter with a paraph (the lower extension of the letter *t*, perhaps also its extended upper section). The paraph of a signature, a supplemental flourish or accent, aims at being a distinctive sign-off to the sign-off of the signature itself. Monet's *t* assumes an odd form that renders his signature memorable, perhaps even kinesthetically (we want to imitate it). This illegible sign, a mere mark like the black smears on the boulevard, has the cultural function of contributing to an authenticating gesture; but, no cipher itself, it adds no coded meaning. If Monet had said of his black figure-like daubs that punctuate the lower area of the boulevard, "I added

Fig. 63. Claude Monet, *Boulevard des Capucines* (detail)

them only because they look good," those marks would be pictorial paraphs—aesthetic signs lacking reference. To counter that they refer indexically to the painter—with the mark revealing the presence of the artist through evidence of the hand's action—is a trivial observation. This is true of all painters' marks, just as it is of anyone's marks. Some indexical marks are more pronounced than others—Monet's to be sure—but everyone makes indexical marks. Mark something, or just sign your name.

Experience

For citizens of the new bourgeois republics of the nineteenth century—France, the prime example—individual experience was favored as a source of understanding by those who resisted the structure of inherited knowledge and the class system it supported. In art, this position of resistance—moral as well as political—elevated representations of nature that purported to derive their appearance from direct sensation as opposed to accepted conventions of pictorial composition. In a landscape, trees in the relative distance along a horizon might remain unmuted. Certain atmospheric effects produce such an appearance; but the aim was not to be the slave of nature, rather the respondent to sensation. If the experience of a natural situation—trees at a distance, the sky meeting a watery horizon—feels bright in color and close-in, paint it accordingly (see *Le Pavé de Chailly in the Forest of Fontainebleau*, 1865, cat. 7; and *Seascape, Storm*, 1867, cat. 17).[6] An artist-observer might perceive distant trees with the same bright hues as objects in the immediate foreground. In the sensation of the moment, blurred details and the intensity of color and light may cause the elements of a view to appear uniformly absorptive of the capacities of the senses—hence: an impression of the whole (eventually labeled "Impressionism"). In the course of completing a painting, an artist would have the opportunity to refine the crude first impression. But why do so? If effects of immediate vision—presumably the closest to the true sensation of nature—were valued as liberated experience, they ought to be preserved in the artist's depiction.

To create a painting of the first impression did not rule out laboring over the effect, as long as the look and feel of spontaneous sensation was maintained. Invariant chromatic intensity as well as coarsely applied paint with correspondingly irregular edges seemed to indicate speed of execution, as if the artist were succeeding in capturing the most transient illumination in a totalizing blur of light (see *The Green Wave*, 1866, cat. 15). The speed might be actual, but not necessarily. Painters are artists of effects, appearances. In any event, Monet allowed the intensity of his application of pigment to show in its full materiality, without it being consumed into the coherence of an "analog" display in which all tones and strokes would seamlessly flow into one another. In *The Green Wave*, unintegrated bars of a darker blue extend through the sky to the left of the primary sailboat. The remarkable *Regatta at Argenteuil* of 1872 (cat. 56) takes *The Green Wave* to an extreme in terms of allowing bars or other deposits of color to maintain their full physical presence as matter. But this feature is actually everywhere to be seen in early Monet, once one looks for it (for example, in *Flowering Garden*, 1866). Monet could make a "picture" even as each of his strokes escaped from it as he made it. Others had featured the materiality of paint—Jean-François Millet, Théodore Rousseau, Gustave Courbet—many others indeed. The "digital" effect, however, the visible separation of mark from mark, is singularly strong in early Monet. The digital screen of his canvas is low-resolution: a coarse raster, relatively few marks in total, each distinct. "Alienation of the sign from the thing," Wölfflin would say.

Monet's storm scene, *Rough Sea at Étretat* (1868–69, fig. 58) comprises a relatively large surface with relatively few marks, perhaps indicating a genuine rush to finish on the part of the painter, working against the timing of the weather.[7] The painting lacks the refinements that might ensue from a layering and accumulation of tones. Monet's strokes, isolated as they are, each attractive in itself, become caricatural abstractions of the geological formation, the wave pattern, as well as the group of people. Graphically, these active strokes leave much to the imagination in terms of the intensity of the storm and the configuration of the land (we recognize Étretat because it is famous). If we were so inclined, Monet's bold signature would likewise leave us wondering what personality its graphic quality actually indicates. Curiosity aside, these are beautiful linear strokes to perceive.

Varieties of Marking

Through unpretentious, even naïve, mimetic painting, the value Newman and Bonnefoy theorized had long been lost could, for their nineteenth-century counterparts, nevertheless be approached: personal sensation, having slipped out of its cultural bonds, slipped into the naturalistic picture. Camille Corot manifested the desired attitude: "Despite his methods, in which people so complacently point out the mistakes . . . [he] belongs to the first rank of landscapists who see nature as it is . . . [His works] are models of

emotionally moving painting . . . with a poetic effect that ravishes the heart."[8] The statement comes from Paul Mantz in 1847. He went so far as to praise certain long-forgotten landscapists who had little else to recommend them but naiveté: "Less able in execution than most others, barely initiated into the subtleties of their craft, they copy like grown-up children, [yet] their painstaking incapacity is not without a strange seductiveness."[9] Lacking subtlety, a mark shows as the clumsy, attractive, engaging object of vision it is.

contradicts himself dramatically because, even as the small scale of the frame invites me to come near, the largeness of the execution holds me at a distance."[11] I can imagine Wölfflin concurring, a half century later. The heavy touch of Monet's *Landing Stage* (1871, cat. 47) would not have satisfied either of these theoretically minded writers. Nor would it have pleased the many thematic history painters who took still another view: they strove for virtually invisible facture, minimizing the potential of touch to distract, protecting the

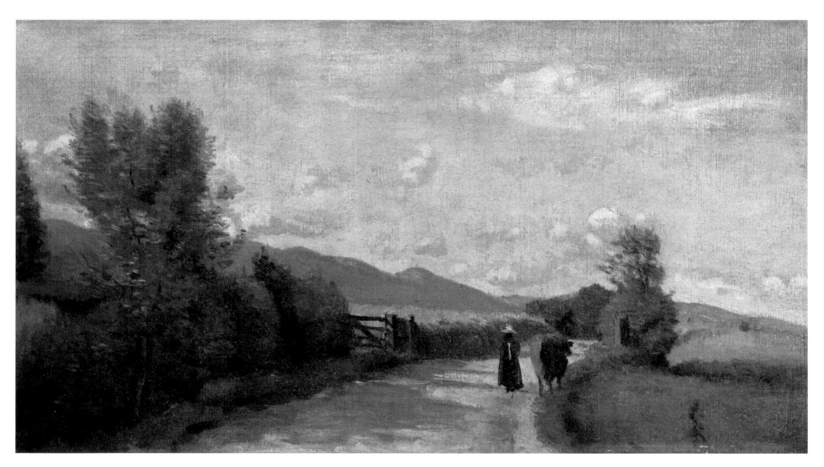

Fig. 64. Jean-Baptiste-Camille Corot, *Dardagny, Morning*, 1853, oil on canvas. The National Gallery, London

Unlike the Romantic and the Impressionist, a more conventional type of naturalist and realist preferred to understand variations in marking primarily as gestures toward descriptive differentiation and accuracy. "Touch should be varied . . . according to the character of the [represented] objects," Charles Blanc wrote in 1867: "When it becomes progressively indefinite, touch . . . indicates [the effect of] the presence of air."[10] He was referring to the atmospheric distance so often lacking in naïve painting. Blanc stated additionally: "The artist who paints with broad strokes within a small format

narrative coherence and credibility of the constructed image from every possible disturbance.[12]

Works like Corot's *Dardagny, Morning* (1853, fig. 64)— in advance of Monet's own—elicited from critics just the right words. Charles Clément commented in 1853: "Corot renders his impression simply and naively . . . He reduces technique to its most elementary form and puts on the canvas only enough painting to say what he feels, as if he feared obscuring his thought with the veil of an abundance of execution."[13] Clément provides a compelling definition of Impressionism

before there ever was Impressionism as such. He applies it to an older artist, Corot. For both Corot and the Impressionists, the key to success with the critics who appreciated them was placing on the canvas "only enough" to project the strength of sensation. Anything more might be better painting in a traditional sense, but would ruin the effect. Such an effect of "only enough" led ultimately to the quality at which Wölfflin balked: "alienation of the sign from the thing."

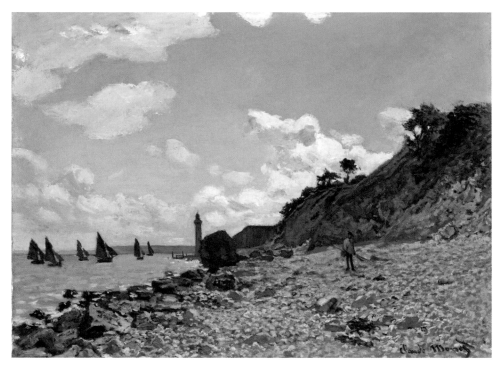

Fig. 65. Claude Monet, *The Beach at Honfleur*, 1864–66, oil on canvas. Los Angeles County Museum of Art

For nineteenth-century painters, no single standard or ideal held. Some believed that the artist's hand ought to describe reality with iconic fidelity, others that too much evidence of the hand undermined a convincing illusion of the real, and still others that such material signs expressed not only an engaged personal presence (the indexical issue) but also, and ever more significantly, the sensory materiality of the mark or array of marking itself—the color, luminosity, texture, movement. Monet's artifice motivated his mark to move. In *The Beach at Honfleur* (1864–66, fig. 65), the trees along the rocky outcropping become fuzzy at the edges, suggesting not only their general movement (in a figurative sense), but movement within the constituent elements, among the painter's materials. To achieve the dual effect, Monet feathered cloud-white into the deep olive and blackish tones of the vegetation.

A viewer feels the texture not only as optical but as tactual; and as the eye shifts, the hand responds kinesthetically. This is the type of "impression" that derives from a low-resolution, unfocused distribution of mobile marks—not merely optical, but physical. Attraction to the movement of marks in isolated areas introduces a factor of perceptual interference; the viewer's attention is divided, and the resolution of the work as a whole decreases. Any assessment is slowed, which deters conclusive interpretation just as it prolongs sensory engagement. To experience Monet's art is to remain at odds with its stock, categorical meanings (landscape, nature painting, labors and pleasures of the sea, whatever). It presents much more than its subject.

Creating his *Beach at Honfleur*, Monet excelled at matters of technique. To stimulate movement in both the depicted land and the observant eye, he activated the cool grays of the sea with warm ochres; at the shoreline, deep Prussian blue in the rocks contributes to this intricate play of warm and cool. The painting is skilled and clever, set in the service of naturalism but left on the edge of naiveté. In other words, Monet had his tricks—devices to ensure that his surface remained engaging and not a mere "picture." In this respect, Newman was his heir, leaving just enough subtle irregularity along the edges of his forms to escape what he considered mere geometry.[14] Monet the naturalist avoided mundane pictorialism; Newman the abstractionist discarded geometry as such. Each in his own way, given the historical context, took a prevailing mode of art and extended it into material, experiential immediacy.

Caricature

The resolution factor of an image is relative, otherwise no need to refer to low and high. A hand-painted or hand-drawn image does not normally compete for high-resolution status except against other works in the same medium (in odd cases, nevertheless, a drawing might yield higher resolution than a photograph). Works of relatively low resolution suggest immediacy, reflect an ongoing process, and draw an observer's attention part by part. I sometimes see a video projection that is too large for its space; the situation causes me to focus on the individual pixels, and I doubt that this was the artist's intent. The

resolution factor induces me to experience the parts ahead of, even instead of, the whole.

When I look with an interpretive eye at Monet's drawing *Cliffs and Sea, Sainte-Adresse* (c. 1864, fig. 66), I remain undecided whether the variation in the curving lines in the stones of the beach has been intended to indicate actual variation in this natural formation or (perhaps more likely) bears witness to the draftsman's haste and impatience with drawing the details precisely. We might say that the drawing provides a general impression of the beach—its disposition, its qualities—but no analytical array of its features. This is what Wölfflin would call appearance, not nature: "a triumph of seeming over

Fig. 66. Claude Monet, *Cliffs and Sea, Sainte-Adresse*, c. 1864, black chalk on ivory laid paper. The Art Institute of Chicago. Clarence Buckingham Collection

being [*Ein Triumph des Scheins über das Sein*]."[15] From his perspective, appearance or "seeming" remains in motion, whereas nature or "being" stands firm. Each of these conditions—transience, permanence—is real, but loses its aesthetic validity if taken to excess. Yet, like resolution, excess is merely a relative matter. In terms of aggressive marking, Newman became still more excessive than Monet.

Whatever the consistency of the correspondence of Monet's forms to the site he visited, his actual drawing is a physical object of a specific size. It addresses our body-oriented sense of scale. When early viewers claimed that Impressionist paintings made visual sense only when stepping back from them, they were indicating that their bodily movement would bring about a needed optical adjustment in resolution. But low-resolution Impressionist images establish their low resolution for a purpose. To step back is not to correct anything, but to change the view.

Monet enthusiastically faced the challenges of naturalistic rendering. His *Cliffs and Sea* includes a linear element that appears to be a draftsman's shorthand for the tapering trail of smoke from a small steamer on the horizon. Smoke would be dense where it emerges from the stack; Monet's line in that area is correspondingly thick and multiple. Then the smoke trails off to the right, becoming thinner. The difference between thick and thin can represent distance but need not. By this simple graphic device, Monet renders a nebulous volume that has no contour, no precise position in space, and no distinct visibility. The problem for me—or rather, my delight—is that I see the line and not the smoke. It would probably take more of an outrageous graphic mark for Wölfflin to be struck with this problem, but very little to cause Newman or Bonnefoy to think this way. In analytical terms, Monet has merely employed a convention for rendering smoke, nothing worth pondering. What, however, determines the shape and length of his line? It must be an aesthetic decision—or something less than a decision, an instinct, a feeling. Monet's graphic flourishes of this sort stand out as more elaborate than what the situation requires. They trace *his* sensory delight. They recall the letter *t* at the tail of his signature, which he extends arbitrarily to form a paraph. Such moments of excess, common in Monet, often offset the tenor of the remainder of the pattern of marks, causing the whole to seem less aggressive than may be.

Monet's earliest art of consequence was caricature. He drew an engaging image of a woman at a piano around 1858 (fig. 67). His young talent shows in the mature way he develops precise rhythms of accented tone across hair gathered in a snood and across the peplum of a dress. The remarkably fluid zigzag to the left of the figure is a graphic convention; it sets the body off from its indistinct ground. (The piano itself is barely visible in the area just above.) By its opposition to the representational form, the squiggle establishes an environment for the figure, while the line itself indicates nothing other than the facility of the artist. Jean-Auguste-Dominique Ingres, a distinguished precedent in portrait drawing, had used similar linear accents to establish the spatial identity of a subject. Monet's version of the line is so accentuated that it becomes not only part of his caricature, but a caricature of drawing technique itself ("alienation of the sign from the thing").

Fig. 67. Claude Monet, *Young Woman at the Piano*, c. 1858, black crayon heightened with white pastel on paper. Musée Marmottan Monet, Paris

Assonant Paraph

The form of an Impressionist painting—and even that of Monet's early drawings—constitutes a tacit recognition (*beyond words*) that life is continuous. Yet for each fluid moment of a sensitive observer, representation itself represents the shock of a new sensation. For a representational artist like Monet, some of the shocks come through observing nature,

but others come in the process of its rendering, as the painter's marks acquire an independent life of interest. If he had had a fixed conception of the appearance of the living land, the water, and the populated streets, it would have quietly waited for his completion of its copy as he made it, like a practiced studio model never stirring.

Monet's *On the Bank of the Seine, Bennecourt* (1868, cat. 30) is a relatively coarsely painted surface, over three feet wide, projecting something like tentative finality, as if it were complete only because it had reached a stage of arrest (life has its moments of arrest while continuing). I sense that Monet was discovering relationships that had little to do with the rigors of representation and more to do with his process. It remains unclear when Monet signed this painting— using something less than his full signature, as he sometimes did for relatively sketchy works. Whatever the case, it had been sold to a collector by 1889.[16] However unsettled in appearance, it contains nodes of curious focus that, despite having no tasteful reason to be located where they are, remain utterly attractive to the eye as visible matter. Such matter (colored substance) no doubt has a representational reference, yet has escaped it. Corot's old critics might conclude that Monet's *Bennecourt* was full of "mistakes," yet its quality of "only enough painting" secured its sensory poetry.[17]

I mention only one of the nodes of attraction (fig. 68). The putty-like color that serves to indicate the lost profile of the female figure abuts to its right a rectangle of similar color, part of a pattern of forms reflected into the water of the far shore. The abrupt shift from presumed planar recession (the turned-away head) to utter frontality (the opposite-shore reflection) appears as if no space were intervening. This configuration is more than curious: it shocks one's sense of pictorial order. Once you notice it, it is difficult not to fix on it. "It must be wrong," may be the first intuition. Yet there it is, demanding to be seen only for what it is. And all the more unavoidable is Monet's simultaneous play of assonant color. The two putty-like hues, presumably mixed quickly during his process, create a relationship that by all convention should not "work" (no harmony, insufficient transition, no clear hierarchy). But there it is. Monet left this bit of awkward assonance to be seen ("alienation of the sign from the thing"). This and other glaring oddities he let remain.[18] *On the Bank*

of the Seine, Bennecourt is a low-resolution painting of many paraphs. Its insistent materiality restores what can be lost in high-resolution, hyper-conceptualized, compartmentalized, twenty-first-century experience.[19] It assuages the nagging desire *"to encounter other people, or trees, or anything*, beyond words, in silence" (Bonnefoy).

During the nineteenth century, especially with the emphasis on art as a response to personal encounter, painting became free to do what it does so well—provide an enhanced, exploratory, sensory experience. "The alienation of the sign from the thing" did not cause

representations. The lower the resolution, the more ambiguous the representational image, and the more forwardly expressive the sensory elements, the material means. In 1915, Wölfflin rejected this quality of Monet as meaningless excess. But it had already been recognized as liberating for younger artists. In 1906, André Derain wrote to Henri Matisse that both were fortunate to belong to the first generation free to capitalize on an acknowledged fact: whatever material an artist chooses will beneficially assume "a life of its own" no matter what it depicts.[21] From this realization

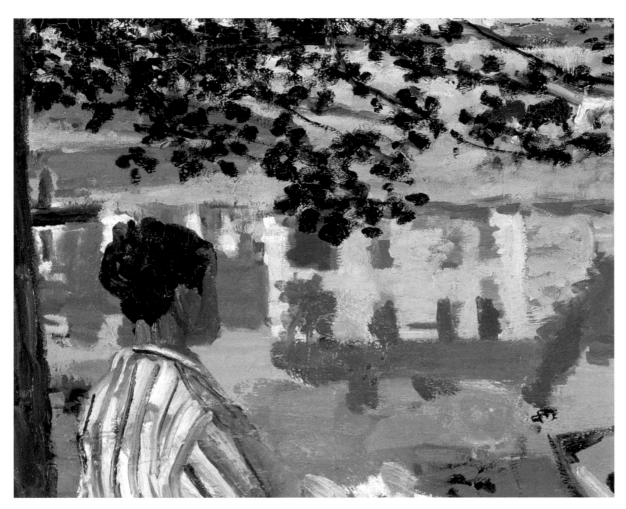

Fig. 68. Claude Monet, *On the Banks of the Seine, Bennecourt* (detail), 1868, oil on canvas. Cat. 30

painting to become socially irrelevant or esoteric.[20] Monet's early Impressionism is an art that demonstrates the expressive potential of a low-resolution surface. What proved so satisfying about abstraction in later art was always (and is) present in Monet's naturalistic

to the radical painting that Newman developed is not a stretch. Nor is it a stretch to grasp Monet's early art in these terms, especially when we project it forward to now, where it so well suits the continuing need—the longing—for "poetic outcry."[22]

Claude Monet:
A Summary Chronology, 1840–1872

This chronology is based on those compiled for two extraordinary exhibition catalogues in the 1990s. The first was published in *Origins of Impressionism* by Gary Tinterow and Henri Loyrette, presented at the Musée d'Orsay and the Metropolitan Museum of Art in 1994; the second in Charles F. Stuckey's *Monet 1840–1926*, organized for the Art Institute of Chicago in 1995. Both of these chronologies recorded and painstakingly documented events gathered from a wide variety of sources; since their publication, the information they impart has become part of the history of Monet and his milieu. Our debt to their research is gratefully acknowledged.

1840

Oscar-Claude Monet is born on November 14, the second son of Claude Adolphe Monet and his wife, Louise Justine Aubrée.

1845

The Monets move from Paris to Ingouville, a suburb of the port city of Le Havre in Normandy (fig. 69). Adolphe Monet enters into the wholesale grocery business of his brother-in-law Jacques Lecadre, husband of Adolphe's half-sister Marie-Jeanne.

Fig. 69. Gustave Le Gray, *The Imperial Yacht "La Reine Hortense" at Le Havre*, 1856, sepia photograph. Private collection

1851–56

As a student at primary school in Le Havre, Oscar (as he is then known) receives training in drawing from Jacques-François Ochard. The artist's first surviving drawings, some dated 1856, are the work of a competent but not remarkable draftsman. The young man excels, however, at caricature, inspired by prints by famous caricaturists, including the photographer Nadar, whom he was to meet later in life (fig. 70). Some of these caricatures are exhibited at an artists' supply store in Le Havre, where they are seen by the painter Eugène Boudin (1824–1898), a friend of Ochard's (fig. 71).

Fig. 70. Claude Monet, *Caricature of Jules Didier ("Butterfly Man")*, c. 1858, charcoal heightened with white chalk on blue laid paper. The Art Institute of Chicago

1856–58

Boudin invites Monet—a teenager half his age—to join him painting out-of-doors. Decades later Monet would recall that while working with Boudin "it was as if a veil suddenly lifted from my eyes and I knew that I could be a painter."

At the beginning of 1857, the widowed Adolphe Monet and his sons move into the Lecadres' home. There Oscar is under the protection of his aunt Marie-Jeanne, who would play a key role in his career, both as a supporter and a skeptic.

In August and September 1858, Monet exhibits a painting for the first time. His *View Near Rouelles* (cat. 1) is presented at the exhibition organized by the Société des amis des arts of Le Havre. He applies for, but does not win, a scholarship from the city of Le Havre to study in Paris. He applies once more—again unsuccessfully—in 1859.

Fig. 71. Pierre Petit, *Eugene Boudin*, c. 1890, photograph. Archives Larousse, Paris

1859

Adolphe Monet takes over the management of the Lecadre firm at the death of his brother-in-law. Monet goes to Paris in May to see the annual Salon for the first time. Boudin has arranged for him to meet the landscape master Constant Troyon (1810–1865), who advises him to learn to draw the human figure and to study nature in the open air. Monet's letters to Boudin reflect his first impressions of the major landscape painters of the day. Back in Normandy in the summer, Monet meets the Realist painter Gustave Courbet (1819–1877), who was to become a friend, advisor, and sometime rival in the coming decade.

1860–61

Fig. 72. Charles Marie Lhuillier, *Portrait of Claude Monet in Uniform*, 1861, oil on canvas. Musée Marmottan Monet, Paris

Living in Paris for the first time, the twenty-year-old Monet avails himself of the opportunities the city offers. He visits the gallery set up at 26 Boulevard des Italiens by the dealer-impresario Louis Martinet, seeing there a private exhibition devoted to some of the major modern painters, including Barbizon artists Camille Corot (1796–1875), Jean-François Millet (1814–1875), Théodore Rousseau (1812–1867), and Troyon, as well as Eugène Delacroix, Gabriel Decamps, and Ernest Meissonier. Monet enrolls at the Académie Suisse to be able to draw from the model but also becomes a regular patron of the Brasserie des Martyrs. "I wasted a lot of time [there]," he later recalled. "It did me the greatest harm."

His attendance is cut short when he receives a low draft number in March 1861. By June, he is stationed in Mustapha, Algeria, as a member of the African Cavalry (fig. 72). His family could have exempted him from service by paying 2,500 francs to hire a soldier in his place; Monet rejected their condition that he abandon hopes of being a painter.

1862

In the summer, Monet returns to the Lecadre home in Le Havre to recover from an illness. By autumn, he is at work again as an aspiring artist and meets the Dutch painter Johan Barthold Jongkind (1819–1891) working along the Normandy coast. Monet presents Jongkind—whom his aunt will call his true master—to his other "teacher," Boudin, in September.

In November, Mme. Lecadre pays the required sum to exempt her nephew from further military duty. The same month, he returns to Paris and enrolls in the studio of the Swiss painter Charles Gleyre (1806–1874). In Gleyre's atelier, Monet meets a number of painters who will be his friends and allies in the future, among them James McNeil Whistler, the American expatriate (1834–1903); Pierre-Auguste Renoir, son of a tailor from Limoges (1841–1919); Frédéric Bazille (1841–1870), a young bourgeois who had come to Paris to study banking; and Alfred Sisley, born in Paris to well-to-do British parents (1839–1899) (fig. 73). Monet stands out amongst his new friends. "Back then Monet amazed everyone, not only with his virtuosity, but also with his ways," recalled Renoir. "Jealous of his superb appearance when he arrived in the studio, the students nicknamed him the 'dandy.' He didn't have a cent and wore shirts with ruffled cuffs."

Fig. 73. *Forty-three Portraits of Painters from Gleyre's Studio*, 19th century, oil on canvas. Musée du Petit Palais, Paris

1863

Monet is still in Gleyre's studio. In March, the dealer Martinet organizes an exhibition that includes works of the Barbizon school as well as *The Quarry* by Courbet (fig. 74) and fourteen works by Édouard Manet (1832–1883), including the *Street Singer* (Museum of Fine Arts, Boston), *The Spanish Ballet* (Phillips Collection), and *Music in the Tuileries* (fig. 15).

The friendship between Monet and Bazille grows, and at the Easter holiday the two go together to paint around the Forest of Fontainebleau, staying at an inn at Chailly, on the edge of the forest near Barbizon. Monet stays on beyond the holiday, reassuring a friend in late May that he had not "abandoned the studio, and besides, I have discovered here a thousand charms that I was unable to resist. I worked a lot and, as you will see, I think I did more research than usual. Also, now, I shall go back to drawing." Curiously, only one painting can be dated to this sojourn.

During Monet's absence, the Salon opens, and because so many of the submitted works have been rejected, the Emperor agrees to the organization of an exhibition of excluded artists—the Salon des Refusés. At this alternate venue are exhibited works by many of Monet's future

Fig. 74. Gustave Courbet, *The Quarry (La Curée)*, 1856, oil on canvas. Museum of Fine Arts, Boston. Henry Lillie Pierce Fund

friends and colleagues—Paul Cézanne (1839–1906), Henri Fantin-Latour (1836–1904), Jongkind, Manet, Camille Pissarro (1830–1903), and Whistler. During the summer, Monet returns to Le Havre, taking up study with Gleyre once more in the autumn.

1864

Gleyre's studio closes definitively in the spring. In April, Monet spends time again at Chailly. After the opening of the Salon, Monet goes with Bazille to Normandy, settling in Honfleur, across the Seine from Le Havre. Over the next few months, Monet is accompanied by friends—first Bazille then Boudin and Jongkind—until October, when he is left alone in Honfleur.

Over these months, Monet's family withdraws financial support, forcing the painter to borrow money from Bazille and to make attempts to market his paintings through his friend, notably to the Montpellier collector Alfred Bruyas. Relief comes when in late October the Le Havre merchant and collector Louis-Joachim Gaudibert commissions two works. In that same month, Monet's second painting to appear in a public exhibition—a floral composition, probably *Spring Flowers* (fig. 75)—is shown in Rouen. It is poorly displayed, in Monet's estimation, and not included in the catalogue. In December, Adolphe Monet visits his son in Paris, where Bazille is sharing his studio, and gives him money to rent another workplace, also with Bazille.

1865

At the beginning of the year, Monet and Bazille rent a space in which to live and work at 6 rue de Furstenberg, Paris (fig. 76). Monet begins two large canvases, destined to be his first submissions to the Paris Salon, basing them on smaller easel pictures painted the year before (cats. 4 and 5; figs. 90 and 91). In April, Monet returns to Chailly to paint. He is back in Paris for the opening of the Salon at the beginning of May, where his Normandy marine paintings are well received and eventually sell to the dealer Cadart. But he returns to Chailly shortly thereafter and begins planning a large-scale painting of a picnic set in the forest. He asks Bazille to join him there, to be a model and to bring needed supplies. Before Bazille's arrival, Monet is injured and confined to his bed, where he is painted by his friend (fig. 77). Preparatory work on the painting continues through the summer, with Bazille returning to pose again for Monet in August.

By October, Monet has returned to Paris to begin painting the large-scale version of *Luncheon on the Grass* (cat. 9) for the 1866 Salon. He chooses a massive canvas some thirteen feet high and twenty feet wide. In November, Bazille reports that the picture is "well under way," and

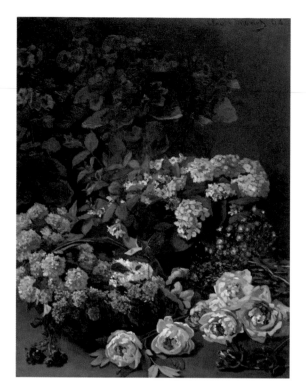

Fig. 75. Claude Monet, *Spring Flowers*, 1864, oil on fabric. Cleveland Museum of Art. Gift of the Hanna Fund

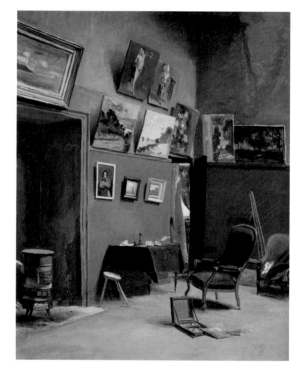

Fig. 76. Frédéric Bazille, *The Studio on the rue de Furstenberg*, 1865, oil on canvas. Musée Fabre, Montpellier

says that Monet sold "a thousand francs' worth of paintings over the last few days" and that "his career has started." At the end of the year, Bazille says that more than twenty painters, including Courbet, had come to see the painting and had "all admired it greatly, although it is far from being complete." Bazille and Monet arrange for separate studios at the end of the year—an inconvenient move for Monet, in light of the scale of the work at hand.

1866

Monet finds a small studio on the place Pigalle, where he continues to work on *Luncheon on the Grass*. With the deadline of March 20 for Salon submissions, he decides that he will not be able to complete the enormous canvas. To replace it, he elects to show a large landscape he had painted at Chailly the previous year (fig. 1) and to paint a new canvas, a full-length, life-size image of a fashionable Parisian. In short order, he completes *Camille (The Woman with a Green Dress)* (fig. 2), for which his lover, Camille Doncieux, is the model.

In April, the dealer Cadart tests a new foreign market for vanguard French painters, sending a group of paintings and prints by Boudin, Courbet, Corot, Jongkind, and Monet, among many others, for exhibition and sale in New York and Boston. Around the same time, Monet and Camille move to the town of Sèvres, just downriver from Paris. He begins work on another large painting, *Women in the Garden* (fig. 3), for which Camille models, and is determined to paint the picture entirely in the open air—an unusual ambition for a large-scale canvas.

At the Salon, opening May 1, *Camille* is admired and praised by many critics; in light of the brio of its execution, one of them asserts that it was painted in only four days. Among the admirers is the critic and future novelist Emile Zola (1840–1902), who names the painting as his favorite work in the exhibition. Zola emerges as a champion of Manet—he resigns his post at the journal *L'Événement* over the issue—and it is at this time that Manet and Monet first meet and that Manet meets Zola.

The success of *Camille* at the Salon reassures Monet's family; his aunt Lecadre agrees to extend her financial help. A copy of the painting is commissioned by Cadart, who plans to send it to America for a second exhibition. Monet's financial security, however, is not assured. While in a letter of May 22 he expresses satisfaction with the sales he has made after the Salon, a month later he asks Courbet for a loan, saying: "My large canvas only made me go deeply into debt. My family considered it a complete failure and refuses to help me get out of this terrible mess." In fact, his expenses at Sevres outstrip his revenues, and he goes into debt.

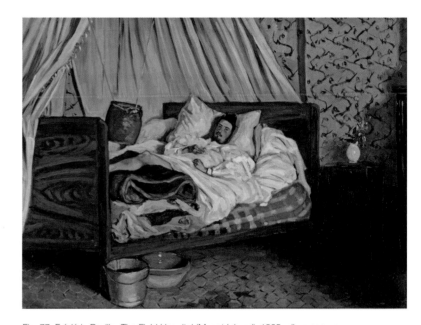

Fig. 77. Frédéric Bazille, *The Field Hospital (Monet Injured)*, 1865, oil on canvas. Musée d'Orsay, Paris

July finds the couple in Honfleur, where Monet works on *Women in the Garden* near Ferme Saint-Siméon, an inn popular with artists, where he and Bazille had stayed before. They keep company with Boudin and his wife, and also—at the Deauville Casino—see Courbet, who invites them to join him for dinner at the home of his host and patron, the Comte de Choiseul. At the beginning of December, Monet asks Bazille to send both *Camille* and the unfinished reduction of it to him; apparently this never happens, as the paintings are still in Paris at the end of the year.

1867

In the new year, Monet remains in Honfleur, painting port scenes and snowscapes and continuing work on *Women in the Garden*. In February, he returns to Paris and lodges with Renoir in Bazille's studio. At the end of March, it is announced that the Salon jury has rejected some two-thirds of the submitted paintings, including *Women in the Garden*, more than eight feet tall, and a seven-and-a-half-foot view of the *Port of Honfleur* (fig. 98).

Monet and his fellow painters Bazille, Jongkind, Manet, Renoir, and Sisley, joined by the older artist Charles-François Daubigny (1817–1878), petition to hold a new Salon des Refusés. They then launch a plan to form an association of independent painters to present their works each year outside the Salon system—an idea that would come to pass for some of them in 1874. At the end of April, Monet writes to the Comte de Nieuwerkerke, minister of fine arts, to be allowed to "paint some views from the windows of the Louvre, and particularly the exterior colonnade." (cats. 18–20). During the Salon, both of Monet's rejected paintings are put on display by Paris dealers; Bazille buys *Women in the Garden* for 2,500 francs.

Monet is mostly at Le Havre during the summer, working on a large number and variety of paintings (cats. 21 and 23); marine subjects and gardens predominate—sometimes in the same picture (fig. 78). He makes periodic visits to Paris to see the pregnant Camille, who gives birth to their son Jean in early August. Still, most of his time is spent in Normandy, where he announces to Bazille that he is painting "a huge steamboat . . . very peculiar" for the Salon of 1868.

For the holidays Monet returns to Paris, where he finds himself again in dire financial straits, relieved somewhat by the sale of a still life painting, arranged by Bazille (fig. 39).

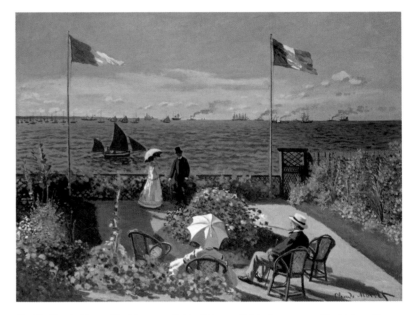

Fig. 78. Claude Monet, *The Terrace at Sainte-Adresse*, 1867, oil on canvas. The Metropolitan Museum of Art, New York

January and February are spent in Le Havre, where Monet works on the paintings that he will submit to the Salon—*Jetty at Le Havre* and *Boats Leaving the Port of Le Havre* (fig. 5). He is in Paris at the beginning of March to ready them for submission to the jury on the twentieth. He lodges with Bazille.

Jean Monet is baptized in Paris at the beginning of April; his godparents are Julie Vellay, Pissarro's companion, and Bazille. Sometime thereafter, the painter moves with his family to an inn in Bonnières, a town on the Seine some forty miles from Paris. Across the Seine lies the village where Monet paints *On the Bank of the Seine, Bennecourt* that spring (cat. 30). The family is evicted from the inn in June because they cannot pay; Monet settles the family nearby and proceeds to Le Havre to beg his family for money, unsuccessfully. Meanwhile, on May 1, the Salon opens, Monet's *Jetty* rejected and his *Port of Le Havre* accepted. Shortly thereafter Monet, back in Paris, meets Boudin at the exhibition; the latter says of the *Port* that it "shows an always commendable search for true tonality that everybody is beginning to appreciate." On the whole, however, the critics do not share Boudin's opinion, and the picture (now lost) is caricatured in the press (fig. 5).

In July, Monet sends four paintings to the fine arts section of a vast International Maritime Exhibition held in Le Havre. These include the painting that had received so much praise in 1866, *Camille (The Woman with a Green Dress)*, as well as two that the Salon jurors had rejected: *Port of Honfleur* from the 1867 exhibition and *Jetty at Le Havre*, spurned in 1868. A fourth painting strikes a very different note. It is *A Hut at Sainte-Adresse*, painted the previous summer (cat. 21) A few weeks later, Monet, Camille, and Jean move to Fécamp, northeast of Le Havre on the coast, staying first at a hotel and then renting a small house. The painter undertakes a series of paintings for Gaudibert, including portraits of his wife and children (fig. 79).

The Maritime Exhibition brings Monet a sale. Arsène Houssaye, a critic, novelist, and editor of the publication *L'Artiste*, purchases *Camille* and vows that he will bequeath it to the State. Monet is awarded one of four silver medals cast to augment another forty that were awarded to the best artists in the exhibition. At its end, however, the works not sold by Monet are seized by creditors and auctioned, but Gaudibert rescues them.

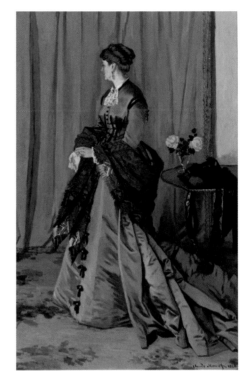

Fig. 79. Claude Monet, *Madame Louis Joachim Gaudibert, Wife of a Merchant from Le Havre*, 1868, oil on canvas. Musée d'Orsay, Paris

Writing to Bazille, Monet draws a distinction between painting in the city and in the country: "One gets too preoccupied with what one sees and hears in Paris," he writes. "What I do here will at least have the merit of resembling no one else's work." From his new home at Étretat, in December Monet asks Bazille to send all his paintings and painting supplies to him at his aunt's home in Le Havre. He shares his plans for "two figure paintings" to be exhibited in the 1869 Salon, "an interior with a baby and two women, and sailors out of doors" done "in a stunning fashion."

1869

Towards the beginning of the year, the art supplier Louis Latouche displays one of the views Monet had painted from the Louvre in the window of his gallery on the corner of rue Laffitte and rue LaFayette in Paris. Boudin encourages a friend to go see it, judging that "it would be a masterpiece worthy of the greatest if the details corresponded to the whole."

Monet returns to Paris in March to prepare for the Salon. In the village of Saint-Michel near the riverside town of Bougival, he rents a house for his family; Bougival and several nearby towns will soon welcome Monet's colleagues Pissarro, Renoir, and Sisley. He works in Bazille's Paris studio to complete two paintings, *Fishing Boats at Sea* (fig. 80) and *The Magpie* (cat. 25). In early April, he learns that both paintings have been rejected by the Salon jury. As when he was rejected in 1867, a dealer comes to his rescue: this time Latouche shows a canvas which, according to Boudin, "draws the whole artistic world," adding that "for the young, the unexpectedness of this violent painting has caused a fanatical reaction."

In spite of this success, Monet claims to Houssaye that "dealers and collectors ignore me," and counts himself "unable to work." The summer is a period of great worry for Monet and his family, who are often without food and depending on the generosity of Renoir and Bazille.

A period of activity brings Renoir and Monet to the riverside bathing place of La Grenouillère, where in tandem they paint remarkable studies of the establishment and its patrons, in Monet's case experimenting with particularly novel ways of depicting reflected light (cats. 31 and 32). But Monet writes to Bazille in August to say that "for eight days, we have no bread, no wine, no fire for cooking, no light." Lack of food is accompanied by lack of art supplies, which calls painting to a halt. Still, Monet writes of making a painting of the Grenouillère, saying that he had completed "some bad sketches, but it is only a dream." Renoir, he says, "also wants to do this painting."

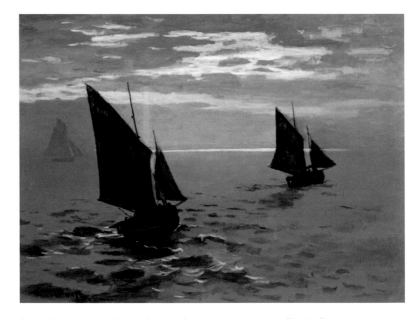

Fig. 80. Claude Monet, *Fishing Boats at Sea*, 1868, oil on canvas. The Hill-Stead Museum, Farmington, Connecticut

At the end of the year, in nearby Louveciennes, Monet paints several views looking down the road on which Pissarro resides; the two painters, in neighboring towns, share many pictorial strategies. Returning to snowy motifs as a challenge for painting in all seasons and with a reduced palette of color, Monet paints several views of the Seine in the cold (cat. 26), a theme to which he returns in subsequent decades.

1870

The jury of the Salon of 1870 votes to reject the two paintings submitted by Monet, *The Luncheon* (fig. 97) and a painting thought to be the large view of *La Grenouillère* that is now lost (fig. 110). Daubigny and Corot resign from the jury in protest. Nonetheless, Monet is able to sell *The Bridge at Bougival* to the dealer Pierre Ferdinand Martin (cat. 33). He receives fifty francs and takes a painting by Cézanne—the first of several he will eventually own—as partial payment (fig. 81).

Monet and Camille are married on June 28 in Paris; Courbet, Dr. Paul Dubois, and Antoine Lafont, a journalist, serve as witnesses. The latter two had introduced Monet to the rising public figure Georges Clémenceau, who would become his lifelong friend. Significantly, in light of the coming Franco-Prussian War and the political unrest that followed, all three of Monet's witnesses were associated with the radical left.

The Monets honeymoon in Trouville, at the Hotel Tivoli, from the end of June until mid-September. They are joined for the last month by Boudin and his wife. Together the couples enjoy the resort, and Monet and Boudin paint views of the beach (cats. 34–37). But the honeymoon is not without its setbacks. Monet's Aunt Lecadre dies about a week after the couple arrive in Normandy; less than two weeks later, on July 19, war is declared between France and Prussia.

French forces are defeated at the Battle of Sedan and Emperor Napoleon III is captured, precipitating the fall of the Second Empire and the declaration of a new government, the Third Republic. Paris comes under siege; the northeast of France and the area around Paris are occupied by German troops. Canvases deposited with Pissarro at Louveciennes before the Monets' departure, along with hundreds of works by Pissarro, are lost when German forces overrun the region.

At the beginning of September, Monet acquires a passport in anticipation of leaving the country; soon thereafter he witnesses boatloads of refugees leaving Le Havre for England. On October 6, the Monets leave for London. Daubigny, also in London, introduces Monet to the dealer Paul Durand-Ruel, likewise in temporary exile; the dealer includes one of Monet's most recent paintings, *Breakwater at Trouville, Low Tide* (fig. 82) in the first of several exhibitions he will stage in the British capital

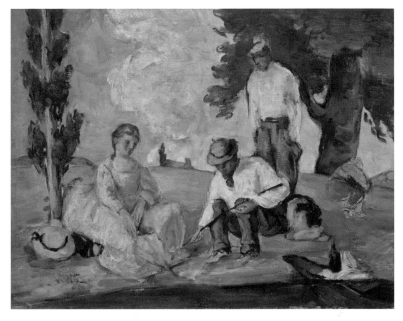

Fig. 81. Paul Cézanne, *Picnic on the Riverside*, 1873–74, oil on canvas. Yale University Art Gallery, New Haven, Connecticut

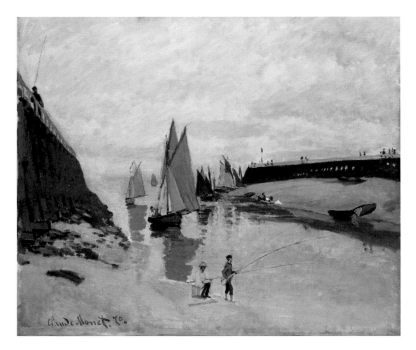

Fig. 82. Claude Monet, *Breakwater at Trouville, Low Tide*, 1870, oil on canvas. Museum of Fine Arts (Szepmuveszeti Muzeum), Budapest, Hungary

to promote French artists. Another work is shown in an exhibition organized by Daubigny, among others, for the benefit of the "Distressed Peasantry of France." Of Monet's friends who remain in France, only Bazille comes to harm; an early volunteer for the army, he is killed in battle at the end of November.

By the end of the year, Monet has undertaken a group of paintings of London. Some focus on the city's vast public parks (cats. 39 and 40) while others reveal his attraction to the broad river Thames, which he would revisit some thirty years later (fig. 83).

1871

Through Durand-Ruel, Monet and Pissarro are reunited. Visiting the London museums, they look closely at the works of the English masters John Constable and William Turner. Both artists submit works to an International Exhibition held at the South Kensington Museum. Among those shown by Monet are the reduction of his 1866 *Camille* and *Meditation, Camille Monet on a Couch* (cat. 38). Neither painter, however, is accepted by the annual exhibition of the Royal Academy.

Monet and Pissarro are removed from the tumult of the fall of Paris, the armistice, and above all the declaration in Paris of an independent Republican government, the Commune, in late March. The Commune is suppressed by government troops in late May, leading to civil war. By the time the Commune falls, some 20,000 citizens have died. Even before the strife comes to an end, the Monets quit England to go to Holland.

The Monets settle in Zaandam, a picturesque town on the outskirts of Amsterdam, easily accessible by ferry (cat. 42). They lodge at the Hotel de Beurs there between early June and early October. During this first visit in Holland (he would return a few years later), Monet completes some two dozen paintings of Zaandam—views of canals lined by fields and windmills and of houses and buildings along the water near the city center. He also visits Amsterdam's Rijksmuseum and the Frans Hals Museum in Haarlem.

In November, the Monets are back in Paris, staying in a hotel near the Gare Saint-Lazare. Monet obtains a studio in the neighborhood, but by the end of December, he has rented a house in the riverside town of Argenteuil, about eight miles from the city, linked to Saint-Lazare by a train every hour.

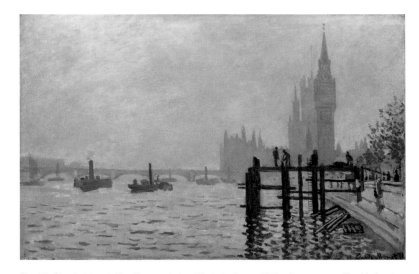

Fig. 83. Claude Monet, *The Thames below Westminster*, c. 1871, oil on canvas. The National Gallery, London. Bequeathed by Lord Astor of Hever

For the first time in many years, the Monet family is at rest. The house and its garden at Argenteuil become their home for the next five years. Monet also achieves greater financial stability, as Durand-Ruel becomes a regular purchaser of his paintings, buying twenty-nine works over the course of 1872. (These include cats. 39, 40, 42, 44–46, 51, and 54.) With this increased income, the family is able to engage two servants and a gardener. Monet also arranges for a boat to be fitted with an enclosed structure to function as a studio, so that he can depict the Seine not only from its banks but also from mid-river (fig. 84).

Argenteuil's relative proximity to Pontoise, to the northwest, and to Louveciennes, to the south, ensures that Monet's contacts with Pissarro and Sisley remain active. Sisley and Monet paint side by side in Argenteuil on several occasions in the first months of the year (cats. 49 and 50).

The year also offers Monet several opportunities for exhibition. In March, he shows at the Municipal Fine Arts Exhibition of Rouen, staying in the Normandy capital long enough to paint many views of its riverbanks and environs. Durand-Ruel places two Monet canvases in a group show held in London—the Fourth Exhibition of the Society of French Artists—which includes works by many of the painters who would eventually come together to exhibit as independents: Degas, Pissarro, and Sisley, as well as their mentor Manet (who will not show with them in the future). A Fifth Exhibition in November will add the names of Renoir and Whistler to the checklist.

In November, from a hotel room on the port of Le Havre, Monet paints an extraordinarily diffuse picture of the rising sun, in which quickly brushed-in mists of thinned blue paint suggest a moody overall background of water and sky, accented and given spatial depth by the addition of dark shadows and bright red reflections in the painter's characteristic horizontal strokes (fig. 85). Eighteen months later, he will include the painting as part of his submission to the exhibition he organizes with a group of independent painters who wish to show outside the Salon system—a group including Cézanne, Degas, Pissarro, Renoir, and Sisley. Years later, he explained: "They asked me the title for the catalogue; it could not really pass for a view of Le Havre, so I replied: 'Put *Impression.*'"

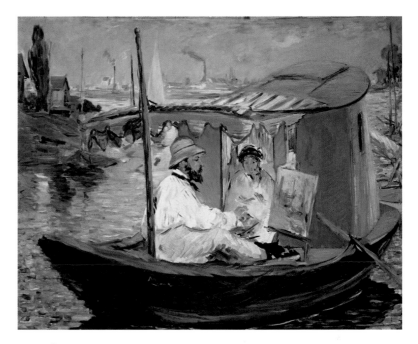

Fig. 84. Édouard Manet, *Monet in His Floating Studio*, 1874, oil on canvas. Neue Pinakothek, Munich

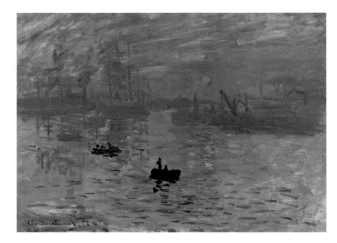

Fig. 85. Claude Monet, *Impression: Sunrise*, 1872, oil on canvas. Musée Marmottan Monet, Paris

Catalogue

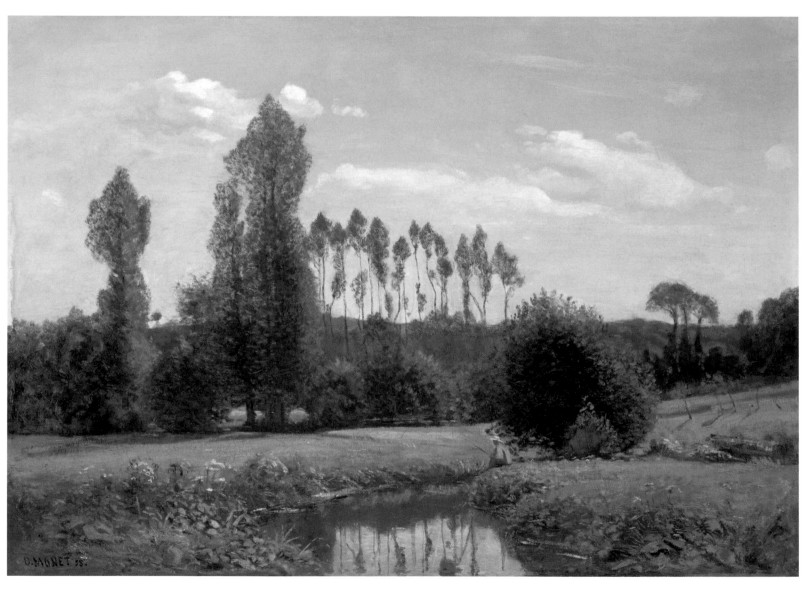

Cat. 1. *View Near Rouelles*, 1858. Marunuma Art Park, Asaka, Japan

Rouelles is a village in Normandy, situated about eight miles to the north and east of Le Havre. The painter Eugène Boudin took his young protégé Oscar-Claude Monet there in 1858; both painters completed works inspired by the Rouelles landscape. Monet's *View Near Rouelles* (cat. 1) is the first painting that he ever presented to the public, submitting it to the *Exposition municipal de la ville du Havre* later that year. Boudin showed two paintings of Rouelles in the same exhibition, both entitled *Landscape (Rouelles Valley)*. The catalogue of this exhibition comprised nearly 750 entries, and no record survives of any reaction to this beautiful landscape by an artistic debutant.[1]

The most remarkable thing about the painting—the first work of some two thousand listed in the catalogue raisonné of the artist's career—is its precocious skill, far exceeding what one would believe possible in the earliest work by any painter. It is likely, of course, that many efforts, now unlocated or unrecognized, preceded such an accomplished picture. But *View Near Rouelles* demonstrates the degree to which the young Monet—not yet eighteen in the summer of 1858—was able to absorb the landscape style of his mentor.

If Boudin is best known as a painter of marine paintings—boats at sea and, above all, scenes of harbors and beaches—his own beginnings in the 1850s include many pure landscapes (fig. 86). As in Boudin's related paintings, Monet's composition is conventional but clever: a river, probably the Fontaine, enters the painting at the right, unseen between its higher banks, and proceeds to the center foreground before turning back and leaving the painting to the right of center; but it returns in the background, its presence revealed by the pattern of the trees and bushes that grow on either side of the water. Choosing a spot from which the river appears with a sloping field of wheat at right and a distant ridge of hills at the horizon, Monet decorates the riverbank with blooming plants and introduces, for scale, the lone figure of a fisherman in a blue smock and straw hat. The model for such a painting is found in the work of Charles-François Daubigny, whose paintings Boudin would have known, passing their lessons on to his pupil (fig. 87).

Everywhere Monet's touch is controlled but still spontaneous, anticipating the way he would, a decade later, paint a cliffside covered with weeds (cat. 21). In fact, the composition is almost a catalogue of the artist's lifelong preoccupations: the contrast between bright light, mid-tones, and deep shadow; the nature of sunlight falling onto trees and grasses; the patterning of trees against the sky; and above all the reflection of earth and sky in water. Monet parted with the painting in 1877, giving it to the director of his son Jean's Argenteuil school in payment of a debt. It remained in Argenteuil for more than one hundred years, until it entered the art market and was purchased by its present owner.

Fig. 86. Eugène Boudin, *Norman Landscape*, c. 1857–58, oil on panel. Present location unknown

Fig. 87. Charles-Francois Daubigny, *The River Seine at Mantes*, c. 1856, oil on wax-lined canvas. Brooklyn Museum of Art, New York

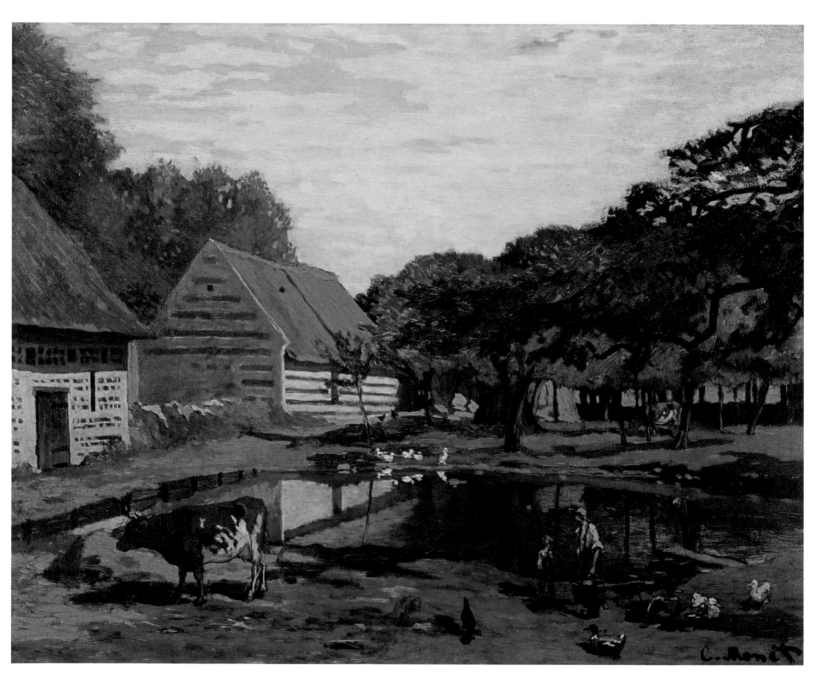

Cat. 2. *Farmyard in Normandy*, 1863. Musée d'Orsay, Paris

During Monet's earliest years as a practicing artist he produced a surprisingly small number of paintings. Between the earliest dated canvas we know, the 1858 *View Near Rouelles* (cat. 1) and *Farmyard in Normandy* (cat. 2), painted five years later, there are only fourteen known works. Among them we count two landscape sketches, a portrait of a woman, and two sketches of the heads of dogs; all the rest are still lifes. None of these paintings gives a clue as to how Monet progressed from the delicate, even exquisite, manner of painting the landscape in 1858 to the tough, uncompromising style of this remarkable painting.

In one of his still lifes, the *Corner of a Studio* (fig. 88) the application of paints in flat passages that accord with the flatness of the tapestry background and the patterned carpet hints that the twenty-year old Monet was attuned to the emerging fashion for "patchy" painting among vanguard artists. On the wall of the studio, cropped by the frame at upper right, hangs a landscape painting that has been associated with the canvas by Daubigny that Monet's Aunt Lecadre gave him. But it is not to Daubigny that Monet turned when setting out to paint the Normandy farmyard in the summer of 1863.

Instead, he seems to have taken inspiration from the painters of the "Generation of 1830," notably from the works of Camille Corot and Theodore Rousseau. From Corot's sketchiest works he might have learned how to delineate three-dimensional form without delicate touches or careful modeling but with forthright contrasts of richly applied highlights and deep shadows. In Rousseau, he would have seen the technique of beginning a work with a quick tonal sketch in thin dark paint, over which more opaque color could be built up in dabs and patches to suggest a surface that, in its final form, appears to be still in progress.

Every corner of *Farmyard in Normandy* makes a show of the artist at work. Rich umber browns are applied thinly and scraped through with a dry brush to create half tone and reflections in the pond's surface at right, while the jagged branches of the tree—another nod to Rousseau at Barbizon—insist on revealing themselves, frankly, as slashes of pigment. And the incidental staffage—the cows, the farm boys, their ducks and chicken, their sketched-in dog—announce that Monet can paint. With a backward glance at the past, he looks forward here to chart a new path for himself.

Fig. 88. Claude Monet, *Corner of a Studio*, 1861, oil on canvas. Musée d'Orsay, Paris

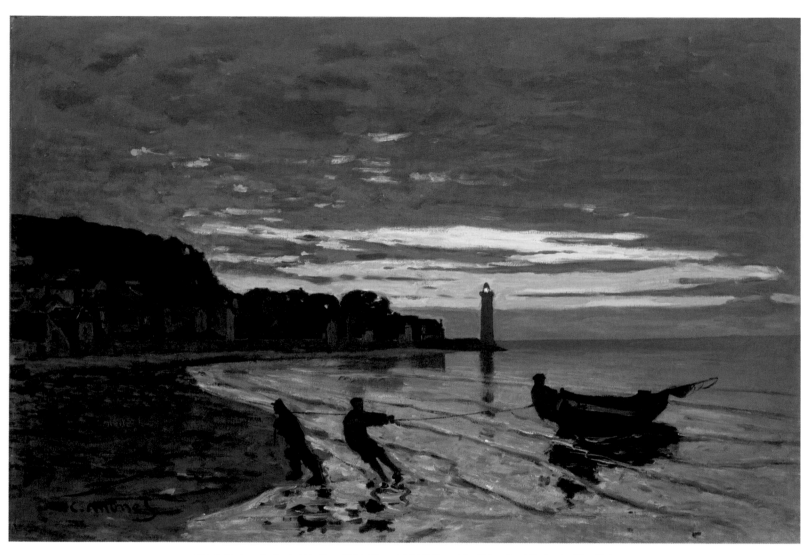

Cat. 3. *Towing of a Boat at Honfleur*, 1864. Memorial Art Gallery of the University of Rochester, New York

Monet spent half of 1864 in Normandy, settling at Honfleur, on the west side of the Seine estuary, opposite Le Havre. There he worked with several of his friends, notably Boudin; they sometimes painted the same motif. This is the painter's first extended campaign in Normandy, his homeland, and his first concentrated period of painting seascapes and coastal views. At this stage in his career, he had no fixed residence and would move from place to place as inspiration—or financial exigencies—moved him. Even after he had established an abode, from the early 1870s on, it was his practice to travel to a particular locale and to explore the motifs it offered.

During this first extended period of painting in Normandy, Monet fixed on some of the compositional formulas that he would so deftly employ in the future. From this stay come the first paintings to study the sky across water, with a point of focus—often a man-made motif—drawing the viewer's eye into the distance and establishing the scale of the pictorial space, a tactic that he would employ at Antibes in the 1880s and in Venice in 1909. Here, too, began Monet's fascination with Normandy's cliffs, particularly when seen from the low vantage point of the beach itself, a recurring theme in his paintings of the 1880s.

From the first of these categories comes the spectacular *Towing of a Boat at Honfleur* (cat. 3). The scene is the beach to the west of the port. From a position on the long jetty that protected and established the port entrance, the artist could look almost due west towards the *Phare de l'Hospice*—the lighthouse named for its location on a rocky outcropping beside the hospital, seen to its left. As sunset merges into twilight, the lantern of the columnar lighthouse is illuminated, shining bright and white against the warm yellow light to the west. The beach appears to curve away from the viewer, but the houses seen in a row in the distance are on a perfectly straight embankment; the tide has dropped, revealing the arcing contour of the strand itself. To animate the landscape, and to signal the close of day and the end of labor, Monet introduces three fishermen hauling in their boat. One, wearing a jacket colored red for visibility, stands in the lapping water, while the others pull the boat towards the beach; the man at left, perhaps the elder of the two, wears foul-weather gear, including a sou'wester, but the other is hatless and bare-legged.

Although he might have set the basic elements of the composition in place on site, *Towing of a Boat* is a studio creation, a testament to Monet's acute eye and visual memory. The shapes of the clouds and the colors of the sunset were based on a pastel that he had made at another time and in another location (fig. 89), following the habit of his

Fig. 89. Claude Monet, *View of the Sea at Sunset*, c. 1862, pastel on paper. Museum of Fine Arts, Boston. Bequest of William P. Blake in memory of his sister, Anne Dehon Blake

friend Boudin, renowned for the beauty and acuity of his pastel sky studies. Enlarging the design of the pastel and adapting what he had first observed to suit his compositional purposes—he increases the size of the farther opening onto the sun to provide a better foil for the lighthouse and its lamp—he relied on the study as an *aide mémoire* to the subtle color harmonies of streaks of yellow breaking through a field of purple-gray tinged with warm mauve underlight. The paints were put on densely—barely a hint of the canvas ground breaks through where the dark mass of the hill abuts the sky. While the painting is broad, even blunt, in its facture, when compared to paintings by Boudin, it is clearly conceived as a highly finished work.

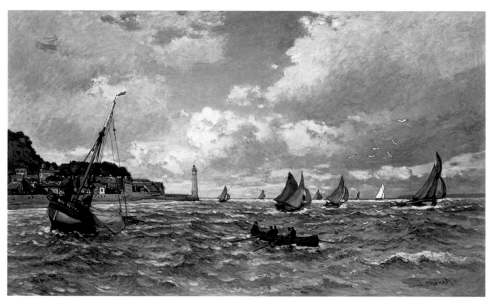

Fig. 90. Claude Monet, *Mouth of the Seine at Honfleur*, 1865, oil on canvas. The Norton Simon Foundation, Pasadena, California

The status of the Zurich *Phare de l'Hospice* (cat. 4) is much less obvious. Monet took his viewpoint from the same jetty he had stood on to plan *Towing of a Boat*, but turned to his right to look out to the channel and towards the land rising at Le Havre on the other side of the estuary, just visible at the right edge. The painting has most often been regarded as a study made with the intention of being enlarged in the studio—the painted equivalent to the pastel sketch the artist used for *Towing of a Boat*.[1] Its overall effect, in fact, could hardly be more different than the sunset view. As suited a daytime scene, the palette is lighter and brighter, and at the same time the execution is as exuberant as the painting of the sunset is measured. The sky has been

painted quickly and with great assurance, a scumble of grays, white, and blue laid in over a luminous ground. From the ways in which the colors overlap each other willy-nilly, it is clear that the artist was working with many tones and hues at the same time. By contrast, the painting of the water seems calm and controlled, its colors softened to a palette of warm and cool grays.

Whether Monet painted *Le Phare de l'Hospice* for its own sake or with the intention of using it as a study for another painting, it was in fact used as the model for one of the two paintings Monet created in early 1865 with the plan of submitting them to the Salon. The resulting composition is *Mouth of the Seine at Honfleur* from the Norton Simon Museum (fig. 90). Measuring some 150 centimeters in width as compared to the 80 centimeter width of the Zurich canvas, it is almost four times as large. As befitted a canvas destined for public exhibition, it was not only larger but more intense, the motif slightly altered for dramatic effect, and with narrative elements added.

In adapting the sketch to the Salon painting, almost every element of the composition was revised. The water's surface, relatively placid in form and color in the model, was animated with greater three-dimensionality: waves that had been only a suggestion were made more luminous, given greater height, and occasionally made to fall into a whitecap. Making the foreground darker and the shaft of sunlight on water brighter intensified the suggestion of daylight falling on the sea near the horizon, as recorded in the sketch. The coast was subtly modulated, the lighthouse growing thinner and taller; and more boats of greater variety were introduced, those in the near ground looming dark, while one sail glows white against the gray horizon, a flock of seagulls extending that light against the shadowed cloud. The sky itself has grown more intense, with greater contrasts between the brightest whites and the darkest grays; the passage of clear blue sky at center is a more saturated and varied blue. If the first painting were a scherzo for piano, the second would be that same melody orchestrated for a symphony.

It was evidently Monet's intention to submit not just one, but a pair of paintings to the Salon, their subjects chosen to complement each other. Both paintings were executed early in 1865 in Paris, in the studio Monet shared with Bazille on the rue Furstenberg (see fig. 76), and were presumably under way simultaneously. If by

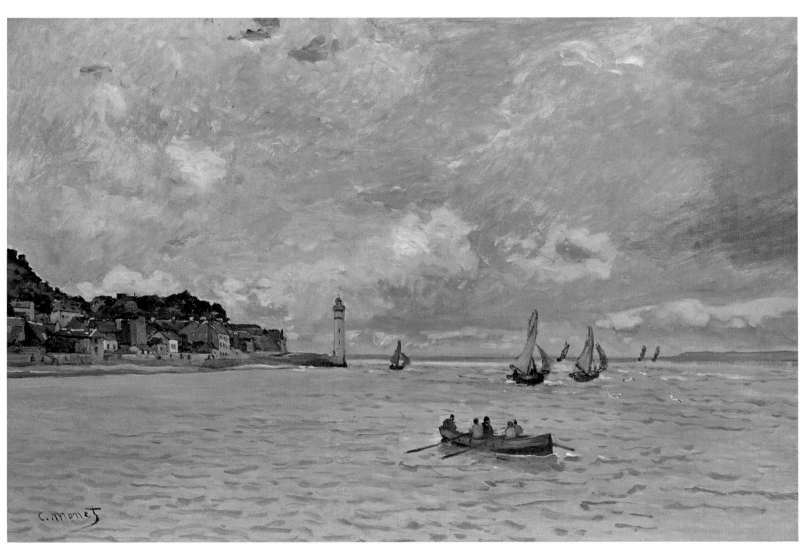

Cat. 4. *Le Phare de l'Hospice*, 1864. Kunsthaus Zürich

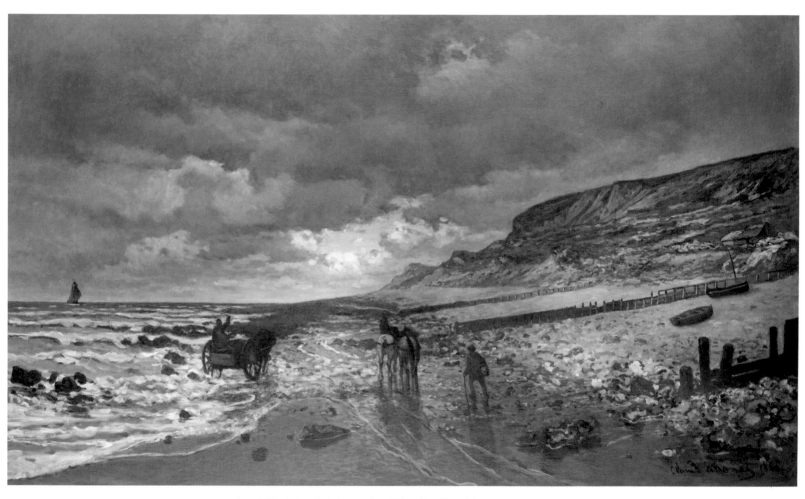

Cat. 5. *The Pointe de La Hève at Low Tide*, 1865. Kimbell Art Museum, Fort Worth

virtue of its finish *Le Phare de l'Hospice* might be regarded as a painted study, *Horses at the Pointe de la Hève* must be seen as a finished painting in its own right (fig. 91). It shares with *Towing of a Boat* a sense of deliberate and patient execution, above all in the depiction of the rocky strand with its pools of sea water and muddy cart tracks.

The scene is set at low tide; the rising sea will eventually come up almost to the base of the cliff at right, covering the wooden breakwaters almost completely. Presumably the men are on the beach to collect seaweed—indicated by the green-black patch

larger canvas, Monet again intensified effects that were present, but much less dramatic, in the first work. The wider format of the Salon painting contributed much of that intensity; the artist stepped away from the motif in his mind, expanding his view on each side, and reducing both in number and in scale the incidental figures. Immediately the landscape seems to grow more powerful, but more changes are made. The lowering sky is heavier, darker, more threatening. The viewer's eye is first drawn to an distant opening in the clouds, where bright sunlight breaks through, and then

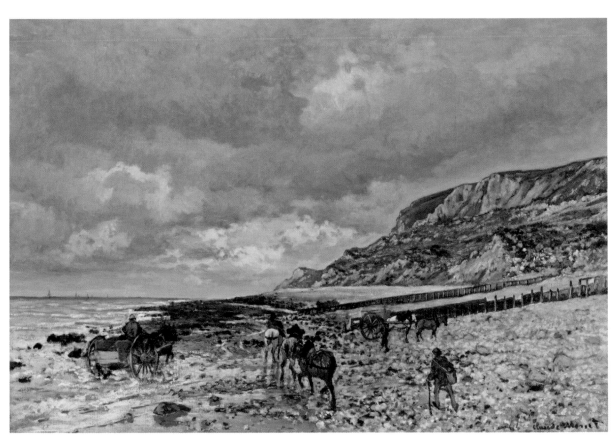

Fig. 91. Claude Monet, *Horses at the Pointe de la Hève*, 1864, oil on canvas. Private collection

ahead of them at the water line. Monet shows their carts still empty, however, and by placing them so that they trudge away from the viewer he thwarts an easy reading of the narrative. They are in the picture, too, to give the viewer a sense of the immensity of the beach and its rather melancholy splendor.

It is that sense of brooding grandeur and the ominous forces of nature that pervades *The Pointe de la Hève at Low Tide* at the Kimbell Art Museum, painted as the pendant to *Mouth of the Seine* (cat. 5). In adapting the smaller painting to the demands of his much

registers that light is being reflected from the surf, in the water in the rutted path, and on the brightest of the exposed rocks on the strand.

Monet's first submissions to the Salon were not only accepted but also warmly received. He was extolled as "the author of the most original and supple, firmly and harmoniously painted seascape exhibited in a long time. . . . M. Monet, unknown yesterday, has immediately made a name for himself with this single painting."[2] This was an auspicious beginning for a twenty-four-year-old painter.

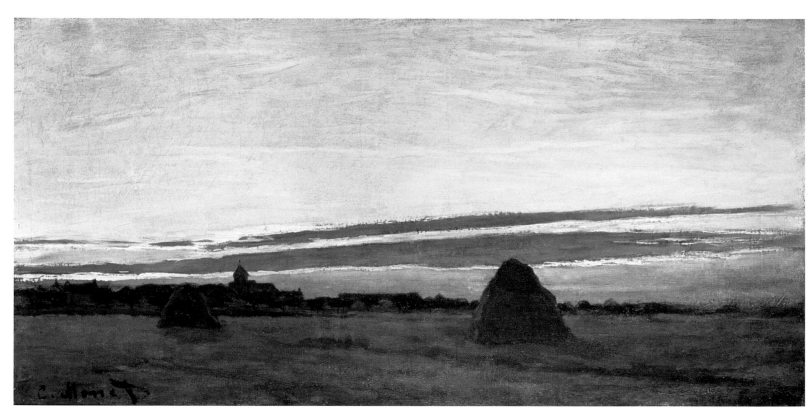

Cat. 6. *Grainstacks at Chailly at Sunrise*, 1865. San Diego Museum of Art

In April 1863, a group of students from the atelier of Charles Gleyre, including Monet, Renoir, Sisley, and eventually Bazille, went for the Easter holidays to the outskirts of the great Forest of Fontainebleau, some forty-odd miles from Paris, a train journey of about two hours. Monet, whose childhood and adolescence had been spent near the sea, found the forest and its surrounding landscape fascinating, so much so that after the others returned to Paris he stayed on in Chailly-en-Bierre, where they had settled. For more than a generation, the forest had been the source of motifs for paintings, drawings, and prints by such artists as Camille Corot, Jean-François Millet, and Théodore Rousseau. Millet and Rousseau had taken up residence in the village of Barbizon, close to the part of the forest where some of its most interesting natural attractions were to be found—attractions that grew in notoriety as a result of their works of art.

Chailly, unlike the more famous Barbizon, did not abut the forest; instead, it stood in the middle of a vast agricultural plain, then, as now, a center for the production of grain and of hay. The level vastness of the plain is the theme of this view Monet painted at Chailly in 1865, on his third period of painting in the region, using a small canvas with an especially narrow horizontal format (cat. 6). The spectacular sunset sky in his Chailly study could either have been painted from memory or from a pastel of the kind he had drawn before the motif then used to paint *Towing of a Boat* (cat. 3) in the studio; above streaky clouds of yellow, orange, and dull red, the heavens shift from greenish yellow at left to a clear, pure, blue at upper right.

Fig. 92. Claude Monet, *Stacks of Wheat (End of Day, Autumn)*, 1890/91, oil on canvas. The Art Institute of Chicago. Mr. and Mrs. Lewis Larned Coburn Memorial Collection

The sky's pyrotechnics contrast with the quiet rendering of the tranquil landscape below. At the horizon, beneath the silhouetted bell tower of the Chailly church, the walls and gables of houses are rendered in soft gray-browns, giving onto the mossy greens of the fields. Among the many delicate details in the landscape are the tiny tendrils of smoke rising from burning piles of brush, to the left of center and in the background at right.

This is the first of many pictures of fields, sometimes with stacks of hay or stacks of wheat, which would take shape under Monet's brush over the next thirty years. These culminate in the celebrated group of 1890–91 canvases that would constitute the first of his series painting campaigns (fig. 92).

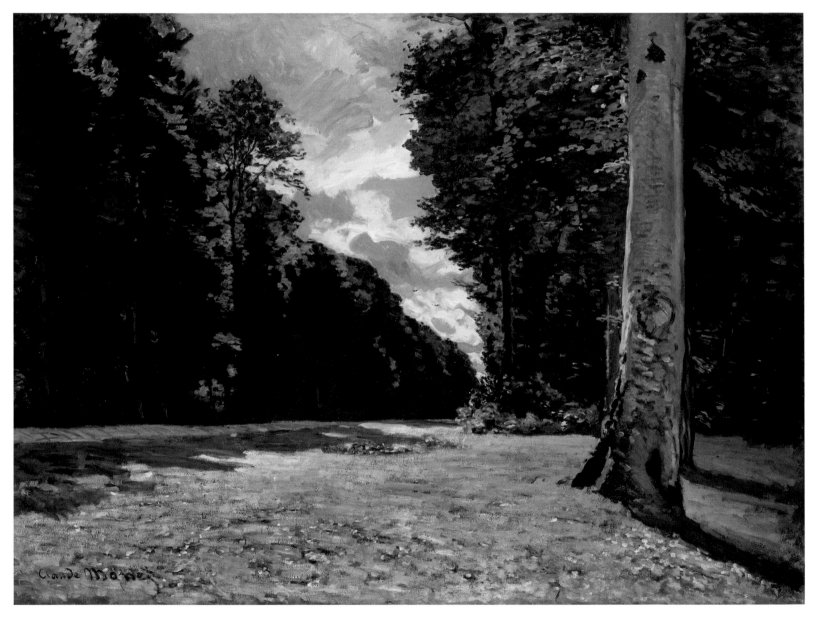

Cat. 7. *The Pavé de Chailly in the Forest of Fontainebleau*, 1865. Ordrupgaard, Copenhagen

None of Monet's paintings or drawings from his 1863 sojourn to Fontainebleau seems to have survived, but on a return visit the next year, he painted some ambitious canvases, including one showing the *Pavé de Chailly*—the Chailly road—within the forest itself (see fig. 24). This wide thoroughfare cutting through the woods was part of a long paved road created under Louis XIV that reached from Paris to the Mediterranean. The stretch linking Chailly to the royal seat of Fontainebleau at the center of the forest was one that was popular with artists. Gustave Le Gray, the pioneer photographer of landscape and seascape, had set up his camera on its verge several years before, like Monet taking pleasure in the patterns of rectangles and triangles that the receding road created across the pictorial surface (see fig. 25).

Monet returned to paint the Pavé de Chailly on two occasions. It is thought that he first made a small, luminous view of the road, taking particular care with the effects that resulted from looking against the light—"*contre-jour*"—notably the cloud-like shapes of trees coming into leaf (fig. 93). This work could have been painted either in 1864 or in 1865, before he set about painting a much larger view, abandoning translucent tones to use dense, opaque oils applied with vigor (cat. 7). In the larger painting, the mass of the trees is denser, for the branches have come into full leaf. The dark black-green shadows, on the other hand, are an extraordinary foil for the tones of bright green that the artist uses to show sunlight penetrating the dense wood, bringing attention to a single tree, as at left, or a scattering of branches and leaves, as at right.

This work, like nearly everything Monet did in the summer of 1865, was executed with a view to the large painting he envisioned making for the Salon of 1866, *Luncheon on the Grass* (cat. 9). In a compositional study for that painting (see fig. 13), the distinctive lines of the receding trees are quickly discerned, indicating that this spot on the roadside was where he first proposed to set the picnic. The change of vantage point in the final painting brought increased unity to the background but more importantly gave Monet a better opportunity to paint the effects of sunlight shining through, rather than on, foliage.

Fontainebleau exerted a strong attraction for young painters of Monet's generation. They found there, above all, an abundance of motifs to study, and most of the most picturesque groves of trees and rocky gorges were easily accessible from Chailly. "The country is wonderful, don't delay," Monet wrote to Bazille in April. "Come quick, join me," he insisted two weeks later, "the forest is delicious, I should have been here long ago... You're wasting your time in Paris," he continued. "Everything is superb here; you

Fig. 93. Claude Monet, *The Pavé de Chailly (Forest of Fontainebleau)*, c. 1865, oil on canvas. Musée d'Orsay, Paris

should take advantage of beautiful days, there'll be plenty of bad ones to spend working in your room."[1]

Not only could the artist find subjects both picturesque and grand at Fontainebleau, these sites were redolent with history. The kings of France had hunted in these woods for centuries, and long before landscape artists came to work from nature, generations of foreign and native painters and sculptors had worked at the chateau at the heart of the forest. For both painters and poets, its nature itself was imbued with a kind of *anima*, a sense of spirit that led them to give identity and feelings to its components in works of art.

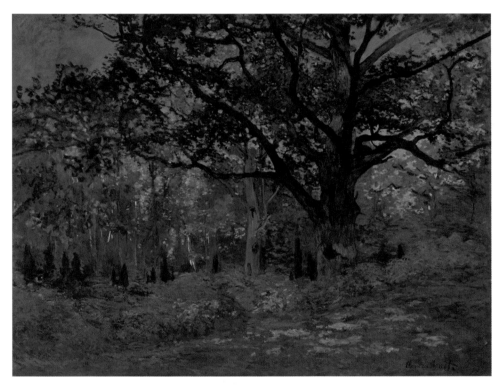

Fig. 94. Claude Monet, *The Bodmer Oak, Fontainebleau Forest*, 1865, oil on canvas. The Metropolitan Museum of Art, New York. Gift of Sam Salz and Bequest of Julia W. Emmons, by exchange, 1964

In Fontainebleau, the majestic trees visitors encountered were often discussed in this way. Because the forest had been a royal preserve, trees had achieved monumental scale seldom seen in other landscapes. "The forest is truly admirable in certain parts," Bazille wrote to his father in the south of France on his first visit in 1863. "We have no idea down in Montpellier of such trees."[2]

One of the most memorable descriptions of the forest occurred in Gustave Flaubert's *Sentimental Education*, where the principal characters leave Paris for an idyll at Fontainebleau. Though set in the 1840s,

the novel was written and published in the 1860s; its evocation of the forest sees nature in distinctly human terms:

> There were rough, enormous oaks, convulsing, stretching the earth, embracing one another and, resting firmly upon their trunks, similar to chests, launching outward with their naked arms in calls of despair and furious threats, like a group of Titans immobilized in their anger."[3]

The section of the forest called Bas-Bréau, at the edge of the great wood near Barbizon and Chailly, was particularly reputed for its trees. Often, distinctive trees were equipped with descriptive nicknames—"The Furious," "The White Queen"—or named after figures from history and myth, such as the Frankish king Pharamond or the Roman god Jupiter. In modern times, one oak had been christened "The Bodmer" in honor of the Swiss painter Karl Bodmer, a longtime resident of Barbizon, whose *Interior of Forest in Winter*, presented at the Salon of 1850, had portrayed the tree.

Monet's most famous portrait of an oak is the large painting now at the Metropolitan Museum of Art (fig. 94), a view of the same tree from a different angle and at a different season. But another distinctive portrait of an oak, traditionally linked to the Bodmer, is *An Oak at Bas-Bréau (The Bodmer)*, exhibited here for only the second time (cat. 8). The Metropolitan picture is notable for its brilliant color—the use of penetrating shades of blue, orange, and green—and for its evocation of one tree as part of a larger light-filled space. Notably more restrained in color while even more tactile in its facture, this smaller canvas is a concentrated study of textured surfaces and how they behave under light. Monet stands with his back to the sun, and from his vantage point the tree is largely in shadow against a brightly illuminated background. Bright patches of light fall through its branches; shadows of the tree's dense green leaves are cast on the trunk; and the artist revels in his ability to suggest texture and volume through closely juxtaposed strokes of gray, brown, white, and pink paint. Through the earnest frankness and sincerity of these impressions, the tree is given a strong sense of personality. Its message is one of dignified bravery: I am an old tree, yes, but I will stand for generations to come.

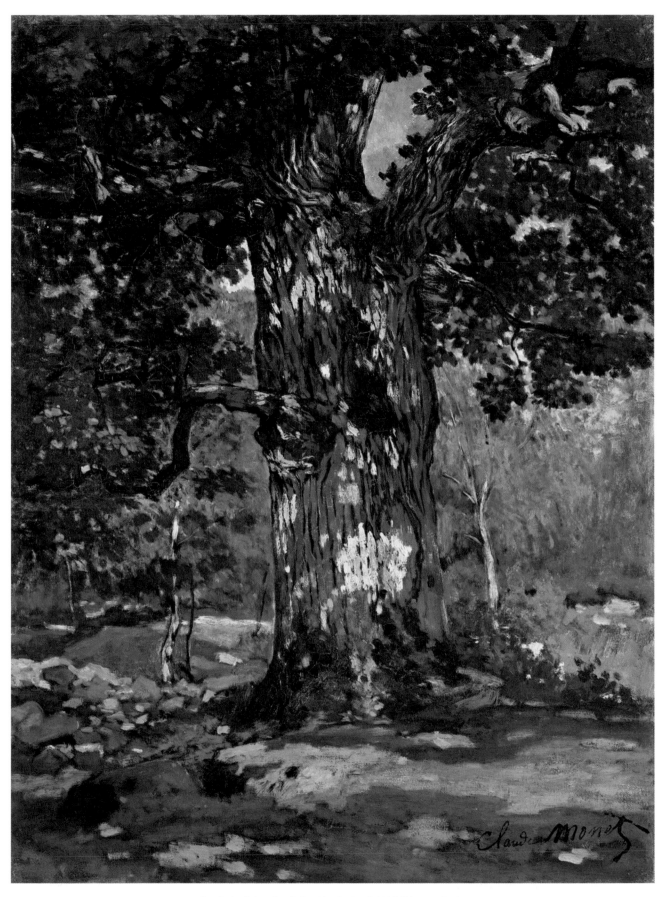

Cat. 8. *An Oak at Bas-Bréau (The Bodmer)*, 1865. Private collection

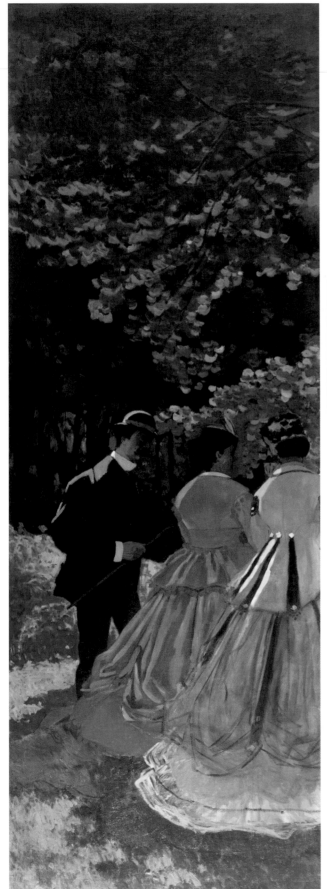

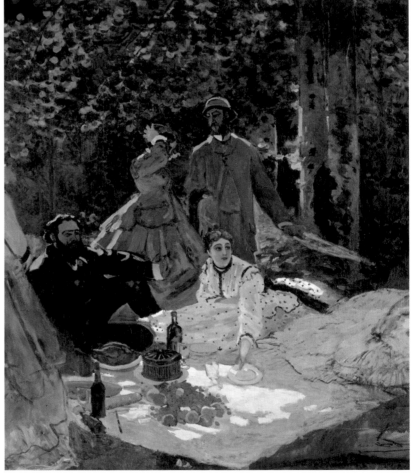

Cat. 9. *Luncheon on the Grass*, 1865–66. Musée d'Orsay, Paris

When Monet wrote to Bazille in the summer of 1865 that "the forest is delicious," he offered an evocative caption for his early masterpiece *Luncheon on the Grass* (cat. 9). For its colorful and energetic composition seems to propose multiple sensory pleasures: a visual feast, on one level, but also suggestions of the flavors of the picnic, the smells of the turf and the greenery of the glade, the textures of cloths and the touch of hands, and—perhaps—the sounds of the forest or of other revelers within its embrace.

The story of its origins and development is told in detail in Mary Dailey Desmarais's *Hunting for Light* (pages 20–33), but a number of observations bear repeating. Over the course of summer and autumn 1865 Monet lived at Chailly, a farming village near the Forest of Fontainebleau, in which he conducted research—painting and drawing—in preparation to paint a large and ambitious picture for the 1866 Salon. Having scouted locations and settled on a view of the forest interior, its leafy cover penetrated by shafts of light, he first painted an easel-size view (fig. 95) establishing the composition and the disposition of lights, darks, and colors across the design. Superposition of images of the study canvas and the final painting reveal that Monet transferred the design of the first painting directly and faithfully to the vast surface of his Salon-sized canvas, making minor adjustments. His methods of expanding the preparatory work to the dimensions of the larger canvas are not recorded, but he might have used any number of tricks common to painters of religious or historical works to enlarge this scene from modern life to a nearly-life-size heroic scale.

The painting we now know is only part of the much larger canvas—two surviving fragments, what was the center of the original composition preserved on its wider right-hand panel and one of two flanking groups in the taller left-hand panel. Monet often told friends about how the painting came to be cut up: he had left it as collateral for a loan, and when he came to retrieve it years later, he found that it had mildewed. Cutting away the damaged parts, he retained two fragments; the taller strip was rolled and stored, while the larger rectangle was framed and displayed at Giverny. (It has, in fact, been trimmed on the right, as can be inferred from the photograph taken of it around 1920 (fig. 11).

It is well known that Monet gave up working on the painting for fear that he would not complete it in time for the Salon—entries were due in March, and he began in earnest only in January. The painting is a work in progress: this is particularly clear in the yellow dress of the woman standing at the center of the composition—the artist is working to fix the edges of her hem vis à vis each other and the grassy turf. Likewise, the skirt of a woman who once was visible at the canvas's right edge seems to be in the process of revision, and

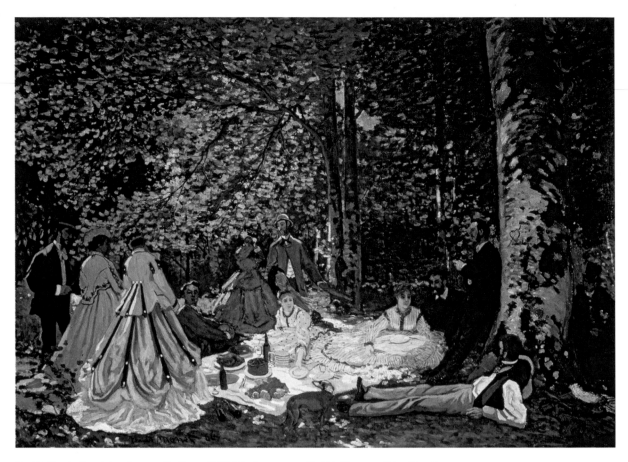

Fig. 95. Claude Monet, *Luncheon on the Grass*, 1865–66, oil on canvas. Pushkin Museum of Fine Arts, Moscow

a gray rectangle of ground covered with a preparatory layer would have taken shape as the leg and foot of a reclining man to the right.

There is every reason to believe, all the same, that the parts of *Luncheon on the Grass* that do not show in-progress revisions are in their finished state. Most apparent is the fact that there is enormous contrast between light and shade in the composition as a whole, but almost no conventional modeling of forms with half-tones. The taller panel to the right, for instance, shows how Monet proposed to show the gradual penetration of sunlight into the forest: at the top it is blocked by the canopy of foliage, which as it grows less dense grows brighter with both transmitted and reflected light. Reaching the lower half of the panel, the light brings out passages of brilliant green foliage and turf and creates sharply defined highlights and shadows on the figures. The extreme contrasts between light and dark that are to be found in such a wood seem to capture the artist's attention and drive his methods. The means with which the painter describes the

figure of the man in a rounded hat as a series of tonal contrasts in which one tangible thing—a coat, a collar, a hat—is shown both in bright light and deep shadow yields pictorial effects that are almost unprecedented. Thirty years later, the Nabis would attempt to convey reality through such abstract processes.

We can only speculate as to the fate of *Luncheon on the Grass* had Monet had time to finish it for the Salon. Might the members of the jury in 1866 have been more daring than the conservatives who in 1867 refused *Women in the Garden* and *The Port of Honfleur,* two paintings in which the artist employed a modified version of the same technique? In the end, a painting of the *Pavé de Chailly* from 1865 and the newly minted *Camille* were exhibited, the latter to considerable approval, and *Luncheon on the Grass* became something of a precious albatross for the artist. Reclaimed, cut into pieces, part discarded and two fragments saved, the painting was nonetheless prized as a milestone of his own biography, a constant reminder of the intertwined evolution of his pictorial technique and his ambitious imagination.

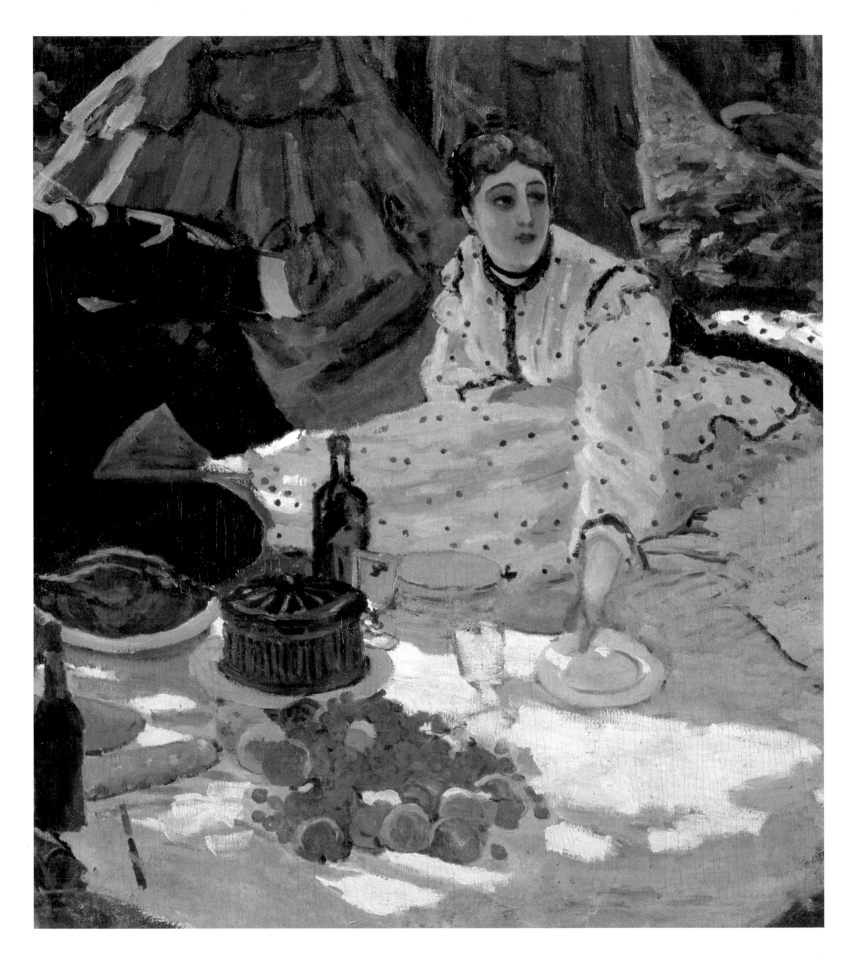

Cat. 10. *The Cradle – Camille with the Artist's Son Jean*, 1867. National Gallery of Art, Washington, DC

Camille Doncieux came into Monet's life, we believe, sometime before the summer of 1865, but the circumstances of their meeting are unknown. Ruth Butler, in her compelling account of Doncieux's relationship with the painter over nearly fifteen years—from the mid-sixties until her death in 1879—guesses that they might have simply met in the neighborhood where they both lived, the Batignolles district in the north of the city, as of the early 1860s a mostly petit-bourgeois neighborhood increasingly popular with artists and writers.[1] Camille probably came to Chailly from Paris to pose for some of the figures in *Luncheon on the Grass*; while neither the study painting of the whole composition nor the finished canvas offers much information as to the women's identities, a drawing for the leftmost woman gives just enough of Camille's characteristic profile, with her large round eyes, to make a secure identification (fig. 96). If it was not posed in Chailly, it must have been made in Paris; but in either case the two knew each other by the time Monet came to execute the Salon painting, and for her to become the model—the inspiration—for the full-length painting that took its place at the Salon in May 1866 (fig. 97).

Over the course of the spring and summer the couple—for in March they had moved together to Sèvres—were engaged in the making of *Women in the Garden*, the painting that would attempt, on a smaller scale, to meet the challenges of depicting the figure in nature that Monet had tackled in his abandoned canvas. Work on the painting continued when they moved in summer to Normandy. By the end of 1866 they had conceived a child together.

From all the evidence, it seems that the succeeding months were spent in a push to move forward and to succeed, masking a kind of suspended fear and anxiety. In May, Monet wrote to his father of his affair and of Camille's state; his letters to Bazille confess his indecision as to which course to take, and even as to what should happen to the child once it was born. Nothing detailed is known of the day-to-day events of Camille's life, but in his correspondence Monet made clear that she was filled with worry and he with ambivalence. When both were in Paris, in May, he did not see her every day; and when he departed for Normandy in June, she was left alone, without the support of her family, while he was prodigiously at work, in Le Havre, producing some of the most remarkable paintings he had ever made.

In August, Camille gave birth to a son, while Monet was still in Normandy; he traveled to Paris for the registry of the child's birth, immediately after which he returned to his family at Sainte-Adresse. From there, he wrote to Bazille with the news that Camille "was delivered of a big beautiful boy, who in spite of everything and I know not how, I feel myself loving."[2] The months that followed were, if anything, more anxious than

Fig. 96. Claude Monet, *Figure of a Woman (Camille)*, 1865, black chalk on laid paper. The Morgan Library and Museum, Thaw Collection

before, the couple and their son living in great poverty, Monet's only solution to which was to beg Bazille to send him money. It was in this atmosphere of worry that Monet, paradoxically, painted one of the most gloriously joyful paintings of his career, *The Cradle* (cat. 10). In a bassinet decked out with a scalloped cover of sprigged cotton edged in pink, beneath white blankets and wearing a cap with a bright blue bow lies baby Jean, his wide eyes two spots of black in his chubby face. A matching curtain that falls from a pole at the top center of the composition casts a shadow over the baby's face and spills onto the adjacent bed.

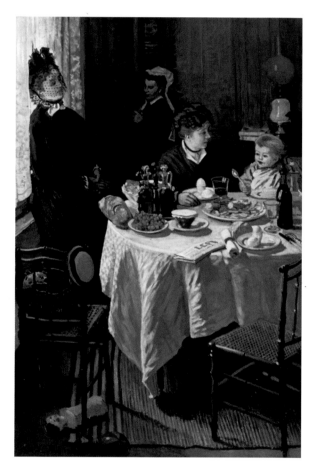

Fig. 97. Claude Monet, *The Luncheon*, 1868, oil on canvas. Städel Museum, Frankfurt

Though a baby could hardly have held a toy drum/rattle, little Jean has one in his hand; a whirligig lies within the crib like a great pink and yellow sunflower. The woman in a gray striped dress and white cap has often been identified as Camille herself, but is instead thought to be Julie Vellay, the companion of Camille Pissarro and mother to his children. She was godmother to the boy when he was baptized in April; Bazille was godfather.

Throughout 1868, the new Monet family was in financial straits. They moved from Paris to an inn in the tiny village of Gloton, near the small town of Bennecourt, on the Seine about five miles upriver from Giverny, where Monet would settle in the 1880s. Thrown out of the inn "naked as a worm" because they could not pay their bills, Monet settled Camille and Jean nearby, as always looking to others for gifts or loans of money to help him out of his difficulties. When in July Camille decided to join him, with their son, in Normandy, the three left Le Havre, where Monet was estranged from his family, and settled in Fécamp, on the Channel coast to the north. Help came, this time, in the form of a commission from Louis-Joachim Gaudibert, a businessman from Le Havre, to paint portraits of his family. In late autumn, the family moved down the coast to Étretat.

Monet's study of his sleeping son must have been painted in Fécamp, in the late summer of 1868, when the boy would have been just a year old (cat. 11). Jean had been included as a figure, on his mother's lap, in *On the Banks of the Seine, Bennecourt*, but his father eventually painted him out. Whether the baby's movements distracted the painter or whether they disrupted the sense of reverie that a single figure inspired is not known. But waiting to find the child asleep, Monet was ready to paint a bold study at lightning speed. Though in reality only the head of the baby and hints of his smock needed to be sketched in a hurry, Monet continued to finish the canvas with the same brevity and brio with which the likeness was secured, painting the pillow, the clothing, and the child's armless doll with the bare minimum of strokes. Curiously, the patterned wallpaper demanded more of his attention than the main subject.

From Étretat, in December, Monet wrote to Bazille announcing his intention of painting two figure pieces for the coming Salon of 1869, the first "an interior with a baby and two women," the second

Cat. 11. *Jean Monet Sleeping*, 1868. Ny Carlsberg Glyptotek, Copenhagen

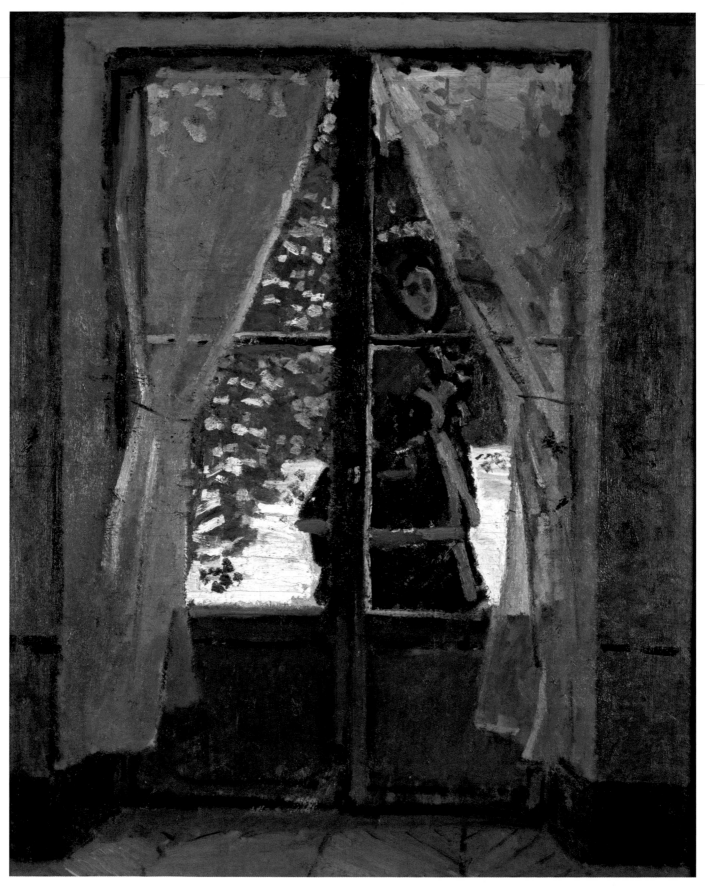

Cat. 12. *The Red Kerchief*, c. 1869. The Cleveland Museum of Art

"sailors in the open air." He went on to say that he wanted to do these paintings "in a surprising way." At last, thanks to Gaudibert, his fortunes were no longer so precarious, and he felt "content, very much enchanted, surrounded here by everything I love." That included his "fine little family," and his "little house with a good fire."[3]

The planned picture of sailors did not come to pass, but the interior with a baby and two women did. *The Luncheon* was a scene of comfortable domesticity, a mother and child seated, a place set for the painter in the foreground, a visitor in walking clothes, gloves, hat, and veil leaning against the curtained window, and a servant hesitating in a doorway in the background. The armless doll and a ball are on the floor beneath a chair on which a tiny hat has been poised; a basket of knitting there, and a pair of paperback novels on a buffet at the upper right, remind the viewer of womanly occupations. After an unsettling beginning to their union as a family, *The Luncheon* suggests that father, mother, and child are in harmony and at peace.

Monet's images of Camille vary enormously in mood, and her role can change from painting to painting. In *Camille*, of course, her identity is explicit; in *Luncheon on the Grass*, she is present only because she was a model; in *Women in the Garden* she functions both as model and, looking at the painter over her bouquet, as an individual. As Butler has noted, recognition of her identity in many genre paintings is a relatively recent phenomenon, early titles of paintings in which she figures being changed to recognize her as model—as *The Reader* became *Camille Monet Reading*.[4]

The title of *The Red Kerchief* has not changed, but it has become recognized as one of the most poignant of all images of Camille Doncieux, the future Madame Monet. Probably painted in early 1869, it is a vivid portrait of mood without being a likeness.[5] The roughly brushed interior in which the painter stands is described in muted and varied tones of gray and brown, curtain, wall, floor, and ceiling giving way to the intense view of the out-of-doors. There, against the green and white of trees and snowy ground, stands Camille. She is depicted walking by the windowed door from left to right, bundled in a fur-trimmed blue-black jacket and skirt, a snow-speckled umbrella above her head, and wearing a brilliant scarlet hooded cape. She turns, as if she has just realized that her husband is within the house, observing her. The shadow of her eyes, just a few dots of paint, nonetheless suggests a wistful or even worried mood: she does not smile.

The painting must have been inspired by just such a passing moment, yet even with Monet's speed of execution the posing sessions that followed must have been uncomfortable for the sitter. The result, however, was one of the most memorable images of Monet's early years. He kept the painting with him for the rest of his life (fig. 11).

Cat. 13. *Boats in the Port of Honfleur*, 1866. Ann and Gordon Getty

There remains only a black-and-white photograph of one of the two paintings that Monet submitted—and had rejected—at the Salon of 1867. It was a large picture, measuring more than seven feet in width, and represented the inner basin of the *Port of Honfleur* (fig. 98). The photograph shows a scene crowded not only with a large number of boats—some indicated just by their sails, arrayed in the middle distance at right—but also with a large number of people. Townspeople in top hats at the left look towards a paddle-wheel steam ferry coming into port with a load of passengers; a rowboat holds five men, seemingly leaving the pool; and the boats and docks at the right are busy with fishermen and women, tending to the sails of a boat or chatting among each other. The painting is the one Monet referred to in a letter to Bazille of December 1866, in which he asks his friend to send two large canvases to him in Honfleur, in care of M. Chasle at the Hôtel du Cheval-Blanc. One was his Salon painting *Camille*, and the other a painting he called a "*femme blanche.*" "I'm going to paint an important marine picture on top of the latter," he said, "and as you see I have barely enough time." It is assumed that this "white lady" lay beneath the port scene, if only because we know that Monet did not have the ready funds to procure another canvas of this size.

Boats in the Port of Honfleur (cat. 13) might have been made as a study for the large picture, or just as likely might have been the successful independent painting that gave Monet the idea to do a Salon-scape port view.[1] Its execution is bold and very free, and the painting seems to have been made in a very short span of time. The blue sky, applied around the sketched-in forms of the masts, was barely dry when the fine lines of the ship's rigging were drawn in—they seem to have been the last touch—but the interplay and liquid blending of colors and brushstrokes in the brilliant reflection below make it clear that the foreground pigments were laid on wet into (and over) wet.

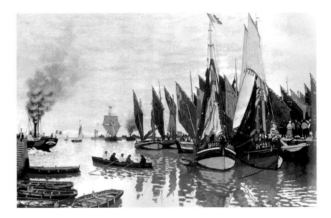

Fig. 98. Claude Monet, *The Port of Honfleur*, 1867, oil on canvas. Presumed destroyed

Fig. 99. Claude Monet, *Fishing Boats, Honfleur*, 1866, oil on canvas. National Museum of Art, Bucarest, Romania

Two smaller studies related to the large painting survive. One, *Fishing Boats* (cat. 14), focuses its attention on the silhouettes of the vessels' masts, visually bobbing against each other, dark shapes on a gray-white ground; the painting's bold geometries and its monochrome palette, with flat bands of yellow, red, and blue, make the modern viewer think of a Mondrian abstraction. This impression of powerful abstraction in a struggle with representation is perhaps even stronger in *Fishing Boats, Honfleur* (fig. 99), where the limpid surface of the water doubles the power of the painted hulls' geometries, and where the white sky seems more a patch of color than the representation of space. If, as it appears from the photograph, the final painting took these effects to heart, it must have been very powerful indeed—as threatening a marine as *Women in the Garden* (fig. 3) is a figure painting. Perhaps it is no surprise that both paintings were turned down by the conservative jury—marking Monet's first experience of official rejection.

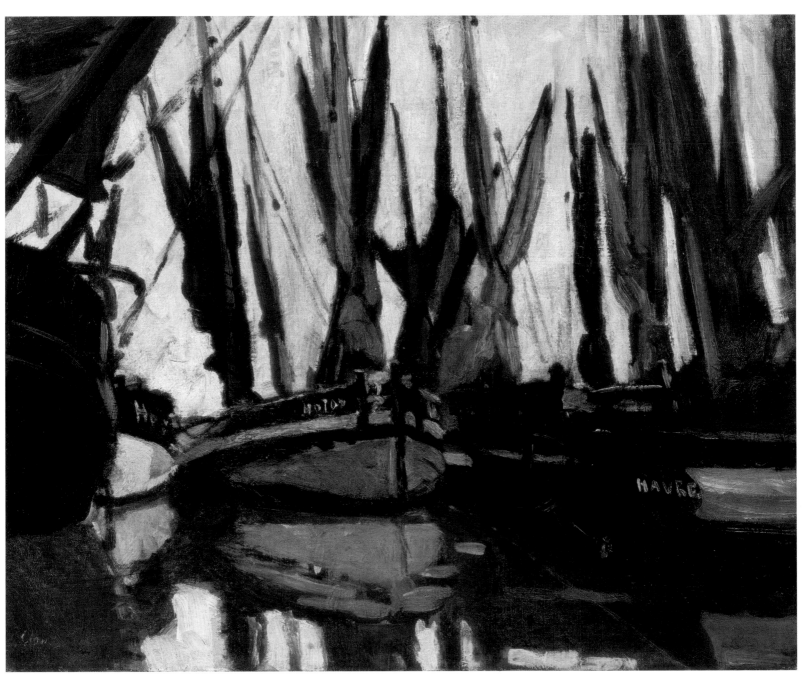

Cat. 14. *Fishing Boats*, 1866. Private collection

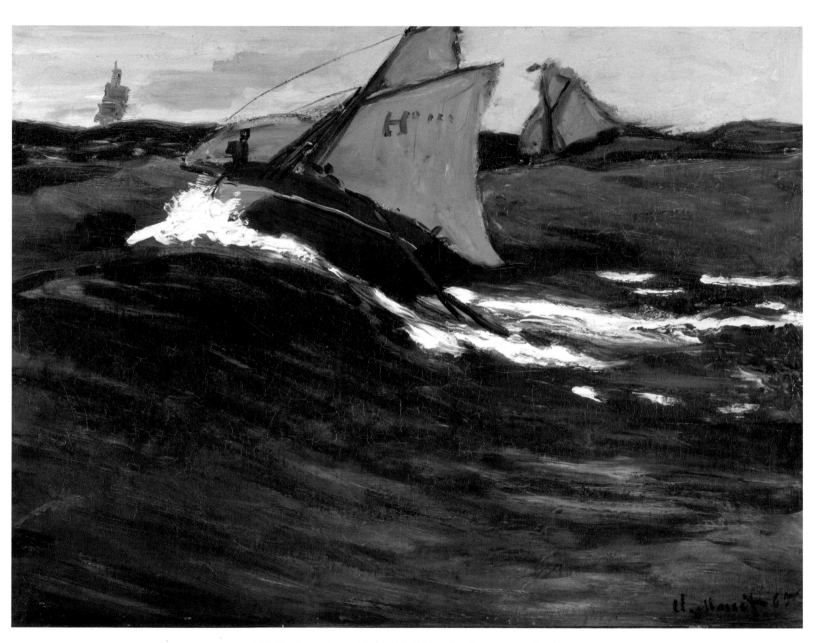

Cat. 15. *The Green Wave*, c. 1866–67. The Metropolitan Museum of Art, New York

The traditional story of Impressionism has stressed the primacy of established *plein-air* landscape practice as a kind of guarantee that the painting in question should be the direct transcription of an ocular sensation. *Boats in the Port of Honfleur* and *Fishing Boats* (cats. 13, 14) give every indication of being life studies—pictures executed on site, in view of the motif, in the open air. But the painting that they inspired, the Salon picture *The Port of Honfleur* (fig. 98) was certainly a product of the studio. A painting could, of course, be a hybrid of a sketch begun before nature and a finish layer applied later, from memory; and very few paintings did not return to the studio for examination and correction, or for the application of a finishing touch or two. But it is clear that in spite of his reputation for steadfastness and bravery in the face of the gravest challenges of site or climate, Monet was willing to (and interested in) making paintings entirely from his imagination—from his imagination, that is, informed by his astonishing visual memory and his equally remarkable ability to render effects seen in the mind's eye.

The Green Wave is just such a painting (cat. 15). At first glance, the image resembles a sort of illustration, simplified and flattened, like the Japanese prints that probably inspired its juxtaposition of curving and straight lines and high horizon line. Begrudgingly giving only a tiny strip at the top of the composition to the sky, that horizon seems as stylized as the cartoon-like shape of the boat mounting the "hill" of the picture's namesake wave. The color elements of the painting, too, are deceptively simple: a great field of dark green broken by slashes of white, three boats in shades of gray, and a bluish-gray band of sky. Going no farther than this first, and unavoidable, impression, the picture might have inspired Maurice Denis's dictum that before it represents its subject, a painting "is essentially a flat surface covered with colors, put together in a certain order."

This extreme simplification of design is common to two other paintings: *Seascape* from the collection of Ordrupgaard, Copenhagen, and the Clark Art Institute's *Seascape, Storm* (cats. 16, 17). Each of these, however, has a horizon line near the center of the canvas—just above or just below the mid-point; each is a view looking out on a choppy ocean surface; and in each the scale of the brushstrokes that represent the waters diminishes from bottom to top, allowing the plane of the ocean to rest comfortably flat and to recede into space.

Seascape gives the impression of being a quickly executed study, perhaps painted on a jetty projecting into the sea that would afford a limitless view, with no indication of shoreline. Although the brushstrokes on the surface of the painting were, in fact, applied quickly, they betray a more studied, less spontaneous progression: at almost the exact center of the canvas Monet brushed in the outlines of a boat with thin gray-black paint, then thought better of it and covered this element with added strokes of green paint, beneath which, 150 years later, traces of the black outlines can be discerned. His goal, in the end, was to preserve—to recapture—the freshness of a first, very free impression in an *esquisse*—a sketch—that had once flirted with becoming a picture—a *tableau*.

The Clark Art Institute canvas was intended, from the start, to be a picture on the subject of movement versus stasis, equilibrium versus imbalance. Its composition is carefully planned as a series of contrasts. Above the horizon, two zones of dark and light, divided roughly equally, depict storm clouds moving away to the right to reveal a brightening sky, illuminating a group small group of clouds—or possibly openings in the bank of gray. Sunlit sea is a band of vivid green at the horizon and shadowed waters are a zone of deep black-green broken by whitecaps of thick white paint applied with a palette knife. The boat rests just to the right of center, its sail and mast blown by the winds just a few degrees off vertical. (Having once established this motif, Monet would feel free to use it again, adding a few harbor details, in a painting from 1868.[1])

The comparison with seascapes by Manet is inevitable and critical, for many of the pictorial devices that Monet contends with in these paintings were first addressed by his older friend (and friendly rival) in the 1860s, as well. As Gary Tinterow has rightly pointed out, the most likely chance for Monet to have encountered a group of Manet's marine paintings was in the exhibition he organized on the occasion of the 1867 Universal Exposition, which featured a number of these

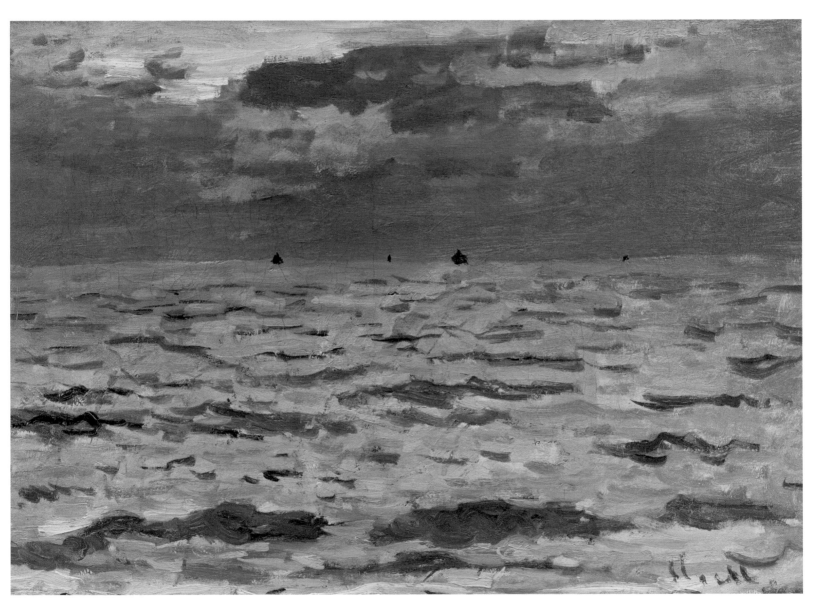

Cat. 16. *Seascape*, c. 1866–67. Ordrupgaard, Copenhagen

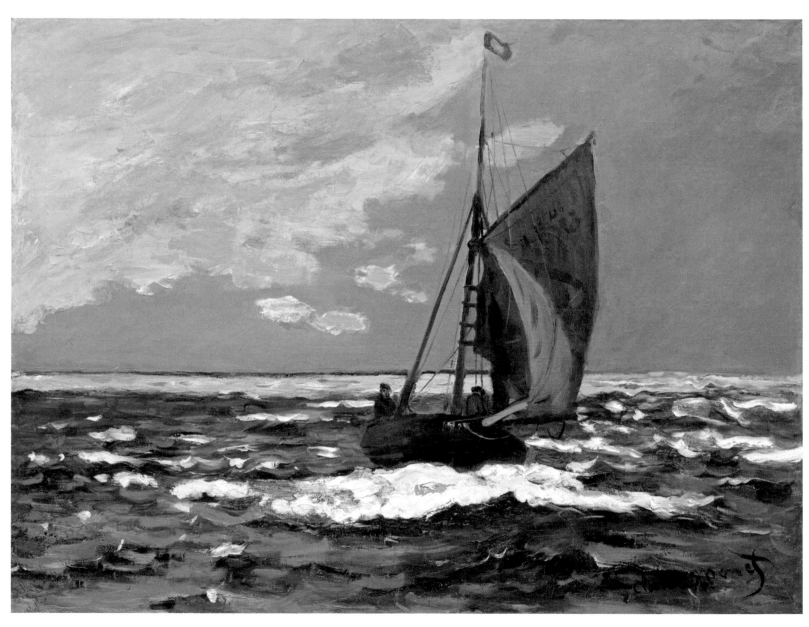

Cat. 17. *Seascape, Storm*, c. 1866–67. Sterling and Francine Clark Art Institute, Williamstown, Massachusetts

seascapes, including the painting then known as *Fishing Boat Arriving, Wind Behind* and now called *The "Kearsarge" at Boulogne* (fig. 100). Other paintings of the sea battle of the American Civil War that took place between the Kearsarge and the Alabama off the French coast were part of the exhibition and shared the deep blue-green tones that Monet used in *The Green Wave* and *Seascape, Storm*. But Manet's striking positioning of the fishing boat as a cut-out shape attached to the composition, in strange contrast with the flattened profile view of the battleship in the distance, not only underscored Manet's paintings' homage to Japanese prototypes but also announced their very conscious artificiality.

Jumping off from this point of inspiration, and notwithstanding the degree of calculation and artifice that lies behind the seascape paintings—the trouble it took, that is, to make a painting that appears to be effortless—Monet is able to maintain his commitment to observed reality, even if observed in recollection. More intense examination of *The Green Wave*, in particular a close look at the principal boat at the top of the wave, reveals the acuity of the painter's observation and visual memory. The boat that appeared to be, at first glance, a sort of caricature in Japanese style is, in fact, a very carefully observed record of reality; for the boat—a "lugger"—is shown in steep foreshortening, the stylization of its stunted and distorted shape caused by the fact that it is heeling sharply towards the horizon. On its deck two fishermen steady the craft; in its wake its nets are submerged, trawling for the catch.

"There is a first-rank seascape painter in him," wrote Émile Zola in 1868. "But he interprets this genre in his own way, and I see this as further proof of his intense love for the reality of the present. . . . [H]e loves the water as a mistress, he knows each piece of a ship's hull and could name any rope of the masting."[2]

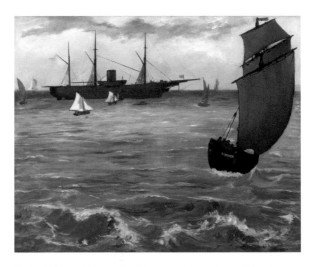

Fig. 100. Édouard Manet, *The "Kearsarge" at Boulogne*, 1864, oil on canvas. The Metropolitan Museum of Art, New York

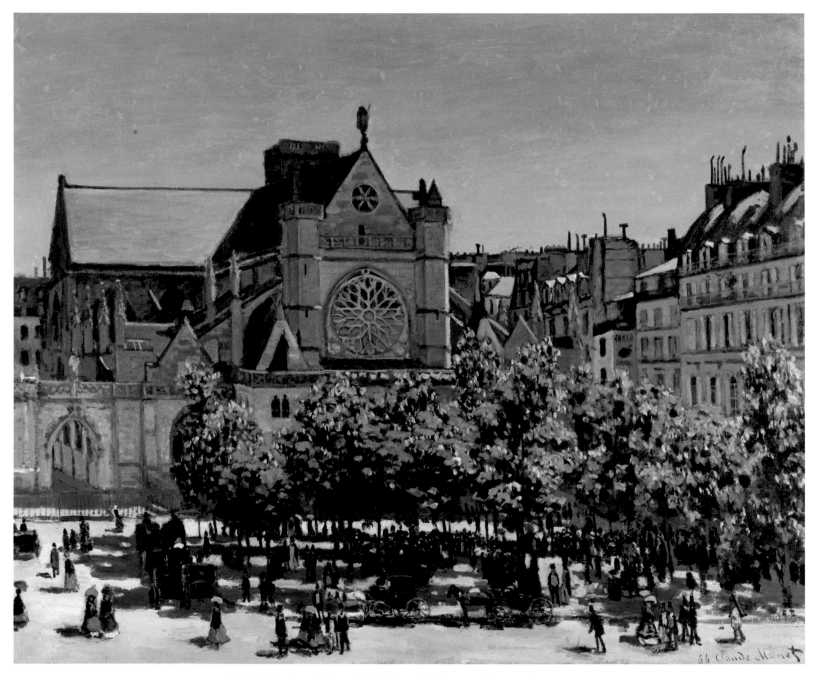

Cat. 18. *Saint-Germain l'Auxerrois*, 1867. Staatliche Museen zu Berlin, Alte Nationalgalerie

On April 27, 1867, Monet wrote to the Comte de Nieuwerkerke, superintendent of fine arts: "Sir . . . I have the honor of asking you to grant me the special authorization to paint some views of Paris from the windows of the Louvre, and particularly the exterior colonnade, in order to do a view of St-Germain l'Auxerrois."[1] The painter's intention was to make a group of paintings of the buildings and vistas visible from the main floor of the palace, one story above the street. Not content with what he could see through a window, he needed the count's special permission to go out onto the colonnade of the east façade of the museum, where, by approaching the railing at the edge of the walkway, he could put the Louvre squarely behind him—using the museum not as a repository of great masterworks but as a sort of platform to enable him to depict an interesting quarter of Paris from an elevated viewpoint.

Monet's request was granted shortly thereafter, and in the ensuing month he completed three views of the areas surrounding the Louvre. In addition to the view of Saint-Germain l'Auxerrois that he mentioned to Nieuwerkerke (cat. 18), he completed two more, on identically sized canvases, looking from the southeast corner of the building towards the distant dome of the Pantheon. One, a horizontal view, surveyed the broad expanse of the *Quai du Louvre*; a second, with the canvas turned on the vertical axis, narrowed the panorama and focused on the upward progression from the *Garden of the Princess*, just below the painter, to the horizon and then to the cloud-dappled sky above (cats. 19, 20).

The sequence in which the paintings were executed is not clear, though as Joel Isaacson points out, the new leaves on the young plane trees in the *Quai du Louvre* suggest that it was at least begun before the *Garden*, where the leaves are thicker and greener.[2] Spring was already well advanced when Monet began to paint, in late April, and the horse chestnuts in the square in front of the Gothic façade of Saint-Germain l'Auxerrois, the parish church of the kings of France, were in leaf and blooming. The painter first laid in the deepest green shadows of the foliage before going back to add, with patches of blue- and yellow-green paint, the sunlight falling on the tops of branches. With a mixed ivory white he then placed the accents of the flowers, each conical grouping of blossoms indicated with one, or at most two, vertical strokes. To bring light and greater volume into the mass of the trees, he came back to introduce touches of bluish gray among the strokes of deepest green, indicating the places in the canopy where glimpses of the stone of the church broke through.

On the Place du Louvre dozens of men and women are depicted. Those walking on the paved street surrounding the planted square are swiftly brushed in but recognizable: at lower right a woman in green with a matching parasol seems to engage two top-hatted men in conversation; two men, possibly in uniform, walk side by side towards a workman in a smock with a load on his back. Ranged around the square is a line of Hackney cabs, the brown horse with black mane and tail contrasting with the sun-drenched white horse to the left. Beneath the trees many more figures can be seen, but Monet blends them into a melee of strokes of black paint.

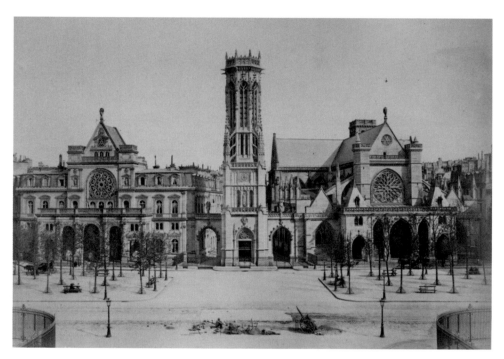

Fig. 101. Anonymous photographer, *St.-Germain l'Auxerrois*, c. 1870, photograph. Private collection

Like the figures in the foreground, the background architecture is carefully indicated, though the artist's apparent touch works against detailed depiction. Comparison of Monet's view of the church and contemporaneous images by any of the many photographers who took a similar vantage point reveals the degree to which the painter was careful to capture not only the forms of the church itself but also the most incidental details of the surrounding architecture. For instance, the succession of rectangles and parallelograms that indicate the façades, rooftops, or dormers of the buildings to the right and behind the church can be detected, one after another, in a

representative photograph of the period (fig. 101). The exactness of his depiction might be attributed to Monet's acute eye, but some critics have speculated that Monet may have made use of similar photographs in establishing the outlines of the composition. If this is true, the artist's use of strong lines of black to break up but also establish his forms could reflect an underlayer now invisible.[3]

But Monet was certainly not a slave to accuracy. The photograph reveals that the pilaster that appears on the façade at the extreme left of Monet's composition is actually the foundation for the bell tower erected beside the church at the end of the 1850s, to designs by Théodore Ballu. (The tower stands between the Gothic church to the south and the Town Hall of the First Arrondisement to the north, designed to echo the church in its massing.) The presence of the recently built bell tower is simply denied by Monet, who eliminates that vertical mass at the left edge in order to offer a distant view and a patch of bright blue sky between the north transept of the church and the edge of the canvas.

Fig. 102. Charles-Henri Plaut, *Le Pont-Neuf et l'Île de la Cité*, c. 1865–70, photograph. Bibliothèque Nationale de France, Paris

Though the historicizing bell tower could be ignored, elements of the modern Paris streetscape caught Monet's attention in the *Quai du Louvre*. Along the street at right he shows the sales and advertising kiosks introduced to the urban fabric in the redesign of Paris by Baron Haussmann, as well as the street lights along the sidewalk. Identical elements appear in contemporaneous photographs of the same view, such as those published by Henri Prault between 1865

Cat. 19. *Quai du Louvre*, 1867. Gemeentemuseum Den Haag

Cat. 20. *The Garden of the Princess*, 1867. Allen Memorial Art Museum, Oberlin College, Ohio

and 1870 (fig. 102).[4] Paris in 1867, at the moment of the Universal Exposition, was resplendent with these newly added ornaments; their careful placement by Monet added not only verisimilitude but also a confirmation of modernity to the scene. The large white sign bordered in red and yellow, placed on the western façade of a building at the end of the Île de la Cité, to the left, can attest to the degree of Monet's faithfulness to his motif. The same sign appears in Renoir's painting of the Pont des Arts (fig. 103), under way at the same time, as Monet told Bazille. There, from below the quai rather than above, and from the left bank rather than the right, Renoir insists on the sign as a sharply commercial shape within the panorama.

That sense of the panoramic, also encountered in the photographs that record this segment of the Seine, is countered, even denied, by the verticality of *The Garden of the Princess*. By contrast, the narrowed lateral vista imposed by turning the canvas ninety degrees created a new "vertical panorama" that, as Isaacson has observed, radically changes the perception of the site. Isaacson characterized the pair of paintings of the same general view—made from slightly different vantage points on the Louvre's south façade—as an experiment conducted by Monet in perspective and perception that revealed the relativity of the viewer's understanding of the same motif and "released the landscape itself, allowing it to determine in each case its own character, its own composition."[5]

As Isaacson observed, the horizontal painting becomes frieze-like and flattened when compared to the almost vertiginous exploration and evocation of deep space—the "panorama in depth"—of the *Garden*. But the two paintings, in concert, convey the landscape "more fully, more multidimensionally, than would one work alone," reminding us of "the relativity of our knowledge of the external world."[6]

It has often been noted that Monet's application to the Comte de Nieuwerkerke, the domineering head of the Empire's beaux-arts establishment, should be to go to the Louvre in order to turn his back on its contents. Monet, like Sisley, is remarkable among the artists in his circle in 1867 in not having drawn or painted directly from the pictures hanging in the galleries there: Cézanne registered as a copyist in 1863–64 and again in 1868; Degas first signed in in 1854 and returned several times before 1868; Fantin-Latour worked there in the 1850s and several times in the early 1860s; Manet studied there as early as 1850; Morisot seems to have been copying from Rubens in the mid-sixties; Pissarro and Renoir first registered in 1861 and 1860, respectively—and Renoir was still making occasional copies nearly forty years later.[7]

In spite of the occasional statement dismissing study from the masters and visits to museums as antithetical to his interests, Monet is known to have sought out the art of the past, as suggested by his statement that his favorite painting in the Louvre was the *Embarkation for Cythera*. But if, in 1867, the world was to have its attention fixed on Paris as a global artistic capital, it would be logical that for Monet such scrutiny necessitated a calling-out, indeed a celebration, of its present-day rather than its hallowed past. To enter a palace of art and then to brazenly look outside it for subjects that were unlike anything that could be found within its walls would suit Monet's purposes precisely.

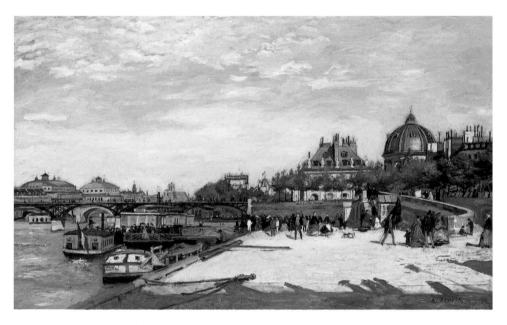

Fig. 103. Pierre-Auguste Renoir, *The Pont des Arts, Paris*, 1867–68, oil on canvas. The Norton Simon Foundation, Pasadena, California

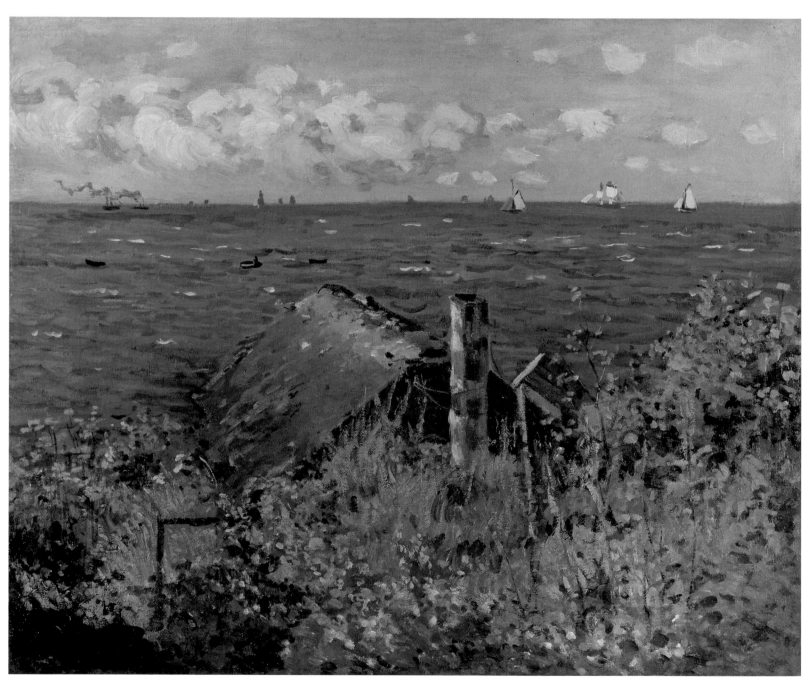

Cat. 21. *A Hut at Sainte-Adresse*, 1867. Musées d'Art et d'Histoire de la Ville de Genève

During Monet's extended campaigns painting up and down the Channel coast in Normandy in the 1880s, he often chose a cliff-top view of the sea as his motif. So often did he paint such views that we can describe them all with the same few phrases: a mass of land, covered with grasses or low shrubs, occupies the foreground, while the middle ground consists of a view of the sea, which recedes to a high horizon line. Despite their similar points of departure, the resulting canvases managed to vary widely in effect, largely dependent on the artist varying his stroke or his color harmonies in tune with the season, the time of day, or the climate. Before the summer of 1867, Monet's views of the coast were inevitably painted from the point of view of the beach or of a jetty, or occasionally from a building slightly elevated above the shoreline. In the summer of 1867, during his furious campaign of work at Sainte-Adresse, he painted the first of his views of the sea from the height of a cliff—notably, in the *Terrace at Sainte-Adresse* (fig. 78), where he took a position a level just above the terraced garden of a house perched above the beach.[1]

At the same time, he approached the sea, perhaps to the railing of that same terrace, to peer down from a more precipitous angle on the descending cliff. In the foreground of this closer view stood a ramshackle hut, its red-and-white striped flue seemingly prevented from falling by a length of rope or wire. Just beyond and to the right, farther down the cliff, stood another such cabin, beyond which the ground fell away to reveal the open sea, dotted with a few fishing boats and sailboats, and with a faraway steamboat on the horizon at left. In contrast to the manicured flowerbeds and strips of carefully tended grass on the terrace above, here plants had been allowed to grow wild.

He decided to paint what he saw (cat. 21). Can it have been some perverse joy in discovering such a dilapidated motif mixed in with the dignity of the gardens he had painted at his aunt's house further inland that led him to document this rude corner of a fashionable coastline? Whatever his motivation, he made an extremely

careful composition of what he found there, giving a sense of detail to the foliage without painting a single leaf, delighting in the contrast between the jumbled foreground and the placid sunlit sea. The painting, not often noticed in Monet literature, evidently was important to him: he exhibited it the following year and brought it to exhibitions three more times in the next two decades.

At the end of the following year, while living at Étretat, Monet painted three pictures of fishing boats at work, likely taking advantage of the view from the cliffs above the beaches where the fishermen anchored their boats between catches. In *Fishing Boats at Sea* (cat. 22) he sketched the dark-sailed boats on their way to their fishing grounds, their speed echoed in his own rapid execution—it seems that the painting was entirely finished before any corner of it had been allowed to dry. This, more than any other painting, reveals the inspiration of his friend Manet, whose seascapes he saw exhibited in Paris in the summer of 1867.

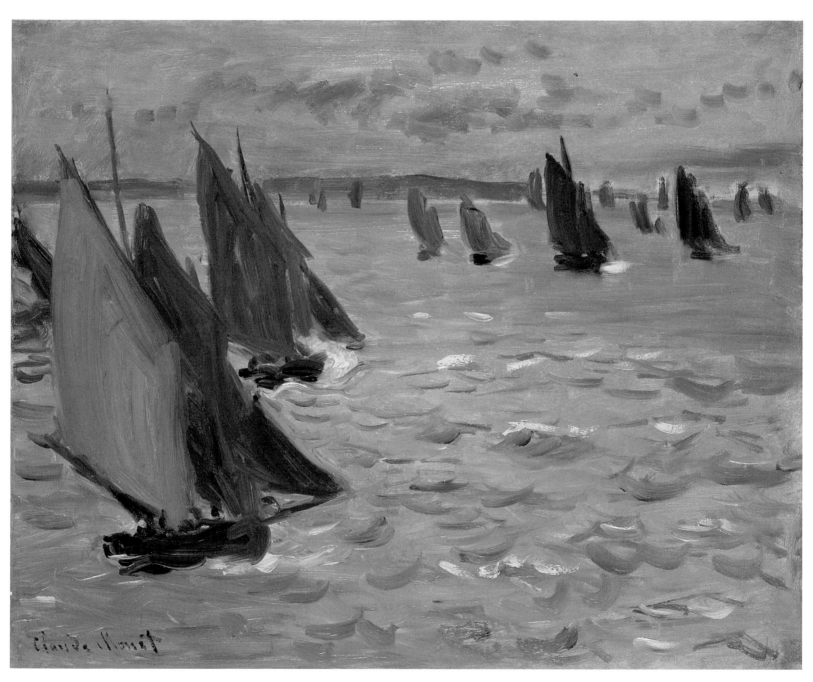

Cat. 22. *Sailboats at Sea*, 1868. Musée cantonal des Beaux-Arts, Lausanne, Switzerland

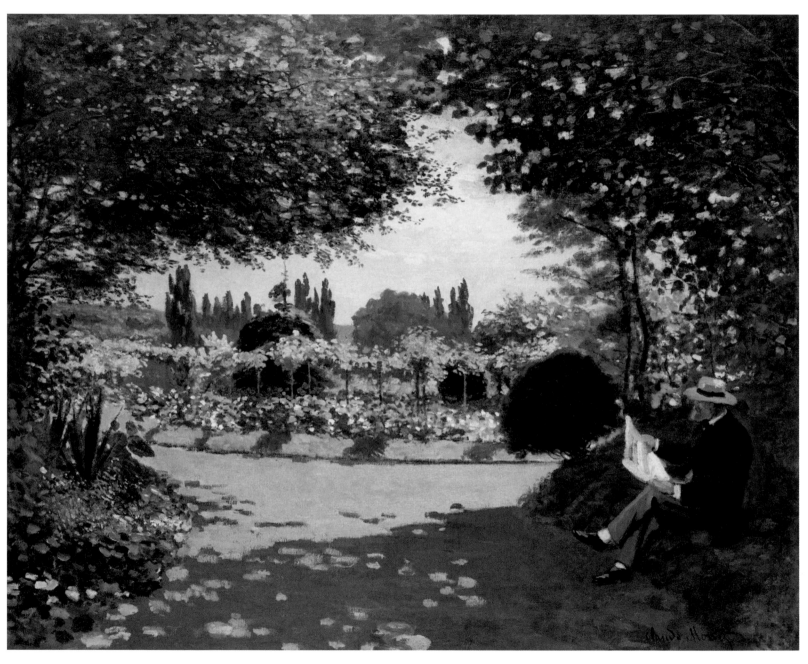

Cat. 23. *Adolphe Monet Reading in a Garden*, 1866. Courtesy of the Larry Ellison Collection

For Monet, the summer of 1867 was a period of intense productivity balanced by grave personal concerns. His *Women in the Garden* had been refused by the Salon in April; Camille was pregnant; Monet was effectively penniless, lacking the funds to work and to take care of his partner; and his family had turned against him—led by his father Adolphe, who was shocked to hear the news that his son was soon to be the father of a child. Still, in May Monet wrote to his father, asking to be permitted to return to Le Havre, where at least he would be lodged and fed and could work. His father relented but was clearly not placated. He was ready to receive his son "if he clearly repents . . . [H]c must renounce his extravagant ideas and his past conduct."[1]

Still, by the end of June, Monet could write to Bazille, "I have been in the bosom of my family for the past two weeks, as happy and as content as possible. They are charming with me, and they even go to the point of admiring every stroke of my brush. I have taken on a lot of work. I have about twenty paintings in progress, some astounding seascapes and figures and gardens, in a word, all manner of things." Among the garden scenes must have been this painting of his father reading in the grounds of Le Coteau, the Lecadres' summer residence in Sainte-Adresse (cat. 23).[2]

Adolphe Monet Reading in a Garden was almost certainly conceived as a pair with *Jeanne-Marguerite Lecadre in the Garden*, of identical dimensions (fig 104). The twin paintings are, moreover, in the same "family" of views as a smaller *Flowering Garden* (Musée d'Orsay) and the larger and better-known *Terrace at Sainte-Adresse* (see fig. 78). Under the bright summer sky, the flower beds of his aunt's garden are resplendent with color, the red of geraniums and the pinks and whites of standard roses set against a wide spectrum of greens—sunlit grass contrasting with deep green shrubbery at the edges of the garden.

Within one of these wooded groves, Monet's father reads a newspaper while seated on a grassy bank. If the view of Mlle. Lecadre is dominated by sunshine, this painting has shadow as its subject. Particularly sophisticated, if simple, is the artist's treatment of the sandy garden path, a warm pink in sunlight and a deep purple gray in shade, the line of demarcation between the two zones breached by spots of the opposite tone. The distant view outside the garden, at center, is almost unexpectedly nuanced, layers of atmosphere softening the deep greens and blues at the horizon.

Despite their surface beauty, these paintings contain hints of anxiety. In none of the paintings of this summer do the figures interact with the artist. The viewer is left to imagine the nature of the relationships between family members, his father and his aunt unable to measure his abilities and doubtful of his wisdom, his father further angry with his son's affair. Monet gives no clue that he knew of his father's hypocrisy: that Adolphe in fact, had a seven-year-old daughter, borne by a household servant whom he would later marry.

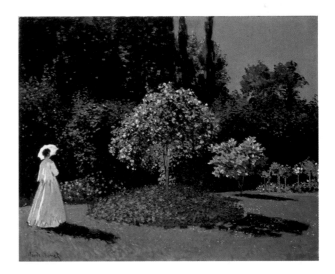

Fig. 104. Claude Monet, *Jean-Marguerite Lecadre in the Garden*, 1866, oil on canvas. The State Hermitage Museum, St. Petersburg

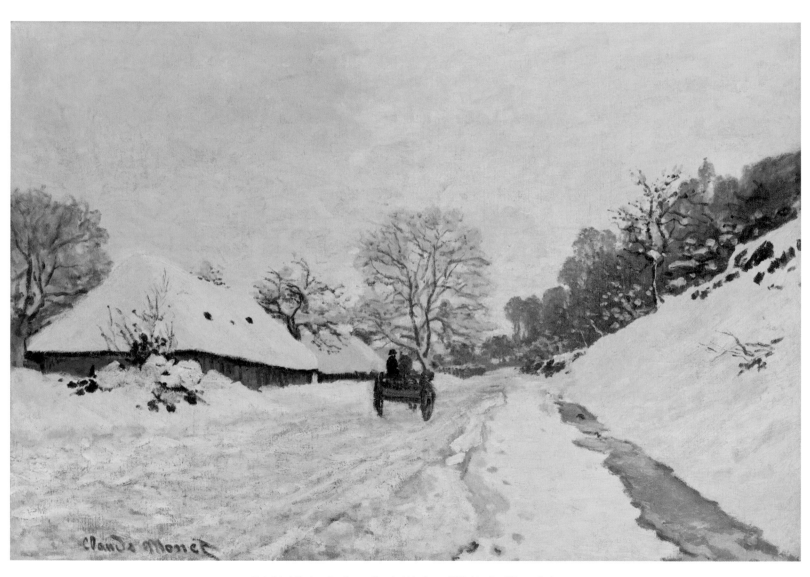

Cat. 24. *A Cart on the Snowy Road at Honfleur*, 1865. Musée d'Orsay, Paris

During the run of the International Maritime Exhibition in Le Havre, held in the fall of 1868, a journalist wrote of having encountered a painter in the region: "We have only seen him once. It was in the winter, during several days of snow, when communications were virtually at a standstill. It was cold enough to split stones. We noticed a foot-warmer, then an easel, then a man, swathed in three coats, his hands in gloves, his face half-frozen. It was M. Monet, studying a snow effect."[1]

This early record of the artist's reputation for derring-do when it came to finding the ideal motif and the most varied conditions for portraying his subjects was to become one of the defining strains of the Monet legend in the succeeding half-century. Painting in snow posed more challenges than that of comfort. Above all, the artist faced that challenge of depicting nature suddenly turned monochrome, and not green, but white. It was a challenge that Monet met from 1865, when he brushed *A Cart on the Snowy Road at Honfleur* (cat. 24) till thirty years later, when in 1895 he both traveled to faraway Norway to paint in the snow and then painted the last of his pictures of a frozen River Seine.

The "Snowy Road at Honfleur" of Monet's first snowscape runs beside the barns of the Ferme Saint-Siméon, a place known by the 1860s for its hospitality and welcome to artists—Monet would return often after his initial stay there in summer and autumn 1864. He must have returned to Honfleur from Paris at the time of a large snowstorm that took place in the first days of January 1865. That visit would have provided the occasion to produce the painting of the road receding towards a vanishing point right of center—to which every other form in the landscape, from farm buildings to the snowy bank, is pointing.

The artist's understanding of just how to paint the snow-covered landscape seems to have been innate: before the painting the viewer is aware of the most delicate nuances in tints, just the right hue chosen to represent each element. The sun barely tinges the densely clouded sky with hints of yellow and pink; these strike the snow below, making it slightly warmer in the sun than the blue-white shadows it casts. The virgin snow contrasts with the gently rutted road, and one tree carrying masses of snow on its dried leaves appears completely different from the others, and different still from the blue shadows of

trees at the horizon. Against all this subtlety the artist knows just how much black is necessary to make the white seem whiter still: he inserts the dense and dark forms of tree branches, rocks, and the wedges of wall beneath the snow-covered thatch; he puts branches in the upper-left corner, too, but paints them away. Having first learned how to paint snow on this spot, he returns to it after snowfalls in February 1867, painting four views on the same road. He begins, as in the 1865 painting, with a view on the road in the direction of Honfleur, then continues further down the road for three more views, in one of which he turns round to see the farm buildings from the Honfleur side.[2]

A year later Monet and his family had taken up residence in Étretat. At the time when he was planning and painting his family interior, *The Luncheon* (fig. 97), he was also actively searching for, and finding, suitable motifs to paint on the seashore and in the surrounding countryside. In his year-end letter to Bazille—in which

he set out plans for *The Luncheon*—he wrote: "I go out into the country which is so beautiful here that I find the winter perhaps more agreeable than the summer, and naturally I am working all the time, and I believe that this year I am going to do some serious things."[3]

By any standard, the painting that he made of a sunlit snowy landscape in the early months of 1869—the painting now called *The Magpie* (cat. 25)—is the most ambitious of all his paintings of winter. From the beginning, it was destined to be a "serious" painting, since Monet chose a large-format canvas for it. This suggests that he had in mind making a picture that, if all turned out well, might go to the Salon in the spring, along with *The Luncheon*. As Gary Tinterow writes, it is tempting to associate the making of *The Magpie* with the request for oil paint that Monet made to Bazille on January 11, in which he asked for large quantities of silver white, ivory black, and cobalt blue, as well as a supply of fine lake, yellow ochre, red brown, bright

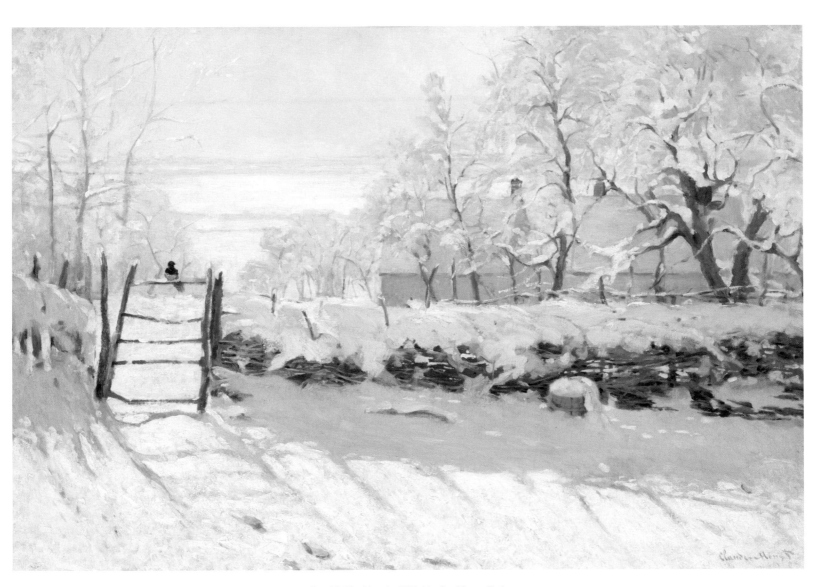

Cat. 25. *The Magpie*, 1869. Musée d'Orsay, Paris

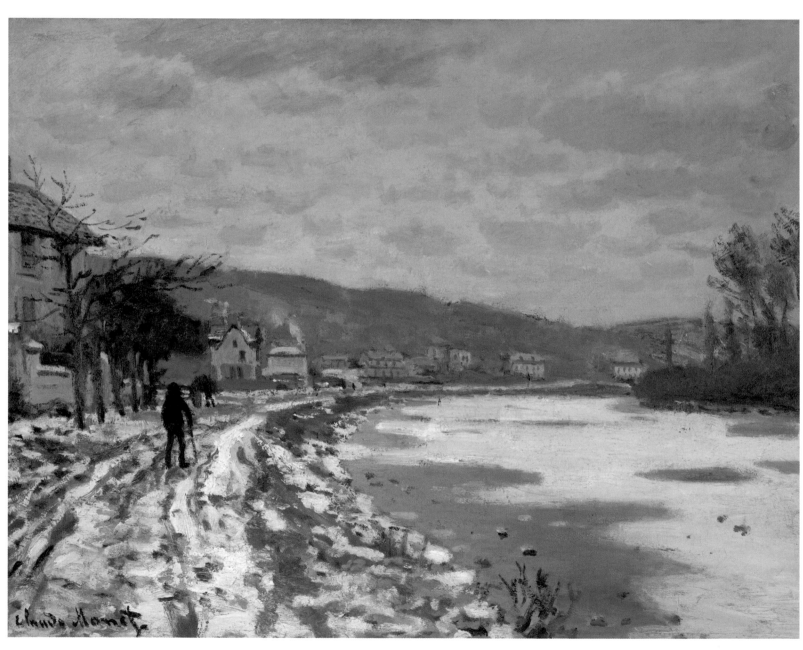

Cat. 26. *The Seine at Bougival*, 1869. Private collection, care of Gladwell & Patterson

yellow, Naples yellow, and burnt Sienna.[4] Monet's request for "a lot" of tubes of white, black, and blue could easily be explained by his plan to paint a large, pigment-consuming canvas.

Monet managed to create a painting that engages the viewer on every level, eliciting a wide range of responses from each individual. Its composition is deceptively simple: a fence, pickets at the left and wattle at the right, cuts through the middle of the painting, dividing the empty foreground from the landscape beyond, in which trees screen a farmhouse at right and at the left frame a view through to a distant expanse of white, receding to a horizon line that divides the brighter earth from the slightly less vivid sky. Sunlight falls into the scene from the upper left, sending shadows forward towards the viewer and brightening the snow-heavy branches. Everywhere the sun brings out delicate color in ordinarily colorless things: the walls of the farmhouse glow pink beneath the snowy blue roof, their chimneys points of dull red that stand out only because of the whiteness around them. The contrast between sunlit and shaded snow is the same as in the *Snowy Road*, but the effects are more dramatic, the shadows long and deep. Though somber in contrast to the sun-bright snow, the blue-gray shadows are themselves radiant, filled with almost imperceptible vibrations of reflected light, as if the cold crisp air were itself aglow.

The romantic lyricism of *The Magpie* is exceptional in Monet's production of 1869, however. It could not be sustained for long, and indeed Monet had other issues to investigate. Coinciding with his springtime move to Saint-Michel, a village near Bougival on the Seine, his contacts with Pissarro were renewed. Living at Louveciennes, the neighboring town, Pissarro had made the street on which he lived, the main road linking Louveciennes and Versailles to the south, his prime subject for painting. The road was straight, lined with houses and gardens, and offered little in the way of picturesque beauty. But Pissarro—and Monet with him—was intent on exploring pictorial possibilities of the ordinary as a route to a landscape art that would have something of the detachment of the urban painters of modern life.

A snowfall in December 1869 gave Monet the opportunity to study the effects of winter within the aesthetic framework of Pissarro's realist approach. Three of the snowscapes he painted in a short period of time actually represented stretches of road at Louveciennes previously painted by Pissarro himself. One experimented with a view into the Marly forest, and a fifth showed the snowy *Seine at Bougival* (cat. 26). The painting is, in almost every way, the antithesis of *The Magpie*. Closer in its effect to *Cart on a Snowy Road, Honfleur*, it is nonetheless more sober, its harmonies of grays and browns contributing to a frank and honest—and very sophisticated—record of the landscape as encountered in the course of everyday life, as if without forethought to the pictorial possibilities of the view.

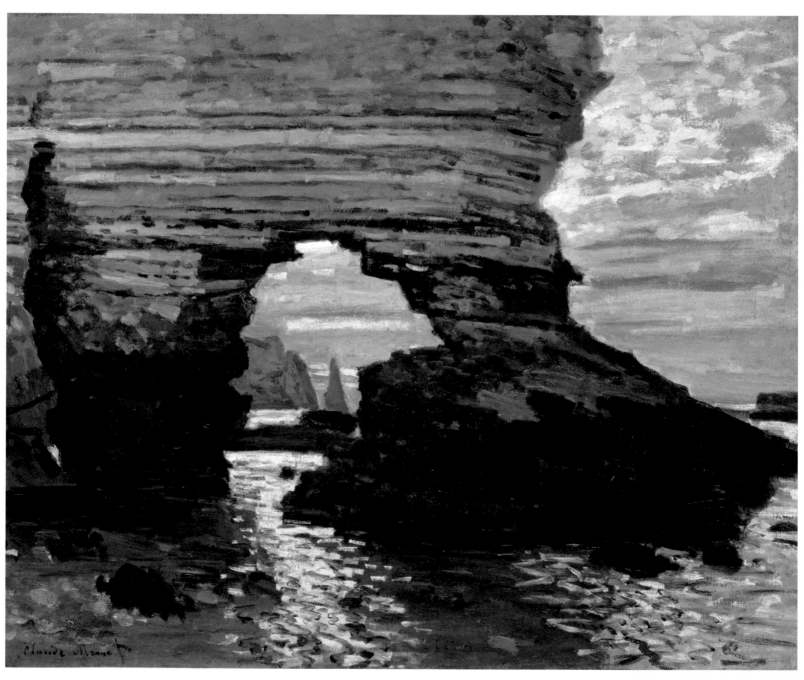

Cat. 27. *The Porte d'Amont, Étretat*, c. 1868–69. Harvard Art Museums/Fogg Museum, Cambridge, Massachusetts

Monet's move to Étretat in October 1868 brought him into contact with a group of landscape motifs that were to become, in succeeding decades, intimately associated with his art. Étretat, essentially a fishing village, was framed by two promontories, in each of which time, tide, and wind had carved fantastic arches, the Portes d'Amont (upstream) and d'Aval (downstream). It was known to such artists as Eugène Delacroix, who had painted there in 1849. Monet himself sketched the site as early as 1864 (see fig. 52), and Gustave Courbet made a first foray there in 1866, returning in 1869.[1]

But before Courbet's visit in the summer of that year, Monet had already painted *The Porte d'Amont, Étretat*, one of the most astonishing paintings of his career (cat. 27). Monet went to the east side of the rock arch to look towards the setting sun. To reach a shelf of rock only exposed at low tide, he hiked from the town to the top of the eastern cliff, then descended a rock path to the beach; the route was not unknown to tourists, but seldom undertaken. Étretat was masked by the cliff at left; the focus through the arch was on the needle rock that stood up from the surf beside the Porte d'Aval, its opening hidden by Monet's foreshortening.

Here Monet could depict, from very close range, the unfamiliar face of the cliff, its lower reaches still wet from the tide, the rest a looming wall built up from distinct strata of chalky rock. Each of these was painted in long, strong strokes of oily paint, great horizontal bands that echoed the distant striated clouds. The dominant horizontals continue into the shallow water in the foreground, where they are broken up into shorter units, then with a loose swirl of the brush, made to ripple back and forth against the immoveable stone.

Most remarkable is the complete lack in the painting of any sign of human life. Before this date, a handful of Monet's smaller works had shown no trace of man's presence. Here, however, the elemental forces of earth, sea, and sky are given a visual power that becomes almost intimidating in the absence of man. In Robert Herbert's perceptive analysis, this isolation gives the viewer the focus to experience the subject with greater empathic power.

Fig. 105. Claude Monet, *Rock Needle Seen through the Porte d'Aval, Étretat*, 1886, oil on canvas. National Gallery of Canada, Ottawa

> Our awareness that nature here is only a painter's artifice suits the romantic quality of the scene, for our emotions are engaged not just by the remarkable formation, but by awareness of the artist's reaction to it. . . . The more successfully our emotions are engaged by it, the more the picture has made us feel we are alone in front of it, despite the fact that we view it in the museum or reproduced in a book. . . .[2]

In 1883 and again in 1885–86 Monet returned to Étretat to investigate its curious formations. On the second of these trips, he attempted to rekindle the sense of awe that he had experienced in 1869. His *Rock Needle Seen through the Porte d'Aval* (fig. 105) shares some of the shadowed mystery of the *Porte d'Amont*, an almost animistic strength emanating from the time-worn rocks, a power that we sense and feel through Monet's visionary mediation.

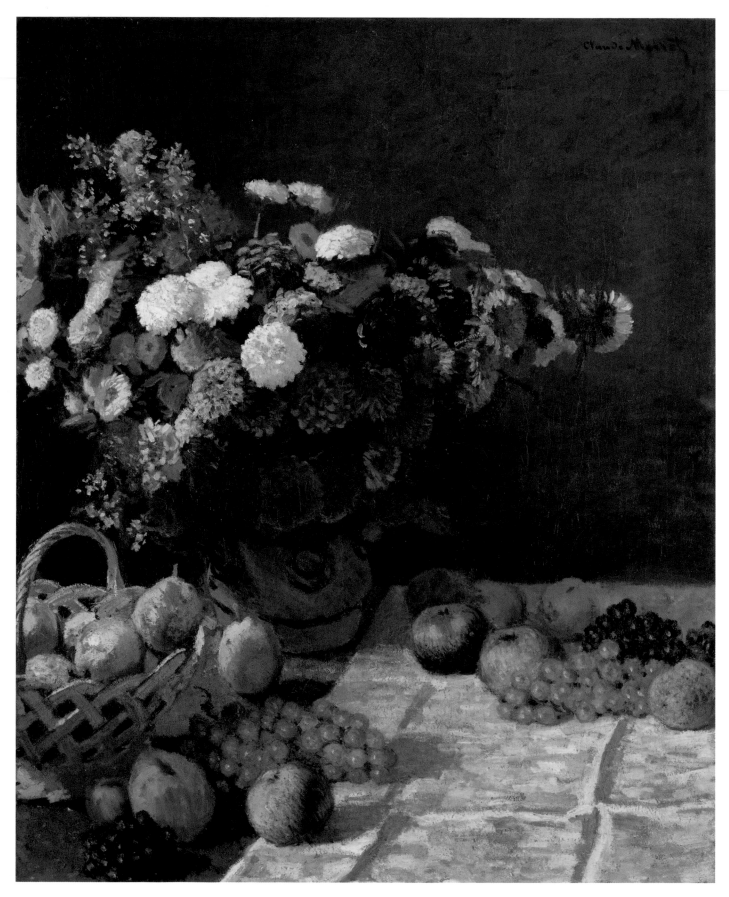

Cat. 28. *Still Life with Flowers and Fruit*, 1869. The J. Paul Getty Museum, Los Angeles

Painting side by side in Bougival in the summer of 1869, Monet and Renoir would produce some of the most innovative landscapes of early Impressionism at the bathing place of La Grenouillère (cats. 31, 32). At some time during their painting partnership, the artists contrived a luxurious bouquet of flowers as a motif to share. Using a stoneware crock decorated in bluc, they filled the container with an abundance of flowers. Red, orange, and yellow dahlias were joined with asters both blue and white, a bit of lilac, and some sunflowers in an irregular arrangement that contrived to look artless and impromptu. The container was placed on a marble tabletop, and a checkered linen cloth was laid beside it. Apples and grapes were strewn on the linen; a basket of pears was also to hand. The setup in place, the artists began work, with remarkably different results.

While Renoir used a panel of cardboard as his support—measuring some 25 x 21 inches—Monet chose a considerably larger canvas of 39 x 32 inches (cat. 28). Perhaps because of the relative scale of the supports, the compositions took very different forms. Renoir's bouquet is placed centrally, much closer to the picture plane, and the number of fruits is reduced to four pears (fig. 106). Monet, standing to Renoir's right, pushes the bouquet back and to the left, freeing the foreground and the cloth to the right for a display of sumptuously painted fruits. Each artist's painting style is immediately apparent, Renoir's flickering and delicate strokes contrasting with Monet's more studied, detailed depiction of individual blossoms. The mood of Monet's painting is more complex, the gorgeous display of blossoms tempered by somewhat moody shadows, in contrast with Renoir's overall illumination, where only a few dahlias are cast into shadow at right. Perhaps in keeping with the luminous outlook of his canvas, Renoir crowns his bouquet with a sunflower; Monet first paints the sunflower then paints it away—it can no longer be seen with the naked eye. In the end, Monet's *Still Life with Flowers and Fruit* is marvelously refined. The grapes are dewy and opalescent; the patterned cloth absorbs and reflects the light as if it were the rippled surface of water; the woven basket and the individual blossoms are given strangely crisp form.

In a far different mood, and again probably in 1869, Monet took a much smaller canvas to begin a still life with contrasting intentions. On the canvas he set the image of two *rougets*—red mullets—lying on a folded white cloth (cat. 29). Using a very restricted

Fig. 106. Pierre-Auguste Renoir, *Mixed Flowers in an Earthenware Pot*, 1869, oil on paperboard mounted on canvas. Museum of Fine Arts, Boston. Bequest of John T. Spaulding

palette of warm and cool grays, white, black, and red-orange, the painter sketched the motif with a minimum of apparent effort. The paint was applied with a variety of brushes, apparently entirely wet-in-wet, so that the edges of the cloth are sometimes on top of, sometimes below the strokes that Monet used to lay in the ochre-gray tabletop. On the whole, the white cloth is painted up to the bodies of the fish; broad strokes of oily white are painted up to the dark brown shadow beneath the head of the foreground fish, but its delicate pectoral fin

Fig. 107. Édouard Manet, *Fish (Still Life)*, 1864, oil on canvas. The Art Institute of Chicago. Mr. and Mrs. Lewis Larned Coburn Memorial Collection

is made of one stroke of red through white, perhaps reinforced by another tiny touch of red. The relative neutrality of the tabletop and cloth is the foil for the display of coloristic brilliance in the painting of the silver-and-coral scales of the little fish. The astonishing shadows that the cloth casts, particularly at right, bring the suggestion of trompe-l'oeil into a composition that in every other way declares the tactility not of the subject represented but of the representation itself.

It is impossible to interpret this painting except as a joyful demonstration of Monet's extraordinary facility, his mastery of pure painting. Though the

fish have an almost emblematic quality—they are arranged tail-to-head in the traditional position of the zodiacal *poissons*, Pisces—such a reading seems forced in light of the painter's insistence on his materials and his manipulation of them. It is also impossible not to recognize this bravura brushwork as an homage and challenge to the painter's friend Édouard Manet. Two years earlier, for instance, Monet would have seen Manet's 1864 *Fish (Still Life) Fish* in the painter's one-man exhibition at the time of the Universal Exposition (fig. 107). Painted in a similar range of colors (Manet adds a lemon and a sprig of parsley), the great *Still Life* bristles with the same exhibitionistic joy in materials but is at the same time redolent of the Old Masters, as if Frans Hals had painted a free copy of a still life by Pieter Claesz.

By placing the cloth so that it projects from the composition on three sides, and by looking at the motif from high above rather than on the same level, Monet banishes all such conventional associations. Instead, he evokes the strange worlds, divorced from any western notion of space, imagined by Ukiyo-e printmakers,

Fig. 108. Utagawa Hiroshige, *Isaki and Kasago Fish*, from the series *Uozukushi (Every Variety of Fish)*, 1830s, polychrome woodblock print. The Metropolitan Museum of Art, New York. Gift of Mr. and Mrs. Bryan Holme, 1980

particularly Hiroshige, whose works he was to collect in large numbers. In Hiroshige's series *Every Variety of Fish* (fig. 108), the fish only occasionally seem to swim; instead of inhabiting space, they seem to float in flatness. Adapting this principle in the wholly different, even alien, medium of oil paint, and applying it to the depiction of an otherwise unexceptional subject, Monet creates an image of complex visual power.

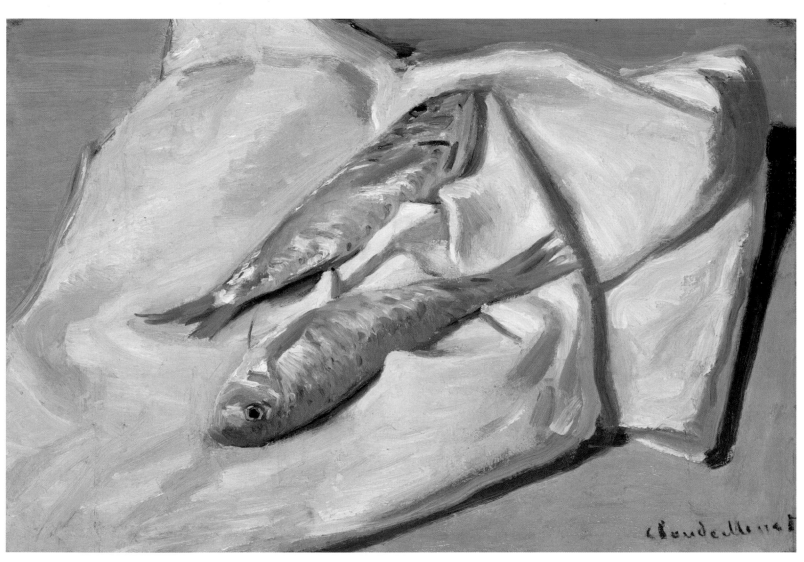

Cat. 29. *Red Mullets*, 1869. Harvard Art Museums/Fogg Museum, Cambridge, Massachusetts

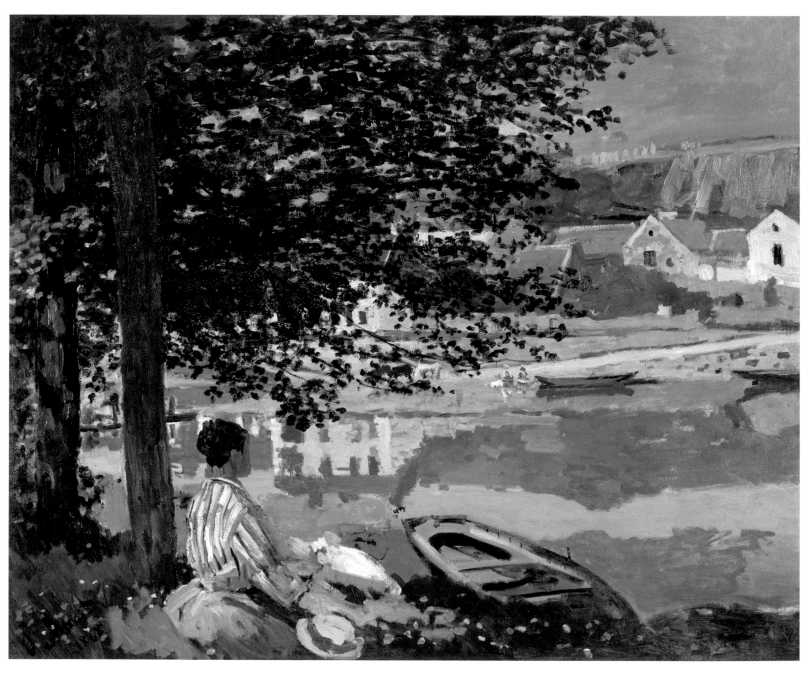

Cat. 30. *On the Bank of the Seine, Bennecourt*, 1868. The Art Institute of Chicago

The whole of Monet's life was linked to the geography of the meandering River Seine. Born in Paris, he moved to Le Havre, where the river flows into the English Channel, as a child, and subsequently lived at Honfleur, opposite on the south bank of the estuary. His three places of residence after the age of thirty—with the exception of a year spent abroad—were three riverside towns, Argenteuil, Vétheuil, and Giverny; in each spot, views of the river are a frequent—sometimes even all-consuming—motif.

On the Bank of the Seine, Bennecourt (cat. 30) is among the first—perhaps even the very first—of these riverscapes.[1] It is, in fact, a view of Bennecourt's distinctive array of buildings, on the right bank of the Seine, seen in bright light and in reflection from the other side, to the south. It was painted while Monet and Camille were in residence at an inn in nearby Gloton, from which they were summarily evicted when they could not pay their bills. What began as an idyll in a town favored by Monet's friends Zola and Cézanne finished in disarray.

The only surviving painting from the couple's two month stay at Gloton, *On the Bank of the Seine* has long been considered, with reason, to be one of the milestones in the maturation of Monet's concerns and pictorial strategies. As Gloria Groom has shown, some of the key features of the painting defy easy interpretation, for the most part due to the process by which the work evolved. Camille Monet sits on the near bank, her gaze apparently fixed on the river; her head is turned to offer just the outline of her cheek. Research has shown that her figure was added to an unpeopled view of the river that was already substantially laid in, if not "finished," and the zone around her much altered in the process. Almost every part of the painting, but particularly the roughly rectangular zone of the canvas between the far bank and near bank, was subject to reconsideration and reworking. This process of building and reconsidering the pictorial elements as the painting progressed left a result that is remarkably bold—even jarring—in its execution, its elements juxtaposed in such a manifest way as to cause some scholars to interpret the painting as abandoned, then retrieved and given a signature at a later date.[2] Instead, the painting should be interpreted as a composition resolved as Monet saw fit, one in which process and personal history are considered simultaneously. It began, as Groom sees it,

. . . as an unpeopled riverscape before the artist reshaped it into a genre painting, now part biography, whose full meaning is painted out but is allowed to linger as flashes of underpainting. Monet staked his painterly claim on this island in the Seine, using the figure of Camille not only to lead our eye across the water but perhaps also as a stand-in for himself. Monet's struggle with the principal figures of this composition, which . . . were either altered or painted out, may suggest his own ambivalence toward his personal situation at the time. For, it was near Bennecourt where he housed his family temporarily and where he no doubt keenly felt the pressures of fatherhood (although unable to keep his household together when faced with eviction); he set out to describe the view from the other bank, using the diaphanous but critically important figure of Camille. This is a portrait of a place, revised and messily resolved through Monet's artistic lens.[3]

When, in the following year, Monet and Camille returned to the Seine, settling at Saint-Michel, near Bougival, the painter resumed his pictorial conversation with the river. The most celebrated results of this reengagement are the two canvases Monet painted on the spot at La Grenouillère, a popular establishment on the banks of the river, where patrons could rent rowboats, eat and drink at its restaurant and bar, and swim. The clientele of the self-styed "frog pond" was a mix of Parisians with a decidedly racy accent. Guy de Maupassant called the tree-shaded corner of the island "the most delightful park in the world" but described the clientele in unflattering terms. "Girls with large breasts and buttocks, faces thick with makeup . . . laced and strapped into fantastic dresses" kept company with "young men looking like models in a fashion-plate with their pale gloves, patent leather boots, and thin canes and monocles, which only emphasized the fatuousness of their smiles."[4]

During two months in the late summer of 1869, Monet and Renoir spent considerable time together. Renoir was important to Monet and Camille as a source of sustenance—he literally brought them bread when they had nothing to eat. Inexplicably, in spite of Monet's drastic personal circumstances, he continued to work, sometimes at Renoir's side, each completing, among other things, an ambitious still life from the same bouquet of flowers (see cat. 28).

Thus it was that the friends found themselves painting La Grenouillère simultaneously, Renoir making three paintings to Monet's two (fig. 109). These have traditionally been seen as a major turning-point in their own careers and in the history of art. As Charles Stuckey put it, their "invention of a stenographic style of brushwork to render the choppy, sun-dappled river initiates the pictorial language of classic Impressionism."[5] Ronald Pickvance cautioned that, for Monet at least, their importance has been overstated, "the urge to wax lyrical" lifting these pictures out of the context of their dependence on what had happened

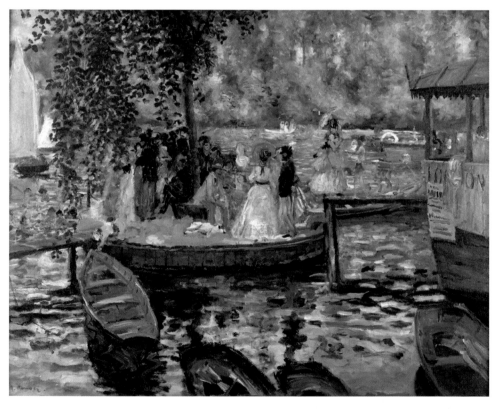

Fig. 109. Pierre-Auguste Renoir, *La Grenouillère*, 1869, oil on canvas. Nationalmuseum, Stockholm

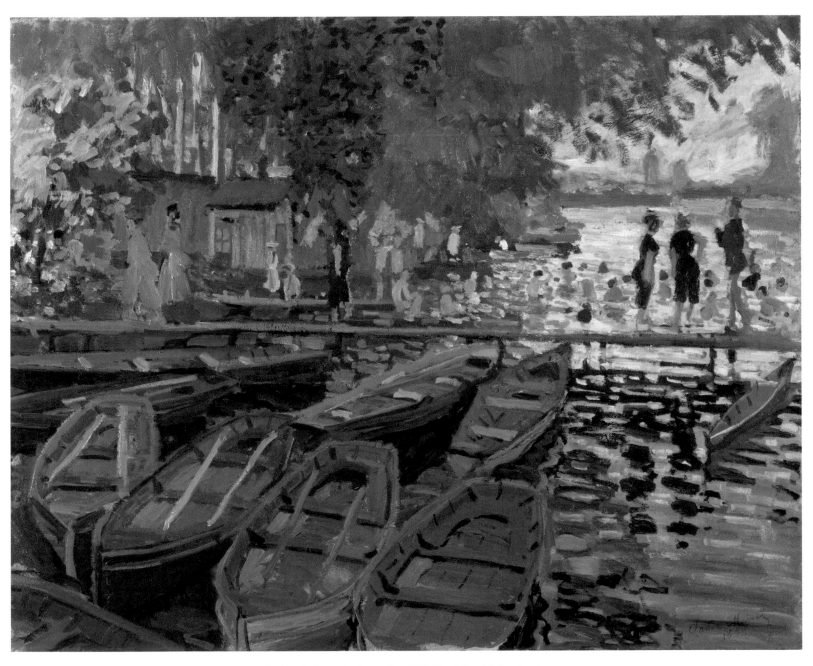

Cat. 31. *Bathers at La Grenouillère*, 1869. The National Gallery, London

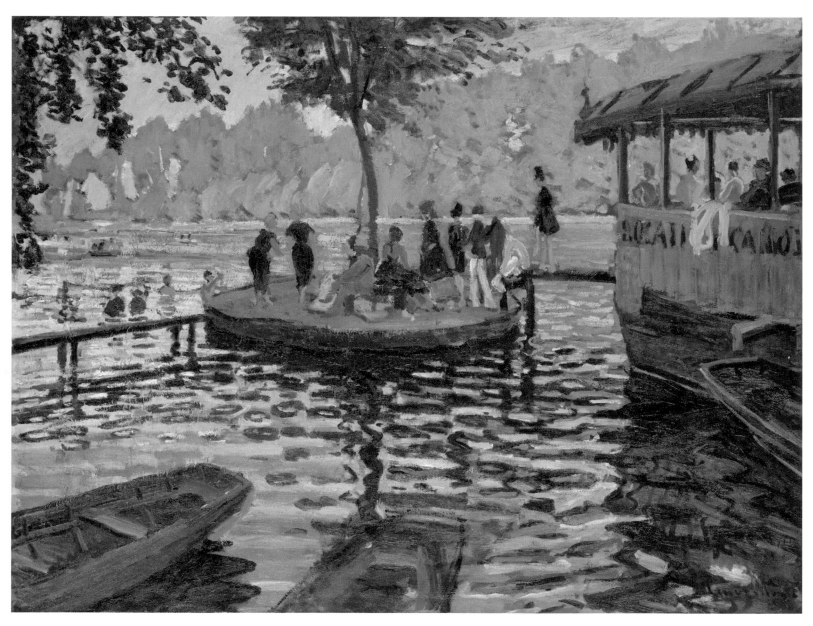

Cat. 32. *La Grenouillère*, 1869. The Metropolitan Museum of Art, New York

before and failing to prove or even evaluate the impact of the "Grenouillère experience" on anything that Monet produced in their immediate aftermath.[6]

Monet himself, in his only direct reference to the pair of paintings, downplayed his satisfaction with them. Writing to Bazille he spoke of "a dream, a painting of bathing at La Grenouillère, for which I have done some bad sketches, but it's only a dream. Renoir, who has just spent two months here, wants to do such a painting."[7] The word Monet used for what is translated as "sketch" was *pochade*, traditionally used to designate an imperfect, hastily executed image, as distinct from an *esquisse*, another kind of sketch, which was made to advance the study of a motif in preparation for a specific finished work. But Monet's modest estimation of the paintings' worth seems insincerely denigrating in light of the paintings themselves. It is true that their visual language is not unprecedented: reflected light on rippling water is a critical element in such paintings as the 1866 *Boats in the Port of Honfleur* and the view of the *Porte d'Amont, Étretat*, completed earlier in 1869. It also seems unlikely that they are simply unfinished, the underlayer, or *ébauche*, for a hypothetical painting that might have taken shape on the same canvas. Instead, they are, as Monet suggests, sketch-finished compositions distinguished by their speed of execution and their allowance of the defects that might arise from that deliberate haste.

In fact, they were destined to have a further purpose as *ésquisses*, even if that is not why they were made. Out of them rose a painting of Salon dimensions, measuring an estimated 66 x 118 centimeters, that is known from photographs but is thought to be lost, destroyed in the Second World War (fig. 110).[8] That painting, from the photographic evidence, is the greatest example of the importance of the "Grenouillère experience." It is thought to have been one of two rejected by the jury of the Salon of 1870. Either that painting or one of the *pochades* was sent to the Impressionist exhibition of 1876; it is probably that painting that Monet chose to show in his self-selected retrospective exhibition in 1889.

Fig. 110. Claude Monet, *La Grenouillère*, 1869–70, oil on canvas. Presumed destroyed

Cat. 33. *The Bridge at Bougival*, 1869. Currier Museum of Art, Manchester, New Hampshire

Still living at Bougival in the autumn of 1869, Monet positioned his easel on the end of the bridge across the Seine from Bougival to Croissy-sur-Seine to its north. The bridge is in two parts: on its way from Bougival (in the distance here) the road passes across this bridge to the Île de Croissy in the middle of the Seine, where Monet stands, and crosses the second fork of the Seine. On the northern fork of the Seine, still on the island, could be found La Grenouillère (cats. 31, 32). Turning his back to the bathing place and the town of Croissy, Monet faced south to look back at Bougival, depicting the receding road and the foot traffic that moves beside it, creating a composition that in its basic structure is kin to the pictures of roads and streets his friend Pissarro was painting in nearby Louvciennes (fig. 111).

Monet chooses the low light of morning, entering his scene from the east, as ideal for this view. That light might be called the central motif in the painting, so much does Monet's depiction of everything he sees depend on its very particular tone and direction. Placing himself in shadow he looks into the toward hills and houses that are themselves still in shadow. The sunlight strikes only one side of the elements that are either flat or vertical: the quai on the opposite shore and the interwoven tops of the trees beside it; the quai on the near bank; the spindly trunks of trees that still bear their autumn foliage; the cap and blouse of a woman walking with a child; the sandy roadway as it crosses the bridge; the left façades and roofs of houses in Bougival; the base of a lamp post; a timber fence; the rounded frame of an arched trellis at the entry to a garden. It strikes the clouds, too, and their luminous mist is what we see reflected in the water of the river at left.

Everything has been stilled by the painter's imagination. The walking figures, the shadows of the trees that will move as the sun rises, the scuttling clouds of a sky in the Île de France: all are fixed on the surface of the canvas as they might have been in one of the photographs that the painting resembles. The application of the paint in careful daubs of pigment, rather than gestural strokes of paint, quiets the visual chatter of the image, so that here Monet, like a latter-day Vermeer, attains that rare state of silent, motionless perfection.

Fig 111. Camille Pissarro, *Route to Versailles, Louveciennes*, 1869, oil on canvas. The Walters Art Museum, Baltimore

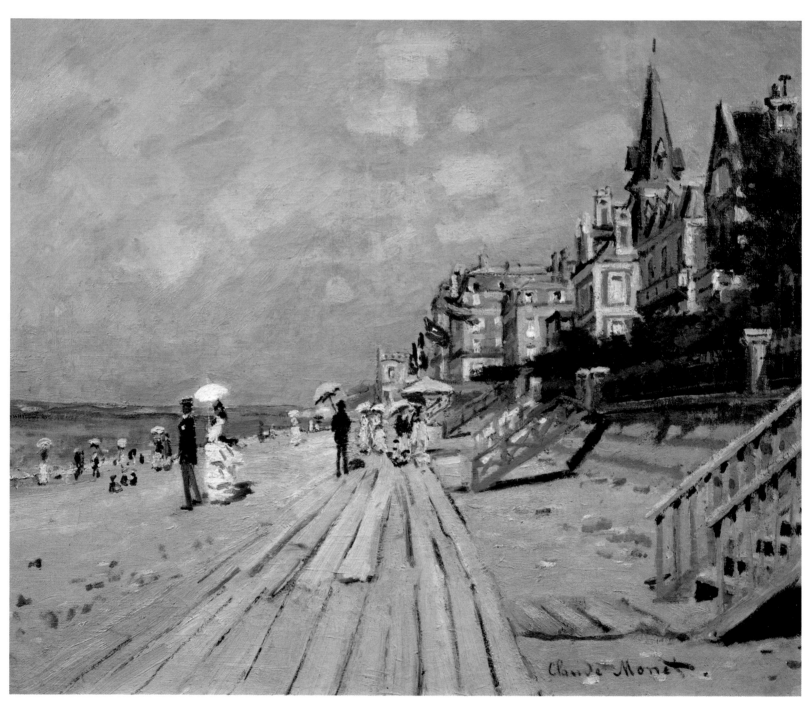

Cat. 34. *The Beach at Trouville*, 1870. Wadsworth Atheneum Museum of Art, Hartford, Connecticut

Claude and Camille Monet were married in Paris on June 28, 1870, and left shortly thereafter for a honeymoon on the Normandy coast in the fashionable resort of Trouville. Since the beginning of the Second Empire, in particular, with the participation of both the court and wealthy Parisian speculators, and following their fashion, Trouville and nearby Deauville had become the most popular summer vacation spots for the aristocracy, the plutocracy, and the haute bourgeoisie. By 1870, on both sides of the River Tocques, the long beaches of Deauville and Trouville were lined with hotels for tourists and villas for the better-to-do. Each town boasted a casino—Monet and Camille had met Courbet in the Deauville casino in 1866, leading to their invitation to dine with the wealthy Comte de Choiseul, Courbet's patron and summertime host, an invitation that was, even if the other guests were artists, above their social norms.

The couple spent three months at Trouville in 1870, not at one of the grand hotels on the beachfront but at the smaller and more modest Hotel de Tivoli on a back street. The newly opened Hotel des Roches Noires was the grandest and most resplendent of them all and drew Monet's attention. He made a spectacular painting of its façade, turning his canvas to the vertical to emphasize its towering height, raised above the level of the sand on a terraced sea wall, its front marked by a succession of flagpoles (fig. 48).

These flags seem to have been changed from time to time, judging from the painting Monet made of a broader stretch of beach on another occasion (cat. 34) where the hotel can be spotted in the background, the red and yellow flag of Spain flying in the place the United States' flag holds in the close-up painting. In this canvas, and in two closely related variants (see fig. 47), the painter's focus is not so much on architecture in its own right but on the hotels and the boardwalk laid over the sand as the stage for social interaction between the tourists who have come to enjoy themselves at the seaside. At right, the line of hotels rises above the beach, accessible via wooden staircases, each painted a different color. At the base of the staircase, a boardwalk has been laid on the sand—literally a succession of boards, which would permit it to be adjusted if necessary for particularly high tides. Blue sky and blue-green sea are separated by a line of blue at the horizon, indicating the distant hills of Le Havre and Sainte-Adresse, where Monet's family was in residence.

Late the same summer, Eugène Boudin and his wife came to join the Monets in Trouville. A view of the beach that Boudin painted on this occasion shows the range of types of people who frequented the beach, cataloguing their poses, the colors and cut of their clothing, even the rainbow hues of their parasols (fig. 112). Monet's beach, by comparison, is remarkably free of crowds, but it is much more energized, not only

Fig. 112. Eugène Boudin, *Beach Scene at Trouville*, 1870, oil on panel. Courtesy Richard Green Gallery, London

by the fact that his figures seem, without exception, to be either moving or caught standing still just for a moment, but also because Monet's touch is just as in motion. It is not so much that the painting was quickly painted—on the contrary, it seems to be very carefully worked, the brushstrokes more consciously placed than improvised—instead, it is that the strokes have been placed in such a way that they seem inherently balanced but also taut, as if barely held in check.

The green staircase at far right, for example, is almost disarming in its carefully observed succession of component parts, which are at once two-dimensionally directional—horizontal, vertical, diagonal—and volumetric, the planar stair treads held in place by the broad diagonal stiles, the whole crisscrossed by the complex rhythm of the railing's spindles. The action of light over these forms has been exactly analyzed, the intense sunshine making deep black shadows appear as dots and rectangles beneath the handrails, the stair treads, and on the sand beneath the full stair; the result is hypnotic, the paint alternating between being a series of strokes of oily pigment and being a real and palpable stair.

Apart from the four paintings that Monet devoted to the hotels and their environs, there are five paintings that study single figures or pairs of figures on the beach. The smallest of these—only eleven inches tall—is a hasty sketch of a standing figure, generally identified as Camille Monet (cat. 35). She wears a pale beige summer dress, carries a parasol, and sports a hat,

similar in color and trimmed with black ribbons, that she also wears in two other studies from the same time (cat. 36; fig. 114). The purpose of this curious painting is hard to determine; Monet hardly needed such a study to paint the figures on the beach in his more panoramic view. It bears comparison to the painting that Boudin had made a few years earlier of *Princess Pauline von Metternich*—wife of the Austrian ambassador to the imperial court and a renowned woman of fashion (fig. 113). For Monet, though, making an independent figure study of this sort is out of keeping with what we know of his working habits. Curiously, in format and composition the closest parallel in Monet's work is with his 1866 standing portrait, *Camille* (fig. 2). Their fundamental differences go to show how much the painter's art had changed in four years.

The remaining four studies of Camille are linked by their format and subject, but enormously varied within this unity. Each canvas is a size "8 *figure*," measuring thirty-eight centimeters on its shorter side and forty-six on its longer—about fifteen by eighteen inches. One of the canvases is vertically oriented, but the other three are horizontal in format. The subject of each is essentially

Fig. 113. Eugène Boudin, *Princess Pauline Metternich (1836–1921) on the Beach*, 1865–67, oil on cardboard, laid down on wood. The Metropolitan Museum of Art, New York. The Walter H. and Leonore Annenberg Collection, Gift of Walter H. and Leonore Annenberg, 1999, Bequest of Walter H. Annenberg, 2002

Cat. 35. *Camille on the Beach*, 1870. Musée Marmottan Monet, Paris

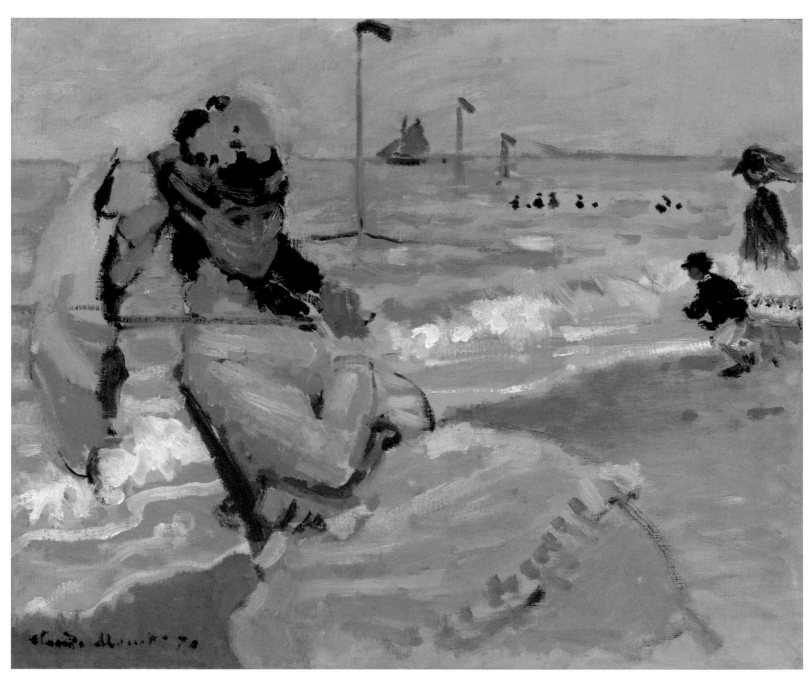

Cat. 36. *Camille on the Beach at Trouville*, 1870. Yale University Art Gallery, New Haven, Connecticut

the same: Camille Monet sits in a chair on the Trouville beach, either alone (in two) or with another figure. All four are quite broadly finished; none has anything like the attention to detail that Monet had lavished on the green staircase in his more encompassing view.

Camille on the Beach at Trouville from the Yale University Art Gallery (cat. 36) is perhaps the most broadly painted of all four. Here Monet makes liberal use of the gray prepared ground, letting it serve as the white of clouds above the horizon at upper right and as the base tone for the sand at lower right. It also serves him to build up the volume of Camille's dress, which is suggested with a few strokes of pale brown, pink, white, and gray; her toilette is completed with a matching hat trimmed in black, a veil indicated with a few strokes of grayish white, and a gray parasol lined with blue. Everything about the painting is restrained: the color scheme is dominated by neutrals, with no tone allowed to be too bright; every object is clearly evoked but never described, as if Monet were setting himself a challenge to use the minimum number of strokes. In comparison with the other paintings in the group, the Yale canvas shows more work with a dry brush, particularly on the parasol and wherever black tones are used.

With the Musée Marmottan Monet's *On the Beach at Trouville* (cat. 37), Monet was equally economical in mark-making but took greater liberty with his use of color. Introducing a rich cobalt blue in the striped dresses of the figures—Camille seen twice, in the opinion of some critics—he continued to use the color in the background, on both figures and landscape, and added touches of bright red, sometimes mixed to make pink, of the same hue that he used on the ear, cheek, and lips of Camille. Also notable in this canvas is the greater role given to modeling. The depiction of the chair back has something of the volume the painter had sought with the boardwalk stair, and in spite of its bold pattern the blended tones used in the dress serve to make it recede and advance as it follows Camille's body.

The vertical painting is the least finished of them all, and in fact seems to have been abandoned before it was fully resolved (fig. 114). Curiously, it is the only one of the four in which Camille seems to take an active interest in her surroundings, leaning forward and pursing her lips beneath her veil as if she is listening or waiting to speak to the painter. Her eyes, nothing but

a few strokes of black, nevertheless give the impression that she is amused. Having been interrupted in mid-process, the painting shows us a few details that may help us understand the process by which the artist composed the remaining horizontal painting, in the collection of the National Gallery, London (fig. 115). In the vertical painting there are clear black lines visible on the edges of thick, opaque strokes, as if the artist looked at the physical volume and drew a line at the point where light and shade would meet, a line that defined an area he then "painted in" as a solid tone.[1]

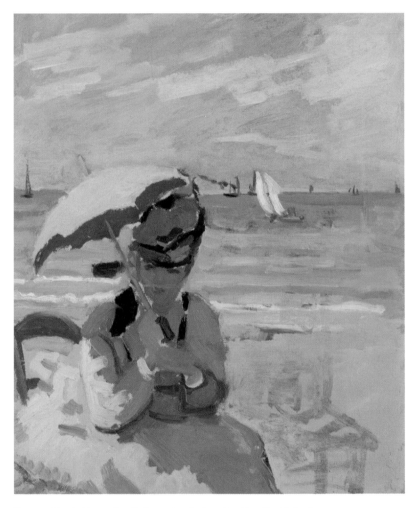

Fig. 114. Claude Monet, *Camille Seated on the Beach at Trouville*, 1870, oil on canvas. Private collection

In the vertical sketch, as in the more resolved London painting, *The Beach at Trouville*, the figures are not modeled at all in any traditional sense. Instead, the three-dimensional forms of a chair, two women beneath parasols, and a series of distant buildings are painted in patches of solid color, with little, if any, blending of paints. The chair, for example, is a

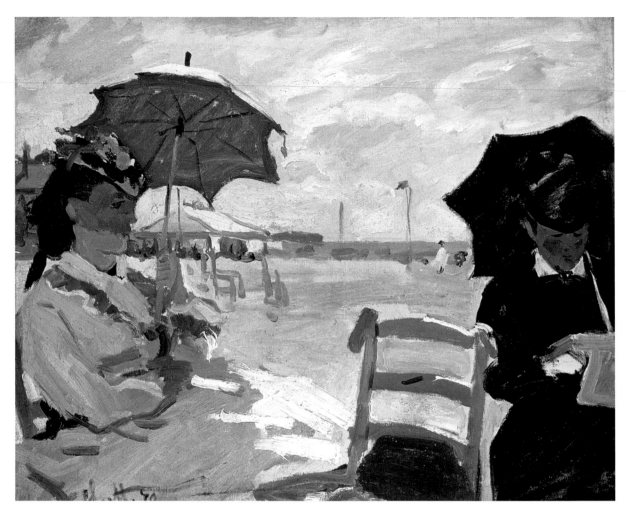

Fig. 115. Claude Monet, *The Beach at Trouville*, 1870, oil on canvas. The National Gallery, London

series of gray verticals and horizontals, given a hit of volume by a solid black line or two of shadow and a similar number of white lines of light. Here and there hints of underdrawing—on the hip of the woman in black, for instance—suggest that Monet might have planned these zones of unified color before beginning to paint, rather than simply finding them in the course of putting pigment on canvas. The resulting image, for all that it conveys the light, the air, and even the smell of the seaside, is the result of calculation and restraint rather than improvisation.

Through four paintings of identical format, and using essentially the same materials to approach the same subject, Monet creates four distinctly different works of art. Perhaps attempting to make up in variety what his summer's work would lack in quantity, he used the beach as a kind of laboratory and studio for experimentation. While he was at work, his wife sat immobile, her thoughts, perhaps, on the war that was raging to the east, the troubling reality that hung over an otherwise joyful occasion, the reality from which she and her family were soon to flee.

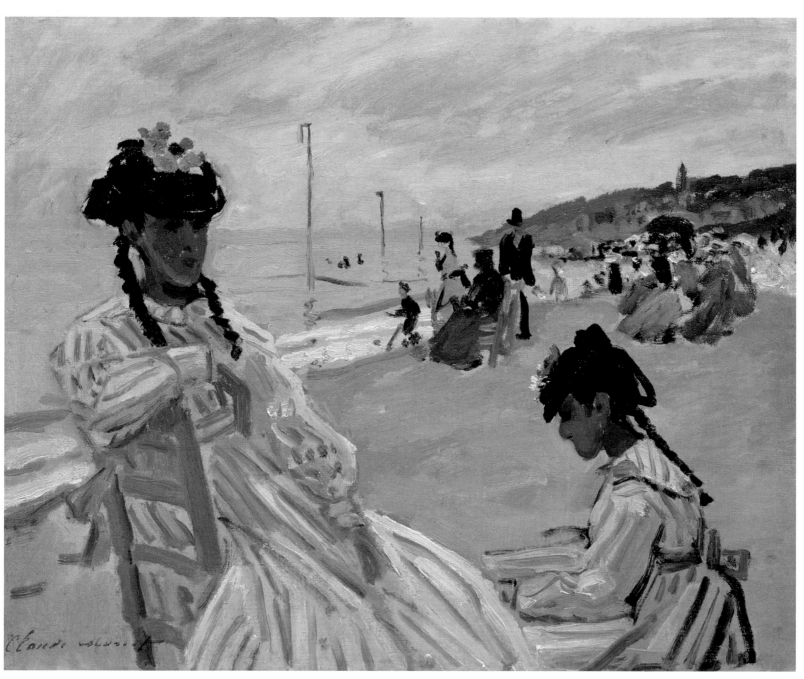

Cat. 37. *On the Beach at Trouville*, 1870. Musée Marmottan Monet, Paris

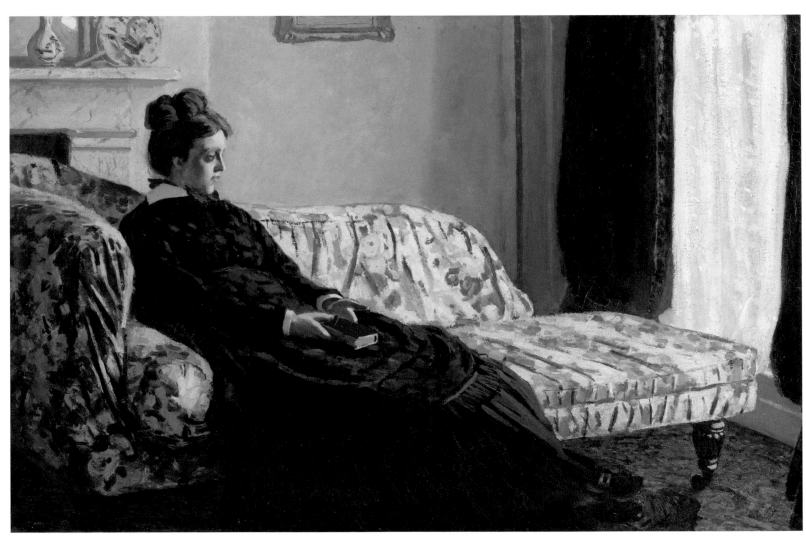

Cat. 38. *Meditation, Madame Monet Sitting on a Sofa*, 1870–71. Musée d'Orsay, Paris

From Le Havre, where he had gone to see his father—presumably to ask for financial assistance—Monet wrote on September 9 to Boudin, who was in Trouville with his wife and Monet's, that Adolphe Monet was unwell and unhappy, so that it would be "impossible to get any money for a few days. I can't come back to the hotel [in Trouville] without a scene," he continued, "and, on the other hand, if something should happen to my wife. What torment!"[1] In his letter, he told Boudin of the mass departures across the channel to England being run by transatlantic lines, their huge boats still insufficient in capacity. "Two hundred passengers were left behind on the dock tonight."

Monet had already obtained a passport and less than a month later would himself leave for London. After a brief stay at lodgings in the city center, he, Camille, and three-year-old Jean settled in Kensington. It is in their sitting room there that he must have painted *Meditation: Madame Monet Sitting on a Sofa* (cat. 38). Camille, dressed soberly in dark blue and black, is shown on a chintz-covered *méridienne*, illuminated by the cool light falling through the window curtains. She has paused from her reading and is lost in thought.

The painting's wistful mood, and above all the artful arrangement of the background as a series of rectangles, invites comparison with the paintings of women that Monet's friend James McNeill Whistler had presented in Paris and London in the 1860s. Perhaps the most apposite of these is Whistler's *Little White Girl*—later given the fore-title *Symphony in White, No. 2*—which the artist had presented at the Royal Academy in 1864 (fig. 116). Monet's studied choices in composing *Meditation*, notably the alignment and the cropping of such elements as the mantelpiece and the framed picture on the wall and the inclusion of a blue-and-white vase and a Japanese hand fan, recall this and other Whistler paintings. They suggest not so much that he was inspired by any one painting, but that he had entered into a nostalgic Whistlerian mood while in London.

His contacts with the world of Paris increased, as it happens, while he was in England. It was during his stay in London that Monet deepened his friendship with Pissarro, who had settled in South London during the hostilities. And through Daubigny, likewise in exile, both artists were introduced to Paul Durand-Ruel, the Paris dealer in Barbizon paintings who was, in fact, the first to show one of Monet's most recent works—a Trouville view, only months old—in the Bond Street gallery he set up at this time.[2]

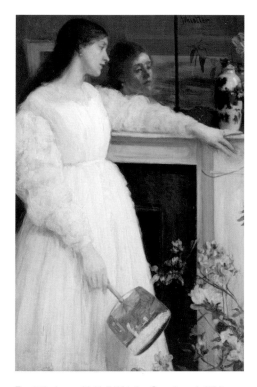

Fig. 116. James McNeill Whistler, *Symphony in White, No. 2: The Little White Girl*, 1864, oil on canvas. Tate, London. Bequeathed by Arthur Studd, 1919

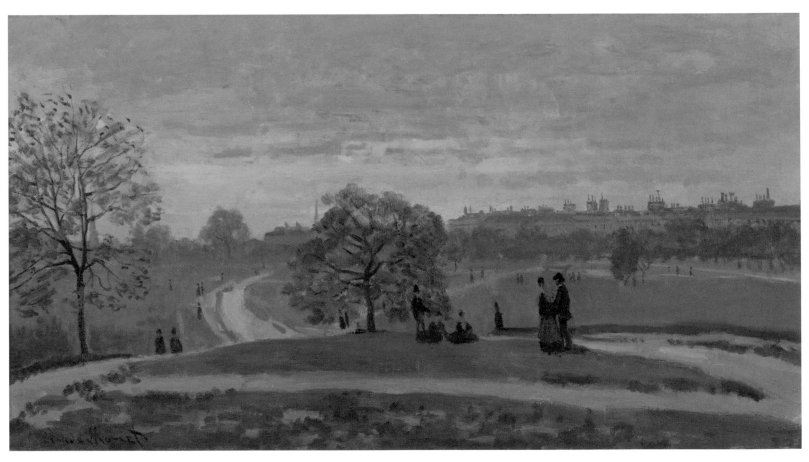

Cat. 39. *Hyde Park*, 1871. Museum of Art, Rhode Island School of Design, Providence

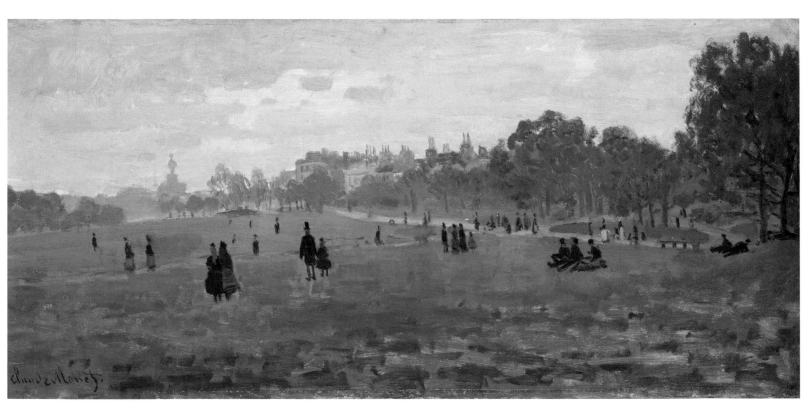

Cat. 40. *Green Park*, 1871. Philadelphia Museum of Art

In addition to *Meditation*, Monet completed five landscapes before his departure with Camille and Jean in May. Three of these were views of the Thames (cat. 41). The other two were views of *Hyde Park* and *Green Park*, similar in their panoramic format but of different sizes (cats. 39, 40). All five paintings are marked by Monet's sensibility for London's chilly, humid winter weather. Pissarro was later to remark that "Monet and I were very enthusiastic over the London landscapes. Monet worked in the parks while I, living in Norwood, studied the effects of fog, snow, and springtime. We worked from nature, and later on Monet painted in London some superb studies of mist."[3]

It is tempting to see in the effects that Monet achieved in London some reflection of a fresh encounter with British painting. The extent to which Monet was influenced by British art during his stay in London has often been debated. The English author who interviewed Pissarro in the first years of the twentieth century reported the old man saying that, together with Monet, he "also visited the museums. The watercolors and paintings of Turner and of Constable, the canvases of John Crome, have certainly had an influence upon us." To this publication, Pissarro responded that, on the contrary, it was to the French tradition that he and Monet had consistently looked, telling his son that Turner and Constable did not have the right "concept of light . . . [and] no understanding of the analysis of shadow."[4] (Speaking before Monet's 1904 exhibition of London paintings at Durand-Ruel, Pissarro may not have recognized to what an extent his friend, after the age of sixty, had come to admire the Turner that did not so strongly influence him at age thirty.)

In fact, the techniques Monet employs in his park paintings are wholly consistent with French nineteenth-century sketching practice, in which topography was regularly abstracted by the simplification of the paint application in broad touches meant to evoke rather than to describe the visual impression of a motif. In many respects, Monet's *Hyde Park* is the progeny of a

Fig. 117. Jean-Baptiste-Camille Corot, *View of Olevano*, 1827, oil on paper affixed to canvas. Kimbell Art Museum, Fort Worth

painting like Camille Corot's *View of Olevano* (fig. 117), emblematic of the kinds of sketches that dozens of artists produced.

But the interest in London's particular climate, where natural forces came together with pollution to make for a unusually visible atmosphere, may have led Monet to think, again, of the views along the Thames that Whistler had produced for the past decade. As his friend had done, Monet used a restrained and very narrow palette for each of these paintings, allowing blues to dominate coloristically but using black, white, and gray abundantly. In one, the spires of the Houses of Parliament and the tower of Big Ben are the dominant feature, emerging from a fog deep in the background; the other two show the so-called Pool of London, the deep stretch of the Thames between London Bridge and Limehouse that was the heart of the port. *Boats in the Port of London*, in a private collection, is the least familiar of all these views. It depicts the port near the

Fig. 118. James McNeill Whistler, *Limehouse*, 1859, etching and drypoint. The Metropolitan Museum of Art, New York. Harris Brisbane Dick Fund, 1917

Customs House, with London Bridge and the spire of Christopher Wren's St. Magnus Martyr beyond. With its crowded foreground, and with the suggestion of a dozen men at work on the docks, it is the London painting with the greatest sense of narrative. It seems likely that Monet had seen Whistler's *Thames Set* etchings mostly made in the previous decade but only published in 1871; *Boats in the Port of London* bears a strong resemblance to the etching *Limehouse*, which depicts a nearby locale (fig. 118). Perhaps Monet calculated that a Victorian audience would prefer a Thames view with more of a tale to tell—not coincidentally he signed the painting and inscribed it, with a flourish, "London."

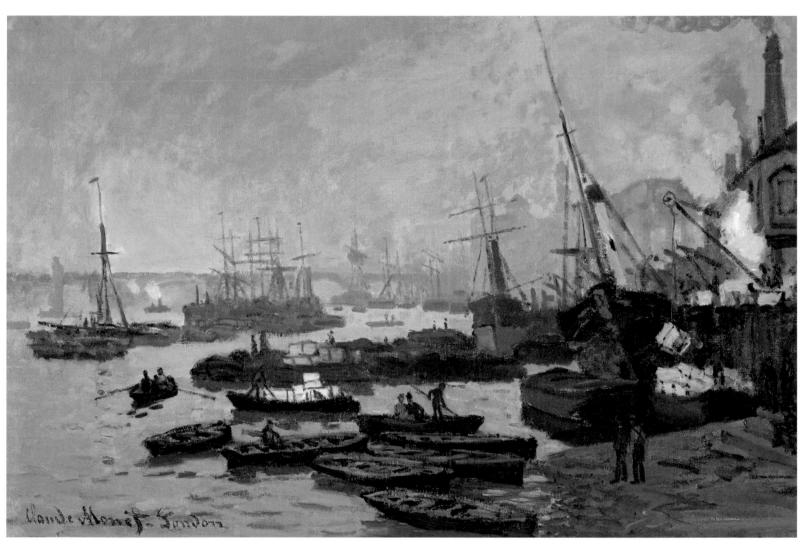

Cat. 41. *Boats in the Port of London*, 1871. Private collection

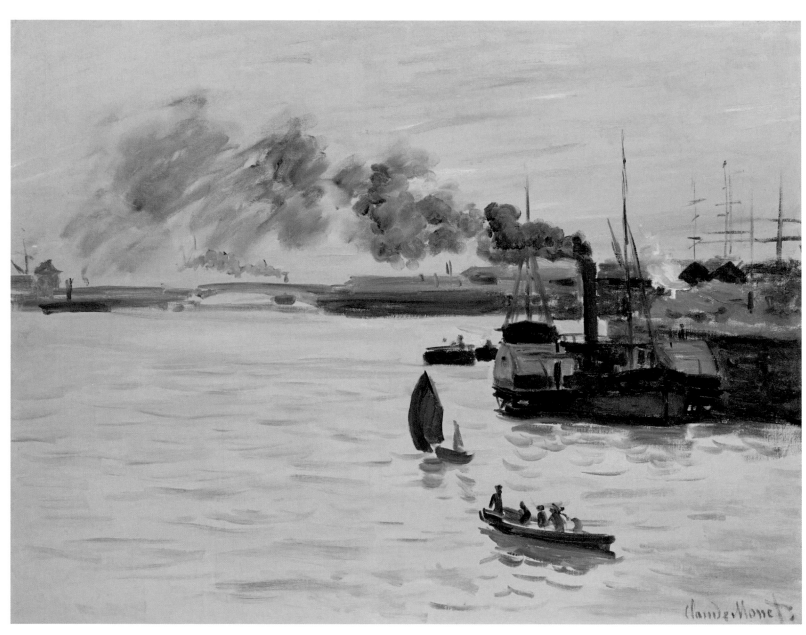

Cat. 42. *View of a Port*, 1871. Private collection

On June 2, 1871, Monet wrote to Pissarro, still in London, to give him news. "We have finally arrived at the end of our journey. . ." he wrote. "We traveled almost the whole length of Holland and, to be sure, what I saw of it seemed far more beautiful than it is said to be. Zaandam is particularly remarkable, and there is enough to paint for a lifetime."[1] The Monet family had traveled by steamship from England to Holland, probably arriving at Rotterdam and taking a train to Amsterdam, making their way on to Zaandam by boat. There they settled in to live at the Hotel de Beurs, on the port, where they remained for the rest of their stay, until early October—it was "very good accommodation," Monet said.[2]

Zaandam was a town of about twelve thousand people that could be reached by ferry from the central Amsterdam docks, making eight to ten hour-long trips in summer and four to six in winter. It is possible that Monet's *View of a Port* (cat. 42) records the Amsterdam end of this trajectory, and it might have been painted when Monet was in Amsterdam around June 22, at which time he paid a visit to the Rijksmuseum, or on some unrecorded visit to the city. Painted with an extraordinary economy of means and with apparent speed and assurance, on the other hand, it might date from near the end of the Monets' stay in Holland, after their return to Amsterdam in October.

The town of Zaandam was dominated by its four hundred windmills, which ground all manner of substances; some were for pressing oil, some for sawing wood (about a hundred each), and then, in diminishing numbers, there were mills for corn, mineral colors, paper, snuff, mustard seed, smalt, and for the beating of hemp. Still others ground a pumice-like stone called "trass" into a mortar that would harden under water, essential for the construction of the dykes that held the sea at bay and made possible the cultivation of the land.[3]

Though travel guides of the period estimated that a sightseeing trip to Zaandam from Amsterdam could be accomplished—including travel time—in four hours, Monet saw enough work there "for a lifetime." In his first two weeks in the town, the painter had time to take stock of the motifs that would be suitable for painting, including "houses of every color, hundreds of windmills, and enchanting boats." Over the course of the next four months, he would produce some two dozen pictures, the majority of them on the

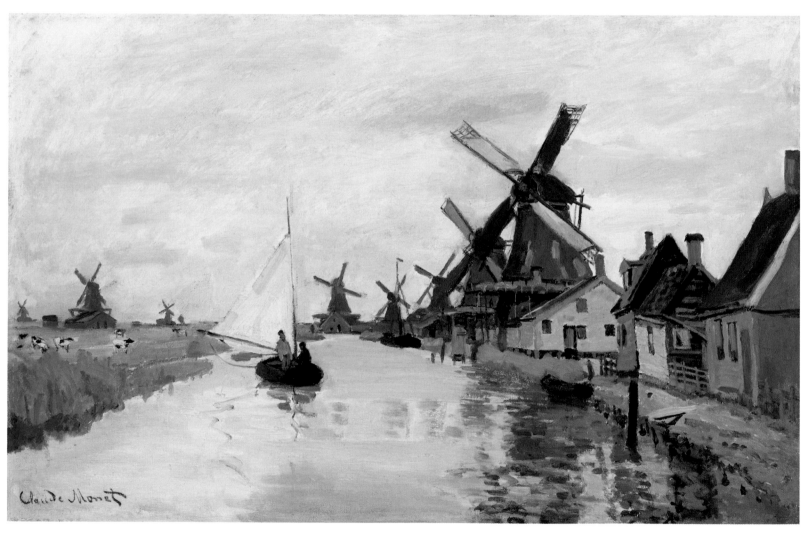

Cat. 43. *Windmills in Holland*, 1871. William I. Koch Collection

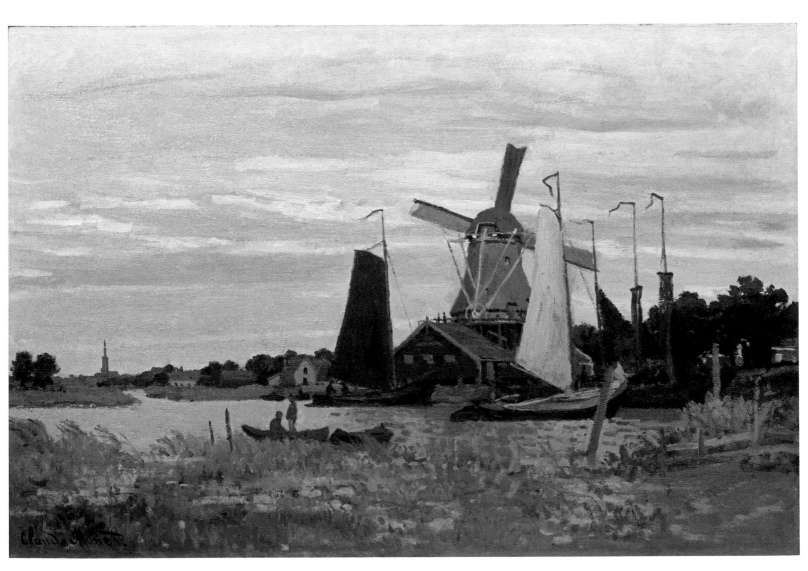

Cat. 44. *A Windmill at Zaandam*, 1871. Daniel Katz Gallery, London

same standard-size canvas, a "marine 20," measuring 48 x 73 cm—roughly 19 x 29 inches.

Of these, about half focus on the windmills that provided the town's employment and were the most conspicuous signs of the prosperity of its citizens, "some of which are said to be millionaires," as the guidebook related. Monet's canvas was undoubtedly chosen for its harmony with the broad vistas over low, flat fields, or *polders*, lying beside the canals dredged in a grid and lined with the mills. *Windmills in Holland* (cat. 43) shows one of these canals, the Noordervaldeursloot. His record of the site is accurate enough to be able to recognize the succession of windmills—each of which had a name—in contemporary photographs made for tourists from the same vantage point. The canal's surface acts as an irregular mirror; some spots provide a shifting reflection of the mills, while others, smoothed by a gust of wind, have a satiny finish. Monet probably stood on a lock to be able to look straight down the canal, resulting in an unusual plunging perspective with receding and converging water lines to establish the basic compositional structure. In portraying the Oosterkattegat mill—*A Windmill in Zaandam* (cat. 44)—Monet adopts a more comfortable sequence of planes, from the soft green grassy foreground to the reflective mid-zone of the water with its sailboats, against the solid shape of the mill. The painter accentuates the flatness of the landscape by painting the clouds in broad strokes of varied grays, over which he adds streaks of blue to break the cover.

Monet dedicated ten more paintings to views of the town of Zaandam itself, its harbor surrounded by commercial buildings, or the houses built along the Zaan. In *The Port of Zaandam* (cat. 45), depicting the harbor at sunset, the view is taken from a landing stage projecting into the water. The gently rippling surface of the water is rendered in perfectly parallel strokes of paint, each a perfect rectangle; the sky is laid on in broad swaths of yellow, pale blue, and rose. The blunt form of a harbor pier jutting from the water interrupts the nuanced dialogue between the sky and its reflection. Monet had first recorded this element in a sketchbook drawing; instead of ignoring it, as a more conventional painter might have done, he makes its dense, black

geometry an almost alarming feature of the foreground. As Ronald Pickvance notes, he uses the incongruous shape much as Degas might have used the projecting neck of a cello or bass violin to interrupt and contrast with the loveliness of a cluster of ballet dancers.

When choosing a viewpoint for *Houses by the Zaan at Zaandam* (cat. 46), Monet avoided any obstruction between him and the colorful eighteenth-century façades on the western side of the Achterzaan canal. Many dwellings were built along the principal canals in Zaandam, including the summer houses built for entertainment rather than habitation, such as the one shown in *The Landing Stage* (cat. 47), the record of a modern-day *fête galante* that calls to mind both *On the Bank of the Seine, Bennecourt* (cat. 30) and the scenes of revelry depicted at the bathing place *La Grenouillère* (cats. 31, 32).

In *Houses by the Zaan*, Monet divided the composition into three nearly equal horizontal bands, the center for the motif itself, the upper for the source of light, and the lower for the watery reflection of that light falling on the gaily decorated gable fronts. He then proceeded to use three different kinds of brushstroke, each appropriate to its purpose. He used a medium-sized brush to paint the ivory-white clouds and the surrounding blue sky, showing them frankly without calling undue attention to them. The buildings were set in place in broad, flat planes, but the texture of the roof was rendered by first painting a series of slanting verticals, then running through these while they were still wet with horizontal bands of shadow. The foliage of the surrounding trees is described using short, daub-like strokes. All of these contrast with the description of the rippling water, composed of hundreds of separate strokes of color, typically laid side by side rather than on top of each other, and applied with a glancing motion so that each end of the stroke comes to a taper. Throughout this zone, tiny areas of the white ground peek through between the brushstrokes; Monet did not paint long bands of reflection and then come back to add the blue-purple waves—each stroke occupies its own space. The result is one of the most complex and nuanced passages of reflected light in the painter's oeuvre.

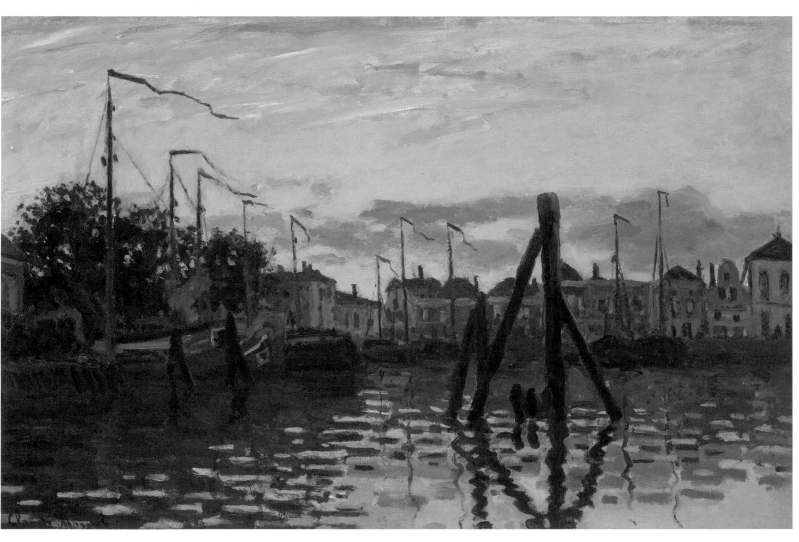

Cat. 45. *The Port of Zaandam*, 1871. Private collection

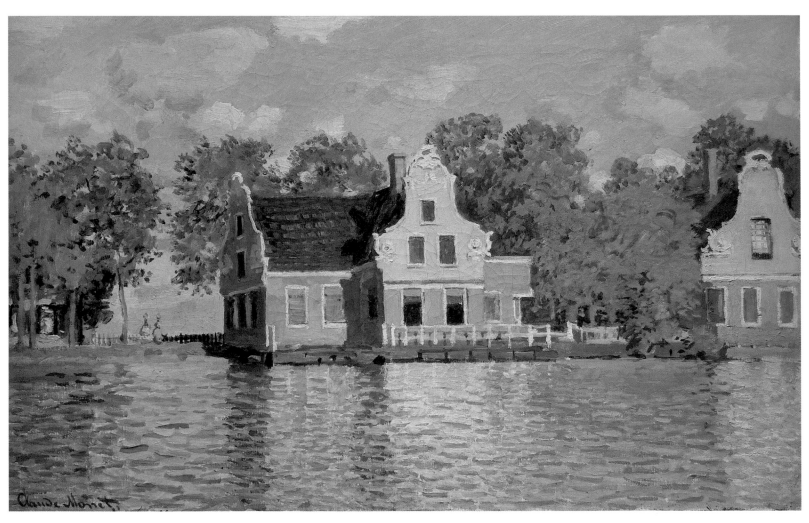

Cat. 46. *Houses by the Zaan at Zaandam*, 1871. Städel Museum, Frankfurt am Main

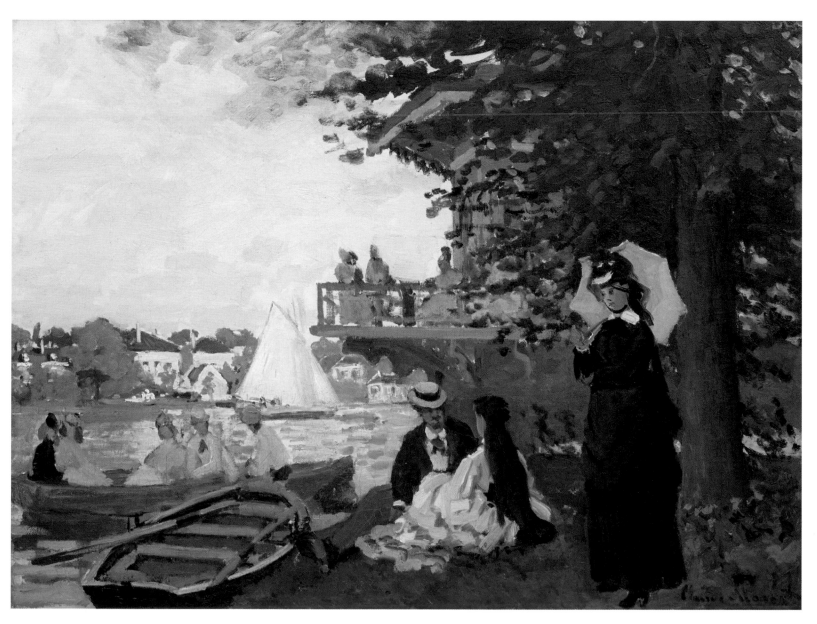

Cat. 47. *The Landing Stage*, 1871. Acquavella Galleries, New York

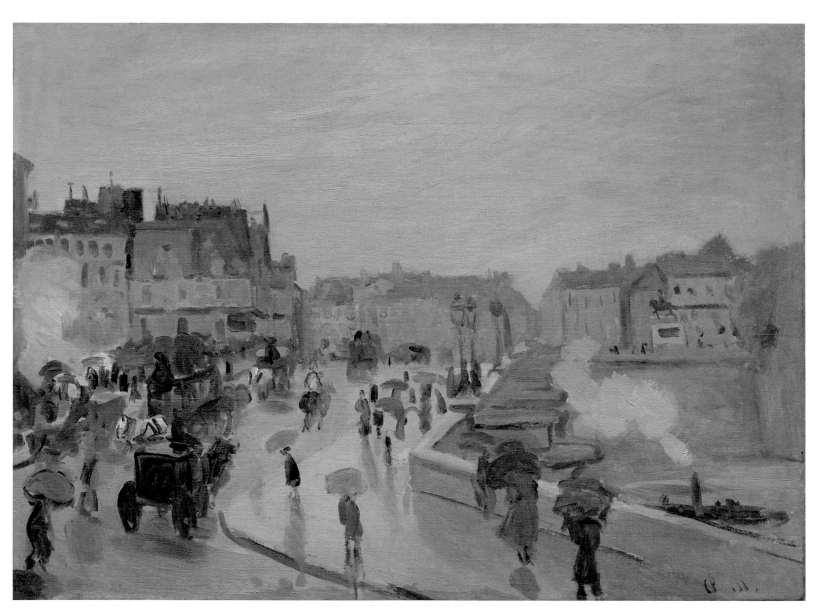

Cat. 48. *The Pont Neuf in Paris*, 1871. Dallas Museum of Art

When the Monet family returned to Paris in October 1871 they encountered a city that had been transformed. While parts of Paris were untouched, others were barely recognizable, not so much because of the siege launched by the Prussian armies but because of the wholesale destruction that occurred during the Commune—the short-lived revolutionary government declared in the wake of national defeat, harshly repressed by the forces of the Third Republic only after a violent civil war. The Monets occupied rooms in a hotel near the Gare Saint-Lazare, but as one approached the monuments of the historic center of Paris, many buildings stood in ruins, walls surrounding empty space. A tourist guidebook to the ruins of Paris proposed promenades to take in the most important sites of destruction; there were enough to occupy four days on foot.[1] When Monet had last painted the banks of the Seine in 1867 (see cats. 19 and 20) the city had been at a highpoint of Imperial power, rejoicing in the newly opened Universal Exposition. At the end of 1871, it was a city struggling to return to order.

While in Paris, Monet painted only one picture, a view of the Pont-Neuf, again observed from the right bank of the river but not from the Louvre (cat. 48). Instead Monet moved to a less august structure giving onto the end of the bridge at the quai. Photographs of the site from the period suggest that there was a business there—perhaps a café—with a mezzanine floor; it is perhaps from this vantage point, above the street but no higher than the first floor above, that Monet looked out on the motif.

The day was cold and rainy, which became the perfect opportunity to make, once more, a monochrome picture closer to his 1869 snow scenes than to any view he had confronted in the previous year. Perhaps because the changeable Paris weather could have meant the cessation of rain and the breaking through of sunshine at any moment, Monet worked very quickly. Beginning with a darker ground than was his usual practice—in this case, a medium gray—he laid in the components of the motif with great assuredness, usually applying no more than one stroke, perfectly chosen and positioned. A walking man could be conveyed with six or seven strokes of a brush loaded with both gray and black, while a few dabs of a lighter gray would render his indistinct reflection. Using the all-over wetness of the canvas and paints to describe misting rain and shining sidewalks was the perfect solution to seizing the effect.

Fig. 119. Pierre-Auguste Renoir, *Pont Neuf, Paris*, 1872, oil on canvas. National Gallery of Art, Washington, DC. Ailsa Mellon Bruce Collection

The painting is, in fact, the kind of work painters could call by the term "impression," denoting not so much the mental picture formed by looking quickly at something, but instead the physical object that was the result of that looking: a rapid sketch of a place under specific conditions of light and atmosphere that would convey everything necessary with the absolute physical minimum. Its status as an informal work is denoted by the artist's signature: he used just his initials instead of his full name. An ideal point of contrast is Renoir's celebrated view of the same site from a nearly identical vantage point (fig. 119), painted less than a year later, which, as a highly finished work, represents a considerable loosening and broadening of

Fig. 120. Alfred Sisley, *Rue de la Chaussé at Argenteuil*, 1872, oil on canvas. Musée d'Orsay, Paris

the budding Impressionists' manner of 1867. Monet's impression has much in common with such canvases as *Fishing Boats at Sea* (cat. 22) and *View of a Port* (cat. 42) in applying this sketch method to the execution of an independent canvas. Still, its first owner bought it from Monet in 1877 with the title *Sketch: Pont Neuf.*[2]

The optimism and self-confidence that seem to pervade Renoir's *Pont Neuf, Paris* are found in Monet's view of the center of the town of Argenteuil, where he settled his family in December 1871. *The Old Rue de la Chausée, Argenteuil* is drenched with sunlight, pouring into the canvas from the left and striking the façades of the buildings at the right, illuminating their buttery stucco fronts and doors, shutters, and signs in gay pastel hues (cat. 49).

The painting is true to its site, if we judge by the canvas that Alfred Sisley painted side by side with his friend Monet (fig. 120). Window by window and door by door, all seems to match—with the exception of the church steeple at right, which Sisley dutifully paints and which Monet, exercising the artist's prerogative, haltingly begins then abandons for the simpler V-shaped roofline of the converging buildings. In both paintings there is a noticeable absence of street life, with only a few women and children, the odd baker or businessman, out and about. All seems calm and peaceful, perhaps the ideal environment for an ambitious painter and his young family.

That confidence and enthusiasm may stem from Monet's considerable change in circumstances since his departure for London in 1870. By virtue of his new connection with Durand-Ruel, he was enjoying, for the first time in many years, a steady income, sufficiently large to allow the family to live in their new town in great comfort, in a large house with handsome grounds and household servants. As Paul Tucker reminds us, Monet's success in his first year in Argenteuil is measureable: he sold thirty-eight paintings in that year, receiving nearly ten thousand francs from Durand-Ruel alone; his income was over twelve thousand francs, a level he had never before imagined. Simultaneously, he was extraordinarily prolific, painting nearly sixty pictures in the year—more than one every week—a lifetime record to that date.[3]

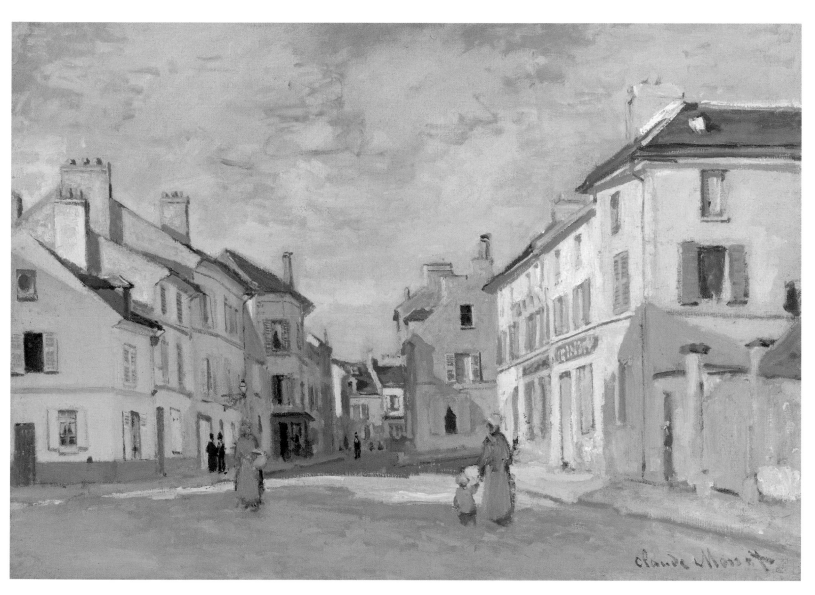

Cat. 49. *The Old Rue de la Chausée, Argenteuil*, 1872. Courtesy of Christie's

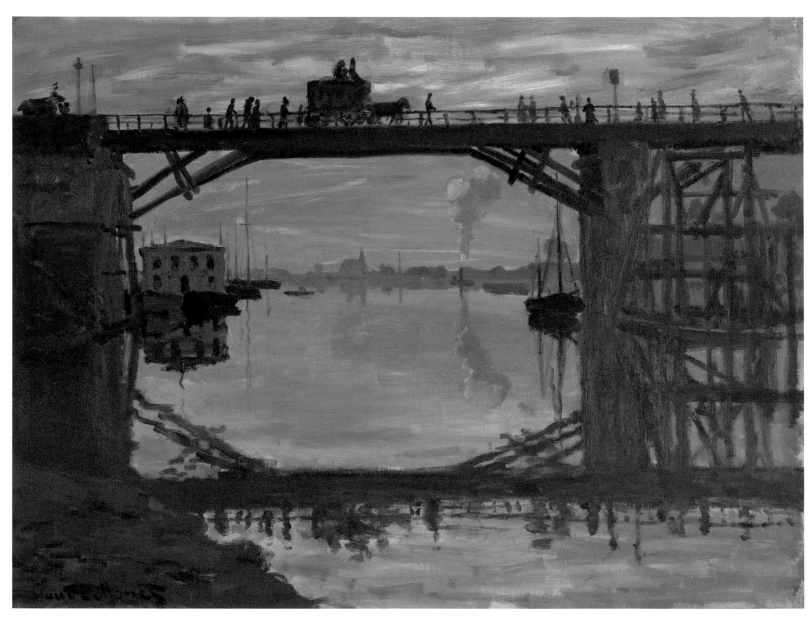

Cat. 50. *The Wooden Bridge*, 1872. VKS Art Inc., Ottawa

Bridges are an intermittent but important theme in Monet's art, from the docks of *La Grenouillère* (cats. 31, 32) and the distant bridges on the Thames in *Boats in the Port of London* (cat. 41) to the end of his career, with the extended series of paintings he devoted to the Japanese bridge in his Giverny garden. It was in Argenteuil, though, that the theme first rose to prominence, in the years 1872–78. Monet devoted eighteen canvases to painting the two bridges that crossed the Seine there, the roadway bridge that linked the town to Petit-Gennevilliers and the railway bridge that led to Paris. *The Wooden Bridge* shows the first of these, as it appeared in early 1872 (cat. 50).

As Annabelle Kienle Pŏnka recounts in her study of *The Wooden Bridge*, the original bridge had been erected in the early 1830s and had served its purpose well until, during the Franco-Prussian war, it was destroyed by French troops to hinder the opposing forces' march on Paris.[1] Monet's first painting of the bridge had shown it encased in scaffolding, some of which is still in place, at right, in *The Wooden Bridge.* By the time the artist returned to the subject, the temporary roadway had been constructed, the bracing timbers linking the road to the stone piers forecasting the iron structure that was soon to be installed—which is visible, for instance, in the distance in *The Port of Argenteuil* (cat. 55). Atop the bridge a thin stream of pedestrian and vehicular traffic is silhouetted against the sky, streaked with sunset reflections.

Monet was surely thinking of the example of the Japanese prints he so admired when he planned the composition. A good example is Hokusai's *Mannen Bridge*, notable for its symmetry and for the interest provided by the line of men and women using the structure—two of whom have stopped to look in the water or at the artist (fig. 121). Monet's bridge is not placed symmetrically on the canvas—left to right, that is—but its reflection creates another kind of symmetry altogether: because the water line hits the piers halfway up the canvas, and because Monet blurs that division so that the bridge and its reflection are almost identical in density, their gray structure, teetering between depth and flatness, pushes forward as a near abstraction of symmetrical reflection.

But Monet complicates the game by framing a distant view within the octagonal "window" the reflected structure creates. At the horizon stand the modern riverside smokestack and mansion—centered on the octagon—that figure prominently in many of Monet's subsequent river views (see cat. 54 and figs. 34–36). The more distant horizon, nearer the top of the composition, and the expanse of water before it, are treated with great subtlety and nuance, confounding the simplified planarity of the gray bridge and its reflection. In all, *The Wooden Bridge* is among the most sophisticated experiments in balance in Monet's *oeuvre.* Comparisons to the equivalent experiments of Kasimir Malevich or Piet Mondrian, in the early twentieth century, or of Ellsworth Kelly, at the century's close, are justified.

Fig. 121. Katsushika Hokusai, *Under the Mannen Bridge at Fukagawa* from the series *Thirty-Six Views of Mount Fuji*, 1830–32, polychrome woodblock print; ink and color on paper. The Metropolitan Museum of Art, Rogers Fund, 1922

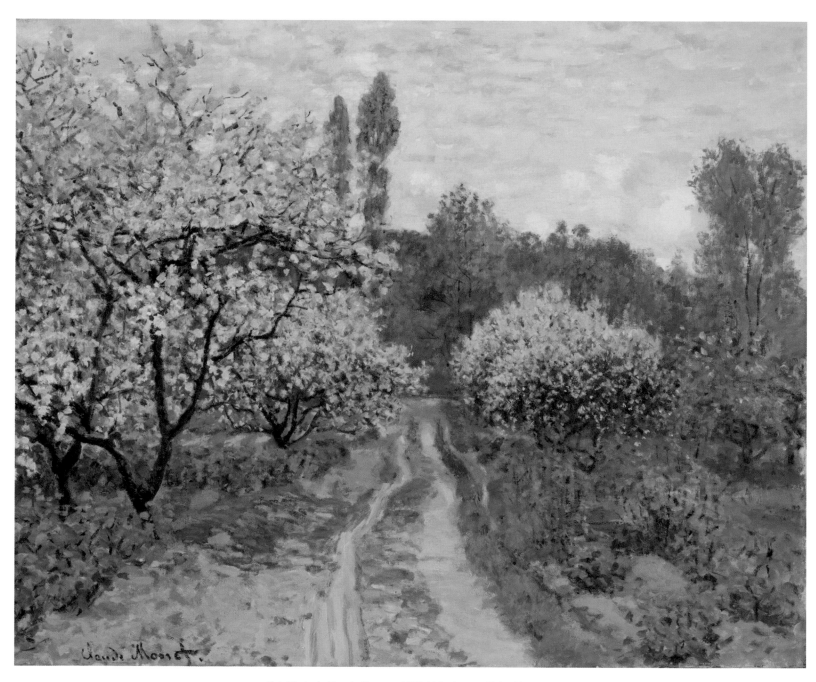

Cat. 51. *Apple Trees in Blossom*, 1872. Union League Club of Chicago

The arrival of spring in 1872 provided Monet with the first opportunity he had had in many years to paint nature in bloom, a subject that was to become one of his favorites and which, in one form or another, he was to be identified with again and again over the course of his career. In this year, he completed four canvases depicting the flowering trees found in his garden. Three were devoted to the garden immediately around the house and celebrated the gently curving trunks and arching branches of lilac trees heavy with flowers. *Lilacs in the Sun* (fig. 122) exemplifies this group, each of which features one or two women resting in the garden, in the sunlight or, as here, sheltering from the sun beneath the trees.[1] (A fourth painting of this type takes a close look at the woman herself, all but omitting the blossoming plants.[2])

Apple Trees in Blossom was sent to the second Impressionist exhibition in 1876 with the title *Springtime*. At first it seems that these trees must be in the countryside, reached by the dirt path that meanders into the distance. But a critic in 1876 leaves a different impression as he describes the subject: "*Springtime* shows a grassy garden path that disappears between blossoming apple trees and shrubs bursting into leaf." He went on to praise the painting's "abundant freshness" and "the impression of the month of May that brings joy to the eyes."[3]

The confirmation that the painting represents a suburban garden rather than a cultivated corner of countryside, then, explains the presence of rows of trimmed vines beneath the trees at left and the young tendrils being trained on spindly poles at right. The former may be there to provide grapes for the table, the latter to bring forth a crop of peas as the spring turns into summer. *Apple Trees in Blossom*, just one of many paintings of the Argenteuil garden that Monet would paint in his time there, is the first to show a flowering fruit tree—a subject to which Monet would return often in future years. If, indeed, the painting represents a "wild" corner of this first garden, then it is also a precedent for the many paintings of the orchard area he inherited then cultivated at Giverny after his move there in 1883.

Fig 122. Claude Monet, *Lilacs in the Sun*, 1872, oil on canvas. Pushkin Museum, Moscow

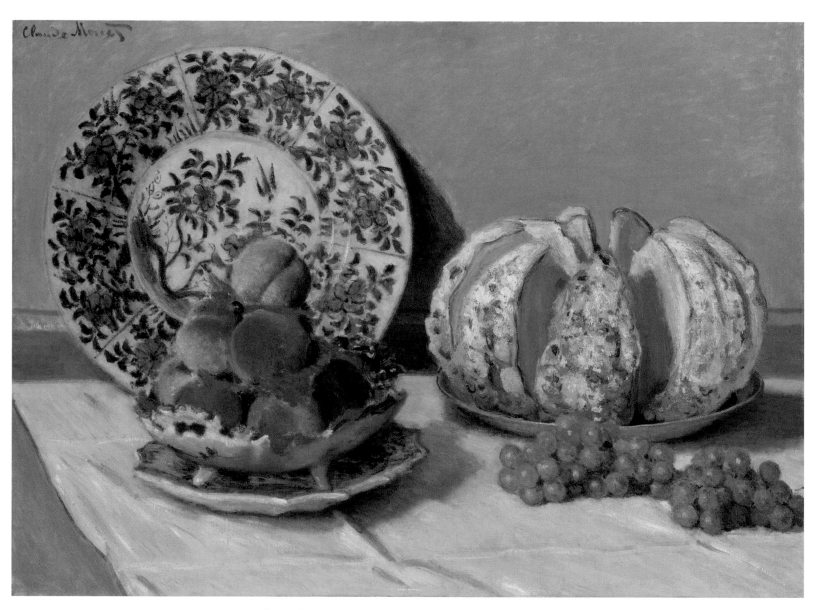

Cat. 52. *Still Life with Melon*, 1872. Museu Calouste Gulbenkian, Lisbon

O ften considered the rainy-day activity of the landscape painter, still-life paintings, by the 1870s, were a popular genre for which a considerable market had developed—a market that called for a response.[1] Both *Still Life with Melon* and *The Tea Service* (cats. 52, 53), painted in 1872, were bought in November of that year by Durand-Ruel, who shortly thereafter bought eleven still lifes from Monet's friend Henri Fantin-Latour. The dealer sold *Still Life with Melon* almost at once; *The Tea Service*, on the other hand, did not immediately find a buyer, and remained in Durand-Ruel's stock for some time.[2]

This fact reflects the essential differences between the two paintings. Though not strictly conceived as a pair, they are of identical dimensions and use simple and identical compositional strategies: from slightly above, diverse objects are seen on a tabletop covered with a white cloth, which is in turn pressed against a background wall, parallel to the picture plane. Beyond these shared characteristics, however, the resemblances give way to dissimilarities, and the differences are complementary.

Still Life with Melon is, of the two, more colorful and lighter in mood. Monet chose and arranged the objects with great care, creating a motif manifestly devised for a painter. At left, a blue-and-white charger of Chinese design is balanced against the back wall. In front of it, a dish is filled with a pile of ripe peaches. At right, a whole melon cut into wedges is arranged on a plate, the colors of its flesh echoing the skin of the peaches. Sunlight pours into the composition from the left, casting deep shadows. The painting, clearly the conceit of an artist, could be a modern response to a picture by Jean-Baptiste Chardin, *Melon, Pears, Peaches, and Plums*, 1760, known as *The Cut Melon*, which was shown in the Galerie Martinet exhibition of the French masters in 1860 and entered the collections of the Louvre in 1869 as part of the bequest of Dr. Louis LaCaze.

If *Still Life with Melon* is almost self-consciously a contrived still life, *The Tea Service* is its opposite. Here, everything is calculated to give the impression of informality and accident. A velvety green plant is placed as if it had been moved to make room on the cloth for the tea tray. The cloth's geometric pattern, reinforced by linear traces where it was folded, sets off the tea tray, casually placed at an odd angle and pushed to one side, a corner touching the picture frame. Monet lavishes considerable attention on the painting of the tray; its shiny surface reflects the tea set as if it were a stretch of water, the cool surfaces of china setting off its vivid red.

The silver spoon, brushed in with great pleasure to look as if it were casually placed, sums it up: *The Tea Service*, to quote Fantin, gives "the appearance of a total lack of artistry."[3] One sunny, the other dim; one filled with color, the other almost minimal; one artful, the other artless: *Still Life with Melon* and *The Tea Service* are so different as to match each other perfectly.

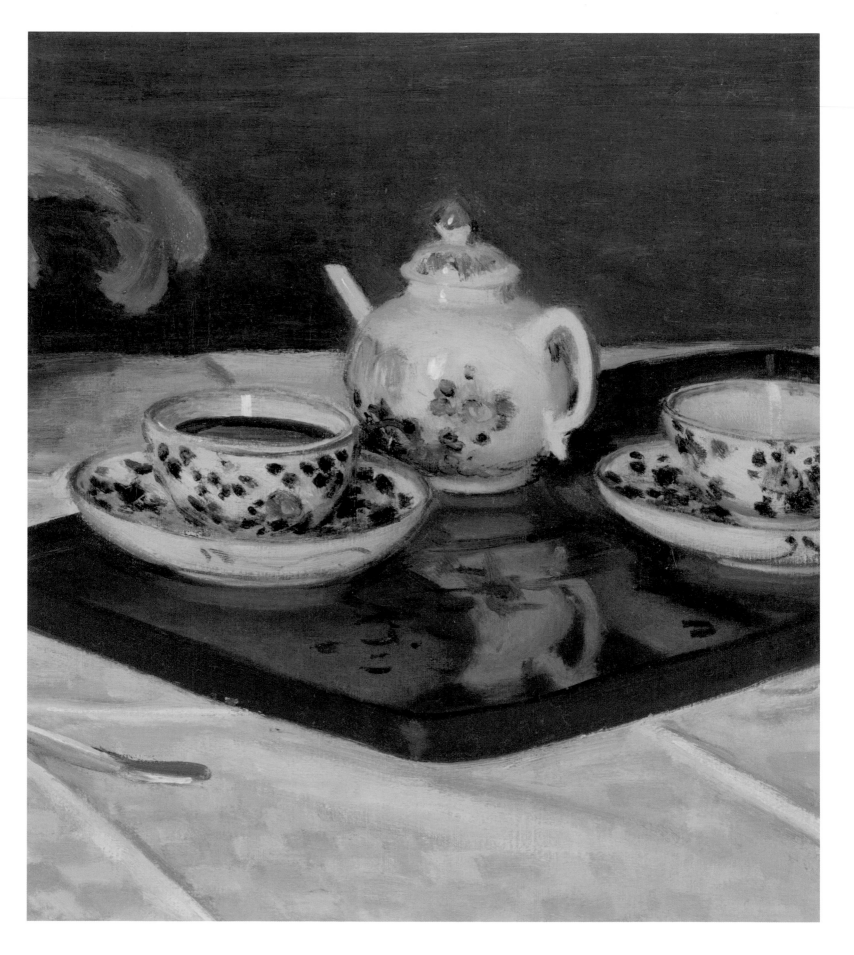

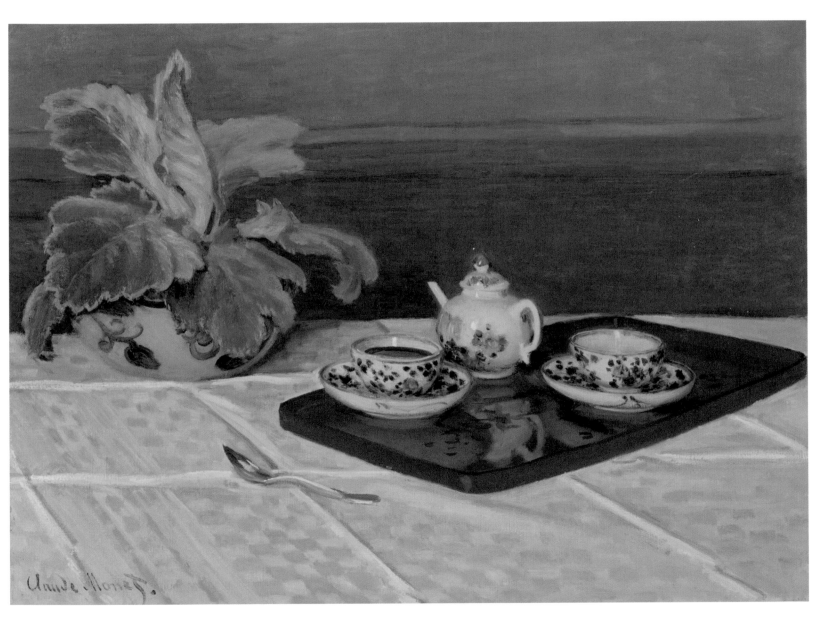

Cat. 53. *The Tea Service*, 1872. Private collection

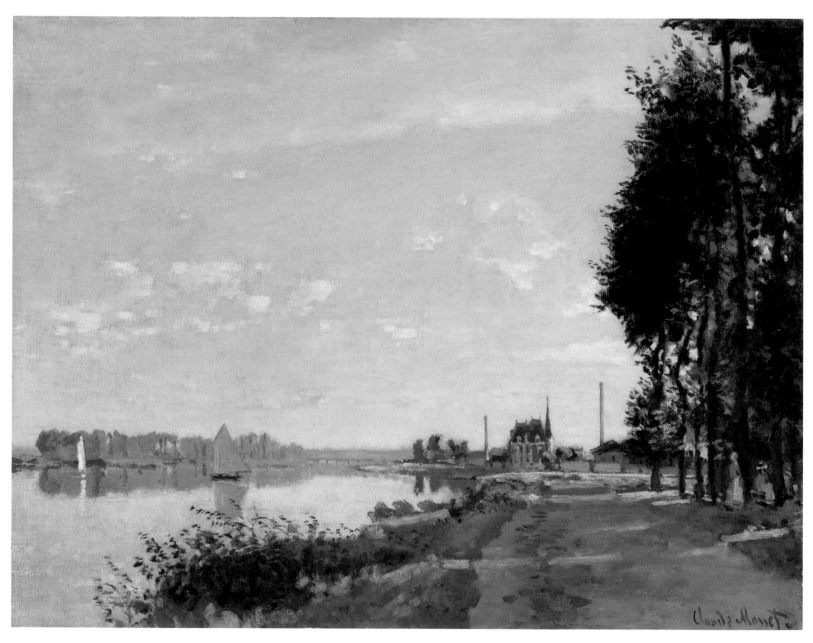

Cat. 54. *Argenteuil*, 1872. National Gallery of Art, Washington, DC

Three paintings from the summer of 1872 serve as a fitting end to the story of Monet's early years, inasmuch as they are not only summations of what came before them, but also indicators of what will happen—and happen very quickly—in the next decade. That decade will see, in 1874, Monet's first exhibition as a member of the group of independent artists who were—on the basis of the most controversial painting of the year, Monet's own *Impression: Sunrise*—soon to become known as Impressionists. At the end of the decade, in 1882, Monet will exhibit for the last time with the group, afterwards seeking recognition on his own in one or another monographic exhibition. Some of these will take a broadly retrospective form—especially in 1889, when his paintings were accompanied by a smaller number of sculptures by Rodin—but most will focus on specific groups of works, more intently through the 1890s and up until 1911, the close of his exhibitions of series.

A measure of his future could be foreseen already in 1872 in the four versions of the composition now best known from the picture called *Argenteuil* in the collection of the National Gallery of Art (cat. 54; figs. 34–36). The Washington canvas is, as Paul Tucker characterized it, "perfectly crafted" and "of consummate beauty," each element of the composition, earth, water, and sky, "in absolute harmony" with the other.[1] Possessing, with its lengthening shadows cast by the setting sun, something of the elegiac mood of *Bridge at Bougival* (cat. 33), it exemplifies Monet's compositional mastery, achieving poise without symmetry, variety of tone and hue within a balanced whole. Whether the sequence was planned or not—and the disparity of canvas sizes suggests not—the group of four constitutes a kind of series, in which two cloudy views would be the first and second in the day, the Washington canvas the third, at sunset, and the *End of the Day* the last. They call up memories of the great champion of the classical French tradition, Claude Lorrain, as suits the poetic character of the subject, the walking path along the Seine, forming the river border of the shaded groves that made up Argenteuil's park-like Champ de Mars.

Within the framework of classical landscape, however, are intrusions of the modern—not unwelcome, necessarily, but not unnoticed. Marking the end of the promenade stood the romantic Château Michelet, a recent construction in the Louis XIII style, owned by a banker who was also a fine sailor and an officer in the yacht club. Beyond the house with its turret and spire are the buildings, and above all the chimneys, of a factory that appears to be part of the house's precinct, but in fact is many yards away. As several authors have noted, the delicate reference to this indication of modern life does not

indicate that Monet found the factories objectionable: as we know, he was capable of simply not painting something that he found distracting. The factories are there—as is the recently repaired iron highway bridge in the background of *The Port at Argenteuil*—as Monet's way of reminding his viewers that his art is capable of having social meaning. If *Argenteuil* is an image of the quiet beauty of Argenteuil as the refuge for his family, perhaps suggested by the figures in the wood at right—then *The Port at Argenteuil* (cat. 55) considers the bustle of everyday business. Although tourists are depicted on the promenade at left, it is the multiplicity of activity on the water—houses to bathe in, houses for washing clothes, rowboats, steamboats, and sailboats—combined with the evocation of a fast-changing sky that gives the painting its sense of business under way.

The Port at Argenteuil looks forward to the kind of painting that was to become essential to Monet in the coming years. It is so nuanced as to be acceptable to the adventurous end of the spectrum of collectors, and while not crafted with popular appeal as its prime motivation, it was the kind of painting that Durand-Ruel could purchase from the artist and be able to sell. In this case, its first owner was Ernest Duez (1843–1896), a collector of paintings by Manet and the Impressionists whose own works were considerably more conservative, often featuring a meticulously dressed, attractive young woman alone or with a friend on a beach of the type painted by Monet in the 1860s. He epitomized the *juste milieu*—the happy medium—between the Salon and the vanguard.

On the other hand, there is the astonishingly bold *Regatta at Argenteuil* (cat. 56), a wholly modern painting that is rich in references to Monet's own recent history. The bold technique the artist had practiced in the working studies for *The Port of Honfleur* (see cat. 14) or *Boats at Sea* (cat. 22) is with him again as he paints the gleaming sails of boats on the Argenteuil basin. The effects that he had broached in the *pochades* of La Grenouillère (cats. 31, 32) lie behind the schematic shorthand he used to paint the bright orange houses reflected in the blue waters of the Seine. But *Regatta at Argenteuil* offers no respite from the glare of modern art: nowhere in this almost garishly colored canvas is there a shadow. The entire surface shouts for attention, must be looked at, considered, absorbed, felt deep inside. It should come as no surprise, then, that the brave first owner of *Regatta at Argenteuil* was a renegade, Monet's friend and fellow painter Gustave Caillebotte, who purchased it in April 1876, just before the opening of the second Impressionist exhibition, in which his own radical *Floor Scrapers* would make its debut. It would be among the first works by Monet to enter the national collections, on the death of Caillebotte, in 1895. By then, as it happened, Monet's distant early years were largely forgotten, in spite of his attempts to keep them before the public eye. Offered to posterity by an artist with a daring and discerning eye, *Regatta at Argenteuil* was the perfect declaration of Monet's past and future, a fitting threshold at the close of the artist's early years.

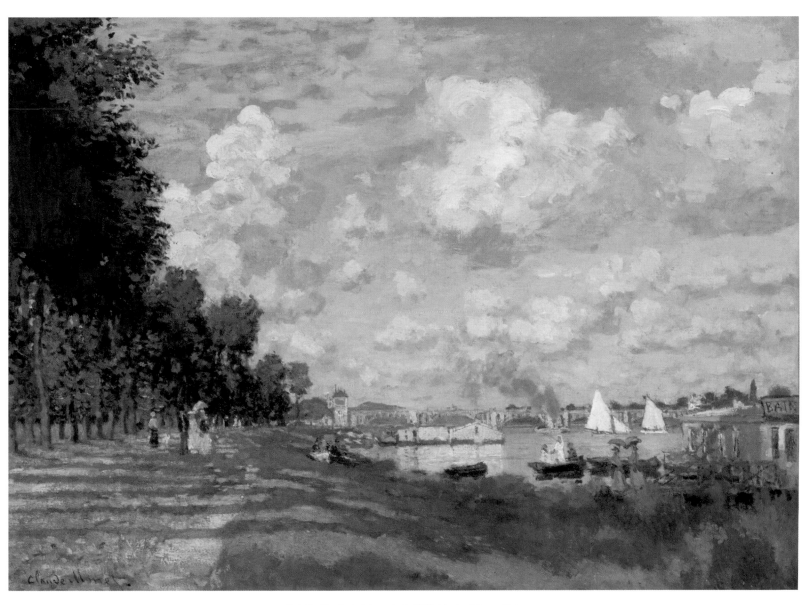

Cat. 55. *The Port at Argenteuil*, 1872. Musée d'Orsay, Paris

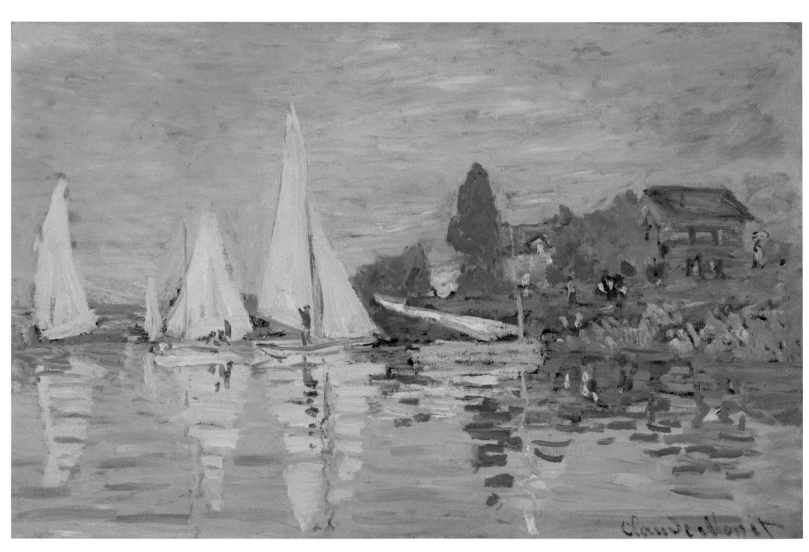

Cat. 56. *Regatta at Argenteuil*, 1872. Musée d'Orsay, Paris

Notes

Introduction: The Invention of Monet

1. Gary Tinterow and Henri Loyrette, *The Origins of Impressionism* (New York: The Metropolitan Museum of Art, 1994); and Charles F. Stuckey, *Claude Monet, 1840–1926* (New York and Chicago: Thames and Hudson and the Art Institute of Chicago, 1995)

2. Guy Cogeval et al., *Claude Monet, 1840–1926* (Paris: Réunion des musées nationaux, 2010)

3. John House, *Nature into Art* (New Haven and London: Yale University Press, 1986). See particularly the excellent discussion "Monet and the Public Exhibition," chapter 13.

4. For example, see Félix Régamey, "The Portrait at This Year's Salon," in *La Vie Parisienne*, May 5, 1866; Bertall, "The Salon of 1866," *Le Journal Amusant*, May 12, 1866.

5. See André Arnyvelde, "At Home with the Painter of Light" in *Je Sais Tout*, January 15, 1914, quoted in Charles F. Stuckey, *Monet: A Retrospective* (New York: Hugh Lauter Levin Associates, 1985), 273.

6. Wildenstein posits that *Port of Honfleur* was shown at the premises of Haagerman and says that *Women in the Garden* was shown by Latouche; Latouche apparently bought one of the views from the Louvre in which the Pantheon figures, either cat. 19 or cat. 20.

7. See Wildenstein 157a.

8. House, *Nature into Art*, op. cit., 206.

9. The painting, titled *Japonnerie* in 1876, is now generally known as *La Japonaise*, at the Museum of Fine Arts, Boston.

10. Wildenstein suggests that the *Grenouillère* exhibited in 1877 may have been not W.134 but W.136, the larger version of the painting now lost.

11. See the documentation of the 1879 exhibition in Ruth Berson, *The New Painting: Impressionism 1875–1886* (San Francisco: Fine Arts Museums of San Francisco, 1996), 114–17. *The Green Wave*, exhibited as *Marine*, was dated 1875, but this may have been meant to be 1865, a more plausible date even to an 1879 viewer; *Jeanne Marguerite Lecadre in a Garden* was shown as "*Un jardin, 1867*"; the famous terrace was shown as "*Jardin à Sainte-Adresse, 1867*"; and two more paintings were situated as being works from 1875.

12. The lamplight scene is either W.129 *The Dinner / The Sisley Family*, National Gallery of Art, Washington, D.C., or W.130, *An Interior after Dinner*, Emil G. Bührle Foundation, Zurich.

13. Octave Mirbeau in Galerie Georges Petit, *Monet-Rodin* (exh. cat., Paris: Galerie Georges Petit, 1889), 22.

14. The exhibited paintings were W. 732 and W. 741.

15. Mirbeau in *Monet-Rodin*, op. cit., 22–23.

16. Louis Vauxcelles, "An Afternoon Visit with Claude Monet," *L'Art et les Artistes*, December 1905, trans. in Stuckey 1985, 247.

17. Walter Pach, "At the Studio of Claude Monet," *Scribner's Magazine*, June 1908, in Stuckey 1985, 254–55.

Hunting for Light: *Luncheon on the Grass*

1. Joel Isaacson's *Monet: Le déjeuner sur l'herbe* (New York: Viking Press, 1972) is the most comprehensive account of the painting, and my work on the subject is indebted to his account.

2. Monet had been to the forest several times as a young boy in the company of family friends. Manet's *Déjeuner sur l'herbe* was originally exhibited as *Le Bain*.

3. Monet told this to the Duc de Trévise. "*Déjeuner sur l'herbe* que j'avais fait après celui de Manet." See Duc de Trévise, "Le pèlerinage de Giverny," *La revue de l'art ancien et moderne*, v. LI, no. 283 (January–May 1927): 121–22.

4. Isaacson, *Monet: Le déjeuner sur l'herbe*, 33.

5. There are many different hypotheses as to why Monet did not complete this picture. Geffroy suggests that Courbet's commentaries discouraged Monet and made him abandon the canvas. Gustave Geffroy, *Claude Monet: sa vie, son temps, son oeuvre* (Paris: G. Crès, 1922), 40. Geffroy states that at this time Monet left the discarded canvas with his landlord as security for nonpayment of rent. Gaston Poulain did say that Courbet visited Monet and Bazille at their rue Furstenberg studio early in 1866, complimenting them on their Salon paintings. Gaston Poulain, *Bazille et ses amis* (Paris: La Renaissance du Livre, 1932), 62. In an interview with the Duc de Trévise in 1920, however, Monet made no mention of Courbet's intervention, and, contrary to popular belief that Monet abandoned the canvas out of frustration, he told Trévise that this painting, "so incomplete and so mutilated," was in fact quite dear to him. Duc de Trévise, "Le Pèlerinage à Giverny," 122.

6. Isaacson too notes most of these connections, although he curiously does not make mention of Manet's *Young Woman Reclining in Spanish Costume*. He does, however, note the connection to Goya's *Maja*. Isaacson, *Monet: Le Déjeuner sur l'herbe*, 55.

7. The same could be said of Manet's relation to Watteau. Although the most obvious historical sources of Manet's *Déjeuner sur l'herbe* date to the Renaissance, there are striking links to eighteenth-century painting, and in the early 1860s, Manet was profoundly engaged with the art of Watteau. See Michael Fried, *Manet's*

Modernism: Or, The Face of Painting in the 1860s (Chicago: The University of Chicago Press, 1996), especially chapter 1, "Manet's Sources," and chapter 2, "Manet's Sources Reconsidered." Although less conspicuous than in some of his other paintings, Manet's interest in Watteau is visible in *Déjeuner,* notably in the crouching figure in the background whose pose, as Fried points out, seems so closely related to Watteau's earlier drawing *La villageoise,* which was reproduced in an engraving by Antoine Aveline. The original title of Manet's painting, *Le bain,* would seem to reinforce its allegiance to the eighteenth-century Rococo tradition in spite of the now clear connections between Manet's *Déjeuner* and a Renaissance print by Marcantonio Raimondi. As Fried writes, "*Le Déjeuner sur l'herbe* is probably the most striking instance of the way in which references to specific works by other painters may obscure a less specific but possibly fundamental reliance upon Watteau." Fried, *Manet's Modernism,* 56.

8. In his article on Monet's *Grandes Décorations* at the Orangerie, François Thiébault-Sisson recounts an anecdote told by Clemenceau about a time when Clemenceau asked which painting Monet would borrow from the Louvre as the two exited the museum together. Clemenceau said he would take Courbet's *Burial at Ornans,* and Monet said he would choose Watteau's painting. "Nous sortirons du Louvre tous deux, et je dis à Monet : – Si j'avais la permission d'emporter une toile, c'est *l'Enterrement à Ornans* que je prendrais. – Pas moi, me répondit-il. Je choisirais *l'Embarquement pour Cythère.*" Thiébault-Sisson concludes his article by saying, "Ce mot simple explique à merveille et la carrier de peintre et l'évolution dernière de Monet. Comme Watteau, ce pur réaliste était un afflamé d'idéal; et c'est pourquoi il y a tant de magie dans son art." François Thiébault-Sisson, "Les Nymphéas de Claude Monet à l'Orangerie des Tuileries." *La revue de l'art ancien et moderne,* T. LII (June 1927): 52. This dialogue was recounted by Clemenceau in *Claude Monet: Les Nymphéas* (Paris, 1928), 68. See also Georges Lanoë, *Histoire de l'École française de paysage depuis Chintreuil jusqu'à 1900* (Nantes, 1905). He says that Monet's art is "quelquechose de très vieux . . . un art où se retrouve le dynamisme de Watteau et de 1830, amplifié à l'extrême." This is cited in Gustave Geffroy, *Claude Monet,* 231. In this publication, Geffroy also discusses Monet in connection to Watteau. See pp. 80, 242. See also Louis Gillet, "L'Epilogue de l'impressionnisme: Les 'Nymphéas' de M. Claude Monet," *Revue Hebdomadaire* 8 (21 August 1909): 397–415.

9. See Mary Tavener Holmes and Christoph Martin Vogtherr, *De Watteau à Fragonard: Les fêtes galantes,* exh. cat. Musée Jacquemart André, Paris, 2014. Joel Isaacson in *Monet: Le déjeuner sur l'herbe* and Robert Herbert in *Impressionism, Art, Leisure and Parisian Society* (New Haven, CT: Yale University Press, 1988) have also noted the connection between Monet's painting and the *fêtes galantes,* but neither scholar goes into much depth on the subject, nor do they discuss the element of the theater or the *jardin d'amour* in Monet's painting.

10. Allison Unruh's dissertation presents a thoroughgoing analysis of the Rococo revival in the Second Empire and has informed my discussion here. See Allison Unruh, "Aspiring to *la vie galante*: Reincarnations of Rococo in Second Empire France" (New York University, 2008).

11. See Gloria Groom, ed. *Impressionism, Fashion, and Modernity,* exh. cat., The Metropolitan Museum of Art (New Haven and London: Yale University Press, 2013), 90.

12. Burger I, p. 266. "Watteau ! Avant lui, on faisait des princesses, et il a fait des bergères ; on faisait des déesses, et il a fait des femmes ; on faisait des héros, et il a fait des saltimbanques—et même des singes!" Cited in Fried, *Manet's Modernism,* 73.

13. See Isaacson, *Le Déjeuner sur l'herbe,* 68–69 and *Impressionism, Fashion, and Modernity,* 86–105.

14. See Mark Roskill, "Early Impressionism and the Fashion Print," *The Burlington Magazine,* vol. 112, no. 807 (June 1970): 390–93, 395. See also Isaacson, *Le Déjeuner sur l'herbe* and Groom, ed. *Impressionism, Fashion, and Modernity.*

15. See Unruh, "Aspiring to *la vie galante.*"

16. I am not the first to notice that Monet's painting rewrites this tradition. Isaacson (p. 39) and Herbert (p. 176) too have noticed the connection to Van Loo's painting in particular. But neither scholar discusses the fact that the hunt was still going on in the forest at this time nor the currency of hunt imagery and metaphors of the hunt as an expression of broader social change. Herbert does briefly mention, however, that Fontainebleau was a royal hunting ground, and so too was the Bois de Boulogne, which was a public park by the time Monet painted *Luncheon on the Grass.* See Herbert, *Impressionism, Art, Leisure and Parisian Society,* 176–77.

17. Thomas E. Crow, *Painters and Public Life in Eighteenth-Century Paris* (New Haven and London: Yale University Press, 1985), 56.

18. In the earliest recorded histories of royal visits to Fontainebleau— including those by Louis VII, Philippe Auguste, Philippe le Bel,

Charles V, and Charles VII—there is always mention of the royal hunting parties. As Edmond Pilon explains in his history of the forest and its château, "The pleasures of the chase have always been a great attraction at Fontainebleau. The Bourbon kings were always passionate devotees of the sport, and if Louis XIV and Louis XVI preferred hunting in the neighborhood of Versailles, Henry II and Louis XIII looked upon the old forest of Fontainebleau as an ideal place for the pursuit of deer with hound and horn, the shooting of birds on the wing, the netting of ground-game and the various other forms of sport practiced in their day." Edmond Pilon, *Fontainebleau* (Grenoble: B. Arthaud, 1931), 152.

19. The revolution of 1848 and the fall of Napoleon III in 1870 brought much the same sequence of events.

20. Sénatus-consulte du 12 décembre 1852, art. 2. Cited in Vincent Cochet, "Les coulisses de Fontainebleau. Le service du palais et l'organisation des séjours," in *Napoléon III et Eugénie reçoivent à Fontainebleau, l'Art de vivre sous le Second Empire*, exh. cat. Musée des Arts Décoratifs, Bordeaux, 2011–12, 13–38.

21. The imperial hunting party was featured in an illustration in almost every issue of *Journal des chasseurs*, and the tally of the emperor's kills was published in hunting journals. For example, on January 7, 1861, in the forest of Fontainebleau, Napoleon III killed 168 animals: 12 deer, 150 pheasants, and 6 partridges. Apparently he improved with age. On January 16, 1868, *Journal des chasseurs* reports that the emperor killed 3 deer, 17 rabbits, 286 pheasants, and 67 grey partridges, for a total of 373 animals—almost triple the next-highest tally of 185 animals, brought in by the prince de la Moskowa. *Journal des chasseurs*, 25th année, 1st semestre, November 1860–April 1861, 192. This is one of innumerable mentions of "Vénerie impériale" in the *Journal des chasseurs*. See also "Vénerie impériale," 30th année, 1st semestre, November–April 1866, 356; "Chasse à Tir de S.M. l'Empereur Forêt de Fontainebleau 16 janvier 1868," 31st année, 1ˢᵗ semestre, November–April 1867, 186; and "Un relais à la gorge aux loups (Fôret de Fontainebleau)," *Journal des chasseurs*, no. 2, 2nd semestre, May–October 1860, ill. May 15, 1860, plus, in same issue, p. 398, the mention of "vénerie impériale."

22. "Une curée aux flambeaux. Fontainebleau, 12 mai 1857," *Journal des chasseurs*, 21st année, June 15, 1857, shows an episode where the imperial hunters, led by the prince de la Moskowa, run after a deer the whole day with the emperor and the hôte de marque, the grand-duc Constantin de Russie, frère du tsar, who was staying in the palace May 11–15. They let the dogs eat the remains of the animal in the middle of the court. According to Annick Notter, in January 1867 tickets were issued to the imperial *chasse à tir* as though it were a theater spectacle. Annick Notter, *Fontainebleau, son château et sa forêt: L'invention d'un Tourisme (1820–1939)*. (Paris: Éditions de la Réunion des musées nationaux, 2007), 9.

23. The artist Alexandre-Gabriel Decamps died in a hunting accident on August 22, 1860; while he rode his horse (some said following the imperial hunting party), a large branch pierced his stomach, and he passed away within hours. *Journal des chasseurs*, 24th année, 2nd semester, May–October 1860, 288. In 1868, *La chasse illustrée* reported an incident in which a group of painters studying nature in the forest found themselves face to face with wild boar. The article was accompanied by an illustration showing an artist about to be run over by a charging *sanglier*. Lennet, "Le peintre et le sanglier," *La chasse illustrée*, no. 10, 2nd année, October 5, 1868, 80.

24. Robert Louis Stevenson, *Picturesque Notes on Edinburgh: Memories of Fontainebleau: Random Memories* (London: Nash & Grayson, 1930), 280.

25. Stevenson, *Memories of Fontainebleau*, 282–83.

26. This line was the Paris-Tonnerre section of the Paris-Lyon railway line. In 1840, the Paris-Orléans line opened the Paris-Corbeil branch, which brought visitors within a short distance of the forest, but it wasn't until 1849 that tourists could travel directly to the forest by rail.

27. Adolphe Joanne, *Fontainebleau. Son palais, ses jardins, sa forêt* (Paris: Hachette, 1856), 2.

28. In 1856, Sand noted with disdain that in the forest "surroundings have become a bit too like a pleasure garden. There are too many names and emblems on the rocks. There are too many of them everywhere." George Sand, March 23, 1856, in *Agendas, tome 1, 1852–1856* (Paris: Jean Touzot, 1990), 367. Philippe Burty grew up going to the forest. After a visit in 1872 he wrote, "Man can be felt everywhere. Large red and blue arrows shoot forth from the intersections of all the trails, as if a forest wasn't made for getting lost in! They've attached a caricature in bronze called Nemorosa to the side of a rock. . . . There is a 'Viewpoint Victor-Emmanuel,' a Rossini oak, and a descent of Orpheus. It's execrable." Philippe Burty, "La forêt de Fontainebleau," *La renaissance littéraire et artistique* 27 (October 26, 1872): 211–12.

29. This guide was published in at least seventeen editions by the time Denecourt died in 1875. Interestingly, Denecourt had been a soldier in the army and then held posts in the Department of War Administration, first in Versailles and then in Fontainebleau. After being dismissed from the department, Denecourt decided to devote himself wholly to the task of describing the forest in what would become the best-known series of guidebooks on the area to date.

30. See Kimberly Jones, "Landscapes, Legends, Souvenirs, Fantasies," in *In the Forest of Fontainebleau: Painters and Photographers from Corot to Monet*, exh. cat. National Gallery of Art, Washington, 2008, 5–27.

31. In his book *The Spectacle of Nature: Landscape and Bourgeois Culture in Nineteenth-Century France* (Manchester and New York: Manchester University Press, 1990), Nicholas Green discusses the rise in forest tourism and the embrace of "natural nature" or *natura naturans* as a

direct outgrowth of the modernization of the city.

32. Wildenstein, I, *Claude Monet, or The Triumph of Impressionism* (Köln: Taschen, 1999), 353.

33. Gustave Flaubert, *A Sentimental Education: The Story of a Young Man*. Translated with an introduction and notes by Douglas Parmée (Oxford and New York: Oxford University Press, 1989), 346. For further examples, see pp. 347–49.

34. Cited in Brian Nelson, "Introduction," in Émile Zola, *The Kill (La curée)*, translated with an introduction by Brian Nelson (New York: Oxford University Press, 2004), xi.

35. For a thorough analysis of the subversive themes of Courbet's hunting pictures, see Gilbert Titeux, *Au temps du brame—: les representations de la chasse dans l'oeuvre de Gustave Courbet et dans la peinture allemande du XIX siècle : 1800–1900* (Dijon, France: Presses du réel, 2014).

36. T. J. Clark, *Image of the People: Gustave Courbet and the 1848 Revolution* (Berkeley, CA: University of California Press, 1999), 114.

37. See, among others, ibid., 83–85.

38. Théophile Gautier, *Abécédaire du Salon de 1861* (Paris: E. Dentu, 1861), 133.

39. For more on this, see Kimberly Jones, *Impressionist and Post-Impressionist Masterpieces from the National Gallery of Art* (New York: Prestel Publishing, 2011).

40. According to Jones in *Impressionist and Post-Impressionist Masterpieces*, Fontainebleau is the setting, and the work was painted in the studio on the rue Visconti. It was rejected from the Salon of 1867 (apparently when it was rejected a patron offered to buy only the painting's lower left-hand quadrant, which contained the dead doe). Ambroise Vollard, *En écoutant Cézanne, Degas, Renoir* (Paris: Grasset, 1938), 153.

41. Charles Baudelaire, *The Painter of Modern Life and Other Essays*, trans. Jonathan Mayne (London: Phaidon, 1965), 11.

42. Carol Armstrong also discusses the slippage between the body and the eye in Baudelaire's essay. See Carol Armstrong, *Manet/Manette* (New Haven and London: Yale University Press, 2002), 123–24.

43. This is Clement Greenberg's thesis. See "On the Role of Nature in Modernist Painting," in *Art and Culture: Critical Essays* (Boston: Beacon Press, 1961), 171. Indeed the fact that this painting is set in a hunting ground offers another example that would seem to literalize Greenberg's notion that the history of modernism is a history of the arts being "hunted" back to their mediums. Clement Greenberg, "Towards a Newer Laocöon," *Partisan Review* 7 (July–August 1940): 296–310.

44. Greenberg portrays the development of Monet's practice this way in the references cited n. 76. His view has been the standard line of formalist criticism of Monet's work.

45. See Gary Tinterow and Henri Loyrette, *Origins of Impressionism* (New York: Metropolitan Museum of Art, 1994); Gary Tinterow et. al, *Corot* (New York: Metropolitan Museum of Art, 1996); Kimberly Jones et al., *In the Forest of Fontainebleau: Painters and Photographers from Corot to Monet*; and Malcolm R. Daniel, *Eugène Cuvelier: Photographer in the Circle of Corot*, exh. cat. Metropolitan Museum of Art, New York, 1996. Monet may also have seen work by photographers like Jean Delton. A series of Delton's photographs of hunting parties was shown in the Salon of 1865. Pierre Petit, who lamented the transformations taking place in the forest of Fontainebleau, was also a well-known photographer of hunting parties. Contemporary critics noted that by occupying all his time with photographing hunting parties in the countryside Petit missed out on money to be made constructing hunting scenes in the studio. "Offre aux heureux propriétaires d'équipages de meutes et de châteaux, d'aller les photographier chez eux. Il économise le champ de pose, mais il perd toute cette partie de la clientèle qui ne monte que sur des chevaux de louage et ne se promène qu'en voiture de remise." Petit, cited in Lacan Ernest Lacan, "Revue de la Quinzaine," *Le Moniteur de la Photographie*, No. 3, April 15, 1861: 18.

46. For more on this, see Daniel, *Eugène Cuvelier*; Tinterow et. al, *Corot*, 265; Aaron Scharf, "Camille Corot and Landscape Photography," *Gazette des beaux-arts* 6, no. 59 (February 1962): 99–102; Kermit S. Champa, *The Rise of Landscape Painting in France: Corot to Monet*, exh. cat. Currier Gallery of Art, Manchester, NH, 1991; and Gustave Le Gray and Carleton E. Watkins, *Pioneers of Landscape Photography: Photographs from the Collection of the J. Paul Getty Museum* (Frankfurt am Main: Städtische Galerie, 1993), 90–106.

47. Other striking comparisons between Monet's painting and contemporaneous photographs include his *Chemin sous bois* (W.58 1865), which might be compared with Constant Famin's *Forest Scene*, c. 1865, and Monet's *Forêt de Fontainebleau*, which looks very similar to John Beasely Greene's *Forest of Fontainebleau*, c. 1852, as well as Gustave Le Gray's *Study of Trees and Pathways*, 1849, and *Tree, Forest of Fontainebleau*, c. 1856.

48. See Rosalind *Krauss*, "*Impressionism*: The *Narcissism* of *Light*," Partisan Review, vol. 43, no. 1 (1976): 102–12.

49. Krauss discusses this. Ibid., 107.

50. Ibid., 106–7.

51. See Anita Brookner, *Watteau* (Paris, Odege, 1967); Norman Bryson, *Word and Image: French Painting of the Ancien Régime* (Cambridge: Cambridge University Press, 1981); Mary D. Sheriff, ed. *Antoine Watteau, Perspectives on the Artist and the Culture of his time* (Newark: University of Delaware Press, 2006).

52. Edmond et Jules de Goncourt, *L'art du XVIIIᵉ siècle* (Paris: A Huot de Goncourt, 1873), 14. "C'est Cythère; mais c'est la Cythère de Watteau. C'est l'amour; mais c'est l'amour poëte, l'amour qui songe et qui pense, l'amour moderne, avec ses aspirations et sa couronne de mélancolie. Oui, au fond de cette oeuvre de Watteau,

je ne sais quelle lente et vague harmonie murmure derrière les paroles rieuses; je ne sais quelle tristesse musicale et doucement contagieuse est répandue dans ces fêtes galantes."

53. Bryson, 70–71.

54. Isaacson, in *Monet: Le déjeuner sur l'herbe*, argues that the difficulty of recognizing illusionism with surface unity should be considered the principal reason for the painting's failure.

Emergent Naturalism: Reflections on Monet's Early Paintings, 1864–1874

1. Ernest Chesneau, "Le Réalisme et l'Esprit Français dans l'Art," in *L'Art et les Artistes Modernes en France et en Angleterre* (Paris: Didier, 1864), 3–41.

2. Ibid, p. 41. (*La vitalité du réalisme français n'est puissante que parce qu'il peut se combiner avec l'idéal.*)

3. Ernest Chesneau, *Les Nations Rivales dans l'Art* (Paris: Didier, 1868), 304–5. (*se montrent originaux, sincères, passionnément épris de la vérité, curieux de tout effet pittoresque nouveau, cherchant sans relâche à pénétrer les secrètes leçons de leur maître unique: la Nature . . . mesquines conventions*)

4. Émile Zola, "Mon Salon," *L'Événement*, May 11, 1866, see É. Zola, *Le Bon Combat: de Courbet aux Impressionnistes*, ed. Jean-Paul Bouillon (Paris: Hermann, 1974), 69. (*un coin de la nature vu à travers un temperament*)

5. David Bomford, Jo Kirby, John Leighton, and Ashok Roy, *Art in the Making. Impressionism* (London: National Gallery, 1990), 130.

6. Letter 53, to Bazille, September 25, 1869, in Daniel Wildenstein, *Claude Monet, biographie et catalogue raisonné*, vol. I, 1840–1881 (Lausanne/Paris: La Bibliothèque des Arts, 1974), 427.

7. John House, *Monet. Nature into Art* (New Haven/London: Yale University Press, 1986), 147.

8. Wildenstein, 1974, nos. 197–98; 199–200; 203–4.

9. Richard Thomson, "Reconstruction and Reassurance: Representing the Aftermath of the Franco-Prussian War," in *Monet. A Bridge to Modernity*, ed. Anabelle Kienle Ponka, (Ottawa : National Gallery of Canada, 2015), 40, 44.

10. Carol McNamara et al., *The Lens of Impressionism. Photography and Painting along the Normandy Coast, 1850–1874* (Ann Arbor: University of Michigan Museum of Art, 2009), repr. p. 181.

11. Émile Zola, "Mon Salon," *L'Evénement illustré*, May 24, 1868. See É. Zola, *Le Bon Combat*, op. cit., 113. (*vagues sales, ces poussées d'eau terreuse qui ont dû épouvanter le jury habitué aux petits flots bavards et miroitants des marines en sucre candi*)

Taking Shape: Monet's Compositional Techniques

1. Carolus-Duran painted Monet's portrait in 1867 and dedicated the painting to him. As noted by John House, *Monet, Nature into Art* (London and New Haven: Yale University Press, 1986), 8. Monet met Whistler in Trouville in 1865.

2. This painting appears post-dated to "64" and may be an earlier work.

3. De Piles, *Les premiers élémens de la peinture pratique . . .* (Paris: 1684), 53.

4. Antoine-Joseph Pernety, "Toile," in *Dictionnaire portatif de peinture, sculpture, gravure . . .* (Paris: Chez Bauche, 1757), 535. He lists standard canvases from no. 4 (12 x 9 *pouces* [inches]), costing four *sous*, up to 'toile de 6 liv.' or [no.]120 [*sous*]: 72 x 48 *pouces*. The *sou* was replaced by the *centime* and the *livre* by the Franc after metrication during the Napoleonic era.

5. Paillot de Montabert, *Traité complet de peinture* (Paris: J. F. Delion, 1829), vol. IX, p. 144; he noted that fixed formats were used throughout Paris and provided the list used by the famed color merchant Mme Belot, rue de l'Arbre-Sec, no. 3, near the Pont-Neuf.

6. For a full analysis, see Anthea Callen, *Artists' Materials and Techniques in Nineteenth-Century France* (PhD thesis, Courtauld Institute of Art, 1980, ch. 2, pp. 50–77.

7. Bourgeois *aîné* 1888, and Lefranc 1896.

8. Winsor & Newton 1849, p. 48.

9. Charles F. Stuckey, *Claude Monet, 1840–1926* (New York and Chicago: Thames and Hudson and the Art Institute of Chicago, 1995), 39, notes Zola's as the first reference to Monet painting in series, in his review "The Actualists" (*L'Événement*, 1868).

10. Zola, "The Acualists," *L'Événement*, 1868, quoted in Stuckey (1985), p. 38.

11. See Robert Herbert's discussion of the influence of Jongkind and Dutch seventeenth-century seascapes on Monet, in *Monet on the Normandy Coast: Tourism and Painting 1867-86* (New Haven and London: Yale University Press, 1994), 9, 10, and 14.

12. He had already used this small format for quick plein-air studies, as in *Fishing Boats, Honfleur* (W74).

13. This is an important distinction: the skyline refers to the line where sky meets land; the horizon-line is literally that—the line of the horizon (the sea) whether visible or not in a particular landscape, and of course normally present in a marine.

14. See Robert Herbert, *Monet in Normandy* and House, *Monet, Nature into Art*.

15. See House's discussion of this tendency and painting in *Monet, Nature into Art*, 47–51.

16. Letter from Boudin to Martin, February 18, 1868, cited by House, *Monet, Nature into Art*, 47.

17. Monet used the same canvas size (horizontal landscape 25; 60 x 81 cm) for W224 and W225, which is almost identical in ratio of proportions to his black chalk drawing at 20.6 x 31.4 cm.

18. Regarding the importance of this canvas to Monet's Salon submissions of 1865, see the citation in the Chronology (1864) in Charles Stuckey, *Claude Monet, 1840–1926*, op. cit., 189.

19. Zola, "Les Actualists," in *L'Evenement*, 1868. Cited in Stuckey, 1985,

38: "The sea swells and heaves in the foreground."

20. On knife painting in this period see Anthea Callen, *The Work of Art: Plein Air Painting and Artistic Identity in Nineteenth-century France*, London, 2015.

21. Winsor & Newton Trade Catalogue, [n.d.] c. 1890?, 34.

22. Cf. other approx. double-square Zaandam pictures, in D Wildenstein, *Monet: catalogue raisonné*, (Cologne: Taschen/Wildenstein Institute, 1996), vol. II, nos. W.174 (33 x 70 cm), W.175 (39 x 71 cm), and W.179 (34 x 74 cm).

23. See the analysis in Anthea Callen, *The Art of Impressionism: Painting Technique and the Making of Modernity* (New Haven and London: Yale University Press, 2000)

24. Paul Mantz, 'The Salon of 1865," *Gazette des Beaux-Arts*, 1865, cited in Stuckey, 1985, 32, and Zola, "Les Actualists," reprinted in Stuckey, 1985, 38.

25. Steven Adams, also Nicholas Green, also Callen, *The Work of Art*.

26. Emile Bergerat, *Journal Officiel*, April 17, 1877, quoted in House, *Monet, Nature into Art*, 45.

Paraph Painter

1. Yves Bonnefoy, statement in Shusha Guppy, "Yves Bonnefoy: The art of poetry LXIX" *Paris Review* 36 (Summer 1994): 108 (italics added).

2. Barnett Newman, "The First Man Was an Artist" (1947), *Selected Writings and Interviews*, ed. John P. O'Neill (Berkeley: University of California Press, 1992), 158.

3. Heinrich Wölfflin, *Principles of Art History*, trans. M. D. Hottinger (New York: Dover, 1950 [1915]), 21.

4. Idem.

5. Idem.

6. *Le Pavé de Chailly*, 1865 [Musée d'Orsay; fig. 93], obviously, shows a different atmospheric effect.

7. My nineteenth-century colleagues—George Shackelford, Anthea Callen, Richard J. Brettell, the late John House, James D. Herbert, and above all, Robert L. Herbert (not to mention many others)—have been joint participants in exploring the issues I discuss here.

8. Paul Mantz, *Salon de 1847* (Paris: Ferdinand Sartorius, 1847), 96, 98–99. I translate Mantz's *peinture émouvante* pleonastically as "emotionally moving painting" to signify the implicit link between psychic and somatic movement in the experience of emotion. (Unless otherwise noted, all translations are the author's.)

9. Mantz, *Salon de 1847*, 98–99, 102. In response to the same Salon, Théophile Thoré had similar thoughts about the expressive potential of a naïve attitude toward representing nature; Thoré-Bürger [Théophile Thoré], "Salon de 1847," *Les Salons*, 3 vols. (Brussels: Lamertin, 1893), 1:477–79, 538.

10. Charles Blanc, *Grammaire des arts du dessin* (Paris: Henri Laurens, 1880 [1867]), 577–78.

11. Charles Blanc, "Salon de 1866," *Gazette des beauxarts* 21 (July 1866): 38. Exaggerated brushwork in paintings by followers of Corot prompted Blanc's comment. See also Blanc, *Grammaire des arts du dessin*, 576–77.

12. On "photographic" transparency in history painting, see Stephen Bann, *The Clothing of Clio* (Cambridge: Cambridge University Press, 1984), 72; *Paul Delaroche: History Painted* (Princeton: Princeton University Press, 1997), 265.

13. Charles Clément, "Les paysagistes français contemporains" (1853), *Études sur les beaux-arts en France* (Paris: Michel Lévey frères, 1869), 336.

14. Newman had deep respect for the work of the major impressionist painters, especially Monet and Camille Pissarro. In his view, they represented a welcome alternative to the modern tradition that derived from the so-called post-impressionist art of Paul Cézanne. See Newman, "Open Letter to William A. M. Burden, President of the Museum of Modern Art" (1953), *Selected Writings and Interviews*, 38-40.

15. Wölfflin, *Principles of Art History*, 22.

16. For information on the history and condition of this work, see the remarkably thorough study conducted by the curatorial, research, and technical staffs of the Art Institute of Chicago, at https://publications.artic.edu/monet/reader/paintingsanddrawings/section/135549 (accessed 23 July 2016). I concur with their conclusion: "Rather than a composition left incomplete, *On the Bank of the Seine, Bennecourt*, with its complex and sometimes unsettling surface, seems to have been the result of initial decisions and later changes of course, suggesting not careful premeditation but instead an organic working method."

17. See statements by Mantz and Clément, notes 8 and 13.

18. I have admired this painting for many years, to the point of hand-copying it several times, not with the aim of representing it precisely in all detail, but at a speed that I thought mimicked the rate at which the artist would have been working. I was attempting to imitate the materiality and material presence of the work, different from the stilled appearance it may have in a reproduction, which captures its state of suspended finish but not its mobile energy. 19. Think of our electronic communication grid, the 24-hour news cycle, the sound bite.

20. Compare my argument with regard to Cézanne and the "loss of subject": Richard Shiff, "He Painted," in Barnaby Wright and Nancy Ireson, eds., *Cézanne's Card Players* (London: Courtauld Gallery, 2010), 72-91.

21. André Derain, letter to Henri Matisse, 15-16 March 1906, quoted in Rémi Labrusse, *Matisse: la condition de l'image* (Paris: Gallimard, 1999), 53.

22. Words of Barnett Newman; see note 2.

Catalogue

Cat. 1, pp. 82–83

1. See the listing for the exhibition in Paul Lacroix, *Revue Universelle des Arts* (Brussels: Labrouque et Cie., 1858), 549.

Cats. 3–5, pp. 86–91

1. See, for instance, *Origins of Impressionism*, op. cit., 421.
2. The author of the review, signed "Pigalle," is thought to be Zacharie Astruc, a friend of Manet. Quoted by Gary Tinterow in *Origins of Impressionism*, op. cit., 421.

Cats. 7–8, pp. 94–97

1. Monet to Bazille, April 9 and April 28, 1865. Wildenstein 1974, letters no. 17 and 18.
2. Bazille to his mother, April 1863, quoted in Kimberly Jones et al., *In the Forest of Fontainebleau: Painters and Photographers from Corot to Monet* (Exh. cat. National Gallery of Art, Washington, D.C., 2008), 65.
3. Gustave Flaubert, *The Sentimental Education*, quoted in Kimbely Jones, et al., op. cit, 65.

Cats. 10–12, pp. 102–7

1. See the chapters devoted to Camille Doncieux and Claude Monet in Ruth Butler, *Hidden in the Shadow of the Master: The Model-Wives of Cézanne, Monet, and Rodin* (New Haven and London: Yale University Press, 2008).
2. Monet to Bazille, August 12, 1867. Wildenstein 1974, letter 37.
3. Monet to Bazille, December 1868. Wildenstein 1874, letter 44
4. Butler, op. cit., 129.
5. The date of the painting has been much debated. Stylistically we feel that its most likely date brings it close to the study of Jean, and therefore at the next snowfall, which took place in January and February 1869. See various discussions in Charles S. Moffett et al., *Impressionists in Winter, Effets de Neige* (Exh. cat., Washington, DC.: The Phillips Collection, in association with Philip Wilson Publishers, 1998).

Cats. 13–14, pp. 108–11

1. See also W. 75, *Boats at Honfleur*, in a Zurich private collection, which seems to be closer to the large painting in factureand may have inspired its surface effects in combination with *Boats in the Port of Honfleur* and the two small studies.

Cats. 15–17, pp. 112–17

1. W. 87, *The Entrance to the Port of Honfleur*, 1868, Norton Simon Foundation, Pasadena, California

2. Émile Zola, "*Mon Salon,*" 1868, quoted by Gary Tinterow in *Origins of Impressionism*, op. cit., 426.

Cats. 18–20, pp. 118–23

1. Wildenstein 1991, letter 2687, p. 188. Quoted in *Origins of Impressionism*, 431.
2. Joel Isaacson, "Observation and Experiment in the Early Work of Monet," in John Rewald and Frances Weitzenhoffer, eds., *Aspects of Monet: A Symposium on the Artist's Life and Times* (New York: Harry N. Abrams, Inc., 1984), 22.
3. These possibilities have been explored by Sr. A. Gonzalez-Alba in a photo essay, "Monet en el Louvre: Estudio iconográfico de los lugares relacionados con las tres obras pintadas por Monet desde la Columnata del Louvre en 1867. This is presented online at www.flickr.com/photos/gonzalez-alba/sets/72157644746635101/with/14183779305/. I would like to acknowledge my indebtedness to his research.
4. Charles-Henri Plaut's views of Paris and its environs are collected in an album at the Bibliothèque Nationale, Paris.
5. Isaacson, op. cit., 24.
6. Isaacson, op. cit, 29.
7. See Theodore Reff, "Copyists in the Louvre, 1850–1870," *The Art Bulletin*, vol. 46, no. 4 (December 1964), 555–56.

Cats. 21–22, pp. 124–27

1. See Joseph Baillio's excellent essay, "Monet at Sainte-Adresse in 1867" in *Monet 1840–1926* (Exh. cat., Paris: Galeries Nationales, Grand Palais / Musée d'Orsay, 2010) 49–59, esp. 57.

Cat. 23, pp. 128–29

1. Adolphe Monet to Frédéric Bazille, 1867, as quoted by Ruth Butler, *Hidden in the Shadow of the Master* (New Haven and London: Yale University Press, 2008), 128.

Cats. 24–26, pp. 130–35

1. Léon Billot, "Exposition des Beaux-Arts," in *Journal du Havre*, October 9, 1868, quoted in John House, *Landscape into Art*, op. cit., 137.
2. These are W. 79–82.
3. Monet to Bazille, December 1868, quoted in Charles S. Moffett et al., *Impressionists in Winter: Effets de neige*, op. cit., 84.
4. Monet to Bazille, January 11, 1868, quoted by Gary Tinterow in *Origins of Impressionism*, op. cit., 438 (translation altered).

Cat. 27, pp. 136–37

1. See W. 22a, which Wildenstein states may have been painted as early as 1864.

Cats. 30–32, pp. 142–47

1. It is difficult for this author to agree with Wildenstein's dating of nos. 105 and 106 to 1868; a date of late 1869 would seem more likely. Compare cat. 26 in this volume.

2. See Gloria Groom, with research assistance by Genevieve Westerby, "Cat. 14. On the Bank of the Seine, Bennecourt, 1868," in *Monet Paintings and Drawings at the Art Institute of Chicago*, ed. Gloria Groom and Jill Shaw (Online publication: Art Institute of Chicago, 2014), para 14.

3. Groom, "Cat. 14. On the Bank of the Seine, Bennecourt, 1868," op. cit., para 17.

4. Guy de Maupassant, *La Femme de Paul*, quoted in Michael Wilson, "Monet's 'Bathers at La Grenouillère," *National Gallery Technical Bulletin*, vol. 5 (1981), 17.

5. Quoted in Colin B. Bailey, Christopher Riopelle et al., *Renoir Landscapes 1865–1883* (Exh. cat. London: National Gallery, 2007).

6. Ronald Pickvance, "La Grenouillère" in Rewald and Weitzenhoffer, *Aspects of Monet*, op. cit., 38 ff.

7. See Bailey and Riopelle, op. cit., 94.

8. The work is W. 136. See also Gary Tinterow in *Origins of Impressionism*, op. cit., 440.

Cats. 34–37, pp. 150–57

1. Thanks are due to Marnie Pillsbury and Peter Johnson for their kindness in providing information on and photography of this painting.

Cats. 38–41, pp. 158–63

1. Wildenstein 1974, letter 55

2. *Entrance to the Port of Trouville*, 1870 (W. 154) was shown in *The First Annual Exhibition of the Society of French Artists*, held at Durand-Ruel's German gallery in 1870.

3. Pissarro to Wynford Dewhurst, quoted in Kenneth McConkey and Anna Gruetzner Robins, *Impressionism in Britain* (New Haven and London: Yale University Press, 1995), 82.

4. Pissarro to Dewhurst, and to Lucien Pissarro, quoted in Kenneth McConkey and Anna Gruetzner Robins, *Impressionism in Britain*, op. cit., 82.

Cats. 42–47, pp. 164–71

1. Monet to Pissarro, June 2, 1871, quoted in *Monet in Holland* (exh. cat., Amsterdam: Rijksmuseum Vincent van Gogh, 1986) 15.

2. Monet to Pissarro, June 17, 1871, quoted in *Monet in Holland*, op. cit., 15.

3. Karl Baedeker. Belgium and Holland. Handbook for travellers, by K. Bædeker. With three maps and thirteen plans (Koblenz: K. Baedeker, 1869), 276.

Cats. 48–49, pp. 172–75

1. Ludovic Hans and J.-J. Blanc, *Guide à travers les ruines. Paris et ses environs, avec un plan détaillé.* (Paris: A. Lemerre, 1871)

2. The collector was one M. or Mme. Du Fresnay of Paris. See W. 193.

3. Paul Tucker, *Claude Monet: Life and Art* (New Haven and London: Yale University Press, 1995), 29. Tucker's studies of Monet's Argenteuil period are fundamental to any discussion of his works there.

Cat. 50, pp. 176–77

1. Pŏnka's comprehensive study of the painting is Anabelle Pŏnka et al., *Monet: A Bridge to Modernity* (exh. cat., Ottawa: National Gallery of Canada, 2015.). It informed the discussion here.

Cat. 51, pp. 178–79

1. See W. 202–204.

2. This is the Walters Art Gallery *Camille Monet Reading* or *The Reader*, W. 205.

3. Charles Bigot, "Causerie artistique: L'Exposition des 'intransigeants,' " *La Revue politique et littéraire*, April 8, 1876, 349–52, quoted in Ruth Berson, *The New Painting*, op. cit., II:60.

Cats. 52–53, pp. 180–83

1. This entry is based on a text by the author in Eliza E. Rathbone and George T. M. Shackelford, *Impressionist Still Life* (exh. cat., The Phillips Collection and Museum of Fine Arts, Boston, New York: Harry N. Abrams, Inc., 2001), 82–85.

2. See the provenance given for the paintings Wildenstein 1995, nos. 245, 244. *The Tea Service* was sent to auction in 1873 by Durand-Ruel but was either repurchased by him or unsold. It left his stock only in 1901.

3. Fantin-Latour to the painter Otto Scholderer, 1874, quoted by Rathbone in *Impressionist Still Life*, op. cit., 100.

Cats. 54–56, pp. 184–89

1. Tucker, *Monet: Life and Art*, op. cit., 60.

Selected Bibliography

Adhémar, Hélène, Anne Distel, and Sylvie Gache [-Patin]. *Hommage à Claude Monet (1840–1926)*. Exh. cat., Grand Palais, Paris, 1980.

Armstrong, Carol. *Manet/Manette*. New Haven and London: Yale University Press, 2002.

Aspects of Monet. A symposium on the Artist's Life and Times. Published under the direction of John Rewald and Frances Weitzenhoffer from a symposium organized in Paris in September 1981. New York: H. N. Abrams, 1984.

Bann, Stephen. *The Clothing of Clio*. Cambridge: Cambridge University Press, 1984.

Bann, Stephen. *Paul Delaroche: History Painted*. Princeton: Princeton University Press, 1997.

Baudelaire, Charles. *The Painter of Modern Life and Other Essays*. Translated by Jonathan Mayne. London: Phaidon, 1965.

Blanc, Charles. *Grammaire des arts du dessin*. Paris: Henri Laurens, 1880 [1867].

Blanc, Charles. "Salon de 1866." *Gazette des beaux-arts* 21 (July 1866).

Bomford, David, Jo Kirby, John Leighton, and Ashok Roy. *Art in the Making. Impressionism*. Exh. cat., National Gallery, London, 1991.

Brettell, Richard R. and Stephen Eisenman. *Nineteenth-Century Art in the Norton Simon Museum*. New Haven: Norton Simon Art Foundation/Yale University Press, 2006.

Brookner, Anita. *Watteau*. Paris: Odege, 1967.

Bryson, Norman. *Word and Image: French Painting of the Ancien Régime*. Cambridge: Cambridge University Press, 1981.

Burty, Philippe. "La forêt de Fontainebleau." *La renaissance littéraire et artistique* 27 (26 October 1872): 211–12.

Burty, Philippe. "Les paysages de M. Claude Monet." *La République français* (27 March 1883).

Callen, Anthea. *The Work of Art: Plein Air Painting and Artistic Identity in Nineteenth-century France*. London: Reaktion Books, 2015.

Champa, Kermit S. *The Rise of Landscape Painting in France: Corot to Monet*. Exh. cat., Currier Gallery of Art, Manchester, NH, 1991.

Chesneau, Ernest. "Le Réalisme et l'Esprit Français dans l'Art." In *L'Art et les Artistes Modernes en France et en Angleterre*, 3–41. Paris, 1864.

Chesneau, Ernest. *Les Nations Rivales dans l'Art*. Paris, 1868.

Clark, T. J. *Image of the People: Gustave Courbet and the 1848 Revolution*. Berkeley: University of California Press, 1999.

Claude Monet — A. Rodin. Exh. cat. galerie Georges Petit, Paris, 1889.

Claude Monet—August Rodin. Centenaire de l'exposition. Exh. cat., Musée Rodin, Paris, 1989.

Clemenceau, Georges. *Claude Monet : Les Nymphéas*. Paris, 1928.

Clément, Charles. "Les paysagistes français contemporains" (1853). In *Études sur les beaux-arts en France*. Paris: Michel Lévey frères, 1869.

Cochet, Vincent. "Les coulisses de Fontainebleau. Le service du palais et l'organisation des séjours," in *Napoléon III et Eugénie reçoivent à Fontainebleau, l'Art de vivre sous le Second Empire*. Exh. cat., Musée des Arts Décoratifs, Bordeaux, 2011–12.

Crow, Thomas E. *Painters and Public Life in Eighteenth-Century* Paris. New Haven and London: Yale University Press, 1985.

Daniel, Malcolm R. *Eugène Cuvelier: Photographer in the Circle of Corot*. Exh. cat., Metropolitan Museum of Art, New York, 1996.

Exposition Claude Monet. Exh. cat. galerie Georges Petit, Paris, 1898.

Flaubert, Gustave. *A Sentimental Education: The Story of a Young Man*. Translated with an introduction and notes by Douglas Parmée. Oxford and New York: Oxford University Press, 1989.

Fried, Michael. *Manet's Modernism: Or, The Face of Painting in the 1860s.* Chicago: The University of Chicago Press, 1996.

Gautier, Théophile. *Abécédaire du Salon de 1861.* Paris: E. Dentu, 1861.

Geffroy, Gustave. *Claude Monet: sa vie, son temps, son œuvre.* Paris: G. Crès, 1922.

Gillet, Louis. "L'Epilogue de l'impressionnisme: Les 'Nymphéas' de M. Claude Monet." *Revue Hebdomadaire* 8 (21 August 1909): 397–415. Goncourt, Edmond et Jules de. *L'art du XVIII^e siècle.* Paris: A Huot de Goncourt, 1873.

Gordon, Robert and Andrew Forge. *Monet.* Translated by Hélène Ternois. Paris: Flammario, 1984.

Gray, Gustave Le and Carleton E. Watkins. *Pioneers of Landscape Photography: Photographs from the Collection of the J. Paul Getty Museum.* Frankfurt am Main: Städtische Galerie, 1993.

Green, Nicholas. *The Spectacle of Nature: Landscape and Bourgeois Culture in Nineteenth-Century France.* Manchester and New York: Manchester University Press, 1990.

Greenberg, Clement. *Art and Culture: Critical Essays.* Boston: Beacon Press, 1961.

Greenberg, Clement. "Towards a Newer Laocöon." *Partisan Review* 7 (July–August 1940): 296–310.

Groom, Gloria ed. *Impressionism, Fashion, and Modernity.* Exh. cat., Metropolitan Museum of Art, New York, 2013.

Hansen, Dorothee. *Monet und Camillefrauenportraits Im Impressionismus.* Exh. cat., Kunsthalle, Bremen, 2005.

Herbert, Robert. *Impressionism, Art, Leisure and Parisian Society.* New Haven: Yale University Press, 1988.

Herbert, Robert. *Monet on the Normandy Coast: Tourism and Painting 1867-1886.* New Haven: Yale University Press, 1994.

Herring, Sarah. *Corot to Monet: French Landscape Painting.* Exh. cat., National Gallery, London 2009.

Holmes, Mary Tavener and Christoph Martin Vogtherr. *De Watteau à Fragonard: Les fêtes galantes.* Exh. cat., Musée Jacquemart André, Paris, 2014.

House, John. "Claude Monet. Le Déjeuner." In *Impressionistes: 6 chefs-d'oeuvre français,* 31–41. Exh. cat., Musée d'Orsay, Paris, 1999,

House, John. *Monet: Nature into Art.* New Haven and London: Yale University Press, 1986.

Isaacson, Joel. *Monet: Le déjeuner sur l'herbe.* New York: Viking Press, 1972.

Jacques, Edmond [Edmond Bazire]. "Beaux-arts. Rodin et Monet." *L'Intransigeant* (7 July 1889): 2–3.

Jones, Kimberly. *Impressionist and Post-Impressionist Masterpieces from the National Gallery of Art.* New York: Prestel Publishing, 2011.

Jones, Kimberley. *In the Forest of Fontainebleau: Painters and Photographers from Corot to Monet.* Exh. cat., National Gallery of Art, Washington, 2008.

Krauss, Rosalind. "Impressionism: The Narcissism of Light." *Partisan Review,* vol. 43, no. 1 (1976): 102–12.

Labreuche, Pascal. "The industrialization of artists' prepared canvas in nineteenth century Paris. Canvas and stretchers: technical developments up to the period of Impressionism." *Zeitschrift f'ur Kunsttechnologie und Konservierung,* vol. 22, no. 2 (2008): 316–328.

Labrusse, Rémi. *Matisse: la condition de l'image.* Paris: Gallimard, 1999.

Lacan, Ernest. "Revue de la Quinzaine." *Le Moniteur de la Photographie,* no. 3 (15 April 1861).

Lanoë, Georges. *Histoire de l'École française de paysage depuis Chintreuil jusqu'à 1900.* Nantes, 1905.

Lennet. "Le peintre et le sanglier." *La chasse illustrée*, no. 10, 2nd année (5 October 1868).

Levine, Steven Z. *Monet and his Critics*. New York and London: Garland Publishing, 1976.

Lochnan, Katharine, John House, Sylvie Patin, et al. *Turner, Whistler, Monet*. Exh. cat., Musées des beaux-arts de l'Ontario, Toronto; Grand Palais, Paris; Tate Britain, London, 2004–2005.

Mantz, Paul. *Salon de 1847*. Paris: Ferdinand Sartorius, 1847.

McNamara, Carol et al. *The Lens of Impressionism. Photography and Painting along the Normandy Coast, 1850–1874*. Exh. cat., University of Michigan Museum of Art, Ann Arbor, 2009.

Montabert, Paillot de. *Traité complet de peinture* (vol. IX). Paris, 1829.

Muir, Kimberley, Inge Fiedler, Don H. Johnson, and Robert G. Erdmann. "An In-depth Study of the Materials and Technique of Paintings by Claude Monet from the Art Institute of Chicago." *ICOM-CC 17th Triennial Meeting Preprints*, Melbourne, Sept. 15–19, 2014.

Nelson, Brian. "Introduction." In Emile Zola, *The Kill (La curée)*. Translated with an introduction by Brian Nelson. New York: Oxford University Press, 2004.

Newman, Barnett. "The First Man Was an Artist" (1947). In *Selected Writings and Interviews*, edited by John P. O'Neill. Berkeley: University of California Press, 1992.

Newman, Barnett. "Open Letter to William A. M. Burden, President of the Museum of Modern Art" (1953). In *Selected Writings and Interviews*, edited by John P. O'Neill. Berkeley: University of California Press, 1992.

Notter, Annick. *Fontainebleau, son château et sa forêt: L'invention d'un Tourisme (1820–1939)*. Paris: Éditions de la Réunion des musées nationaux, 2007.

Pernety, Antoine-Joseph. "Toile." In *Dictionnaire portatif de peinture, sculpture, gravure . . .* Paris, 1757.

Pickvance, Ronald and Zwolle Wanders. *Monet in Holland*. Exh. cat., Rijksmuseum Vincent van Gogh, Amsterdam, 1986.

Pilon, Edmond. *Fontainebleau*. Grenoble: B. Arthaud, 1931.

Poulain, Gaston. *Bazille et ses amis*. Paris: La Renaissance du Livre, 1932.

Roskill, Mark. "Early Impressionism and the Fashion Print." *The Burlington Magazine*, vol. 112, no. 807 (June 1970).

Scharf, Aaron. "Camille Corot and Landscape Photography." *Gazette des beaux-arts* 6, no. 59 (February 1962): 99–102.

Sheriff, Mary D., ed. *Antoine Watteau, Perspectives on the Artist and the Culture of his time*. Newark: University of Delaware Press, 2006.

Shiff, Richard. "He Painted." In *Cézanne's Card Players*, edited by Barnaby Wright and Nancy Ireson. London: Courtauld Gallery, 2010.

Spate, Virginia. *Claude Monet, la couleur du temps*. Translated by Élisabeth Servan-Schreiber and Denis-Armand Canal. Paris: Chêne, 1993.

Stevenson, Robert Louis. *Picturesque Notes on Edinburgh: Memories of Fontainebleau: Random Memories*. London: Nash & Grayson, 1930.

Stuckey, Charles F. with Sophia Shaw. *Claude Monet: 1840–1926*. Exh. cat., Art Institute of Chicago, 1995.

Stuckey, Charles F. ed. *Monet: A Retrospective*. New York: Hugh Lauter Levin Associates, Inc., 1985.

Thiébault-Sisson, François. "Claude Monet, les années d'épreuves." *Le Temps* (26 November 1900). Reprinted Claude Monet, *Mon histoire, recueillie par Thiébault-Sisson*, Paris: L'Échoppe, 1998.

Thiébault-Sisson, François. "Les Nymphéas de Claude Monet à l'Orangerie des Tuileries." *La revue de l'art ancien et moderne*, T. LII (June 1927).

Thomson, Richard. "Reconstruction and Reassurance: Representing the Aftermath of the Franco-Prussian War." In *Monet. A Bridge to Modernity*, edited by Anabelle Kienle Ponka. Ottawa: National Gallery of Canada, 2015.

Tinterow, Gary, et. al. *Corot*. New York: Metropolitan Museum of Art, 1996.

Tinterow, Gary and Henri Loyrette. *Origins of Impressionism*. New York: Metropolitan Museum of Art, 1994.

Titeux, Gilbert. *Au temps du brame—: les representations de la chasse dans l'oeuvre de Gustave Courbet et dans la peinture allemande du XIX siècle : 1800–1900*. Dijon, France: Presses du réel, 2014.

Trévise, Duc de. "Le pèlerinage de Giverny." *La revue de l'art ancien et moderne*, v. LI, no. 283 (January–May 1927).

Tucker, Paul Hayes. *Claude Monet: Life and Art*. New Haven: Yale University Press, 1995.

Tucker, Paul Hayes. *Monet at Argenteuil*. New haven and London: Yale University Press, 1984.

Tucker, Paul Hayes. *Monet in the '90s: The Series Paintings*. Boston: Museum of Fine Arts, 1990.

Unruh, Allison. "Aspiring to *la vie galante* : Reincarnations of Rococo in Second Empire France." PhD diss., New York University, 2008.

Vollard, Ambroise. *En écoutant Cézanne, Degas, Renoir*. Paris: Grasset, 1938.

Wagner, Anne M. "Why Monet Gave up Figure Painting." *The Art Bulletin*, vol. 76, no. 4 (December 1994): 612–629.

Wikenden, Robert J. "Charles-François Daubigny." *The Century Magazine* vol. XLIV, no. 3 (July 1892).

Wildenstein, Daniel with Rodolphe Walter, France Daguet, Madeleine Manigler, Michèle Paret, et al. *Claude Monet: biographie et catalogue raisonné*. 5 vols. Lausanne and Paris: La Bibliothèque des arts, 1974–1991.

Wildenstein, Daniel with Nicole Castais, Annie Champié, Marie-Christine Decroocq, Elisabeth Raffy, et al. *Monet, or, The Triumph of Impressionism*. 4 vols. Köln: Taschen; Paris: Wildenstein Institute, 1996.

Wilson-Bareau, Juliet, Henri Loyrette, Philip Conisbee, et al. *Manet, Monet: la gare Saint-Lazare*. Exh. cat., Musée d'Orsay, Paris; National Gallery of Art, Washington, 1998.

Wölfflin, Heinrich. *Principles of Art History*. Translated by M. D. Hottinger. New York: Dover, 1950 [1915].

Zola, Émile. "Mon Salon." *L'Evénement* (11 May 1866). In Zola, E. *Le Bon Combat: de Courbet aux Impressionnistes*, edited by Jean-Paul Bouillon. Paris, 1974.

Zola, Émile. "Mon Salon." *L'Evénement illustré* (24 May 1868). In Zola, É. *Le Bon Combat: de Courbet aux Impressionnistes*, edited by Jean-Paul Bouillon. Paris, 1974.

Checklist of Works in the Exhibition

Cat. 1
View Near Rouelles
1858, oil on canvas
18 x 25 ½ in. (46 x 65 cm)
Marunuma Art Park, Asaka, Japan

Cat. 2
Farmyard in Normandy
1863, oil on canvas
25 ⅝ x 32 ⅛ in. (65.2 x 81.5 cm)
Musée d'Orsay, Paris

Cat. 3
Towing of a Boat at Honfleur
1864, oil on canvas
21 ¾ x 32 ⅜ in. (55.2 x 82.1 cm)
Memorial Art Gallery of the University of Rochester, New York
Gift of Marie C. and Joseph C. Wilson

Cat. 4
Le Phare de l'Hospice
1864, oil on canvas
21 ¼ x 31 ⅞ in. (54 x 81 cm)
Kunsthaus Zürich

Cat. 5
The Pointe de la Hève at Low Tide
1865, oil on canvas
35 ½ x 59 ¼ in. (90.2 x 150.5 cm)
Kimbell Art Museum, Fort Worth, Texas

Cat. 6
Grainstacks at Chailly at Sunrise
1865, oil on canvas
11 ⅞ x 23 ⅝ in. (30.16 x 60.48 cm)
San Diego Museum of Art

Cat. 7
The Pavé de Chailly in the Forest of Fontainebleau
1865, oil on canvas
38 ¼ x 51 ⅜ in. (97 x 130.5 cm)
Ordrupgaard, Copenhagen

Cat. 8
An Oak at Bas-Bréau (The Bodmer)
1865, oil on canvas
21 ⅜ x 16 ⅛ in. (54.4 x 41 cm)
Private collection

Cat. 9.
Luncheon on the Grass
1865–66, oil on canvas
Left panel: 164 ⅝ x 59 in. (418 x 150 cm); central panel: 97 ⅞ x
85 ⅞ in. (248.7 x 218 cm)
Musée d'Orsay, Paris

Cat. 10
The Cradle – Camille with the Artist's Son Jean
1867, oil on canvas
45 ¾ x 34 ⅞ in. (116.2 x 88.8 cm)
National Gallery of Art, Washington, DC
Collection of Mr. and Mrs. Paul Mellon

Cat. 11
Jean Monet Sleeping
1868, oil on canvas
16 ¾ x 19 ⅝ in. (42.5 x 50 cm)
Ny Carlsberg Glyptotek, Copenhagen

Cat. 12
The Red Kerchief
c. 1869, oil on canvas
38 ⅞ x 31 ⅜ in. (99 x 79.8 cm)
The Cleveland Museum of Art
Bequest of Leonard C. Hanna, Jr.

Cat. 13
Boats in the Port of Honfleur
1866, oil on canvas
19 ⅝ x 25 ⅝ in. (49 x 65 cm)
Ann and Gordon Getty

Cat. 14
Fishing Boats
1866, oil on canvas
17 ¾ x 21 ⅝ in. (45 x 55 cm)
Private collection

Cat. 15
The Green Wave
c. 1866–67, oil on canvas
19 1/8 x 25 1/2 in. (48.6 x 64.8 cm)
The Metropolitan Museum of Art, New York
H.O. Havemeyer Collection, Bequest of Mrs. H.O. Havemeyer

Cat. 16
Seascape
c. 1866–67, oil on canvas
16 7/8 x 23 3/8 in. (43 x 59.5 cm)
Ordrupgaard, Copenhagen

Cat. 17
Seascape, Storm
c. 1866–67, oil on canvas
19 1/8 x 25 3/8 in. (48.7 x 64.6 cm)
Sterling and Francine Clark Art Institute, Williamstown, Massachusetts
Acquired in 1950 by Sterling and Francine Clark

Cat. 18
Saint-Germain l'Auxerrois
1867, oil on canvas
31 1/8 x 38 5/8 in. (79 x 98 cm)
Staatliche Museen zu Berlin, Alte Nationalgalerie

Cat. 19
Quai du Louvre
1867, oil on canvas
25 5/8 x 36 1/4 in. (65 x 92 cm)
Gemeentemuseum Den Haag

Cat. 20
The Garden of the Princess
1867, oil on canvas
35 7/8 x 24 3/8 in. (91 x 62 cm)
Allen Memorial Art Museum, Oberlin College, Ohio
R. T. Miller, Jr. Fund
Fort Worth only

Cat. 21
A Hut at Sainte-Adresse
1867, oil on canvas
20 1/2 x 24 3/8 in. (52 x 62 cm)
Musées d'Art and d'Histoire de la Ville de Genève, Switzerland

Cat. 22
Sailboats at Sea
1868, oil on canvas
19 5/8 x 24 in. (50 x 61 cm)
Musée cantonal des Beaux-Arts, Lausanne, Switzerland
Bequest of Edwige Guyot, 2006

Cat. 23
Adolphe Monet Reading in a Garden
1866, oil on canvas
31 7/8 x 38 in. (81 x 99 cm)
Courtesy of the Larry Ellison Collection

Cat. 24
A Cart on the Snowy Road at Honfleur
1865, oil on canvas
25 5/8 x 36 3/8 in. (65 x 92.5 cm)
Musée d'Orsay, Paris

Cat. 25
The Magpie
1869, oil on canvas
35 1/8 x 51 1/8 in. (89 x 130 cm)
Musée d'Orsay, Paris

Cat. 26
The Seine at Bougival
1869, oil on canvas
19 3/4 x 25 5/8 in. (50 x 65 cm)
Private collection, care of Gladwell & Patterson

Cat. 27
La Porte d'Amont, Étretat
c. 1868–69, oil on canvas
31 1/8 x 38 3/4 in. (79.1 x 98.4 cm)
Harvard Art Museums/Fogg Museum, Cambridge, Massachusetts
Gift of Mr. and Mrs. Joseph Pulitzer, Jr.
San Francisco only

Cat. 28
Still Life with Flowers and Fruit
1869, oil on canvas
39 1/2 x 32 in. (100.3 x 81.3 cm)
The J. Paul Getty Museum, Los Angeles

Cat. 29
Red Mullets
1869, oil on canvas
14 x 19 ³⁄₄ in. (35.5 x 50 cm)
Harvard Art Museums/Fogg Museum, Cambridge, Massachusetts
Friends of the Fogg Art Museum Fund

Cat. 30
On the Bank of the Seine, Bennecourt
1868, oil on canvas
32 ¹⁄₈ x 39 ⁵⁄₈ in. (81.5 x 100.7 cm)
The Art Institute of Chicago
Potter Palmer Collction

Cat. 31
Bathers at La Grenouillère
1869, oil on canvas
28 ³⁄₄ x 36 ¹⁄₄ in. (73 x 92 cm)
The National Gallery, London
Bequeathed by Mrs. M. S. Walzer as part of the Richard and Sophie
Walzer Bequest, 1979

Cat. 32
La Grenouillère
1869, oil on canvas
29 ³⁄₈ x 39 ¹⁄₄ in. (74.6 x 99.7 cm)
The Metropolitan Museum of Art, New York
H. O. Havemeyer Collection, Bequest of Mrs. H. O. Havemeyer, 1929

Cat. 33
The Bridge at Bougival
1869, oil on canvas
25 ³⁄₄ x 36 ³⁄₈ in. (65.4 x 92.4 cm)
Currier Museum of Art, Manchester, New Hampshire
Museum purchase, Currier Funds, 1949

Cat. 34
The Beach at Trouville
1870, oil on canvas
21 ¹⁄₄ x 25 ¹⁄₂ in. (54 x 64.8 cm)
Wadsworth Atheneum Museum of Art, Hartford, Connecticut
The Ella Gallup Sumner and Mary Catlin Sumner Collection Fund

Cat. 35
Camille on the Beach
1870, oil on canvas
11 x 5 ¹⁄₂ in. (28 x 14 cm)
Musée Marmottan Monet, Paris

Cat. 36
Camille on the Beach at Trouville
1870, oil on canvas
15 x 18 ¹⁄₄ in. (38.1 x 46.4 cm)
Yale University Art Gallery, New Haven, Connecticut
Collection of Mr. and Mrs. John Hay Whitney, B.A., 1926, Hon. 1956

Cat. 37
On the Beach at Trouville
1870, oil on canvas
15 x 18 ¹⁄₈ in. (38 x 46 cm)
Musée Marmottan Monet, Paris

Cat. 38
Meditation, Madame Monet Sitting on a Sofa
1870–71, oil on canvas
18 ⁷⁄₈ x 29 ¹⁄₂ in. (48 x 75 cm)
Musée d'Orsay, Paris

Cat. 39
Hyde Park
1871, oil on canvas
15 ⁷⁄₈ x 29 ¹⁄₈ in. (40.5 x 74 cm)
Museum of Art, Rhode Island School of Design, Providence
Gift of Mrs. Murray S. Danforth

Cat. 40
Green Park
1871, oil on canvas
13 ¹⁄₂ x 28 ¹⁄₂ in. (34.3 x 72.5 cm)
Philadelphia Museum of Art
Purchased with the W. P. Wilstach Fund, 1921

Cat. 41
Boats in the Port of London
1871, oil on canvas
18 ¹⁄₂ x 28 ³⁄₈ in. (47 x 72 cm)
Private collection
Fort Worth only

Cat. 42
View of a Port
1871, oil on canvas
19 ³⁄₄ x 25 ⁵⁄₈ in. (49.8 x 65 cm)
Private collection

Cat. 43
Windmills in Holland
1871, oil on canvas
19 x 29 in. (48.3 x 73.7 cm)
William I. Koch Collection
Fort Worth only

Cat. 44
A Windmill at Zaandam
1871, oil on canvas
19 x 29 in. (48.5 x 73.5 cm)
Daniel Katz Gallery, London
Fort Worth only

Cat. 45
The Port of Zaandam
1871, oil on canvas
18 1/2 x 29 1/8 in. (47 x 74 cm)
Private collection

Cat. 46
Houses by the Zaan at Zaandam
1871, oil on canvas
18 3/4 x 29 in. (47.5 x 73.5 cm)
Städel Museum, Frankfurt am Main

Cat. 47
The Landing Stage
1871, oil on canvas
21 1/4 x 29 1/8 in. (54 x 74 cm)
Acquavella Galleries, New York

Cat. 48
The Pont Neuf in Paris
1871, oil on canvas
21 x 28 3/4 in. (53.34 x 73.03 cm)
Dallas Museum of Art
The Wendy and Emery Reves Collection

Cat. 49
The Old Rue de la Chausée, Argenteuil
1872, oil on canvas
21 5/8 x 28 3/4 in. (55 x 73 cm)
Private collection

Cat. 50
The Wooden Bridge
1872, oil on canvas
21 1/4 x 28 3/4 in. (54 x 73 cm)
VKS Art Inc., Ottawa

Cat. 51
Apple Trees in Blossom
1872, oil on canvas
22 1/2 x 27 1/8 in. (57 x 69 cm)
Union League Club of Chicago

Cat. 52
Still Life with Melon
1872, oil on canvas
20 7/8 x 28 3/4 in. (53 x 73 cm)
Museu Calouste Gulbenkian, Lisbon

Cat. 53
The Tea Service
1872, oil on canvas
20 7/8 x 28 3/8 in. (53 x 72 cm)
Private collection
Fort Worth only

Cat. 54
Argenteuil
1872, oil on canvas
19 7/8 x 25 5/8 in. (50.4 x 65.2 cm)
National Gallery of Art, Washington, DC
Ailsa Mellon Bruce Collection

Cat. 55
The Port at Argenteuil
1872, oil on canvas
23 5/8 x 31 3/4 in. (60 x 80.5 cm)
Musée d'Orsay, Paris

Cat. 56
Regatta at Argenteuil
1872, oil on canvas
18 7/8 x 29 1/2 in. (48 x 75.3 cm)
Musée d'Orsay, Paris

Photography Credits

All image rights belong to the works' respective owners unless otherwise indicated.

Archives Larousse, Paris / Bridgeman Images
Fig. 71

Photo: Anders Sune Berg
Cat. 16

© Bibliothèque nationale de France
Figs. 25, 38, 102

bpk, Berlin / Nationalgalerie / Jörg P. Anders / Art Resource, NY
Cat. 18

Bridgeman-Giraudon / Art Resource, NY
Fig. 72

Bridgeman Images
Cats. 4, 6, 17, 20, 29, 35, 36, 37; figs. 1, 17, 18, 20, 23, 24, 26, 35, 42, 56, 62–64, 67, 75, 81, 83, 84, 97, 109, 115

© The Calouste Gulbenkian Foundation / Scala / Art Resource
Cat. 52

Cameraphoto Arte, Venice / Art Resource, NY
Cats. 19, 46

Photo © Christie's Images / Bridgeman Images
Frontispiece; cat. 43; figs. 30, 35, 36

Photo courtesy Christie's Images
Cats. 45, 49

Photo: J.-C. Ducret, Musée cantonal des Beaux-Arts, Lausanne
Cat. 22

© Harvard Art Museum / Art Resource, NY. Photo: Katya Kallsen
Fig. 27

Photo: Pernille Klemp
Cat. 7

Photograph by Robert LaPrelle / © Kimbell Art Museum
Cat. 5

Photo © Lefevre Fine Art Ltd., London / Bridgeman Images
Cat. 41

Erich Lessing / Art Resource, NY
Front cover; cats. 11, 12; figs. 2, 60, 99

Digital Image © 2016 Museum Associates / LACMA. Licensed by Art Resource, NY
Fig. 65

Photo © National Gallery of Canada, Ottawa
Cat. 50

© National Gallery, London / Art Resource
Fig. 15

© 2016 The Barnett Newman Foundation, New York / Artists Rights Society (ARS), New York / photo courtesy Bridgeman Images
Fig. 61

Noortman Master Paintings, Amsterdam / Bridgeman Images
Cat. 1

The Philadelphia Museum of Art / Art Resource, NY
Cat. 40

© RMN-Grand Palais / Art Resource, NY
Cats. 2, 9, 24, 25, 38, 55, 56; figs. 3, 6, 14, 48, 58, 73, 76, 77, 79, 82, 88, 93, 120

Scala / White Images / Art Resource, NY
Back cover; cats. 30, 33, 34

Photograph courtesy Service de Documentation, Musée d'Orsay
Fig. 4/31

The Stapleton Collection / Bridgeman Images
Fig. 69

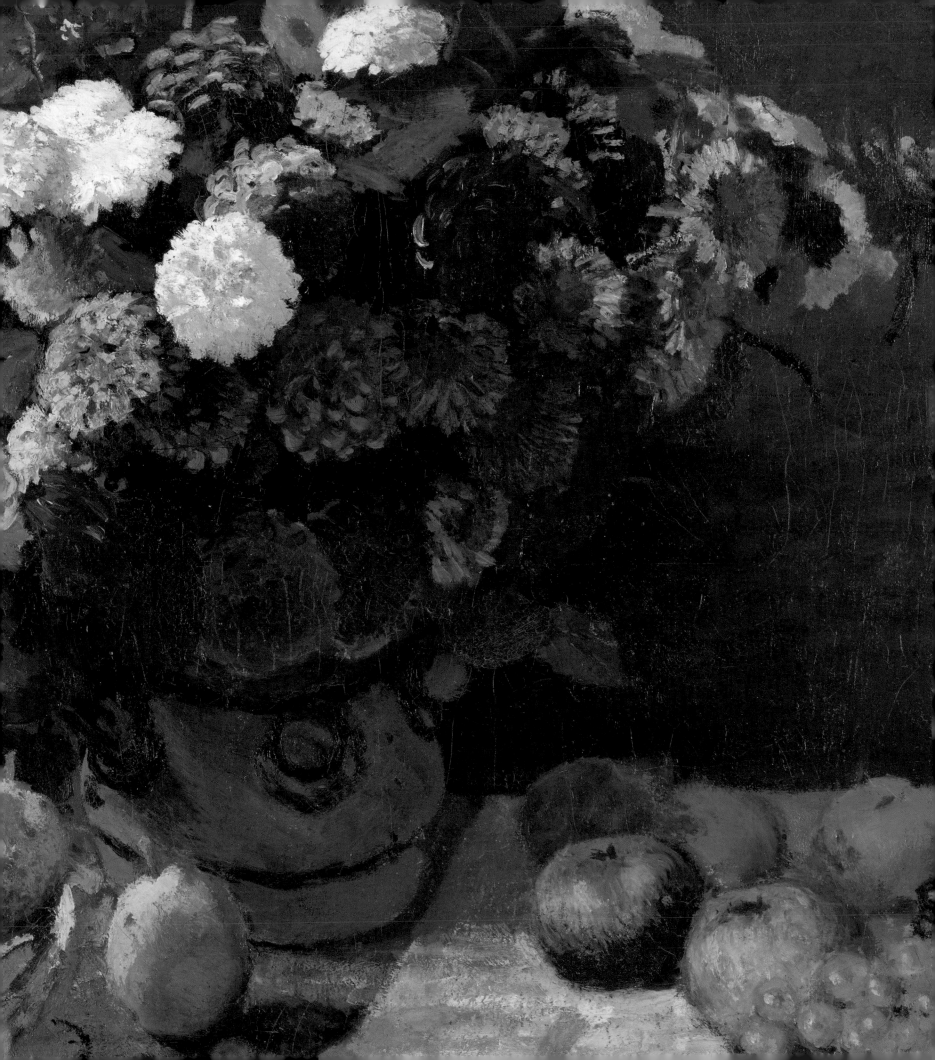